THE
GRANDMA MOSES
AMERICAN SONGBOOK

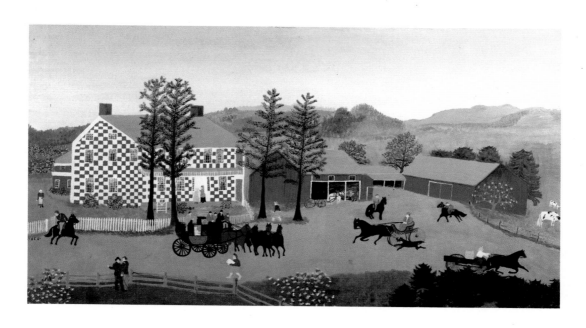

THE OLD CHECKERED HOUSE

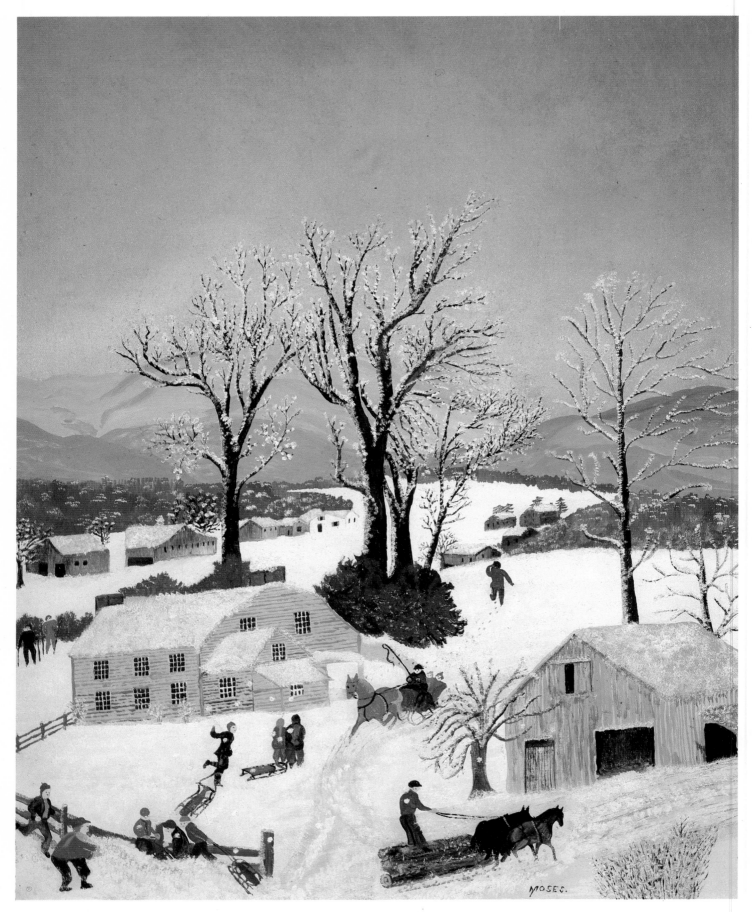

SNOWBALLING

THE GRANDMA MOSES AMERICAN SONGBOOK

Paintings by Grandma Moses

Music arranged for piano and guitar by Dan Fox

Harry N. Abrams, Inc., Publishers

New York

The Publishers wish to thank Jane Kallir and Hildegard Bachert
of the Galerie St. Etienne for their generous cooperation and
Jim Levas of The New York Public Library (Music Research
Division) for his assistance.

Music engraving by Hal Leonard Publishing Corporation,
Milwaukee, Wisconsin

Editors:
Ruth Eisenstein
Lois Brown

Designers:
Betsy Perlman and Tina Strasberg

Library of Congress Cataloging in Publication Data
Main entry under title:

The Grandma Moses American songbook.

For voice and piano; with chord symbols.
Includes index.
1. Music—United States. 2. Songs, English—United
States. 3. Folk-songs, English—United States. 4. Music,
Popular (Songs, etc.)—United States. I. Moses,
Grandma, 1860–1961, ill. II. Fox, Dan. arr.
M1629.G693 1985 85–750799
ISBN 0–8109–0990–1

R
784.5

Printed and bound in Japan

On the Cover: THE BARN DANCE

DOWN MEMORY LANE

ALL FOR LOVE

THE BIRDS AND THE BEASTS WERE THERE

UPWARD AND ONWARD

BUT ONCE A YEAR

OF THEE I SING

A LITTLE WORK

A LITTLE PLAY

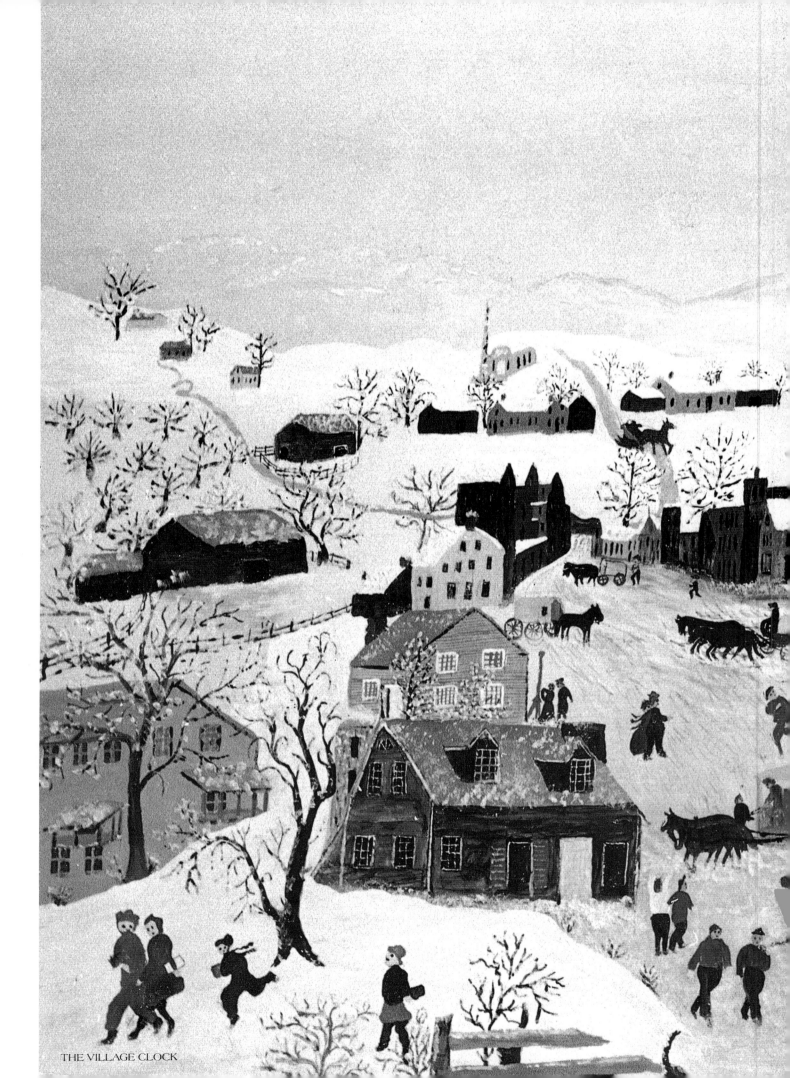

THE VILLAGE CLOCK

DOWN
MEMORY LANE

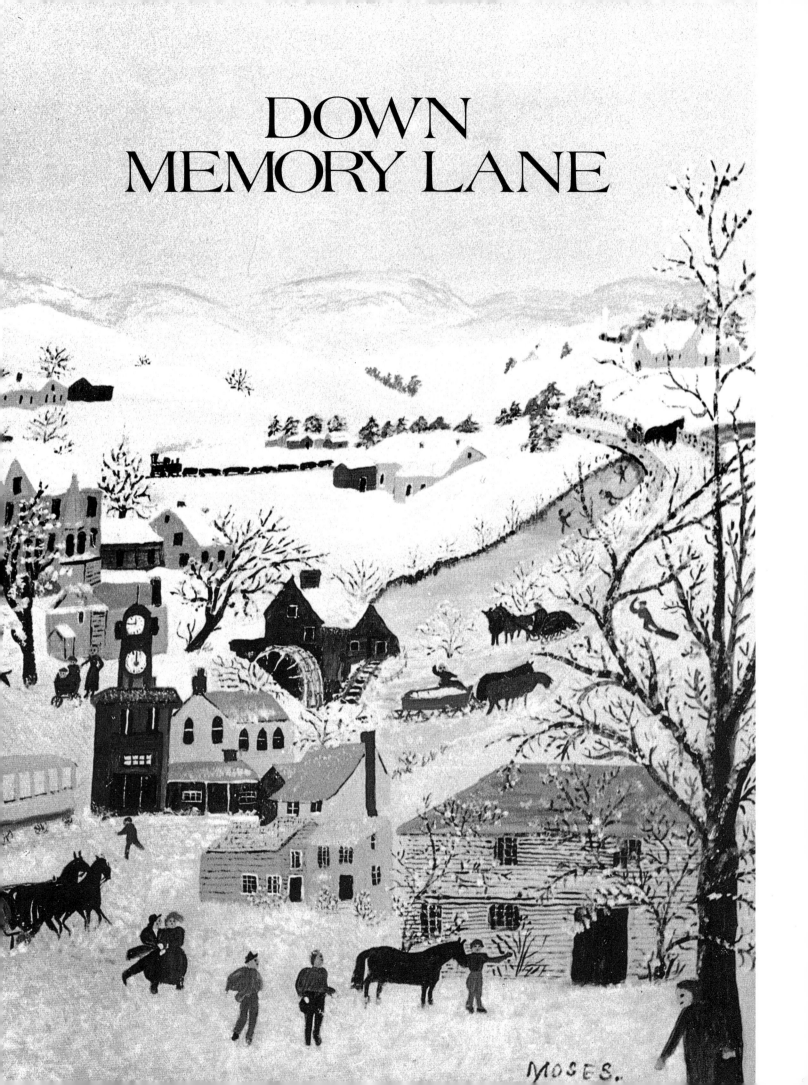

MOSES.

AULD LANG SYNE

Words and music by Robert Burns

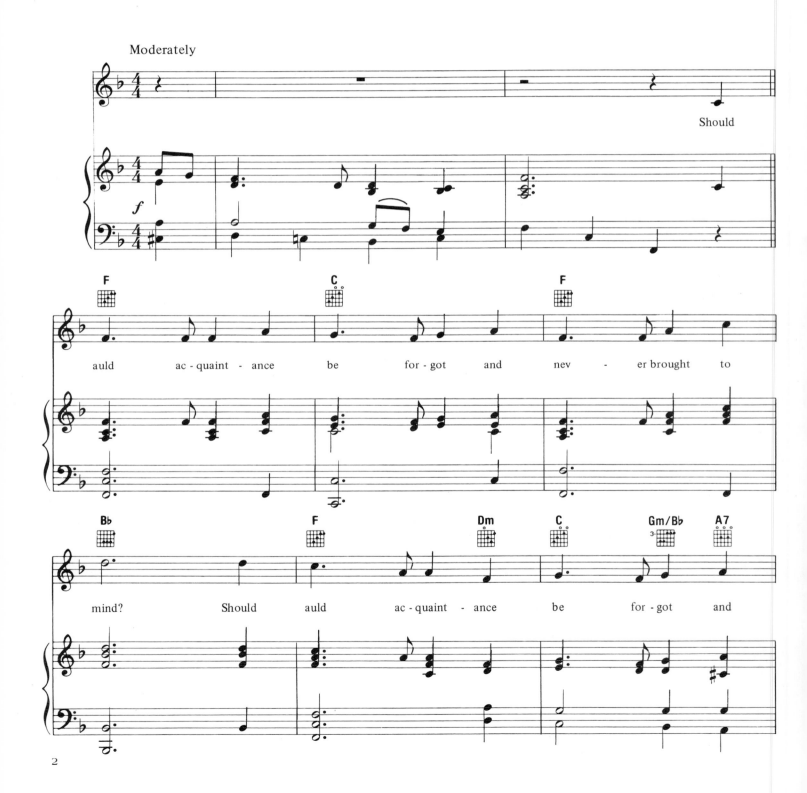

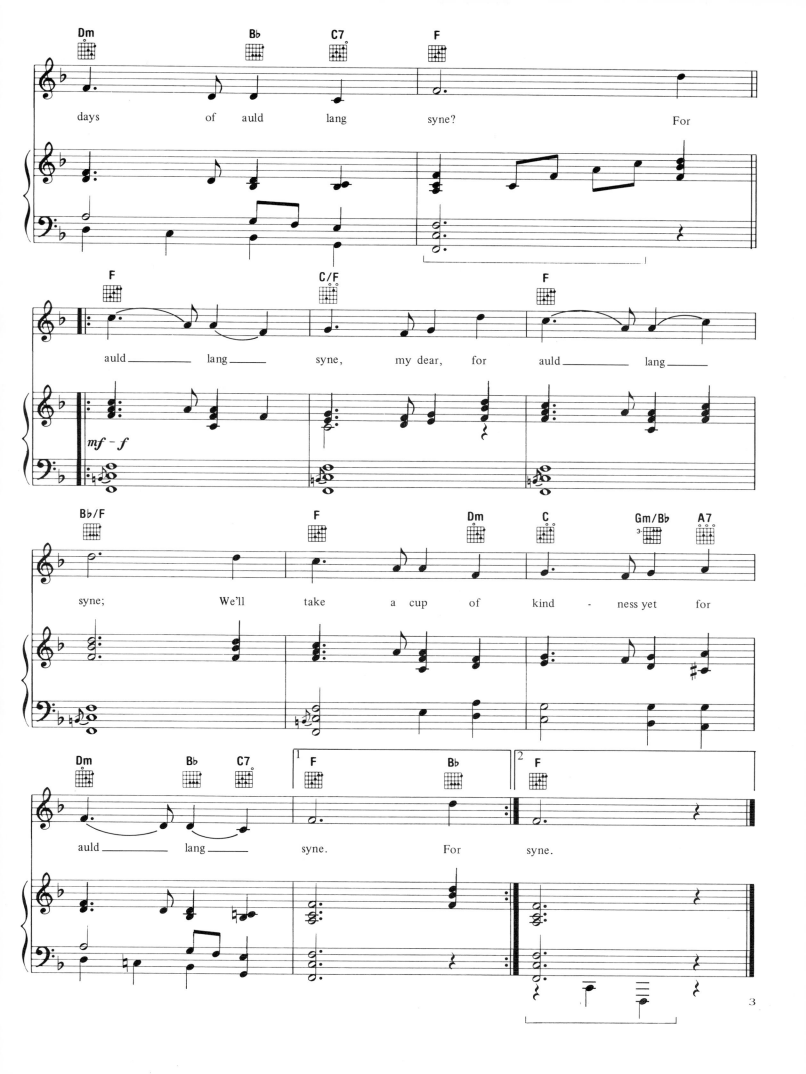

days of auld lang syne? For

auld _____ lang _____ syne, my dear, for auld _____ lang _____

syne; We'll take a cup of kind - ness yet for

auld _____ lang _____ syne. For syne.

GRANDFATHER'S CLOCK

Words and music by Henry C. Work

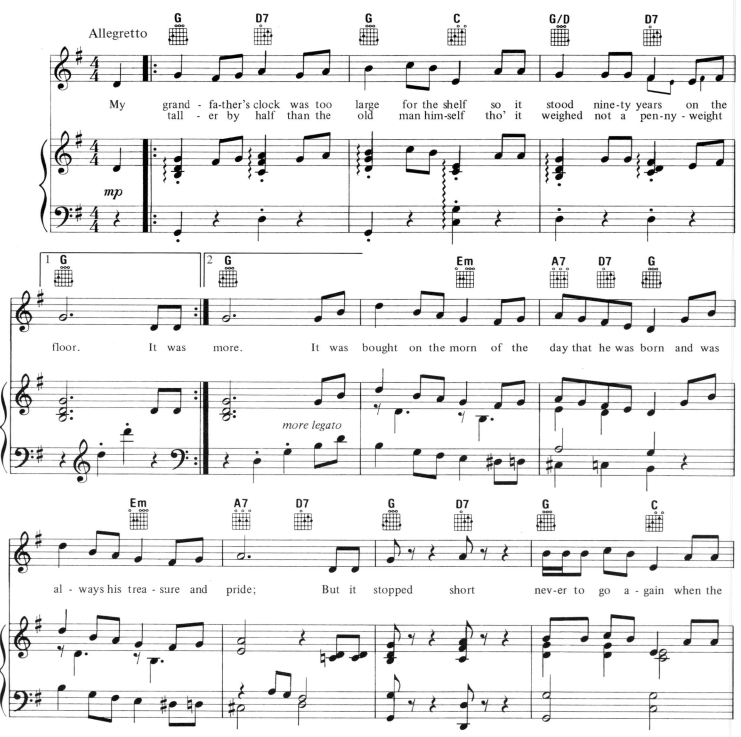

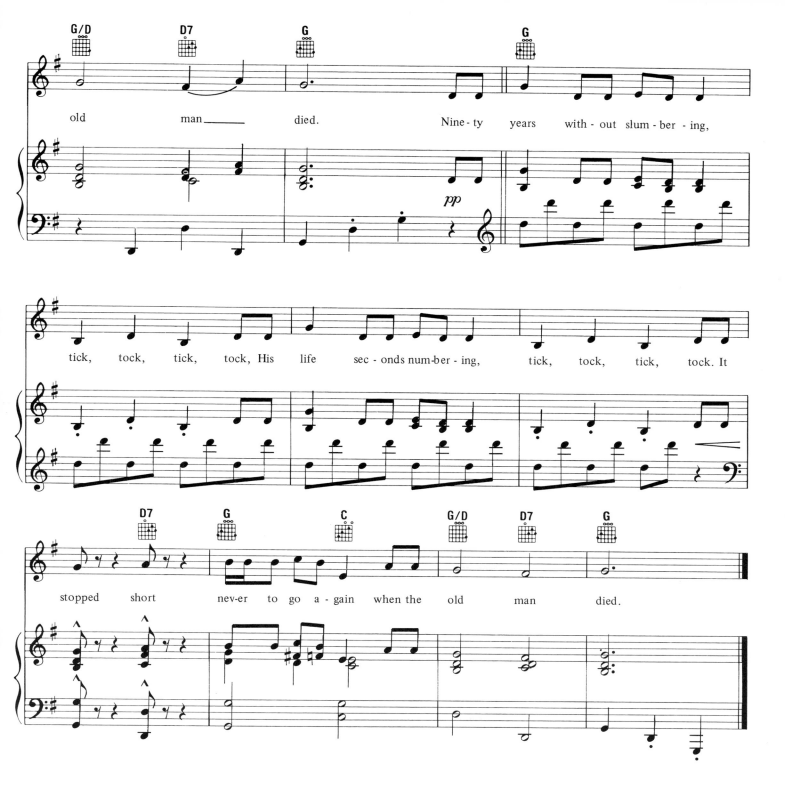

old man____ died. Nine-ty years with-out slum-ber-ing, tick, tock, tick, tock, His life sec-onds num-ber-ing, tick, tock, tick, tock. It stopped short nev-er to go a-gain when the old man died.

In watching its pendulum swing to and fro,
Many hours had he spent while a boy;
And in childhood and manhood the
 clock seemed to know,
And to share both his grief and his joy.
For it struck twenty-four when he entered
 at the door,
With a blooming and beautiful bride.

My grandfather said that of those he could hire,
Not a servant so faithful he found;
For it wasted no time, and had but one desire,
At the close of each week to be wound.
And it kept in its place, not a frown upon its face,
And its hands never hung by its side.

It rang an alarm in the dead of the night,
An alarm that for years had been dumb;
And we knew that his spirit was pluming its flight,
That his hour of departure had come.
Still the clock kept the time, with a soft
 and muffled chime,
As we silently stood by his side.

HOME! SWEET HOME!

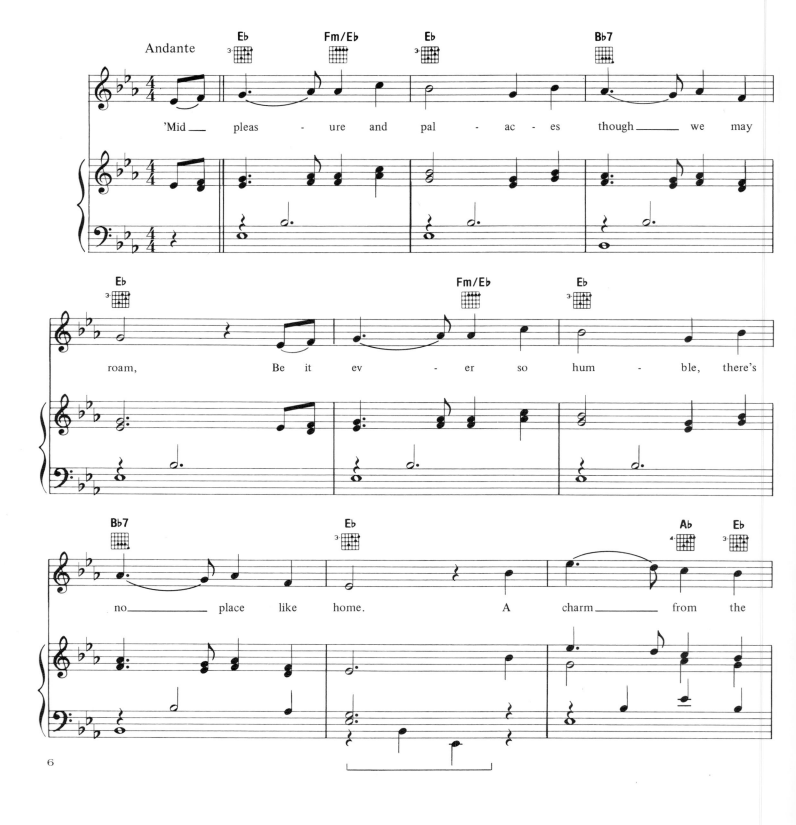

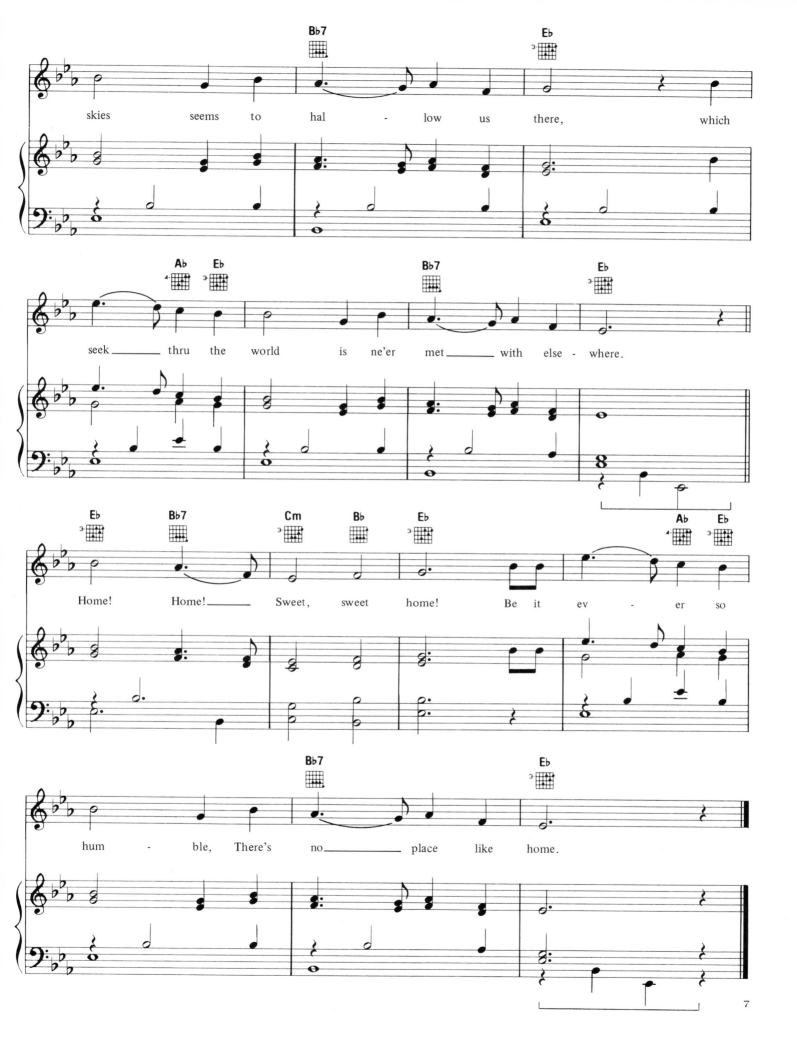

skies seems to hal - low us there, which seek _____ thru the world is ne'er met _____ with else - where. Home! Home! _____ Sweet, sweet home! Be it ev - er so hum - ble, There's no _____ place like home.

IN A LITTLE RED BARN

Words and music by Joe Young, Jean Schwartz, and Milton Ager

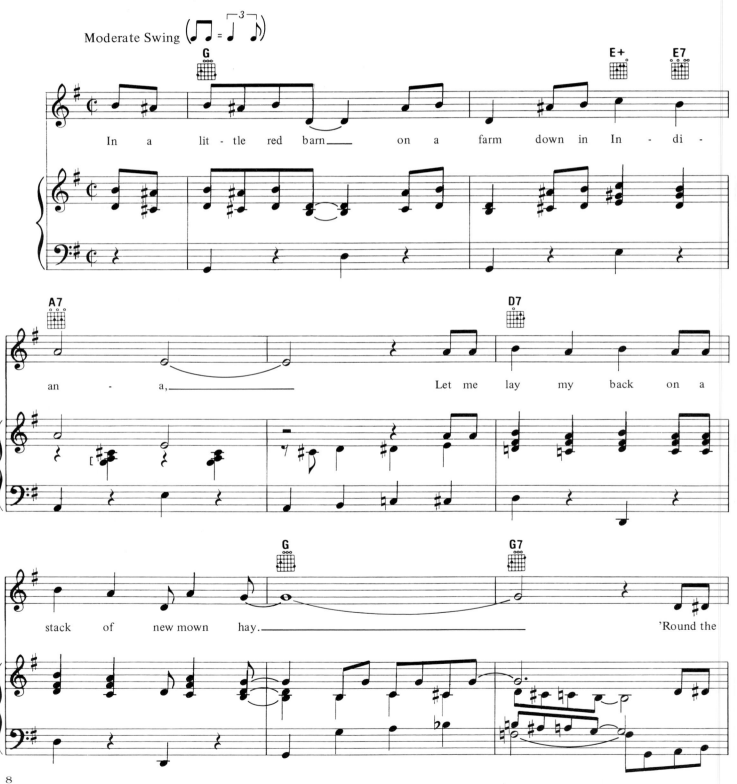

barn - yard where the farm - yard folks are pal - ly,

Let me dil - ly dal - ly all the live long day. ____

I'm a Hoo - sier who's blue, ___ thru and thru, and my heart is pin - ing _____ For the

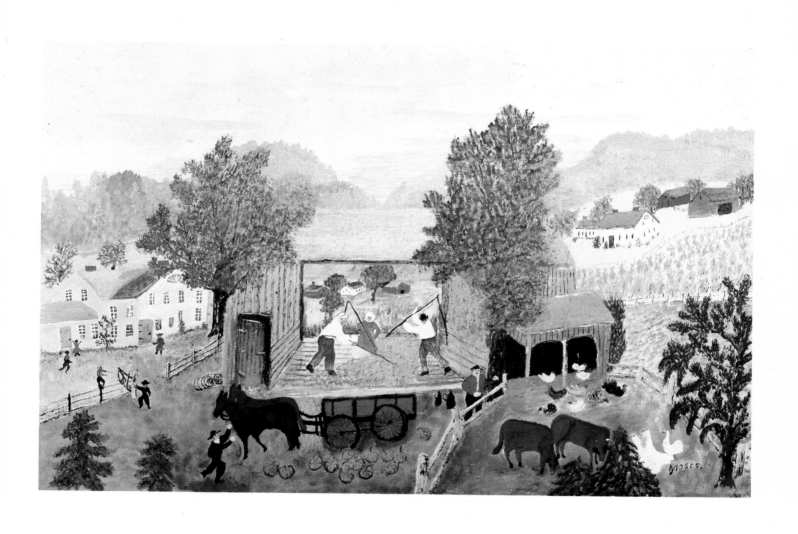

PUMPKINS

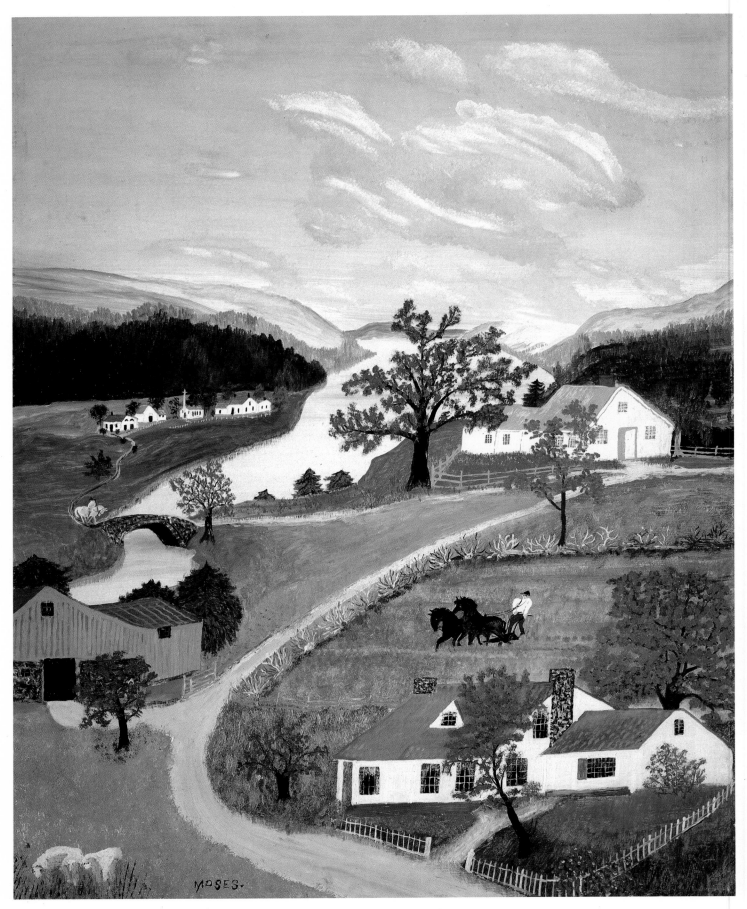

THE SPRING IN EVENING

JUST A SONG AT TWILIGHT

Words by G. Clifton Bingham
Music by J.L. Molloy

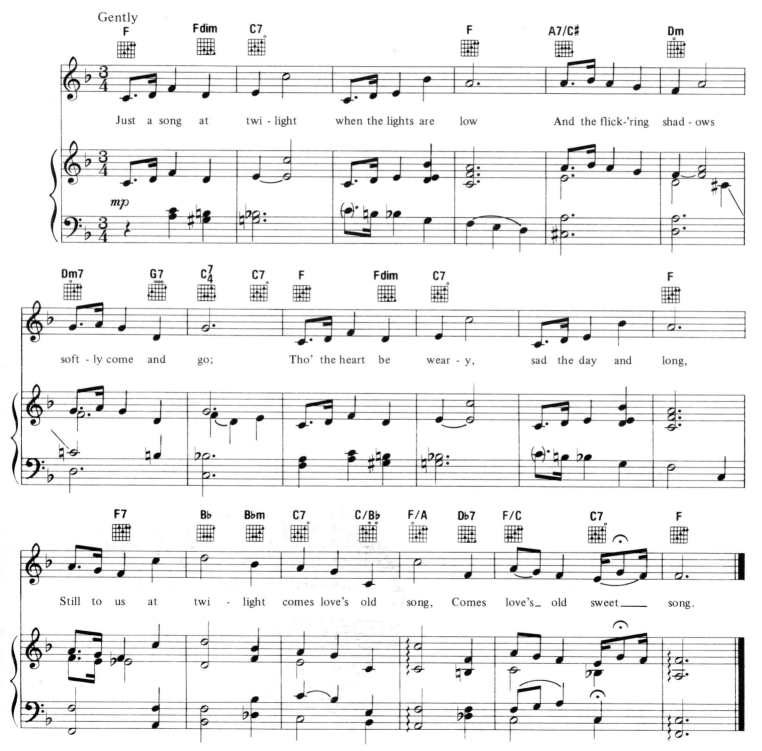

IN THE GLOAMING

Words by Meta Orred
Music by Annie Fortescue Harrison (Lady Arthur Hill)

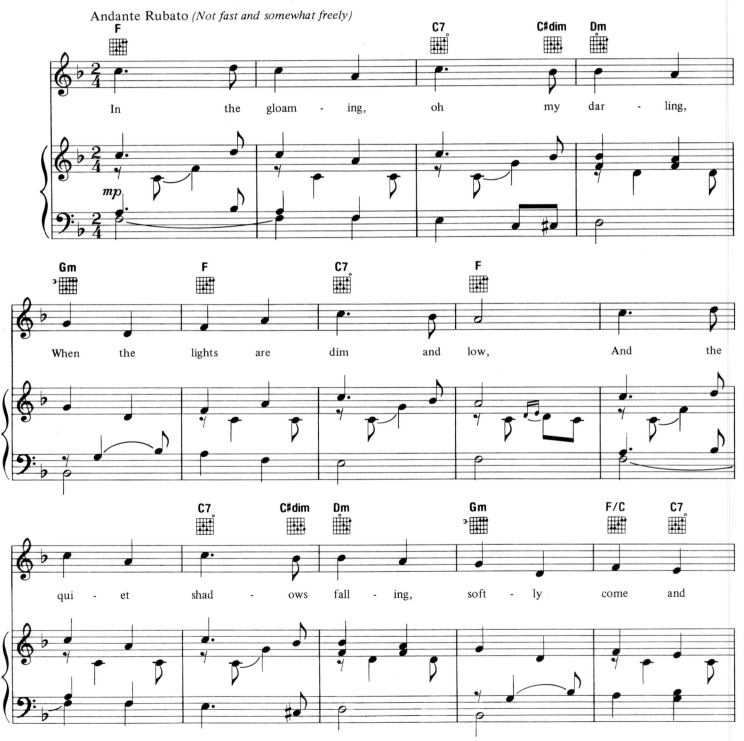

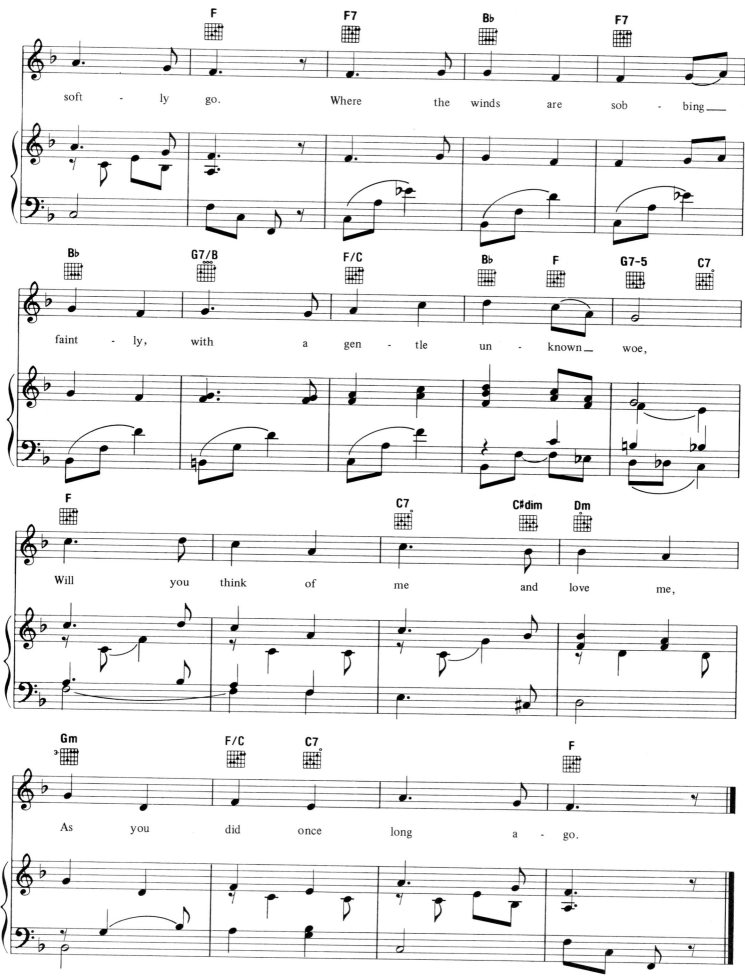

soft - ly go. Where the winds are sob - bing

faint - ly, with a gen - tle un - known woe,

Will you think of me and love me,

As you did once long a - go.

LISTEN TO THE MOCKING BIRD

Words by Alice Hawthorne (pseud. of Septimus Winner)

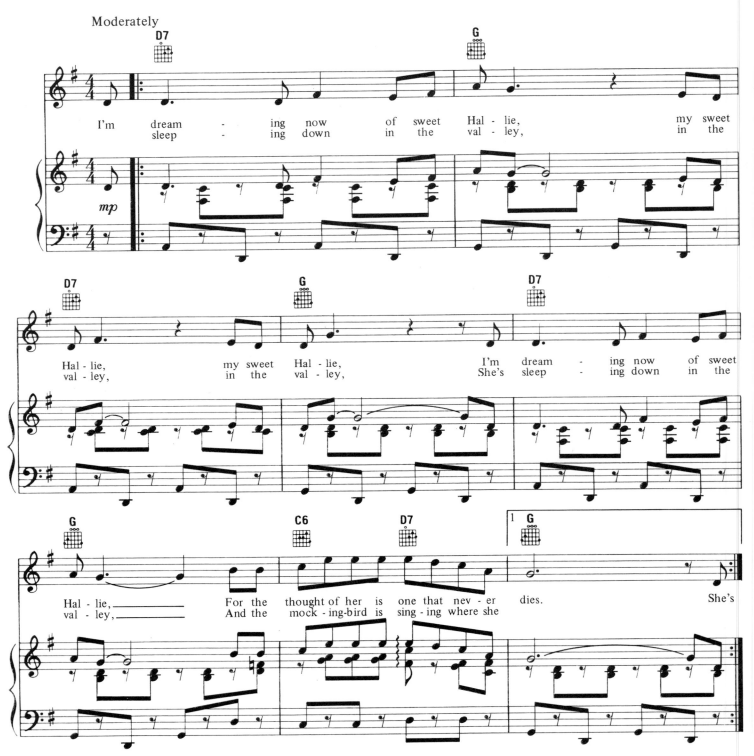

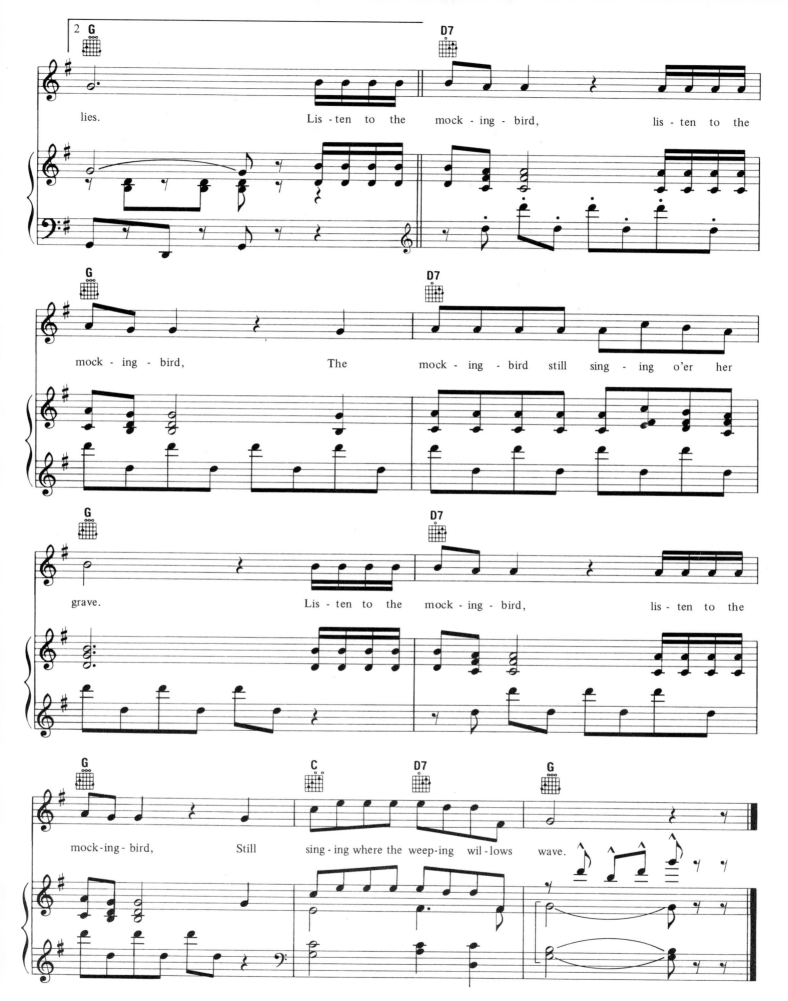

LITTLE BROWN CHURCH IN THE VALE

Words and music by W.S. Pitts

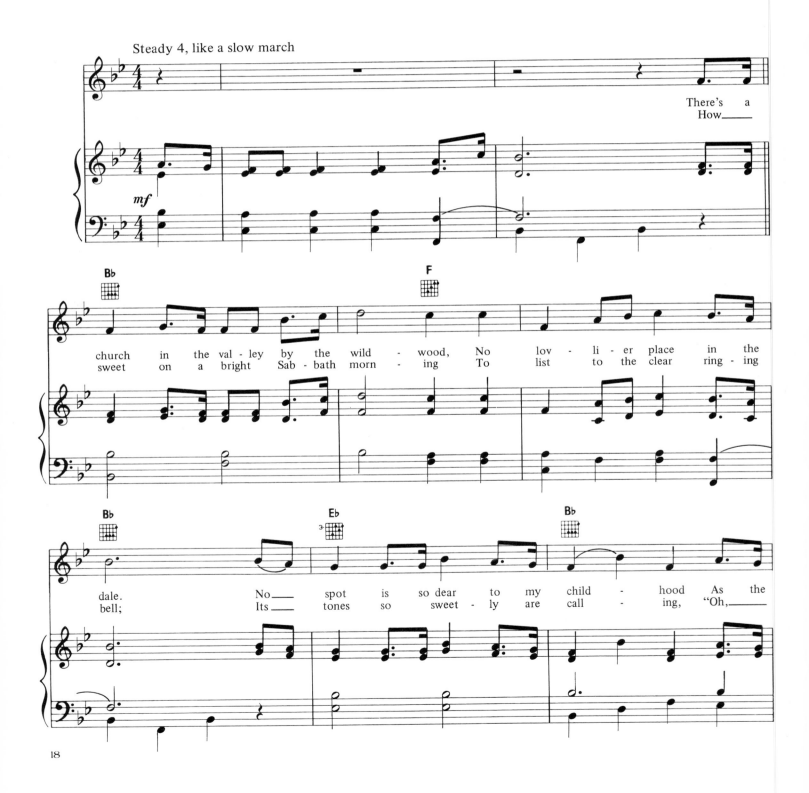

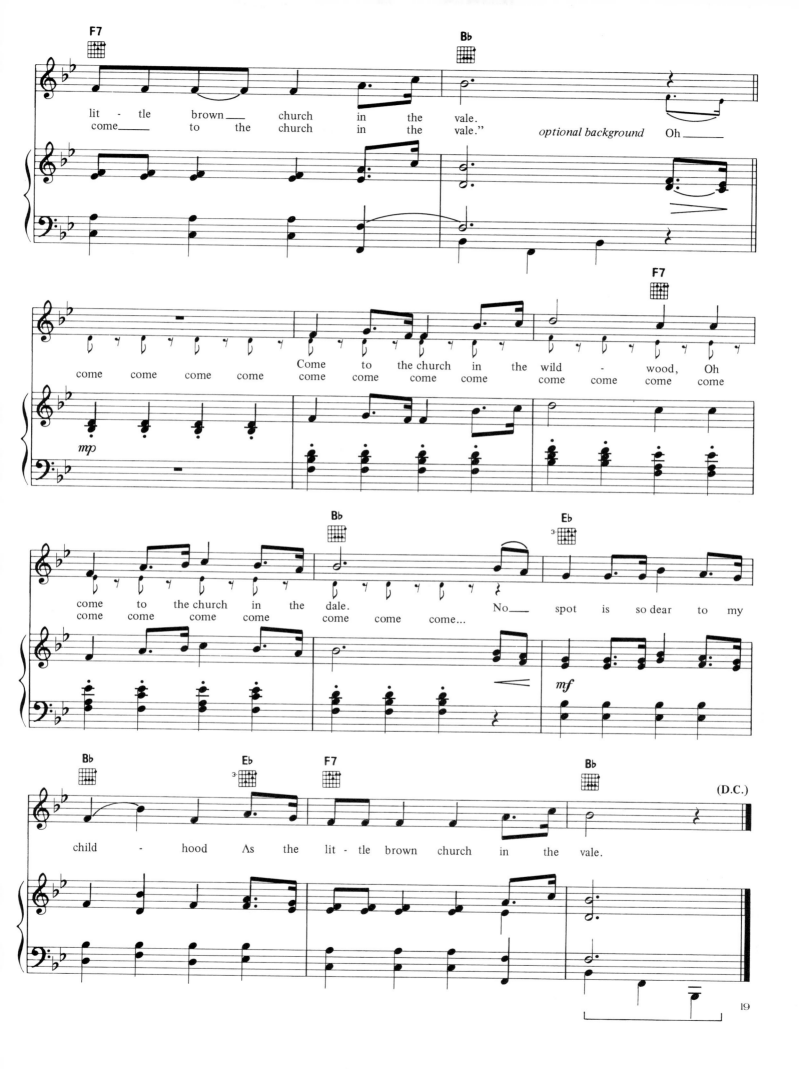

LONG, LONG AGO

Words and music by Thomas Haynes Bayly

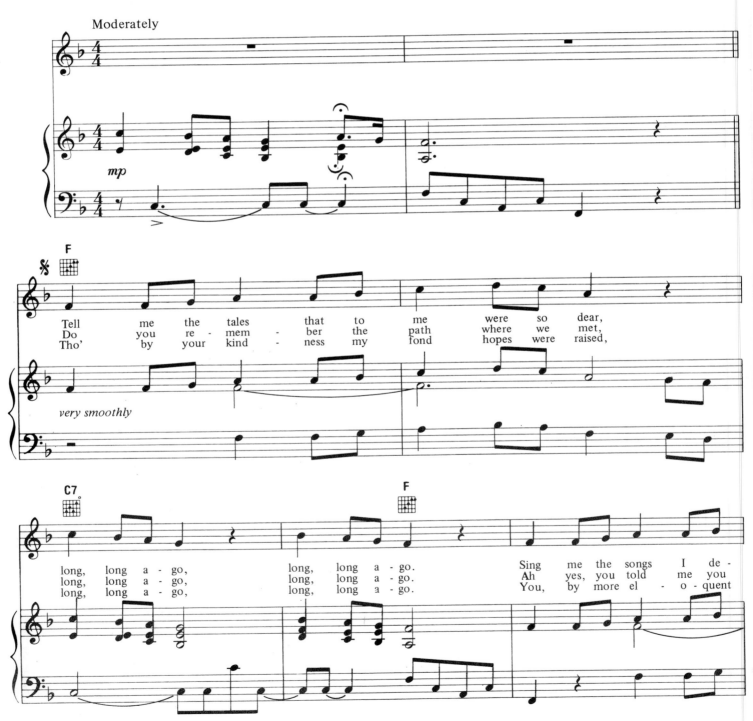

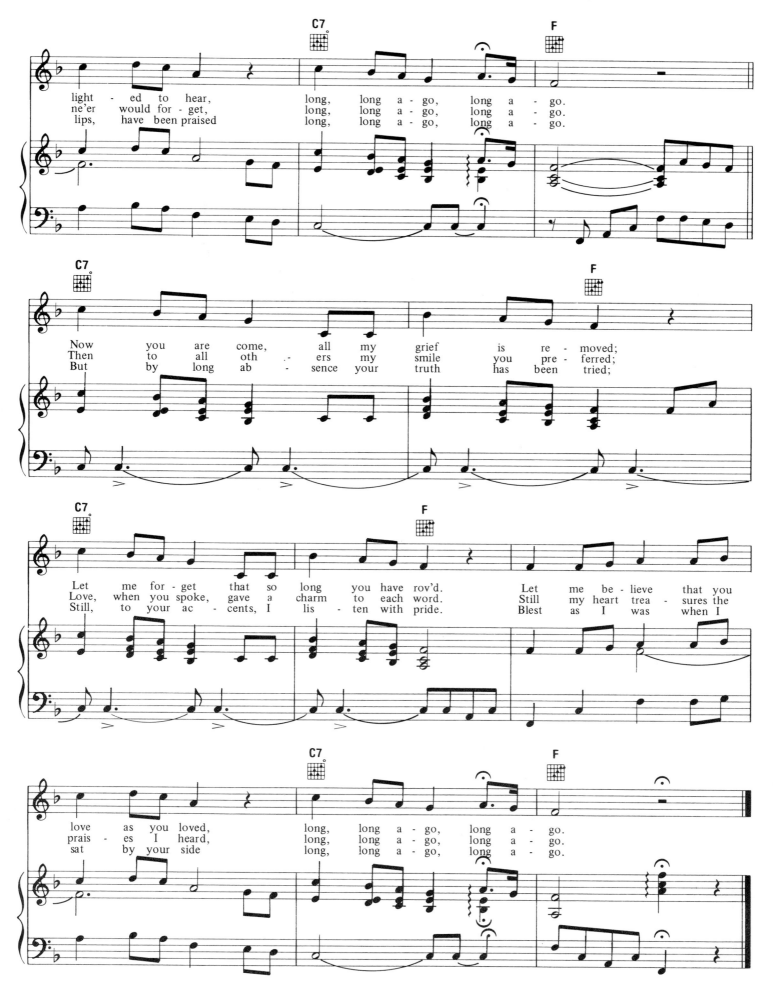

THE OLD OAKEN BUCKET

Words by Samuel Woodworth
Music by G. Kiall Mark

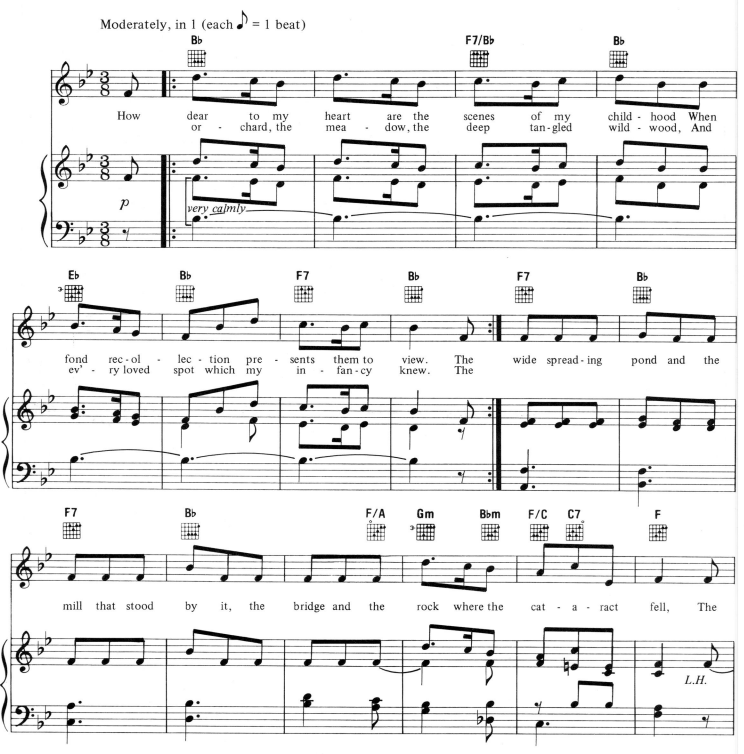

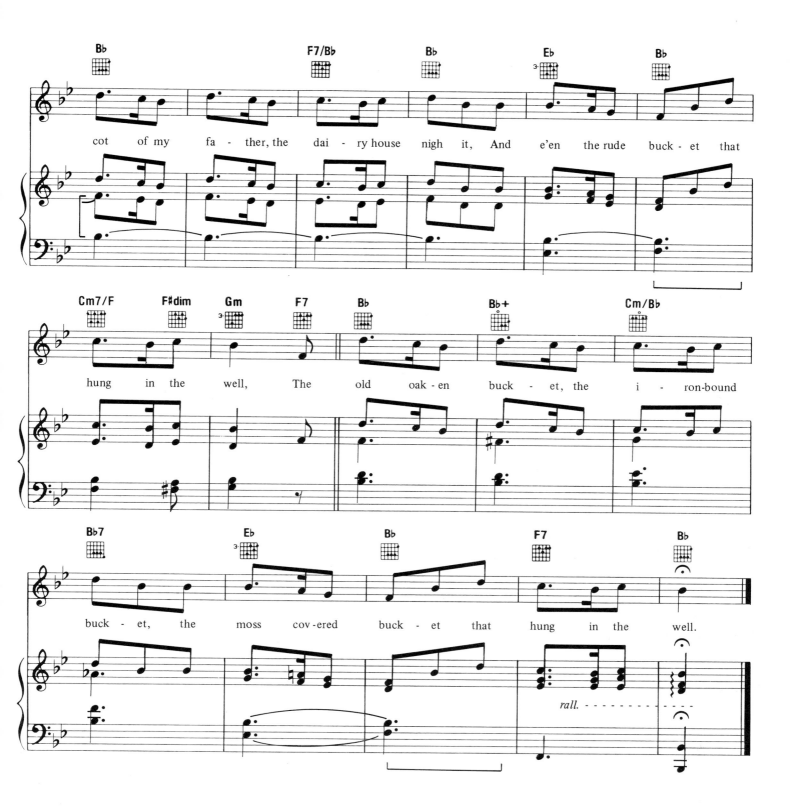

Additional lyrics:

That moss covered bucket I hailed as a treasure,
For often at noon, when returned from the field.
I found it a source of an exquisite pleasure,
The purest and sweetest that nature can yield.
How ardent I siezed it, with hands that were glowing,
And quick to the white pebbled bottom it fell.
Then soon, with the emblem of truth overflowing,
And dripping with coolness, it rose from the well.
Chorus:

How sweet from the green, mossy brim to receive it,
As poised on the curb it inclined to my lips!
Not a full blushing goblet could tempt me to leave it,
Tho' filled with the nectar that Jupiter sips.
And now, far removed from the loved habitation,
The tear of regret will intrusively swell,
As fancy reverts to my father's plantation,
And sighs for the bucket that hung in the well.
Chorus:

23

THE QUILTING PARTY

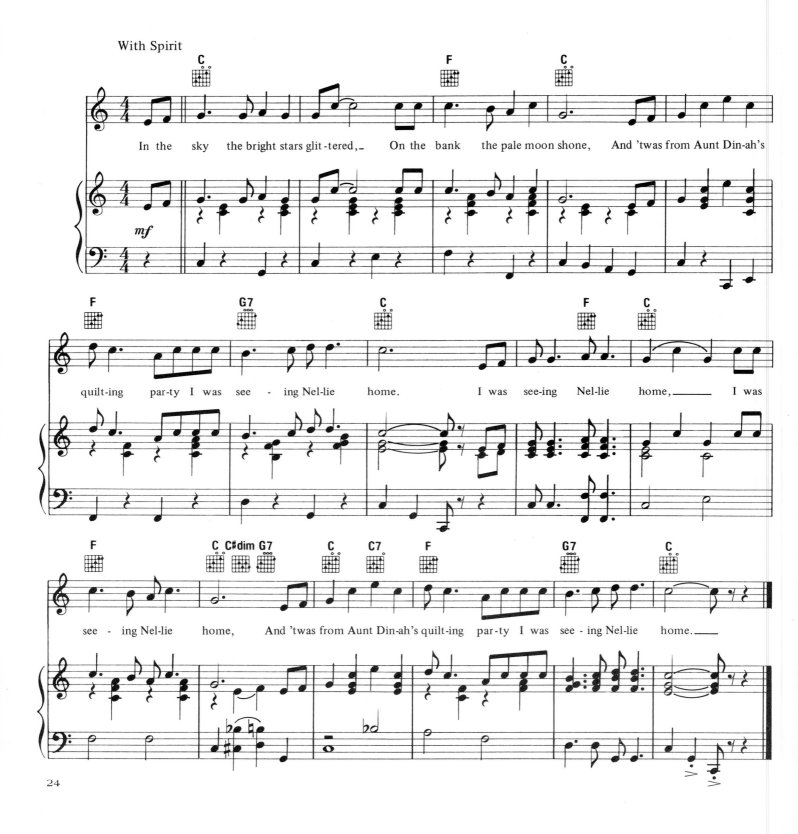

With Spirit

In the sky the bright stars glit-tered, On the bank the pale moon shone, And 'twas from Aunt Din-ah's

quilt-ing par-ty I was see - ing Nel-lie home. I was see-ing Nel-lie home, I was

see - ing Nel-lie home, And 'twas from Aunt Din-ah's quilt-ing par-ty I was see - ing Nel-lie home.

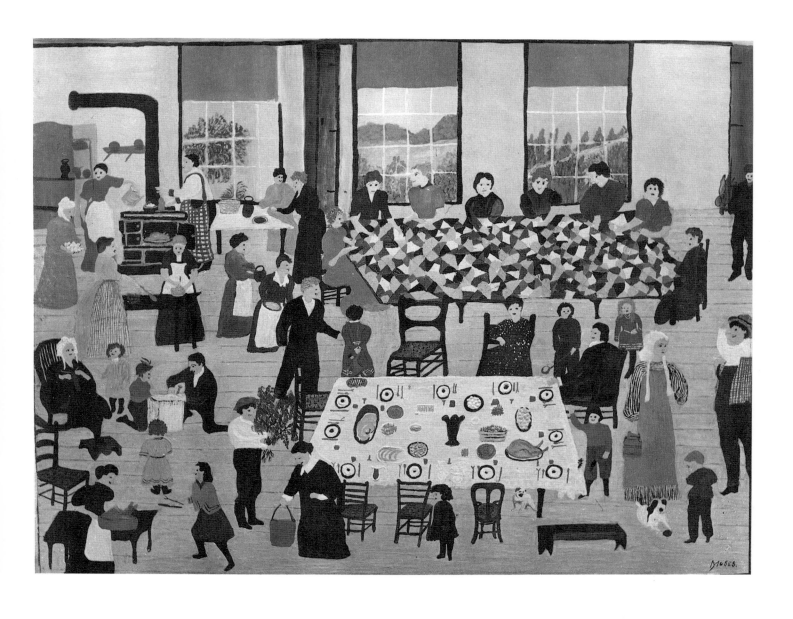

THE QUILTING BEE

SUNRISE, SUNSET

Words by Sheldon Harnick
Music by Jerry Bock

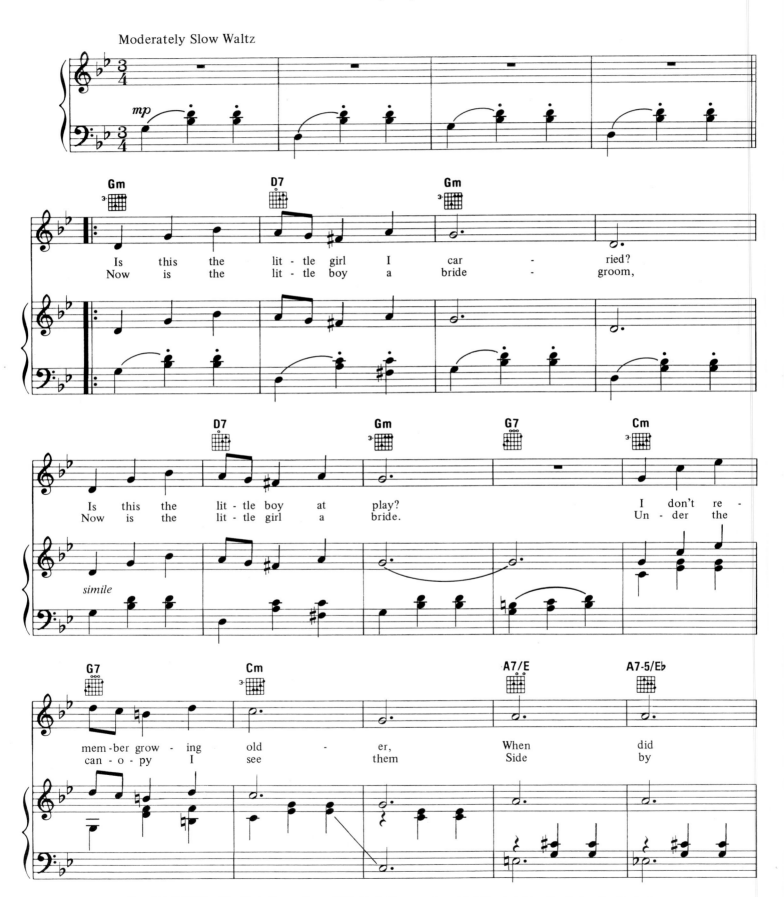

Moderately Slow Waltz

Is this the lit - tle girl I car - ried?
Now is the lit - tle boy a bride - groom,

Is this the lit - tle boy at play?
Now is the lit - tle girl a bride.

I don't re -
Un - der the

mem - ber grow - ing old - er,
can - o - py I see them

When
Side

did
by

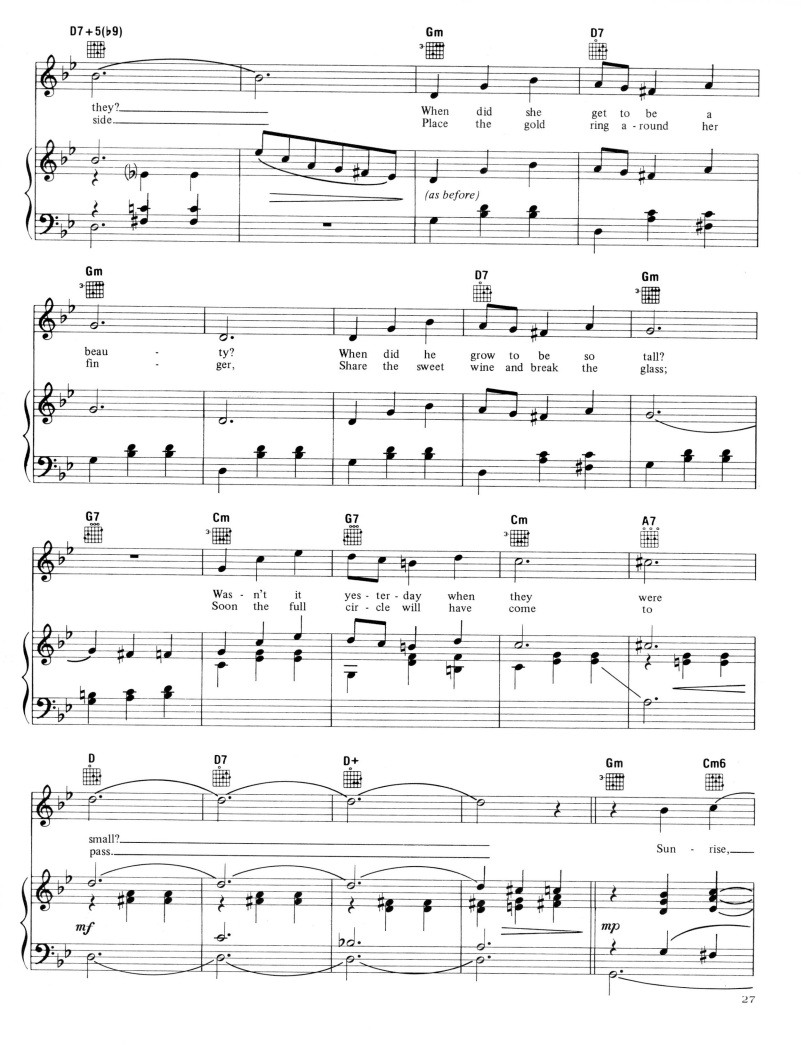

27

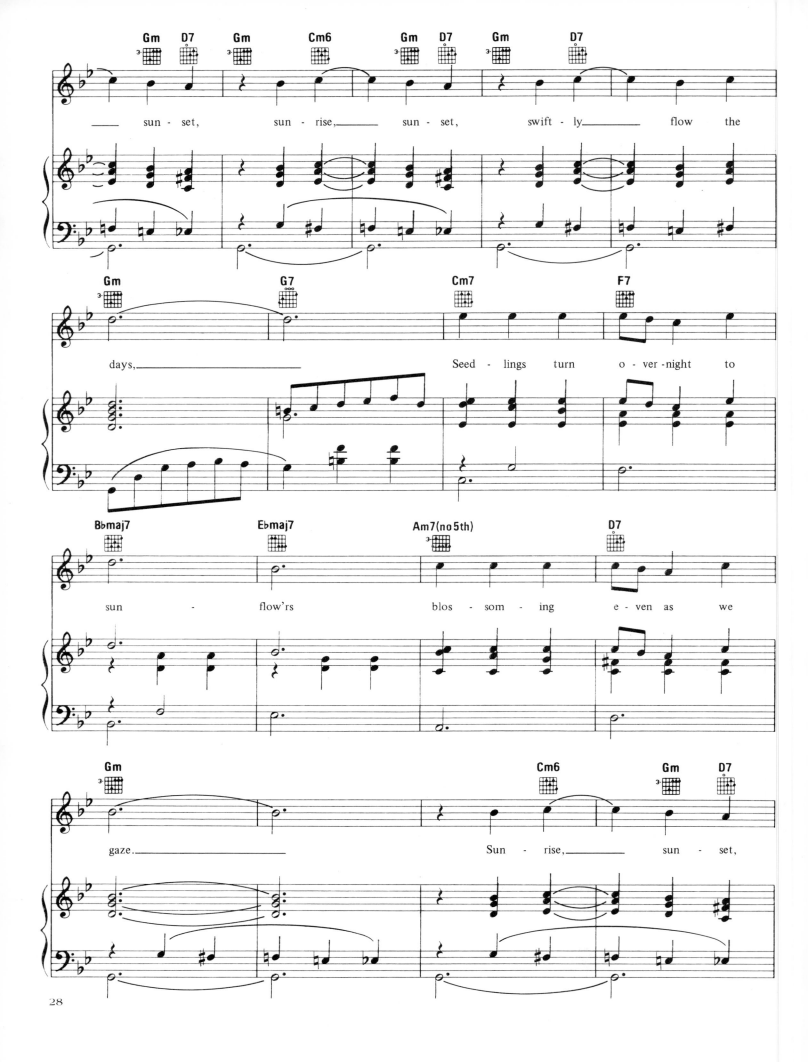

sun - set, sun - rise,___ sun - set, swift-ly___ flow the

days,_____ Seed - lings turn o-ver-night to

sun - flow'rs blos - som - ing e - ven as we

gaze._____ Sun - rise,___ sun - set,

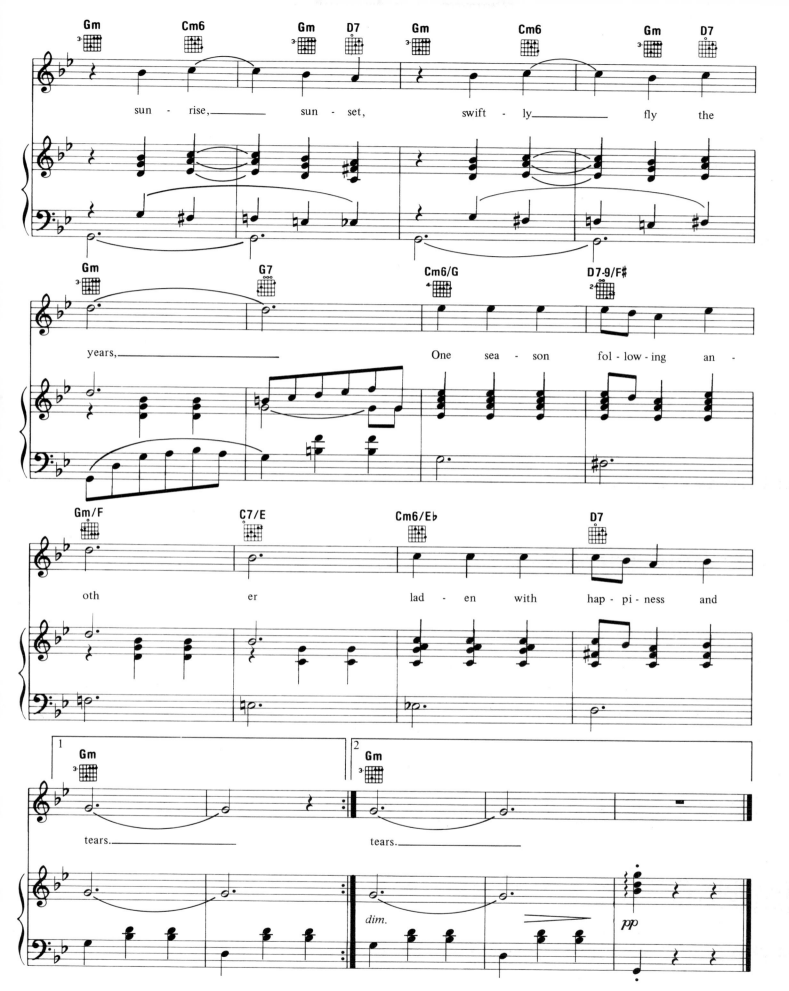

TRY TO REMEMBER

Words by Tom Jones
Music by Harvey Schmidt

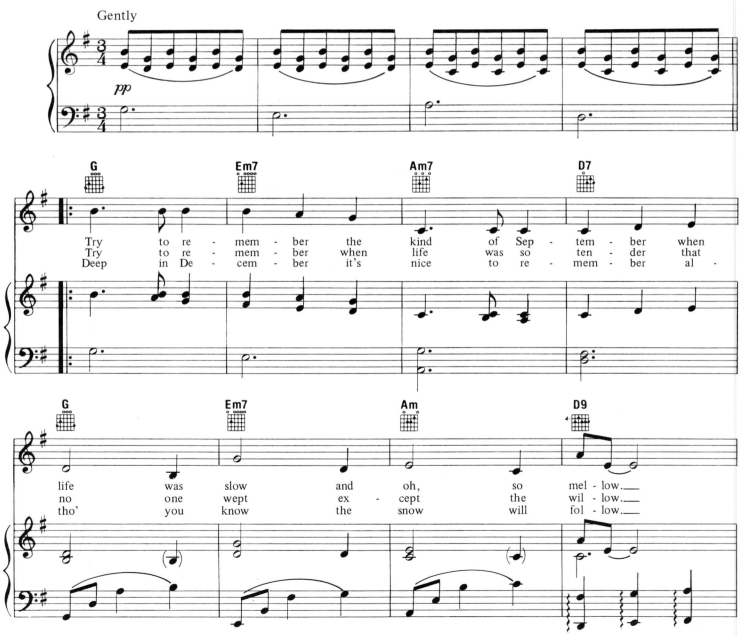

Try to remember the kind of September when
Try to remember when life was so tender when that
Deep in December it's nice to remember al -

life was slow and oh, so mellow.___
no one wept ex - cept the willow.___
tho' you know the snow will follow.___

30

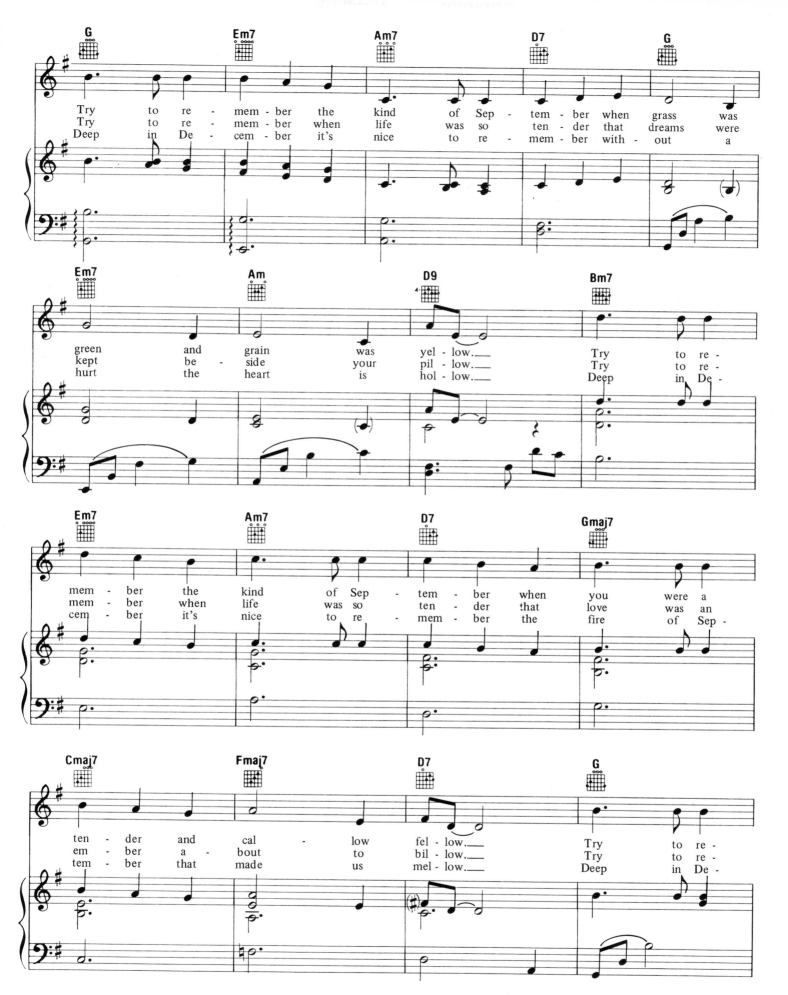

mem - ber and if you re - mem - ber then fol - low._____
mem - ber and if you re - mem - ber then fol - low._____
cem - ber our hearts should re - mem - ber and

(echo) Fol - low, fol - low, fol - low, fol - low, fol - low, fol - low, fol - low, fol - low.

fol - low._____ Fol - low, fol - low, fol - low, fol - low, fol - low,

fol - low, fol - low, fol - low, fol - low._____

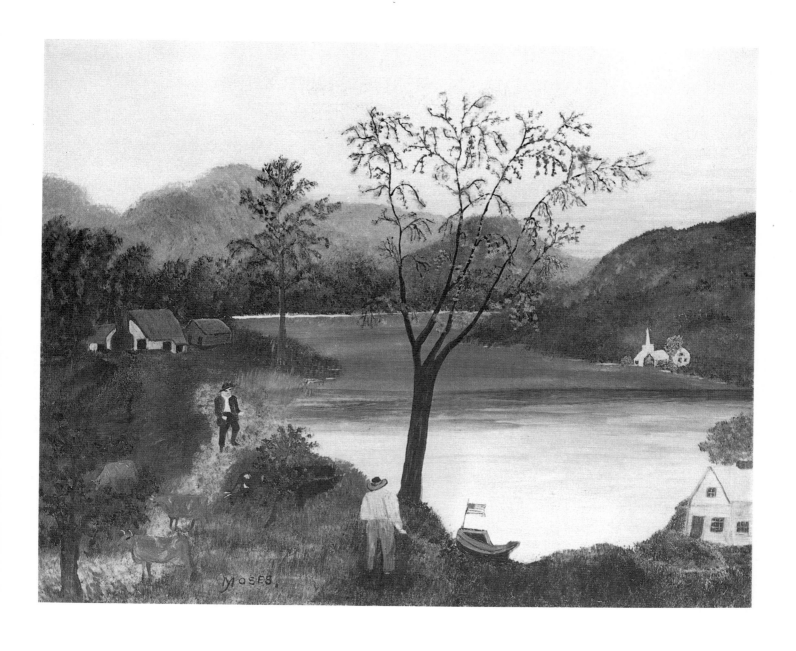

GOLDEN SUNSET

WOODMAN, SPARE THAT TREE

Words by George Pope Morris
Music by Henry Russell

Additional lyrics:

When but an idle boy I sought its grateful shade
In all their gushing joy, Here, too, my sisters played;
My mother kissed me here; My father pressed my hand,
Forgive this foolish tear, But let that old oak stand.

My heart-strings round thee cling, Close as thy bark,
old friend! Here shall the wildbird sing,
And still thy branches bend. Old tree, the storm thou'lt brave,
And, woodman, leave the spot; While I've a hand to save,
Thy axe shall harm it not!

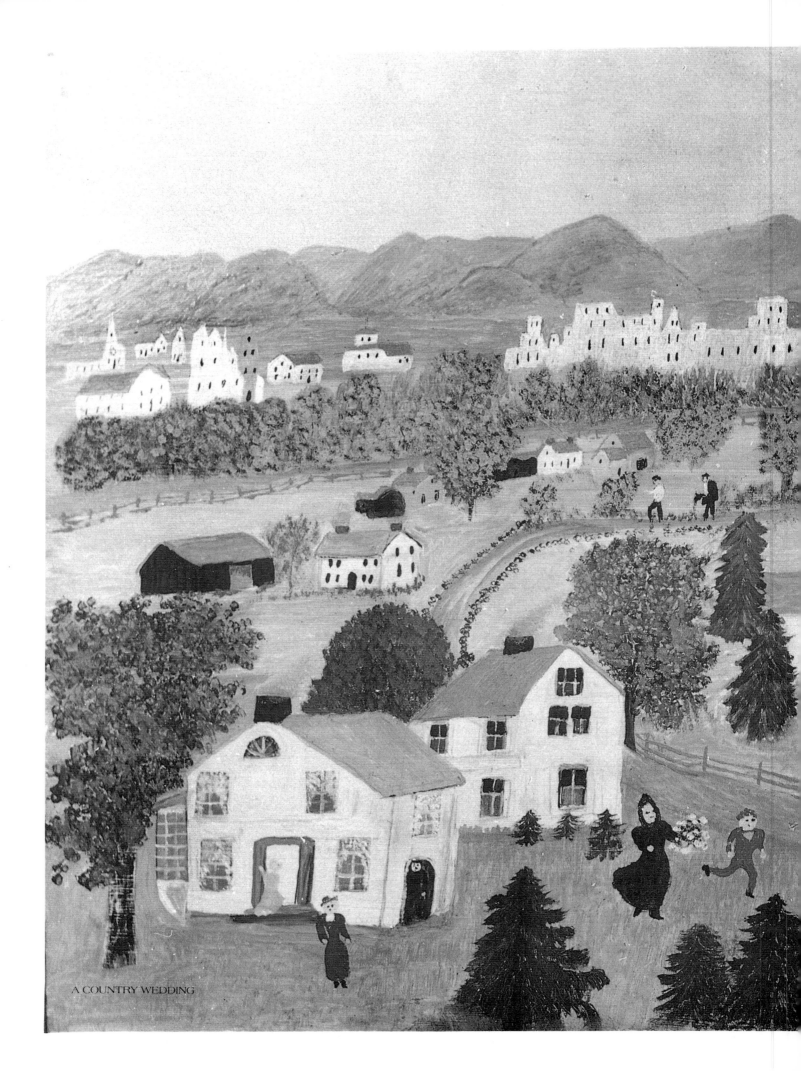

A COUNTRY WEDDING

ALL FOR LOVE

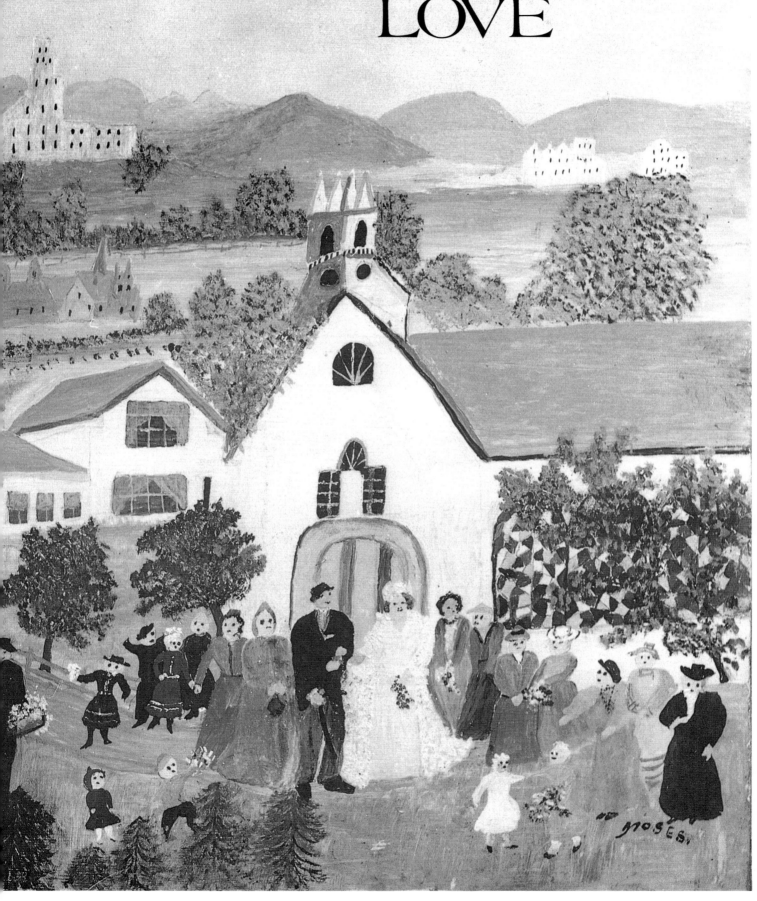

BEAUTIFUL DREAMER

Words and music by Stephen C. Foster

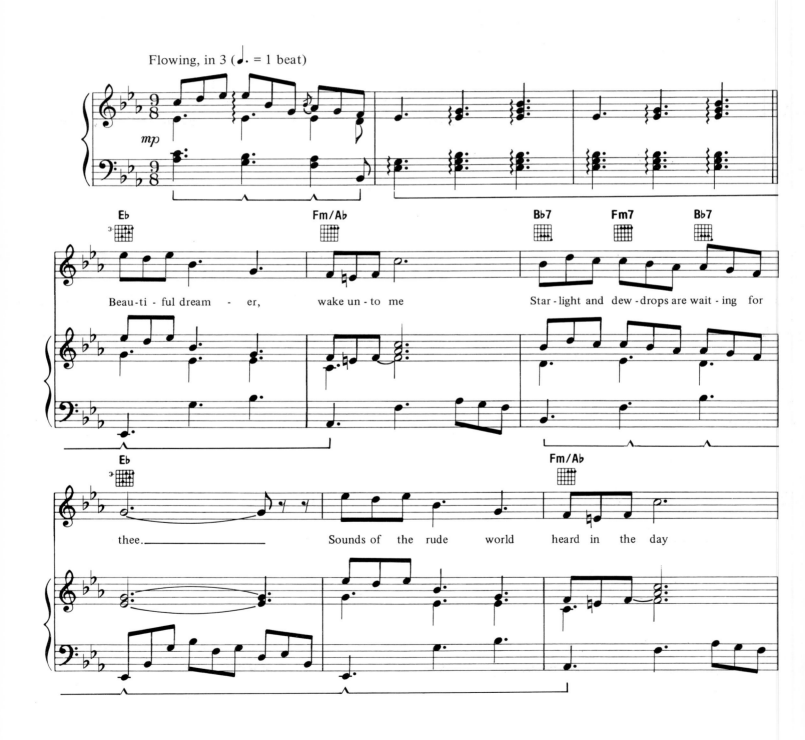

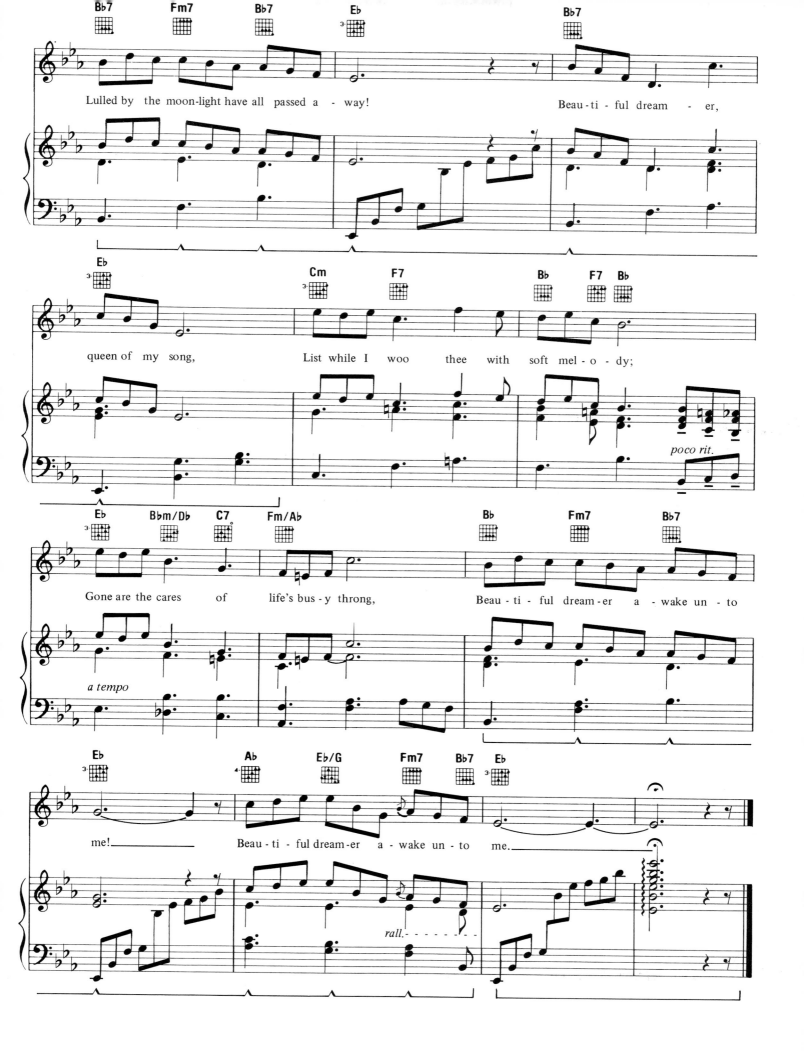

BILLY BOY

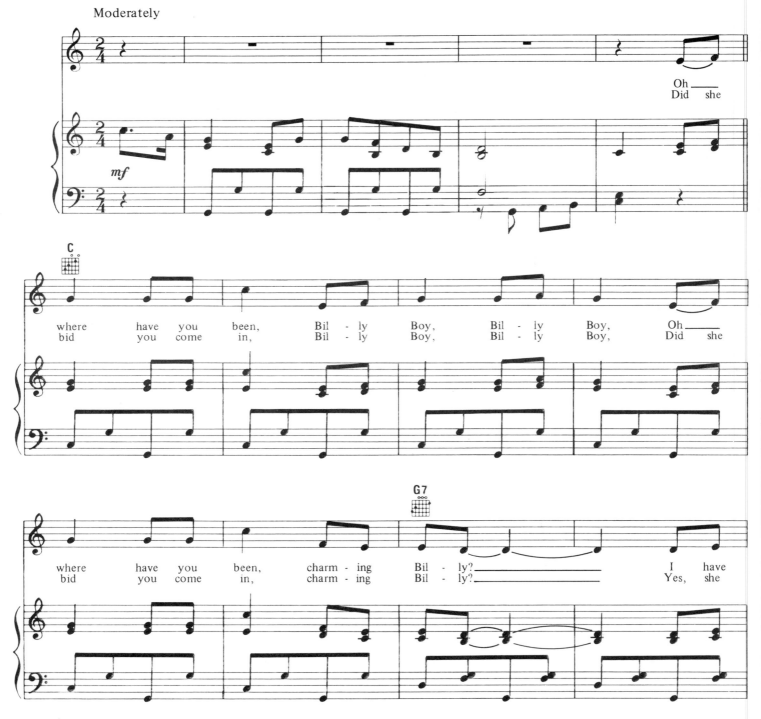

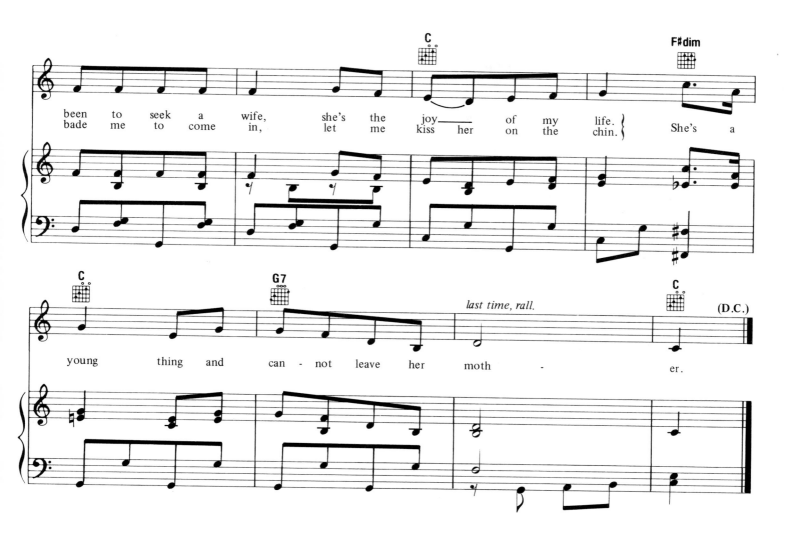

been to seek a wife, she's the joy—— of my life.
bade me to come in, let me kiss her on the chin. } She's a

young thing and can - not leave her moth - er.

last time, rall.

(D.C.)

Did she set for you a chair, Billy Boy, Billy Boy,
Did she set for you a chair, charming Billy?
Yes, she set for me a chair,
And the bottom wasn't there,
She's a young thing and cannot leave her mother.

Can she bake a cherry pie, Billy Boy, Billy Boy,
Can she bake a cherry pie, charming Billy?
She can bake a cherry pie,
Quick as a cat can wink her eye,
She's a young thing and cannot leave her mother.

How old is she, Billy Boy, Billy Boy,
How old is she, charming Billy?
She's three times six and four times seven,
Twenty-eight and eleven,
She's a young thing and cannot leave her mother.

Can she sing a pretty song, Billy Boy, Billy Boy,
Can she sing a pretty song, charming Billy?
She can sing a pretty song,
But she gets the words all wrong,
She's a mother and cannot leave her young thing.

Are her eyes very bright, Billy Boy, Billy Boy,
Are her eyes very bright, charming Billy?
Yes, her eyes are very bright
But unfortunately lack sight
And she can't describe me to her mother.

CHERRY PINK AND APPLE BLOSSOM WHITE

French words by Jacques Larue
English words by Mack David
Music by Louiguy

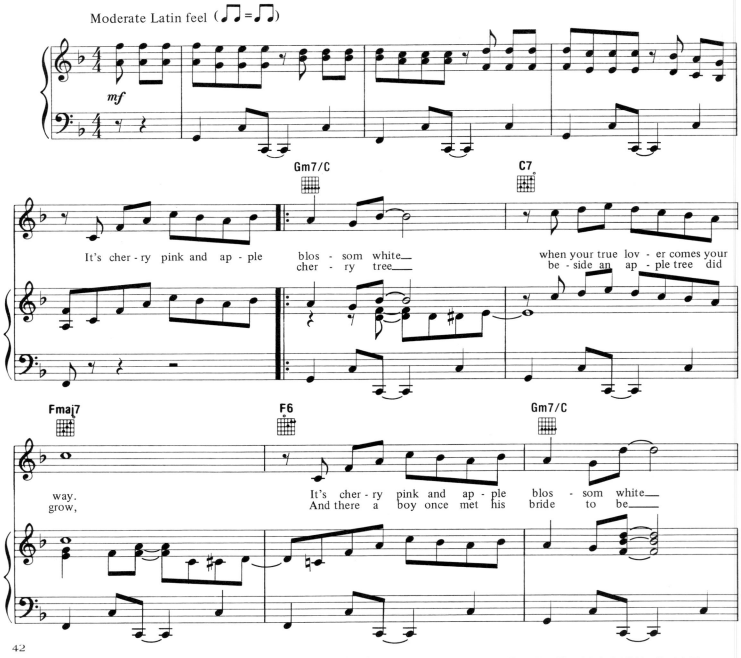

the po - ets say.
long long a -
The sto - ry goes that once a

Guitar Tacet

go.
The boy looked in - to her eyes, it was a

sight to en - thrall, The breez - es joined in their sighs, the blos - soms

start - ed to fall. And as they gent - ly ca - ressed, the lov - ers

43

looked up to find The branch-es of the two trees were in-ter-

twined. And that is why the po-ets al-ways write,— if there's a new moon bright a-

bove, It's cher-ry pink and ap-ple blos-som white—

when you're in love._____

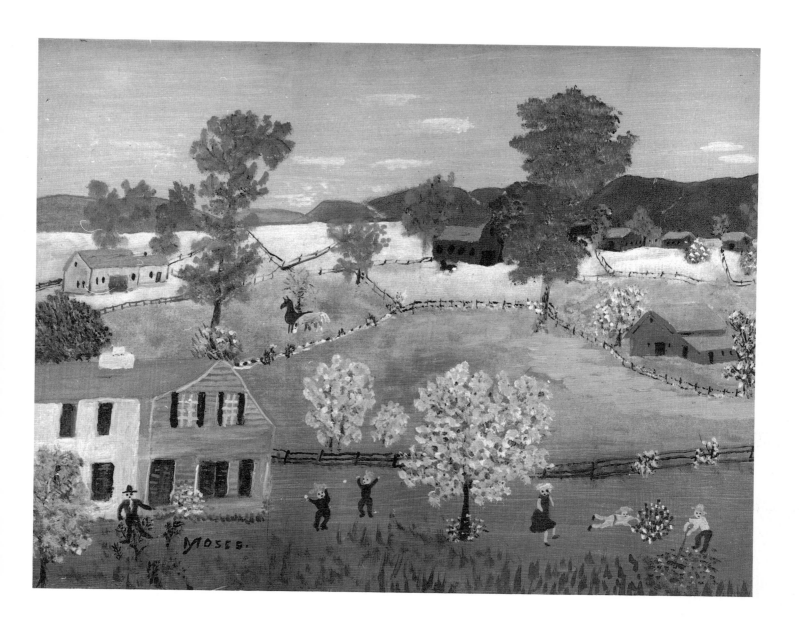

SOFT SPRING

DOWN IN THE VALLEY

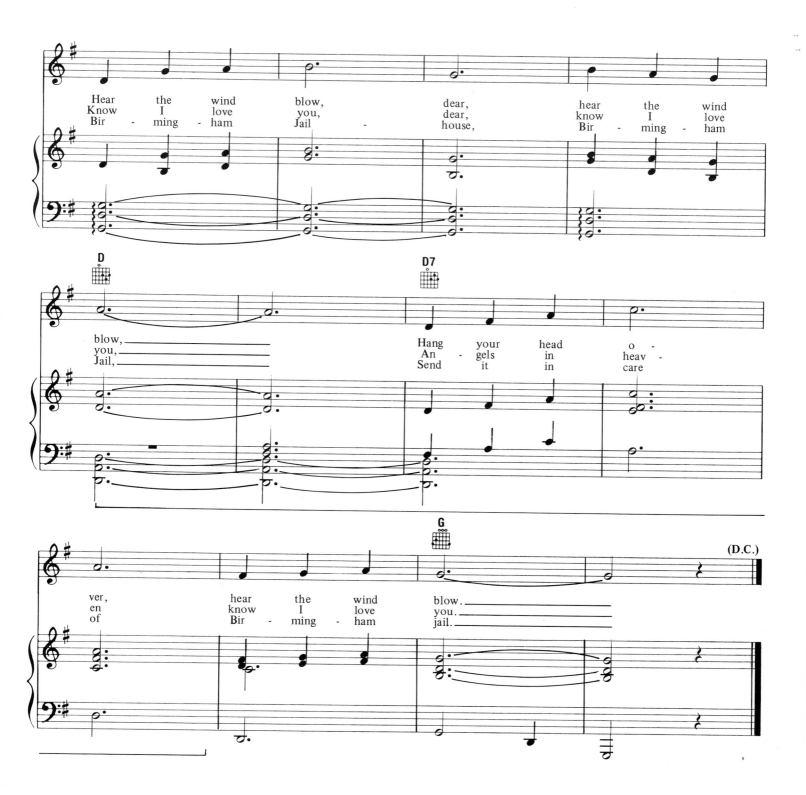

Hear the wind blow, dear, hear the wind
Know I love you, dear, know I love
Bir - ming - ham Jail - house, Bir - ming - ham

D

blow, Hang your head o - ver,
you, An - gels in heav -
Jail, Send it in care

D7

G

(D.C.)

ver, hear the wind blow.
en, know I love you.
of Bir - ming - ham jail.

HONEYSUCKLE ROSE

Words by Andy Razaf
Music by Thomas ("Fats") Waller

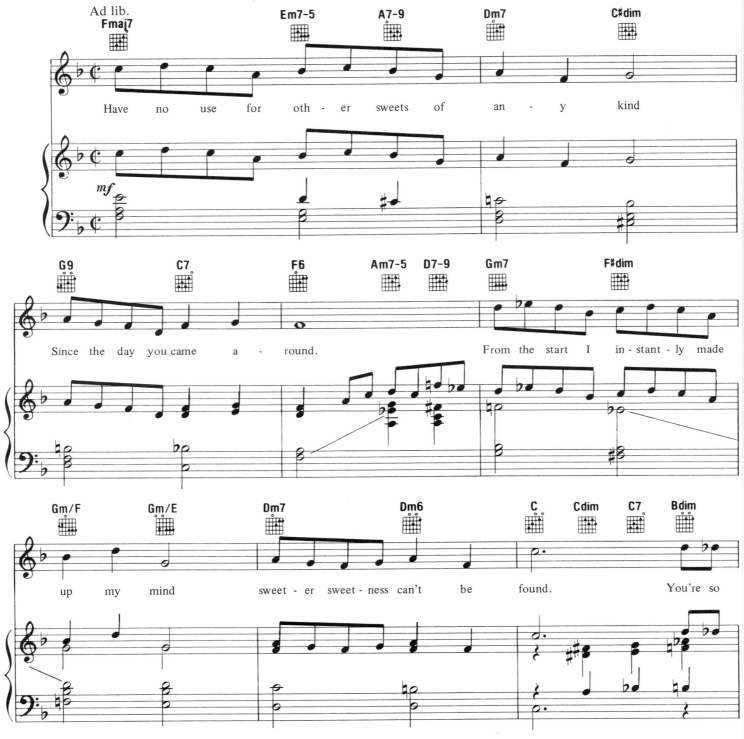

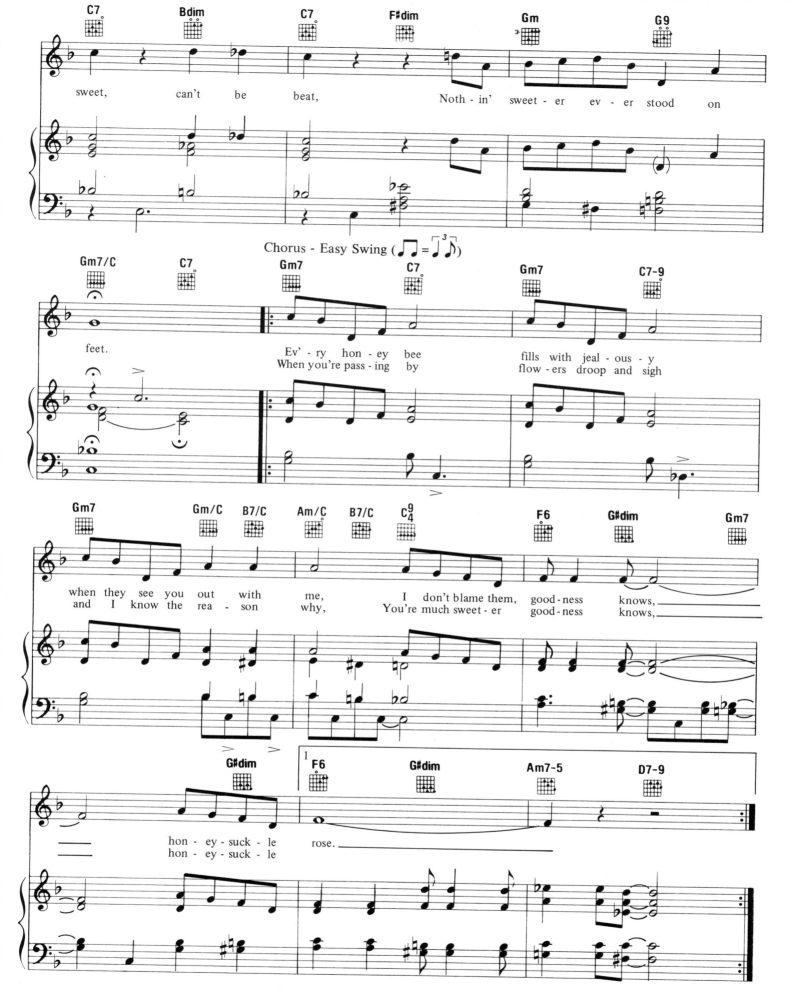

49

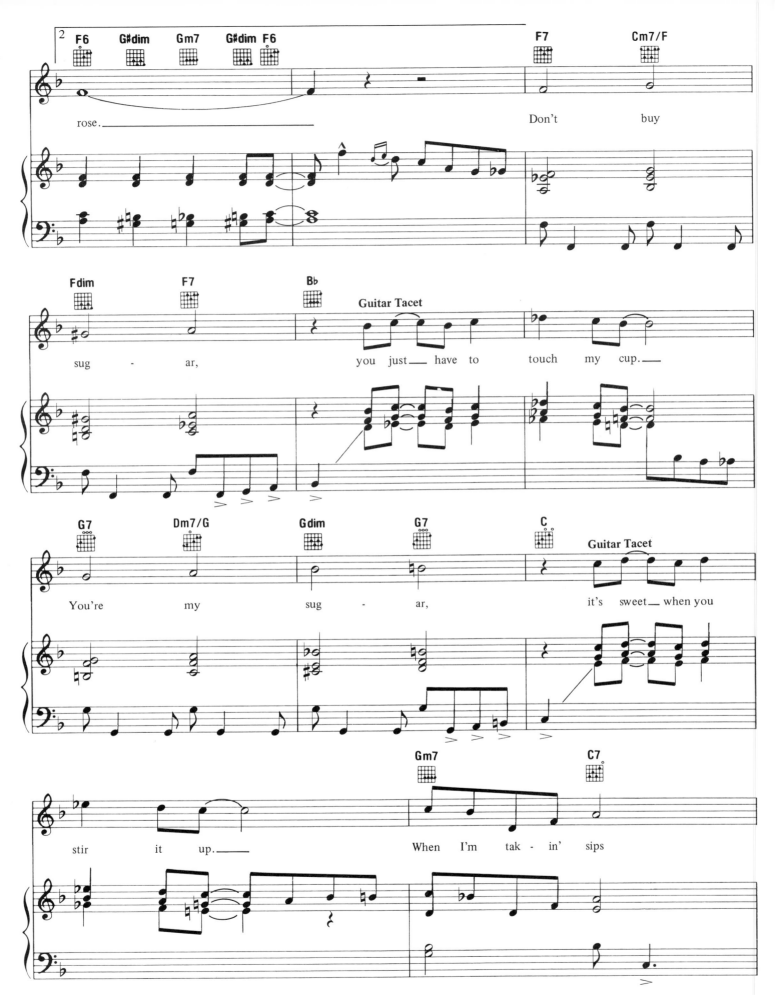

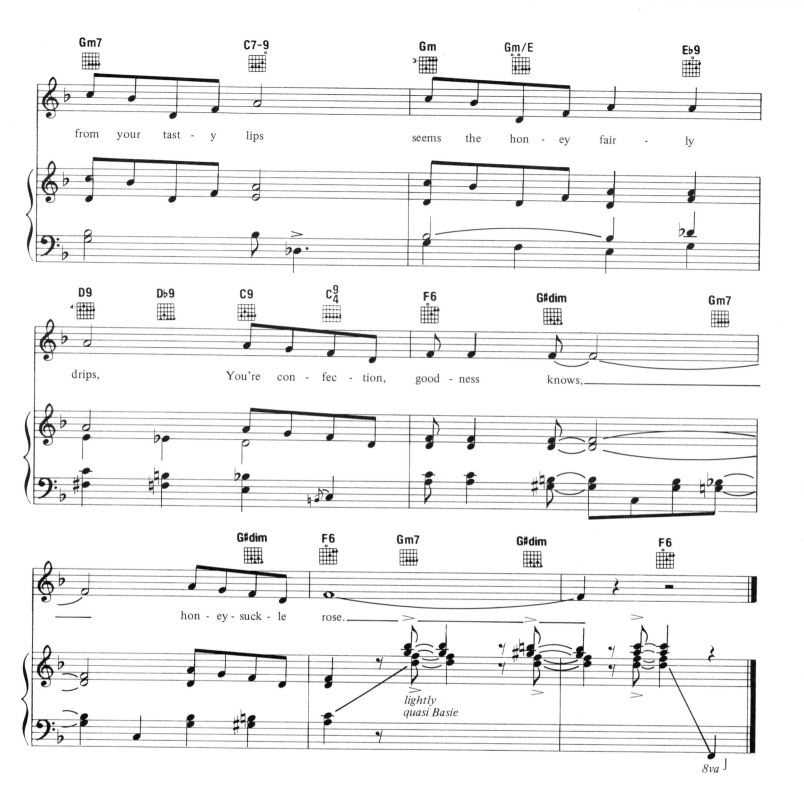

from your tast-y lips seems the hon-ey fair - ly

drips, You're con- fec - tion, good - ness knows,

— hon - ey - suck - le rose.

lightly
quasi Basie

8va

51

IN THE SHADE OF THE OLD APPLE TREE

Words by Harry W. Williams
Music by Egbert Van Alstyne

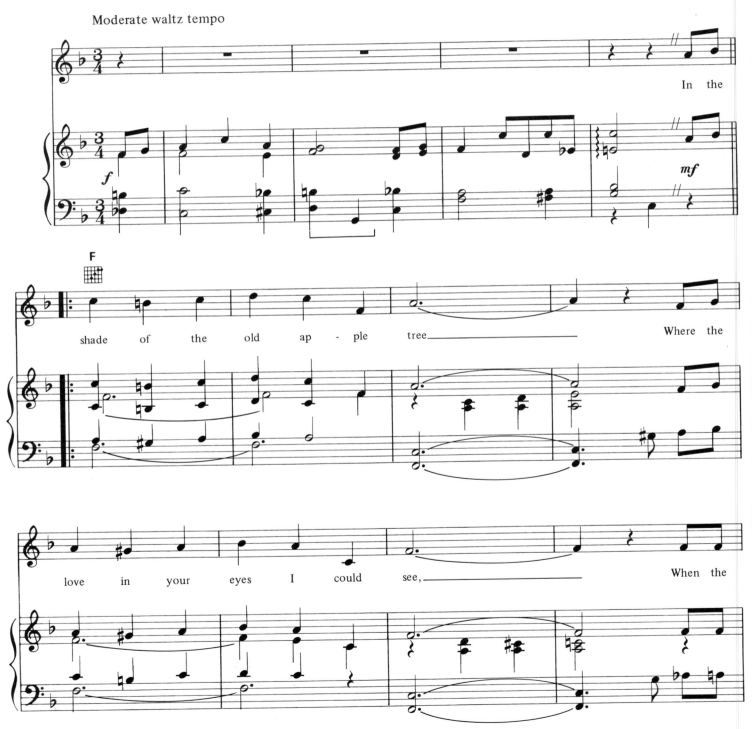

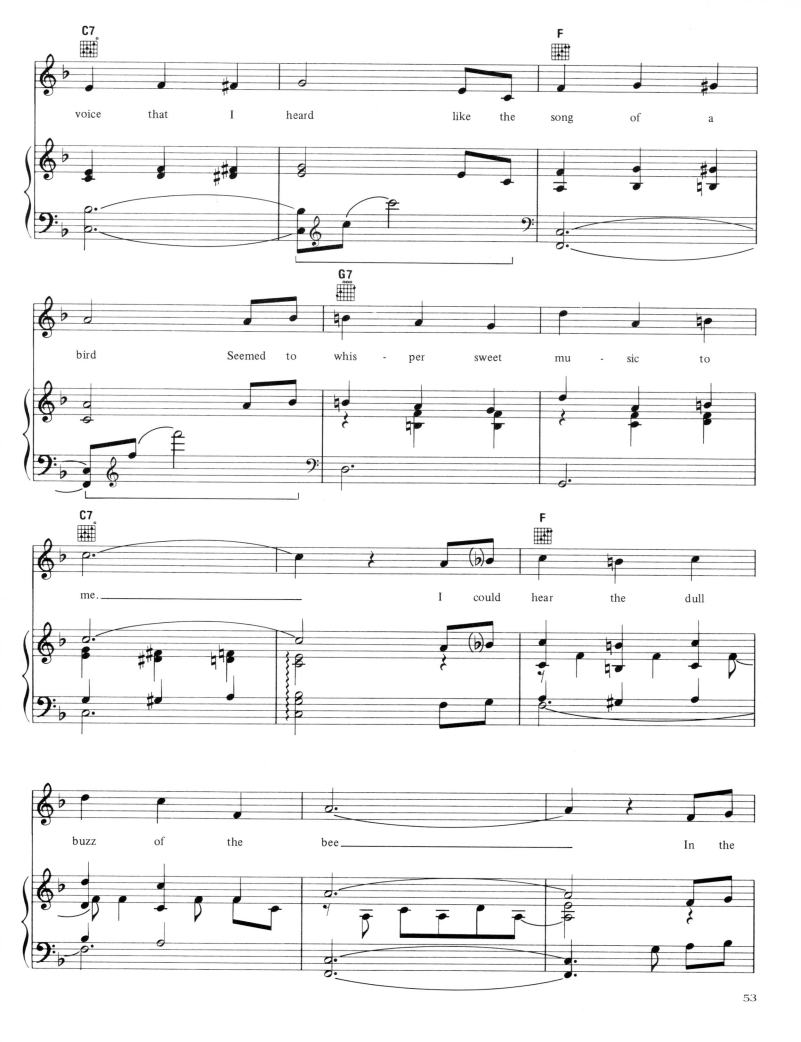

voice that I heard like the song of a bird Seemed to whis - per sweet mu - sic to me._____ I could hear the dull buzz of the bee_____ In the

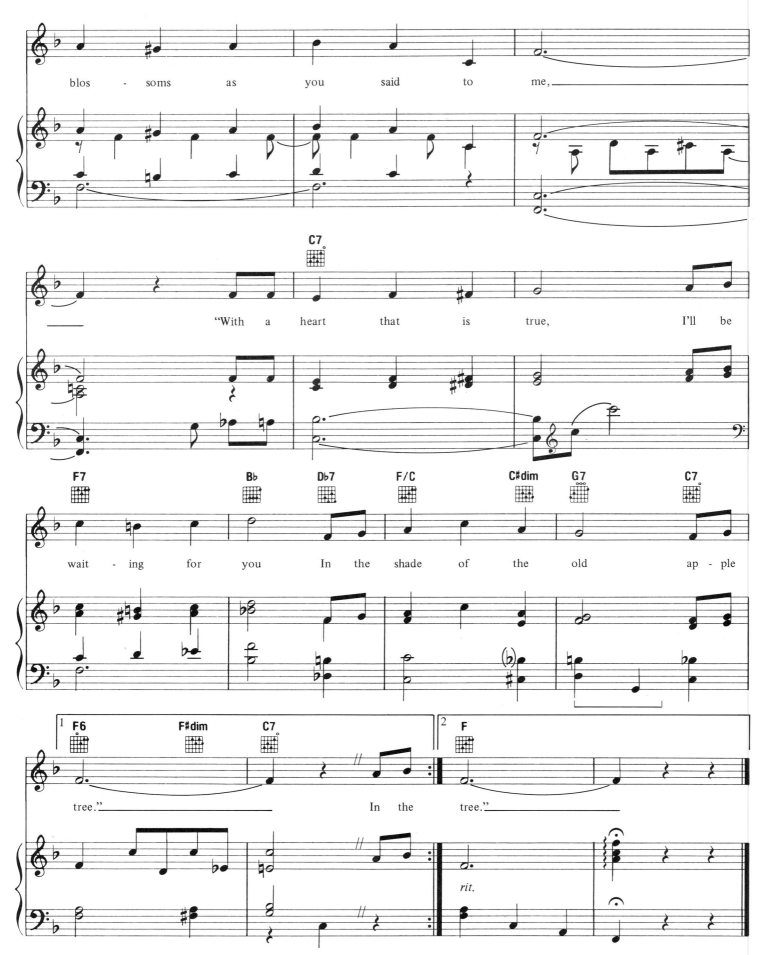

blos - soms as you said to me, _____ "With a heart that is true, I'll be wait - ing for you In the shade of the old ap - ple tree." _____ In the tree." _____

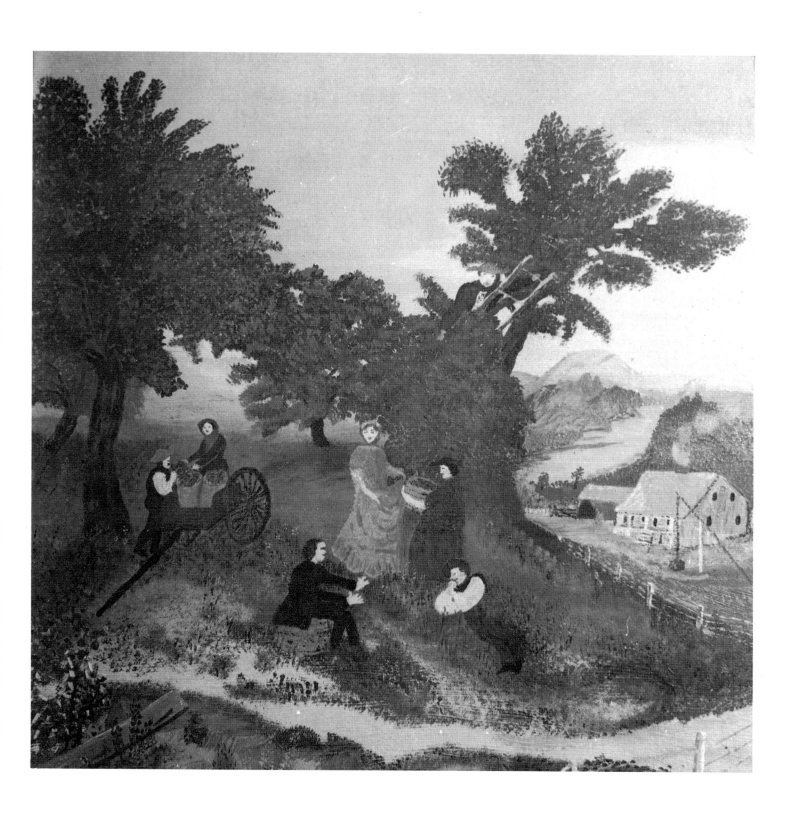

APPLE PICKERS

I TALK TO THE TREES

Words by Alan Jay Lerner
Music by Frederick Loewe

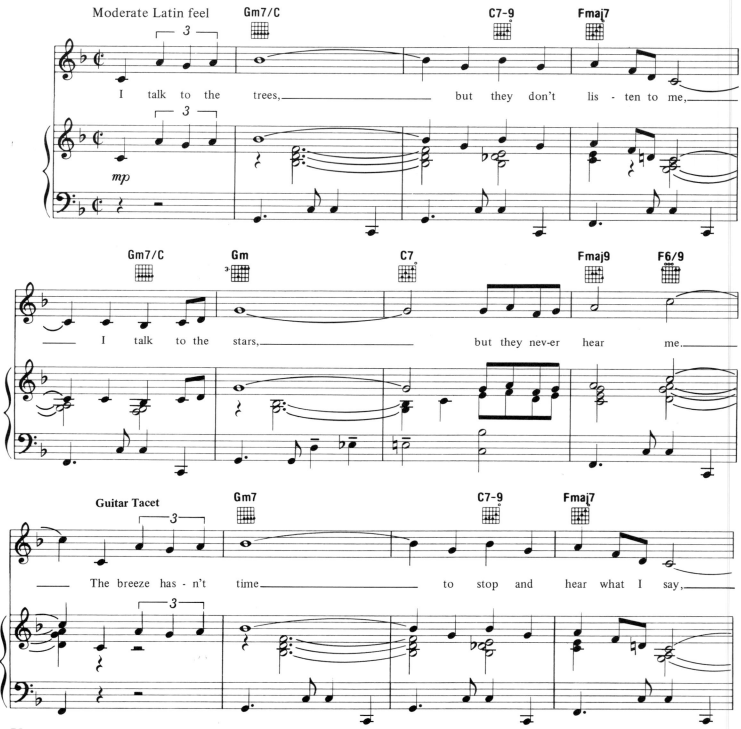

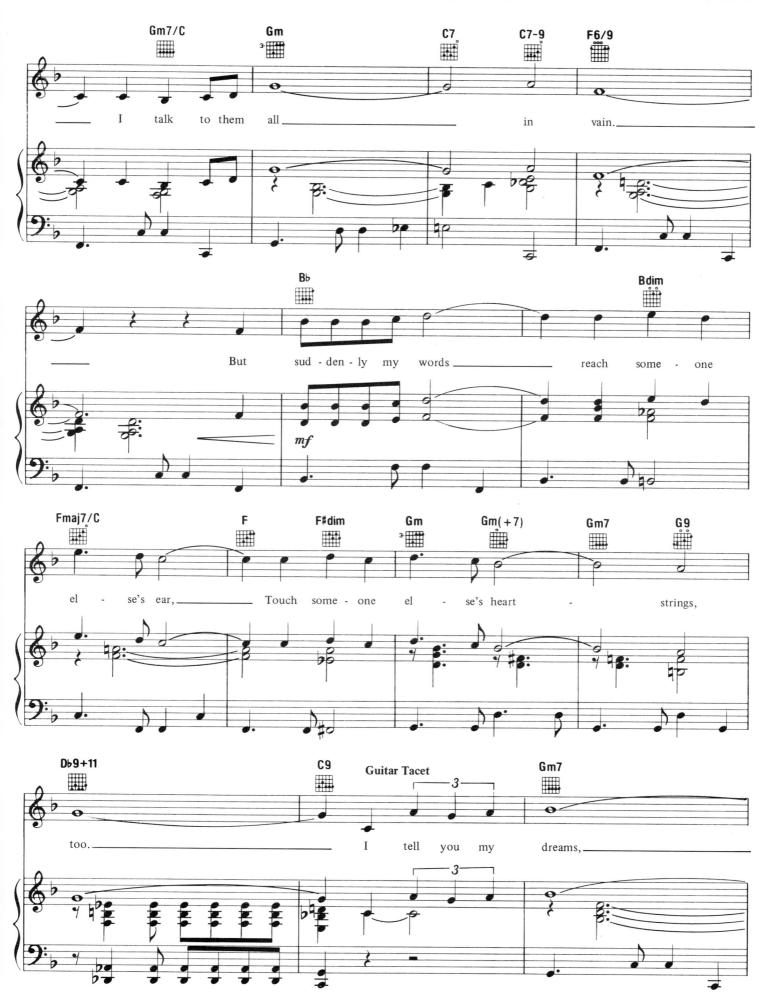

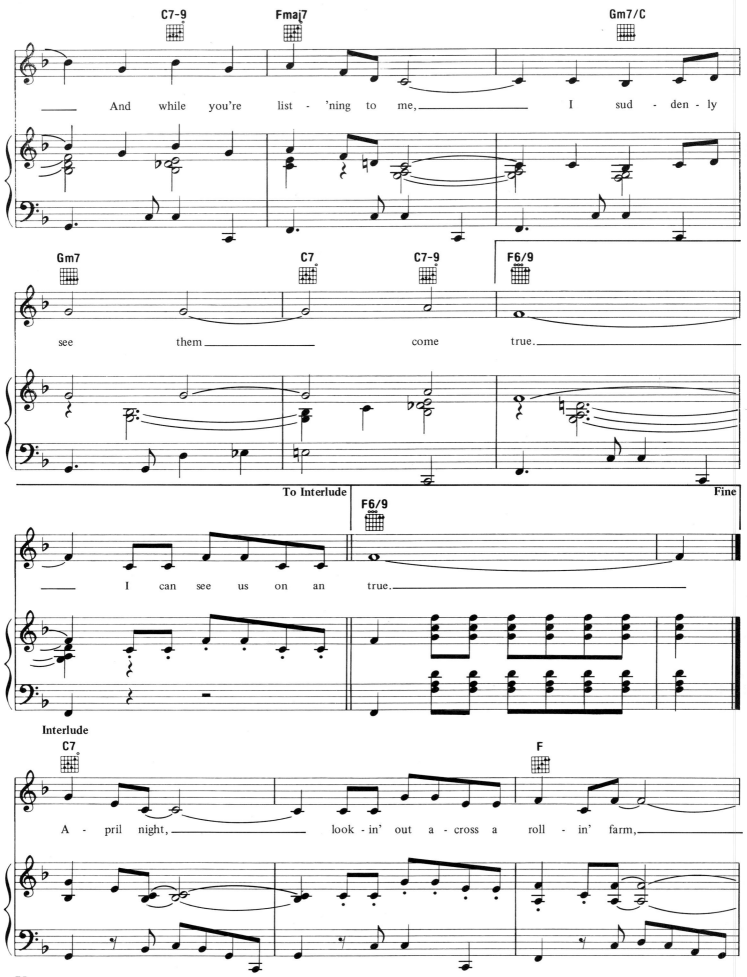

And while you're list - 'ning to me, _____ I sud - den - ly

see them _____ come true. _____

To Interlude Fine

____ I can see us on an true. _____

Interlude

A - pril night, _____ look - in' out a - cross a roll - in' farm, _____

58

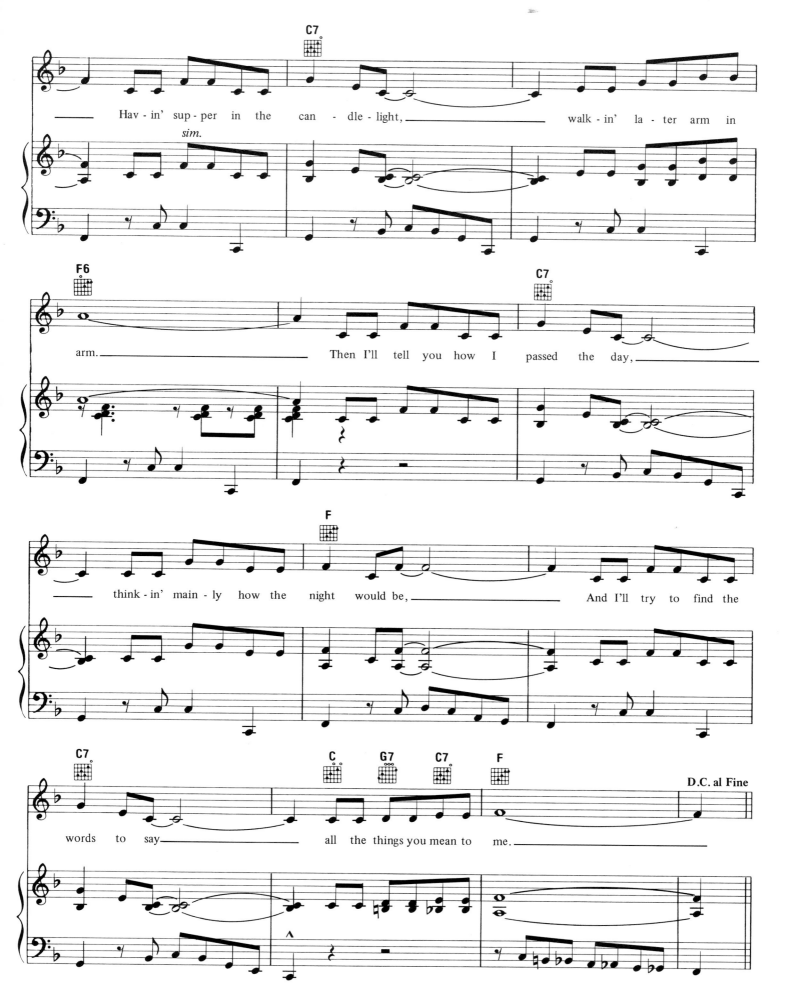

C7

Hav-in' sup-per in the can-dle-light,_____ walk-in' la-ter arm in

sim.

F6 C7

arm._____ Then I'll tell you how I passed the day,_____

F

_____ think-in' main-ly how the night would be,_____ And I'll try to find the

C7 C G7 C7 F D.C. al Fine

words to say_____ all the things you mean to me._____

LAZY AFTERNOON

Words by John Latouche
Music by Jerome Moross

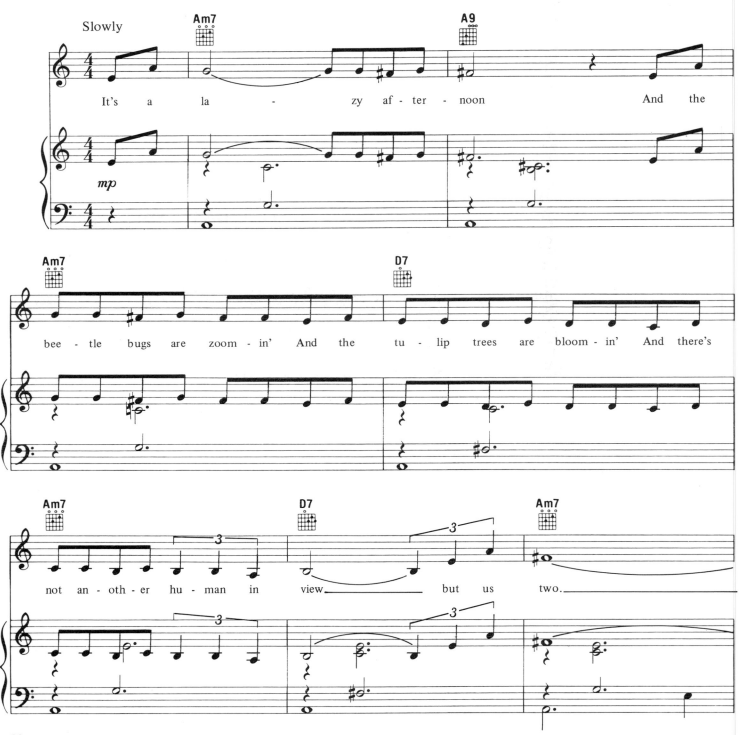

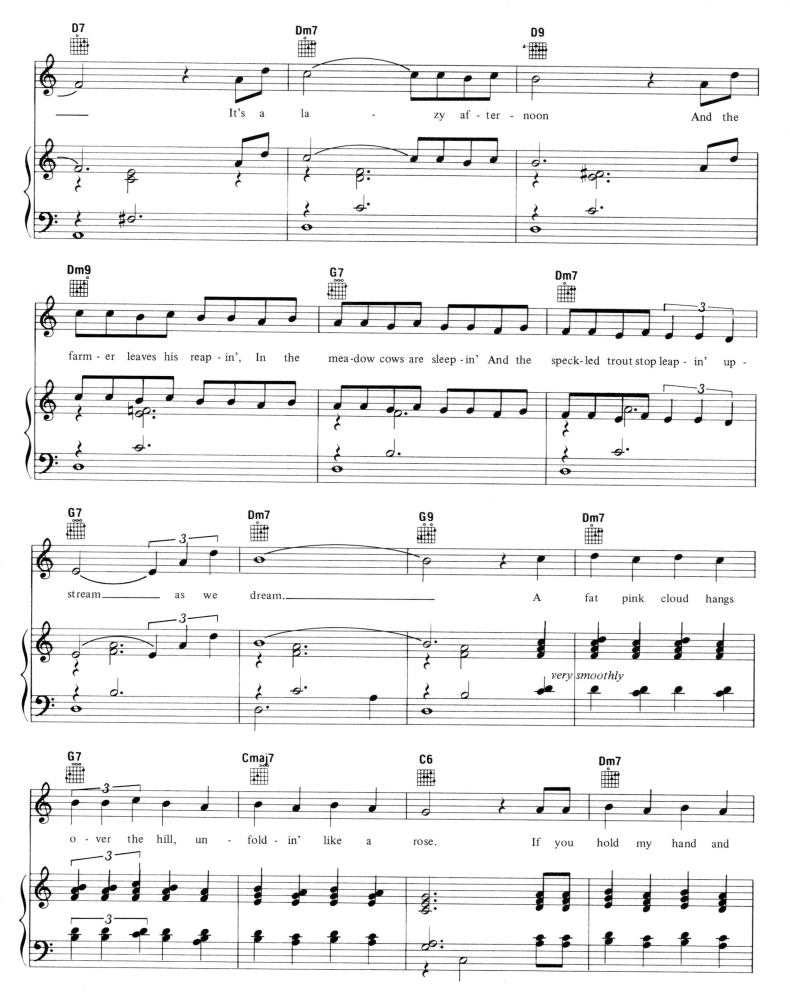

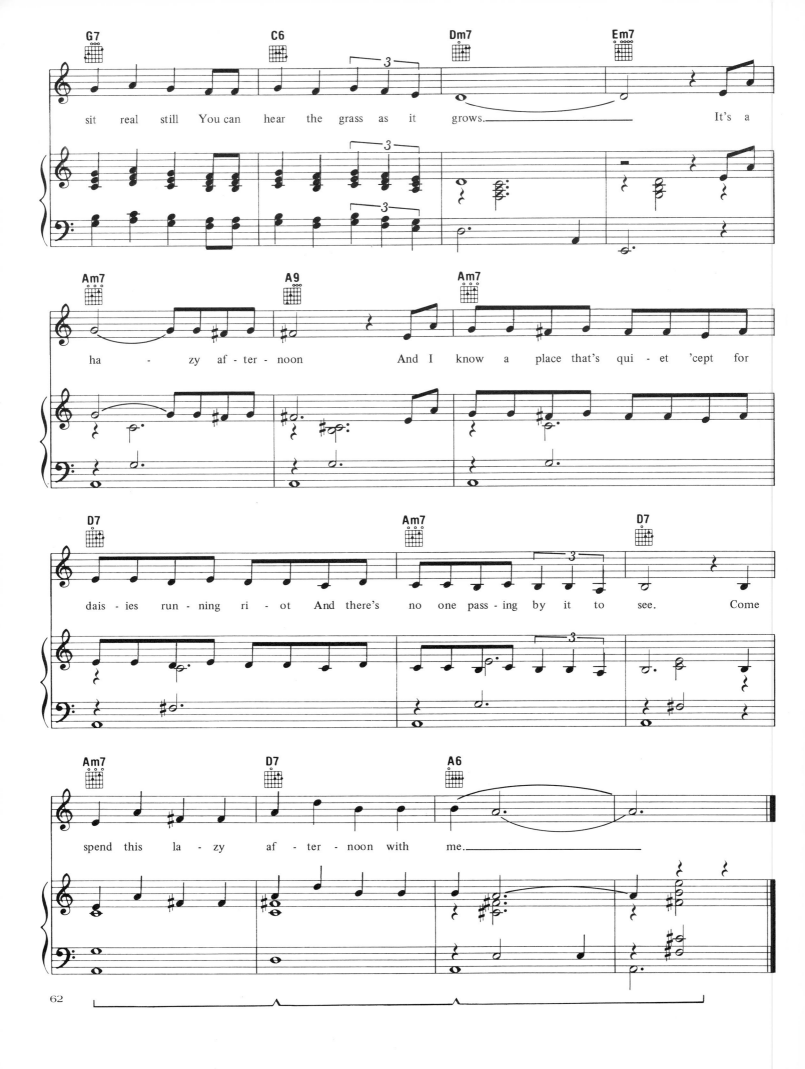

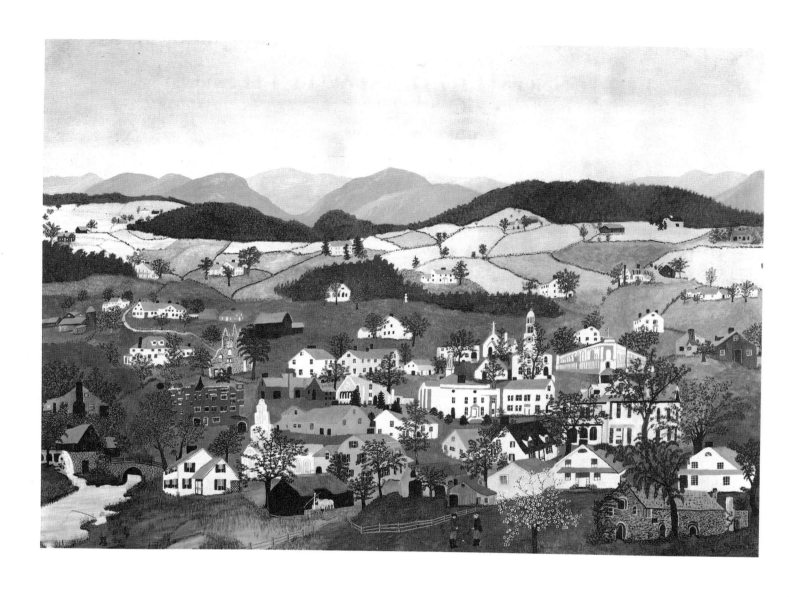

WILLIAMSTOWN

LET IT SNOW! LET IT SNOW! LET IT SNOW!

Words by Sammy Cahn
Music by Jule Styne

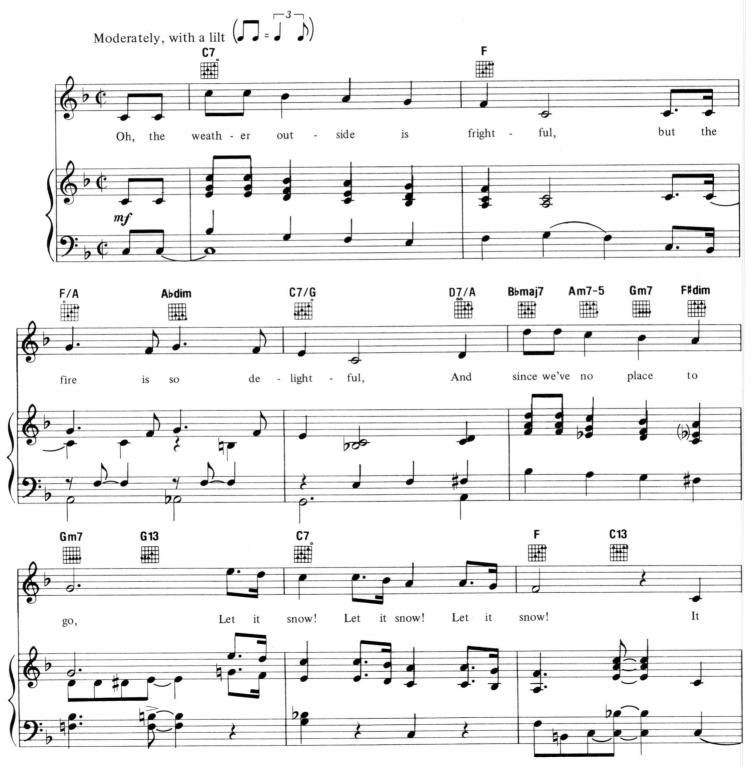

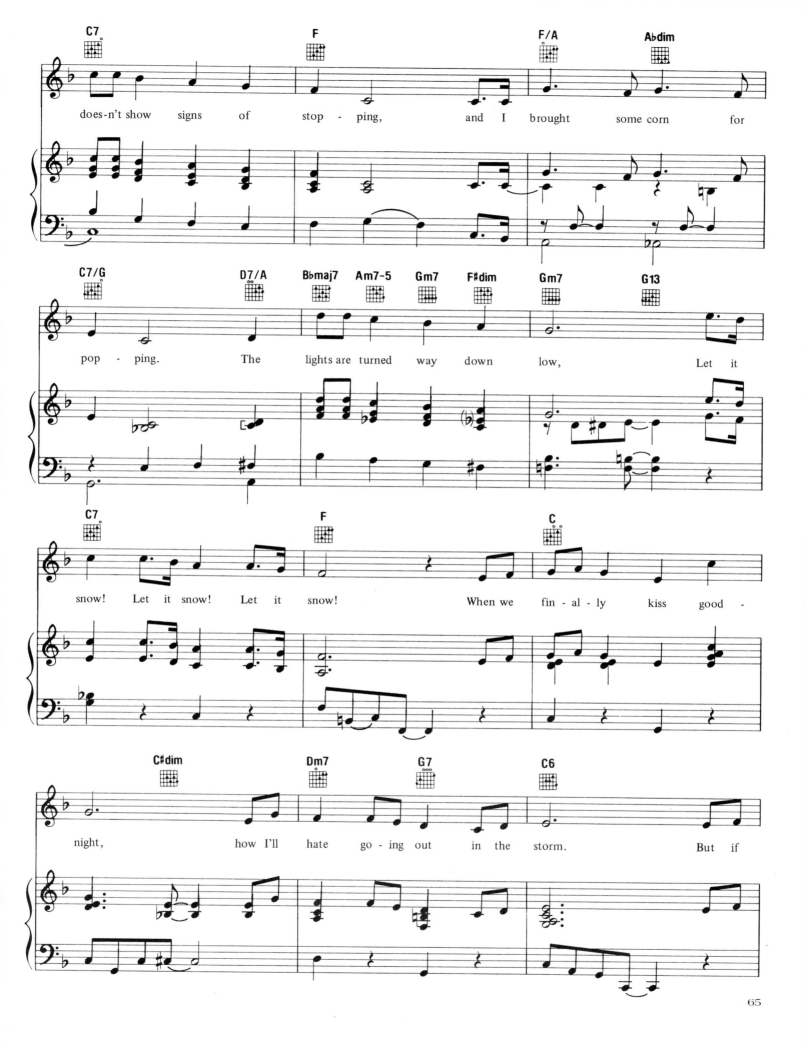

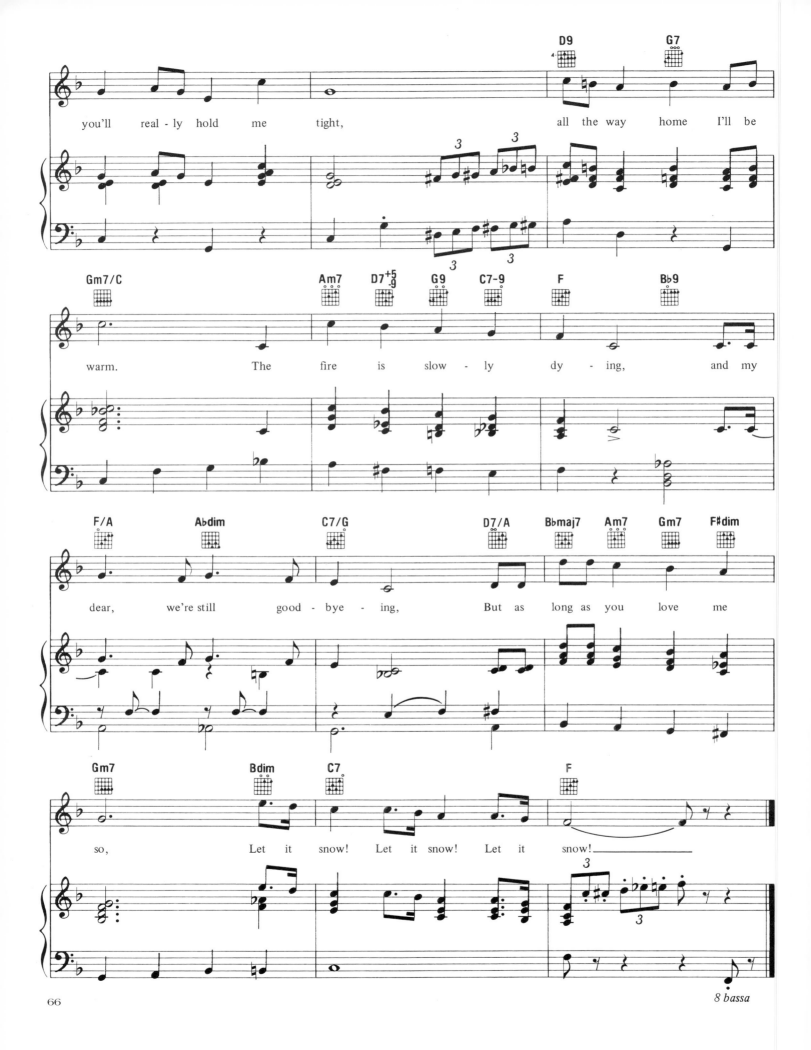

8 bassa

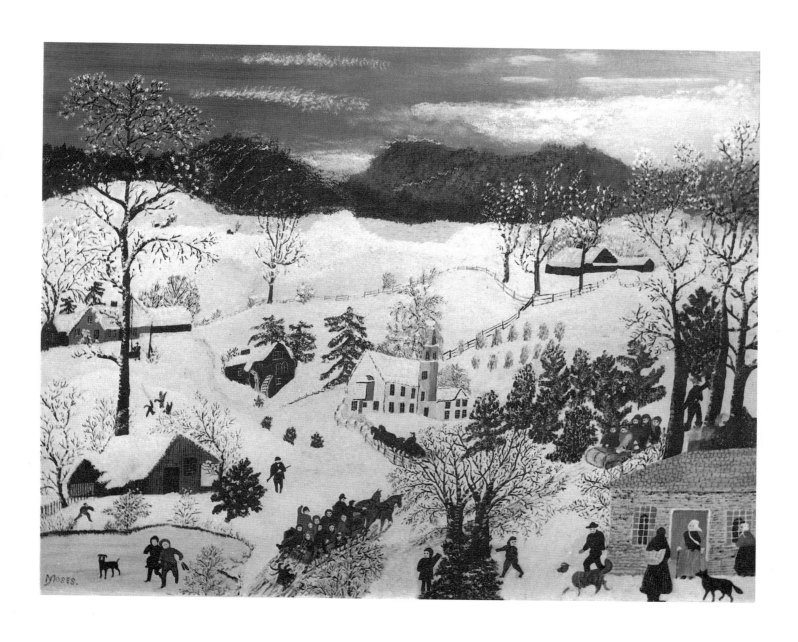

IT SNOWS, OH IT SNOWS

OH! DEAR, WHAT CAN THE MATTER BE?

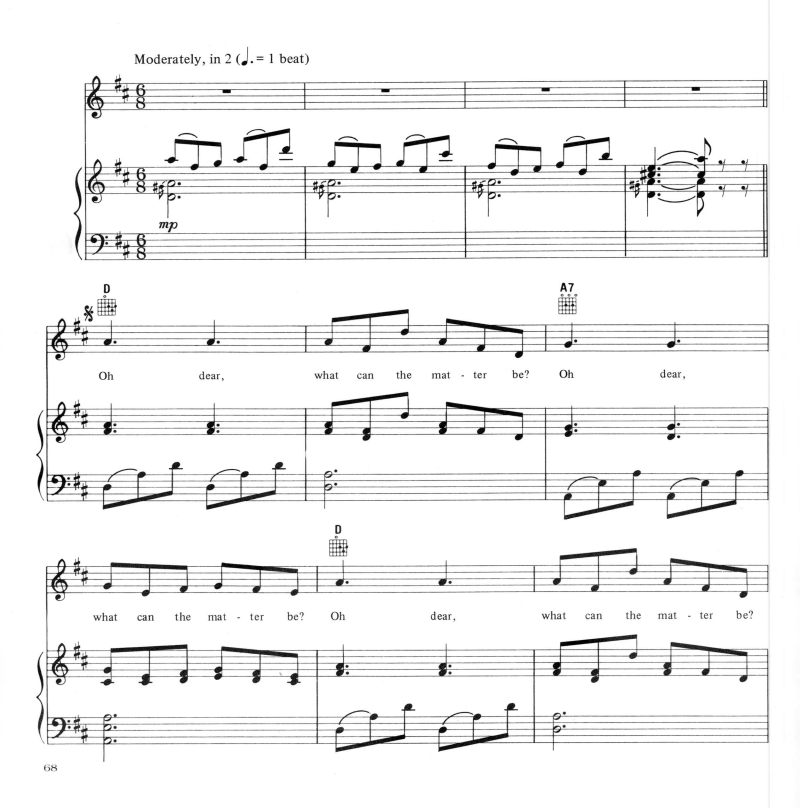

Moderately, in 2 (♩. = 1 beat)

Oh dear, what can the mat - ter be? Oh dear,

what can the mat - ter be? Oh dear, what can the mat - ter be?

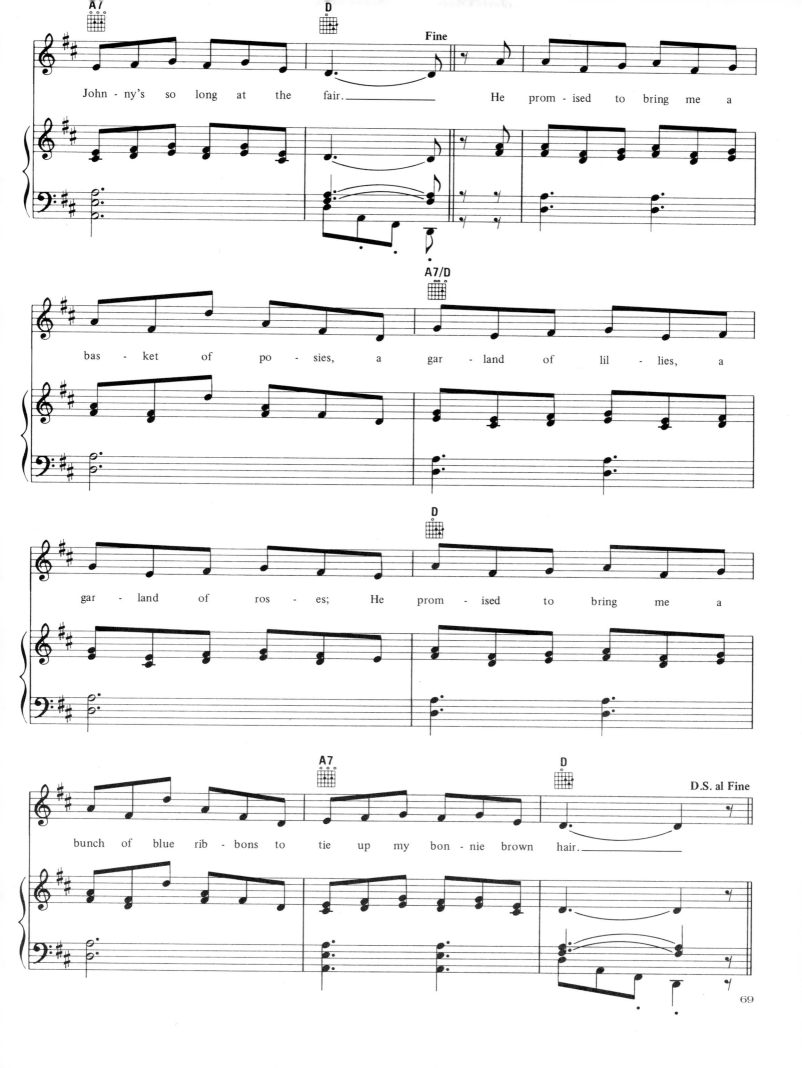

SEPTEMBER SONG

Words by Maxwell Anderson
Music by Kurt Weill

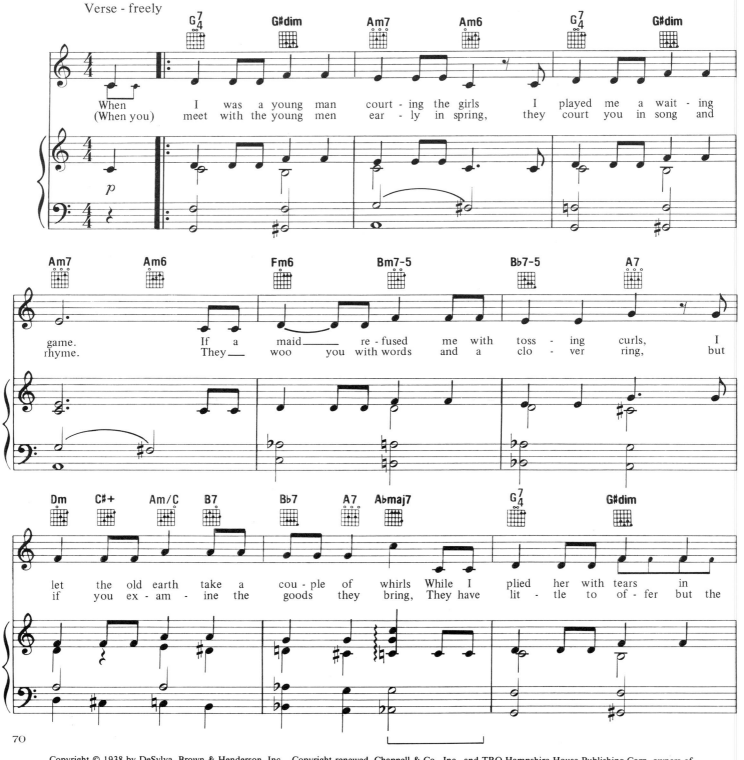

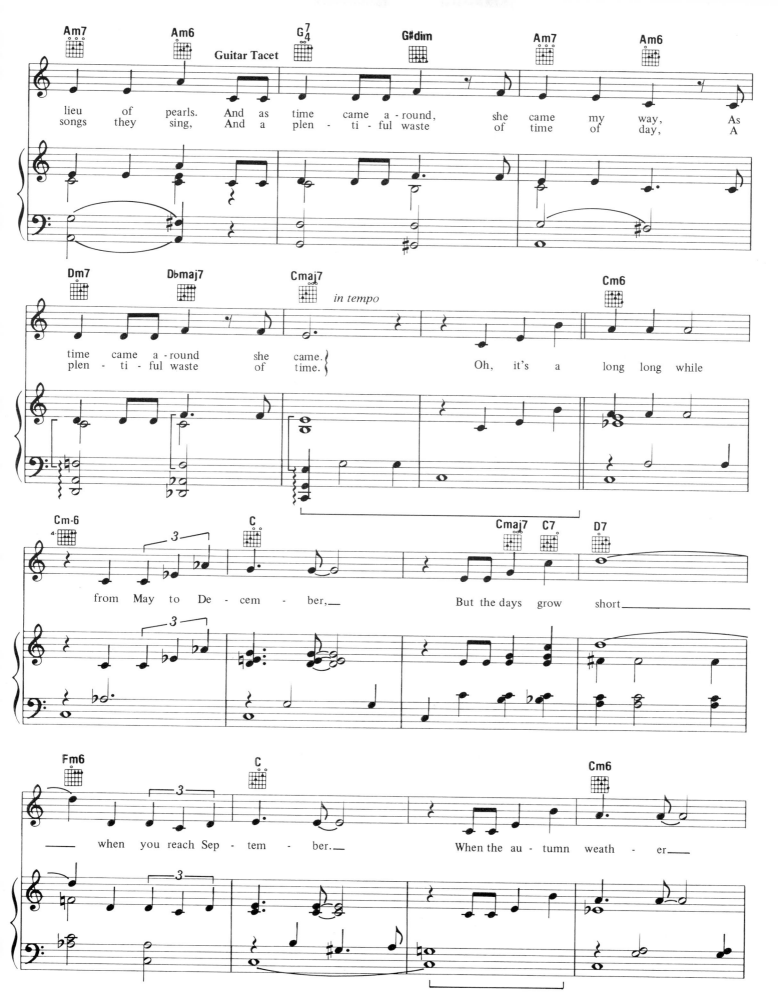

71

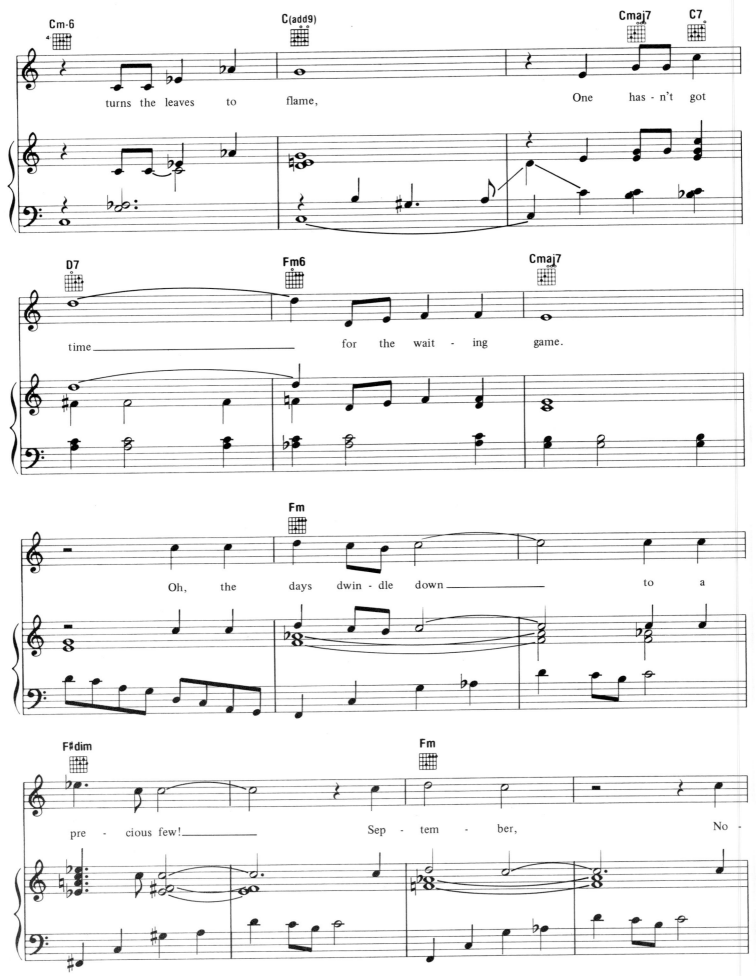

turns the leaves to flame, One has-n't got time _____ for the wait - ing game. Oh, the days dwin - dle down _____ to a pre - cious few! _____ Sep - tem - ber, No -

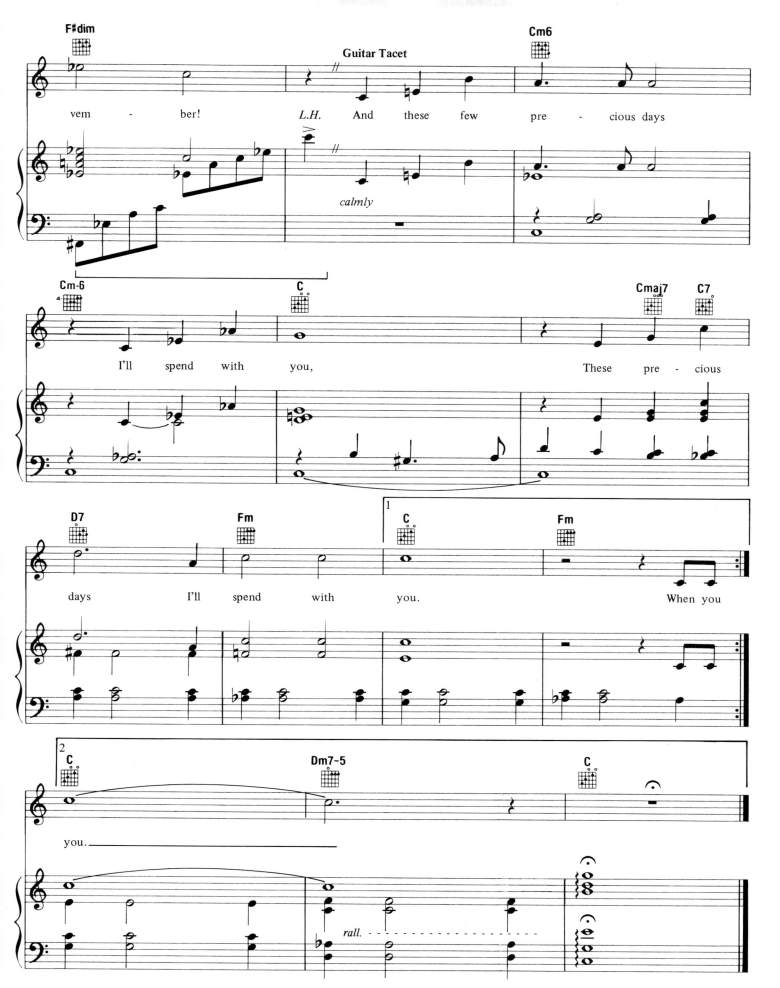

SOON IT'S GONNA RAIN

Words by Tom Jones
Music by Harvey Schmidt

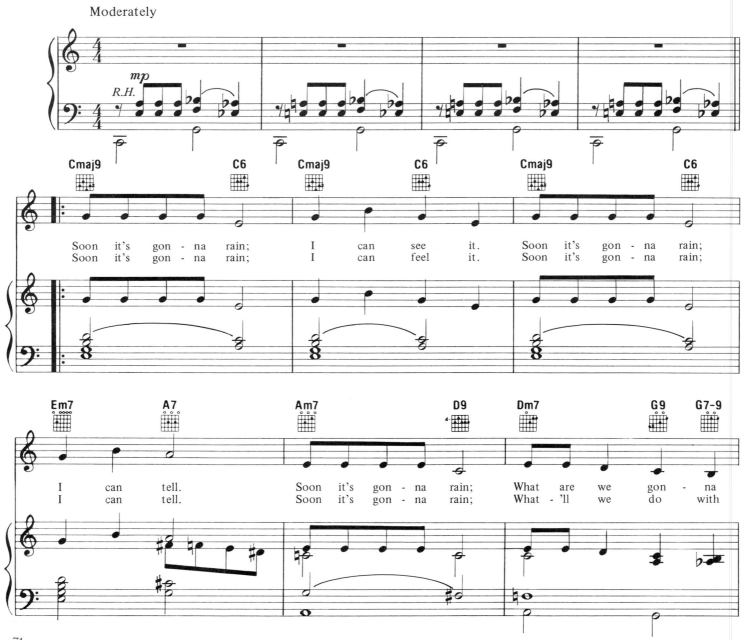

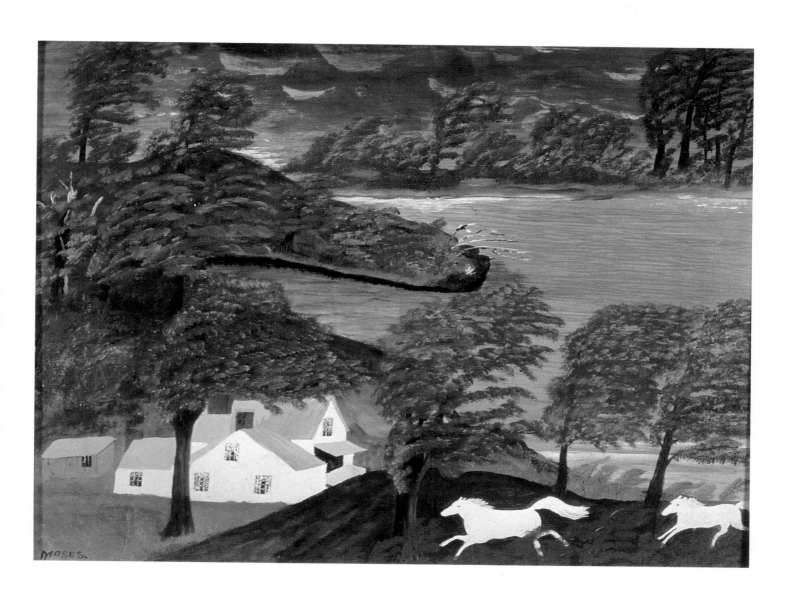

A STORM IS ON THE WATERS NOW

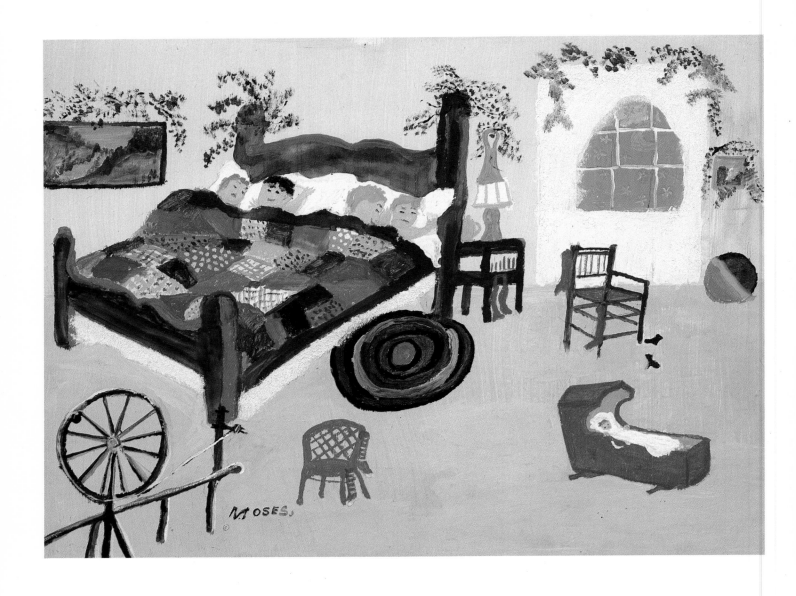

WAITING FOR SANTA CLAUS

TELL ME WHY

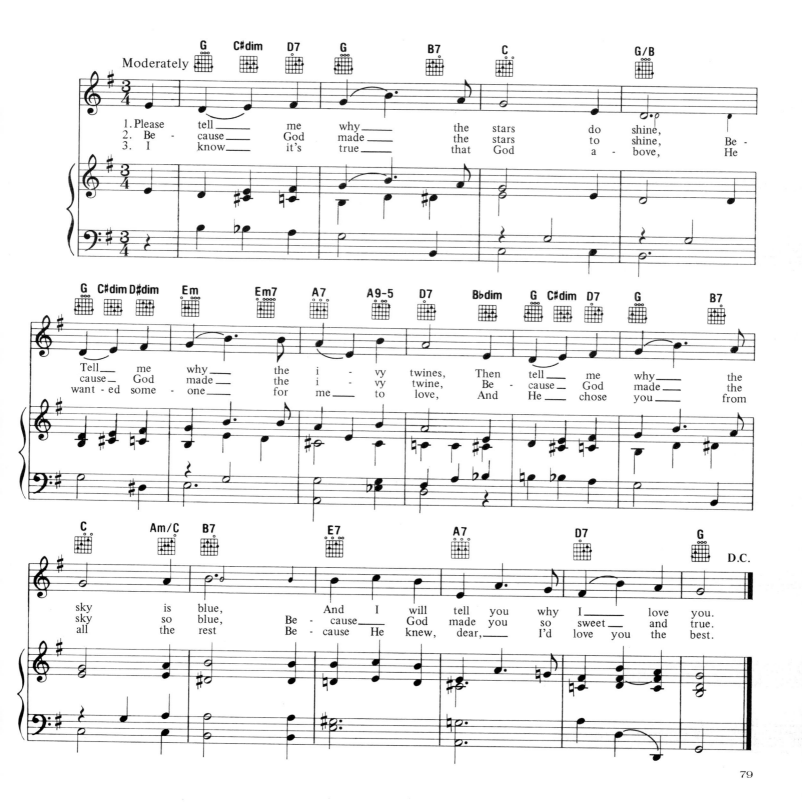

SWEET GENEVIEVE

Words by George Cooper
Music by Henry Tucker

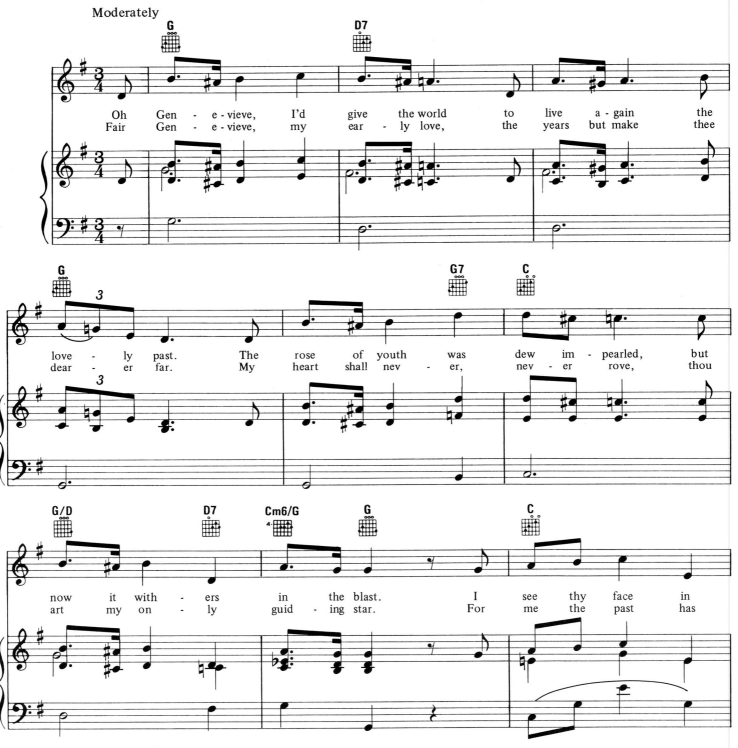

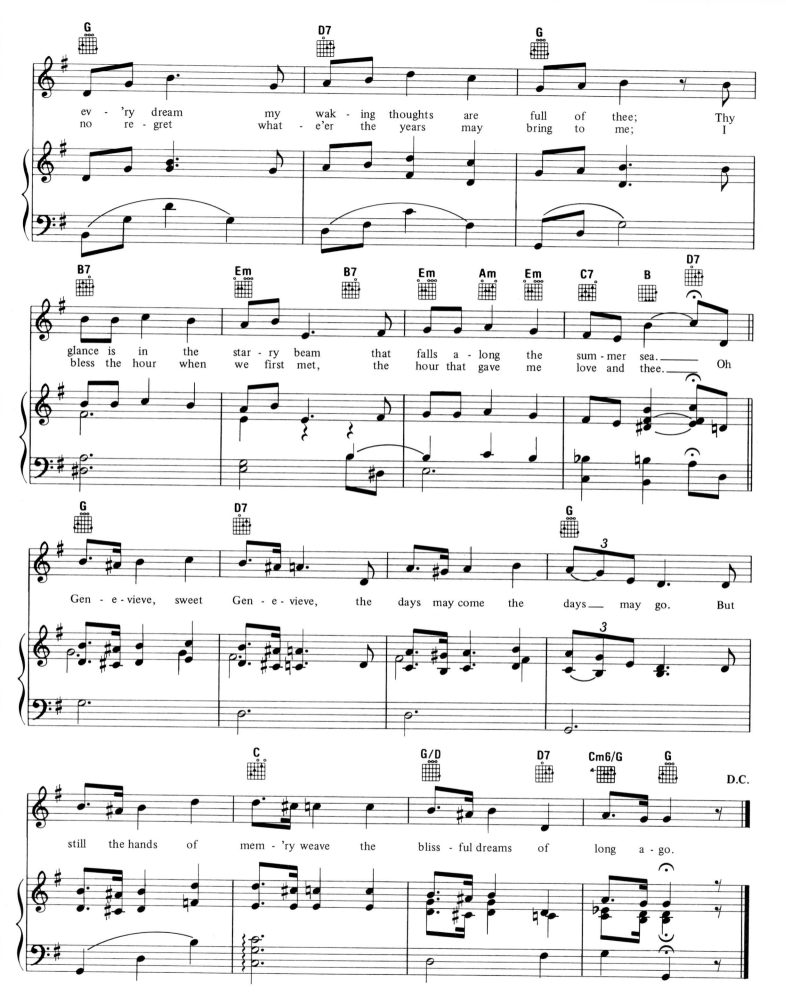

81

WAIT FOR THE WAGON

Words and music R.B. Buckley

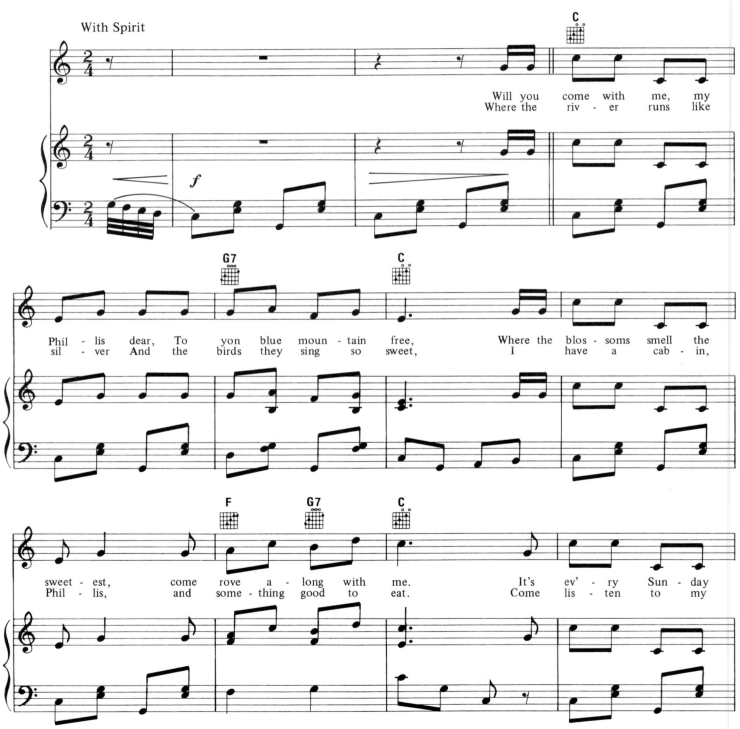

With Spirit

Will you come with me, my
Where the riv - er runs like

Phil - lis dear, To yon blue moun - tain free,
sil - ver And the birds they sing so sweet,

Where the blos - soms smell the
I have a cab - in,

sweet - est, come rove a - long with me.
Phil - lis, and some - thing good to eat.

It's ev' - ry Sun - day
Come lis - ten to my

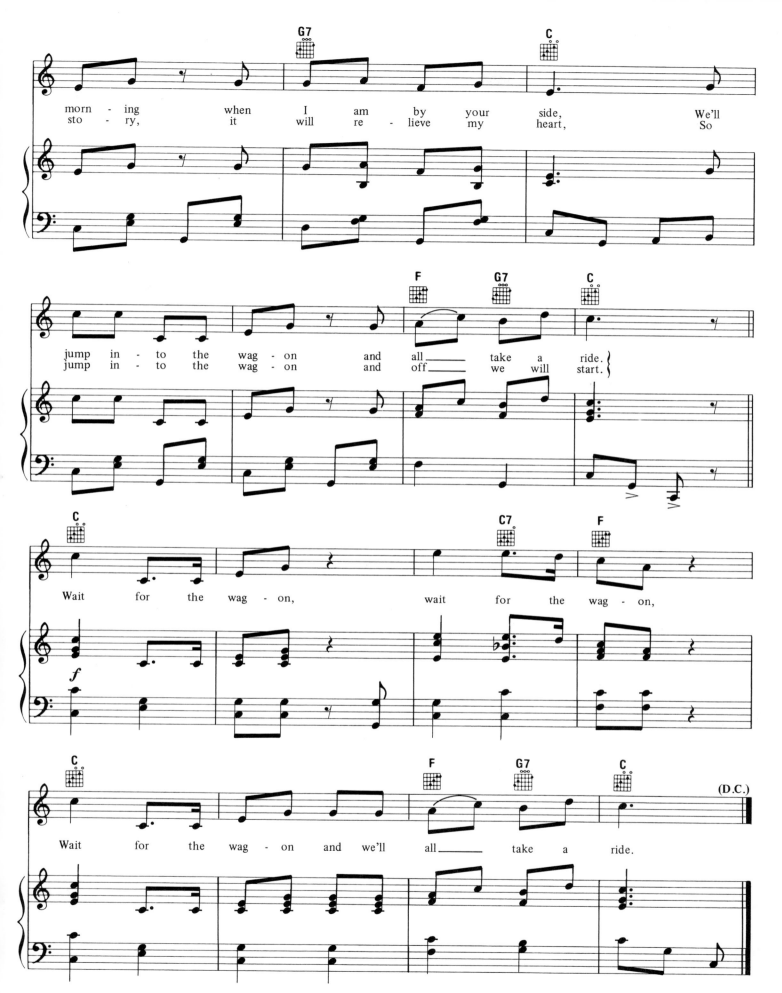

morn - ing when I am by your side, We'll
sto - ry, when it will am re - lieve my heart, So

jump in - to the wag - on and all _____ take a ride.
jump in - to the wag - on and off _____ we will start.

Wait for the wag - on, wait for the wag - on,

Wait for the wag - on and we'll all _____ take a ride.

(D.C.)

WHEN THE CORN IS WAVING, ANNIE DEAR

Words and music by Charles Blamphin

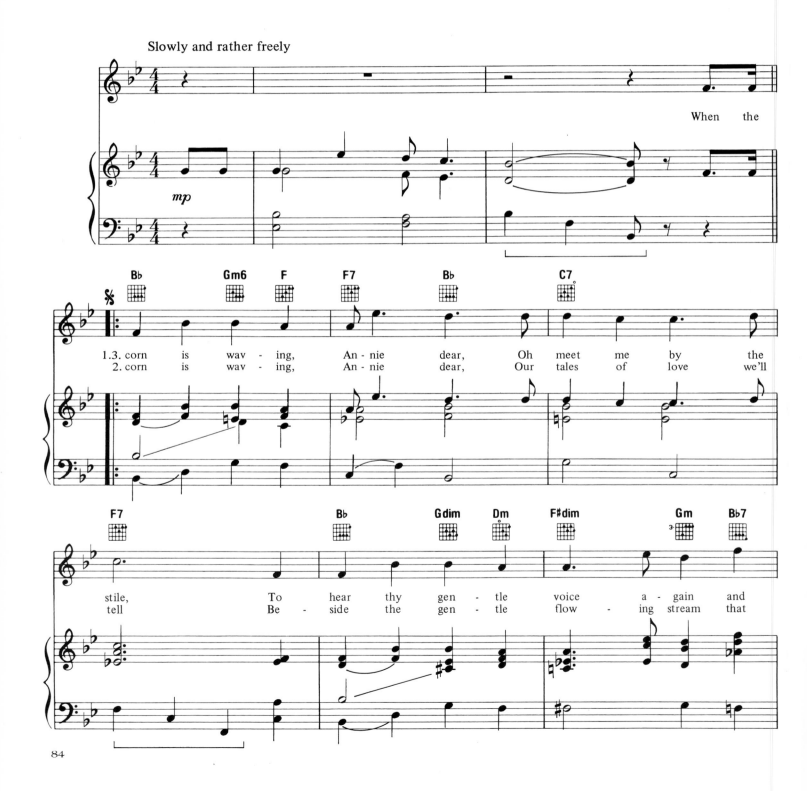

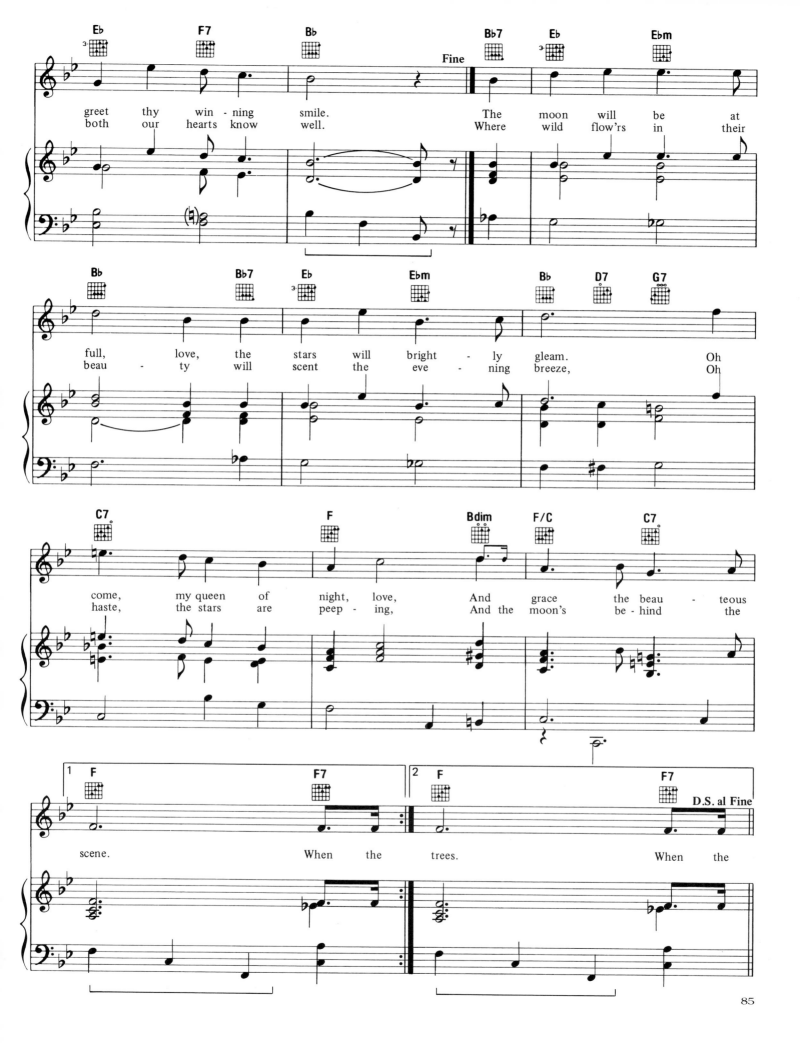

THE WORLD IS WAITING FOR THE SUNRISE

Words by Eugene Lockhart
Music by Ernest Seitz

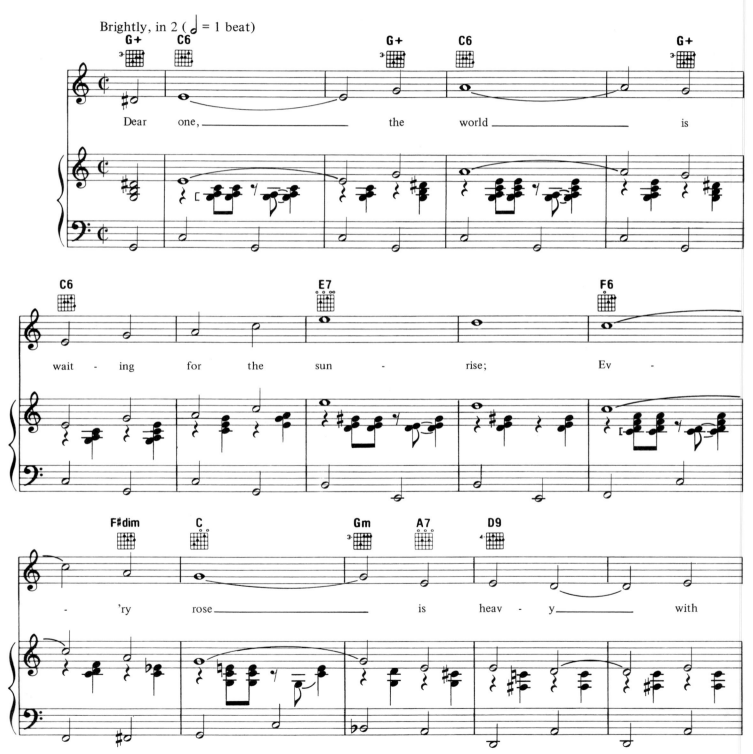

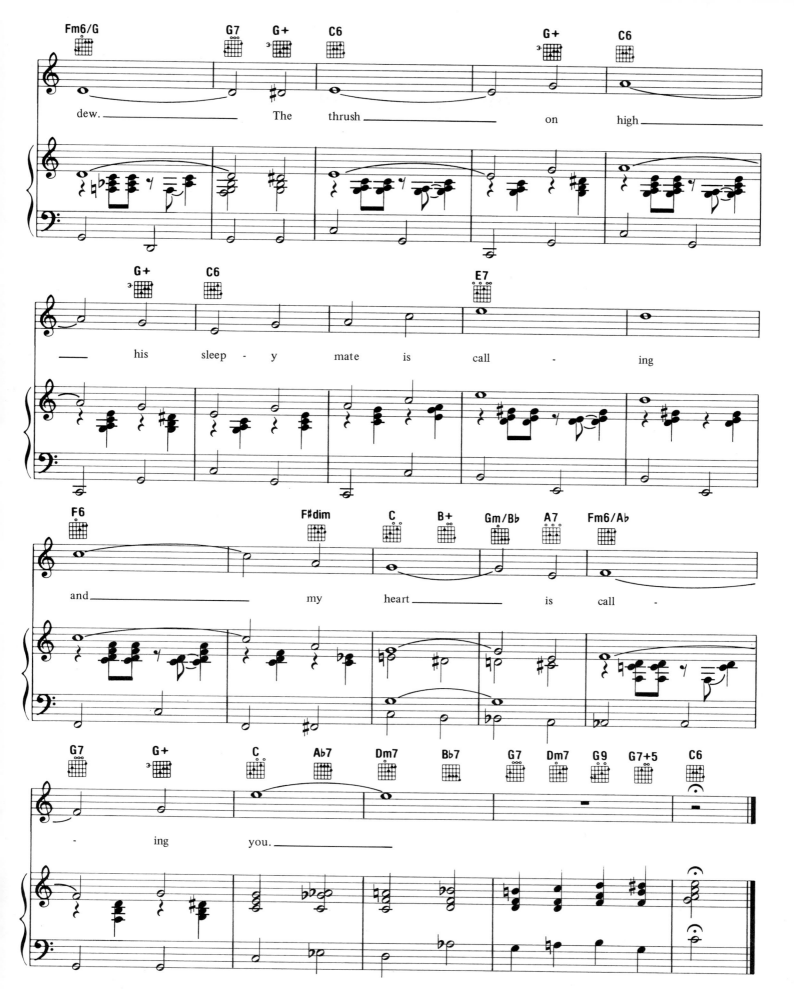

dew. _____ The thrush _____ on high _____

_____ his sleep-y mate is call ___ ing

and _____ my heart _____ is call -

- ing you. _____

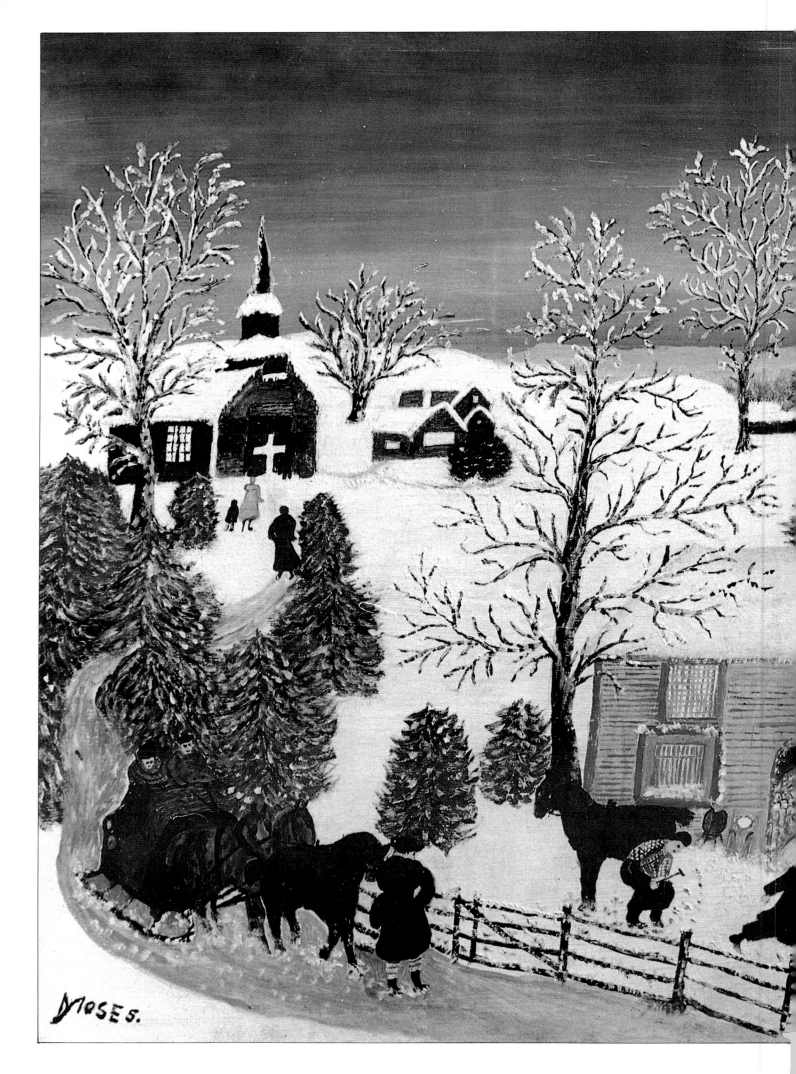

THE BIRDS AND THE BEASTS WERE THERE

RUN PIG RUN

ANIMAL FAIR

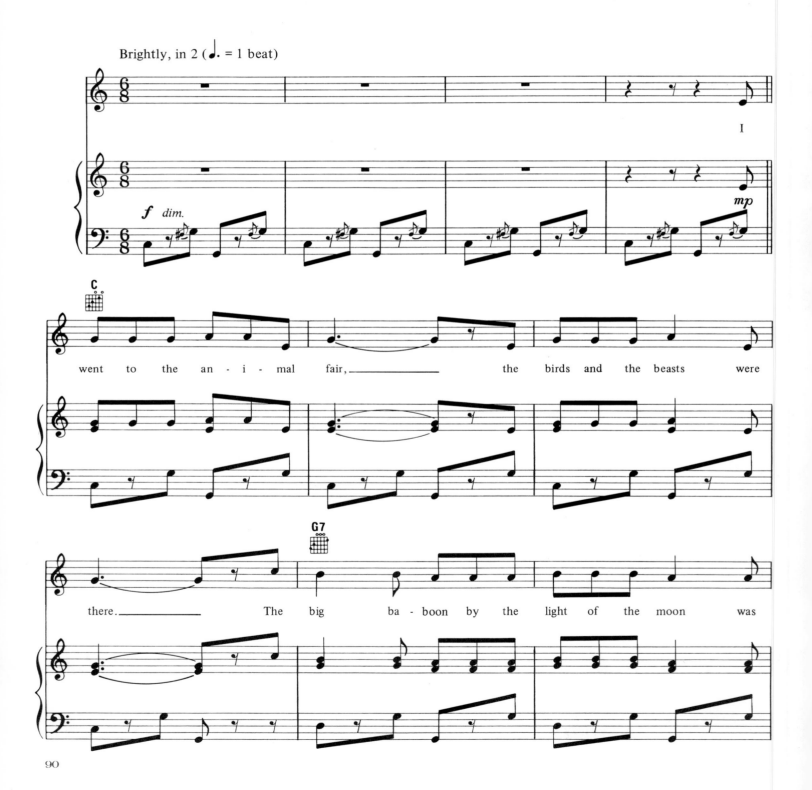

Brightly, in 2 (♩. = 1 beat)

I went to the an-i-mal fair, _____ the birds and the beasts were there. _____ The big ba-boon by the light of the moon was

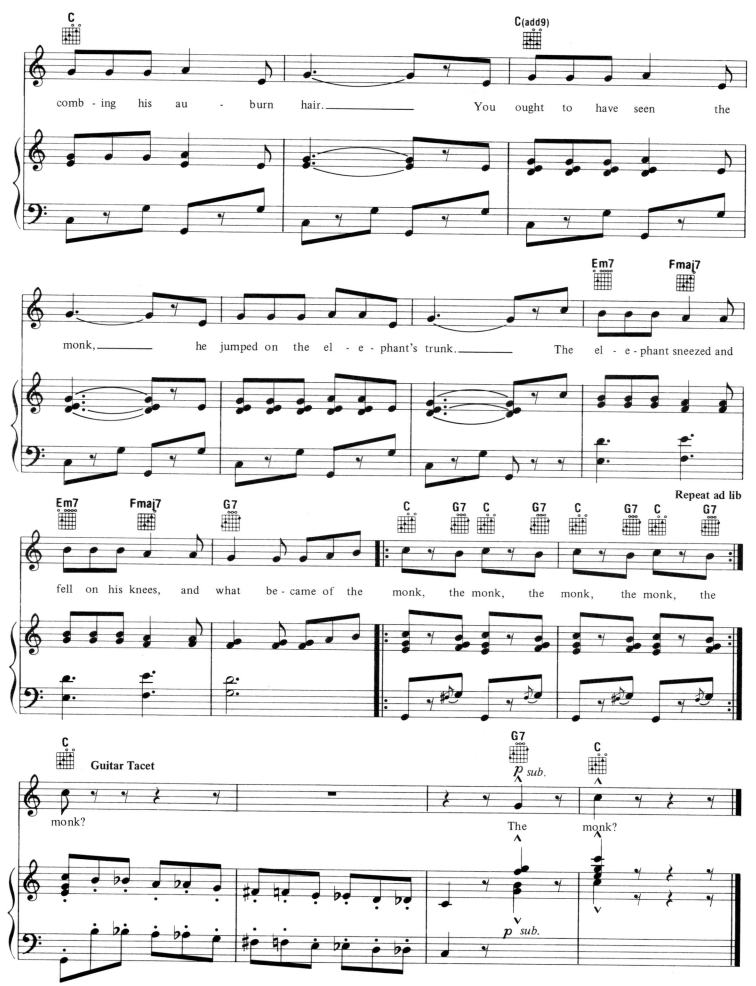

combing his au - burn hair._____ You ought to have seen the

monk,_____ he jumped on the el - e - phant's trunk._____ The el - e - phant sneezed and

fell on his knees, and what be - came of the monk, the monk, the monk, the monk, the

Guitar Tacet

monk?

The monk?

THE BARNYARD SONG

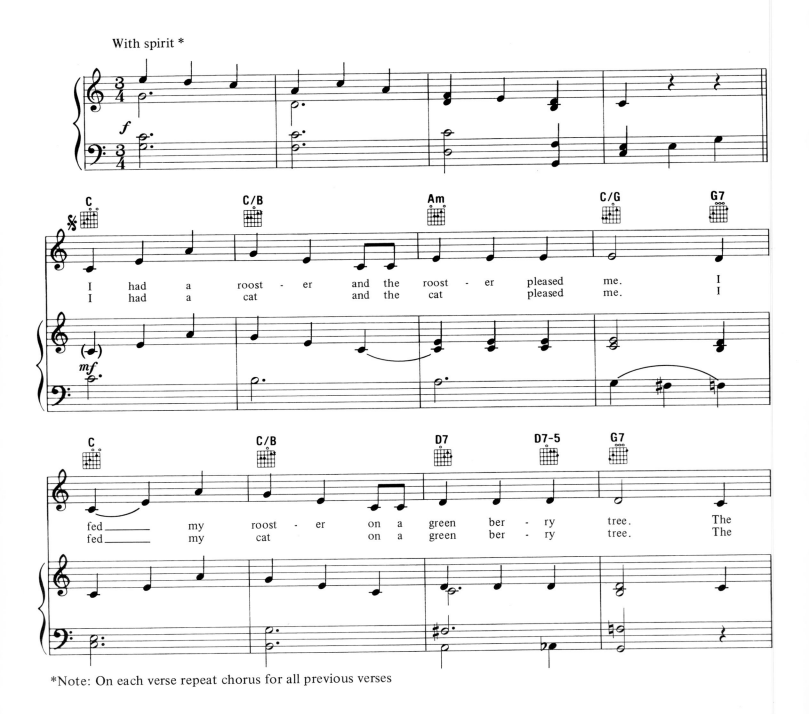

*Note: On each verse repeat chorus for all previous verses

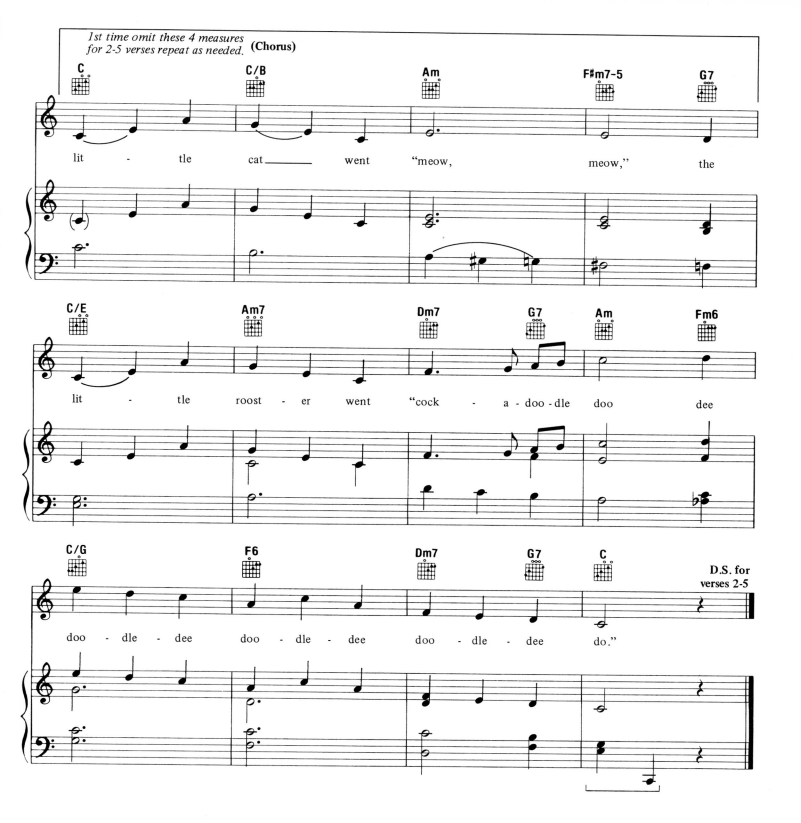

Additional lyrics:

I had a pig and the pig pleased me.
I fed my pig on a green berry tree.
The little pig went "oink oink"
Chorus:

I had a cow and the cow pleased me.
I fed my cow on a green berry tree.
The little cow went "moo moo"
Chorus:

I had a baby and the baby pleased me.
I fed my baby on a green berry tree.
The little baby went "waah waah"
Chorus:

BAA! BAA! BLACK SHEEP

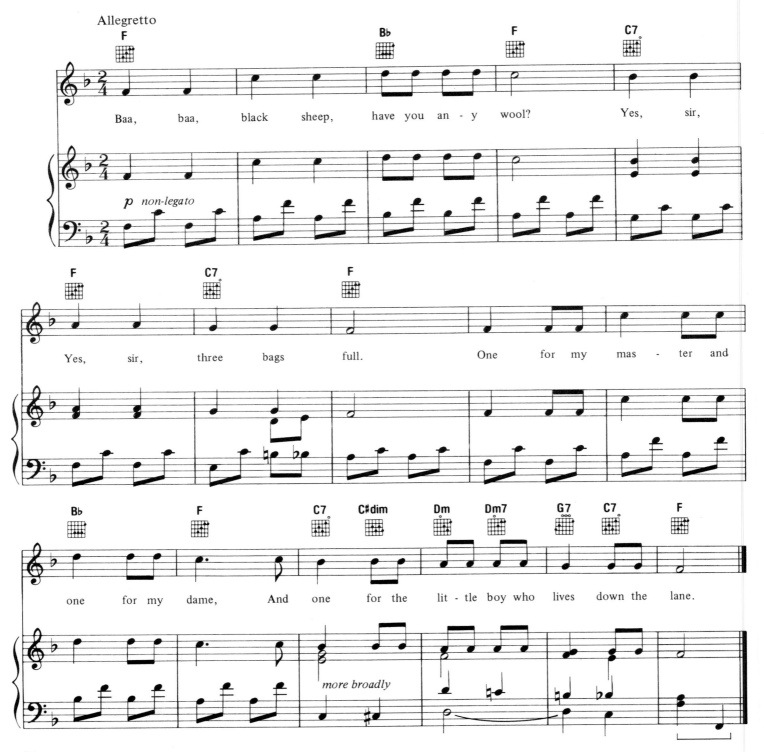

Baa, baa, black sheep, have you an-y wool? Yes, sir,

Yes, sir, three bags full. One for my mas - ter and

one for my dame, And one for the lit - tle boy who lives down the lane.

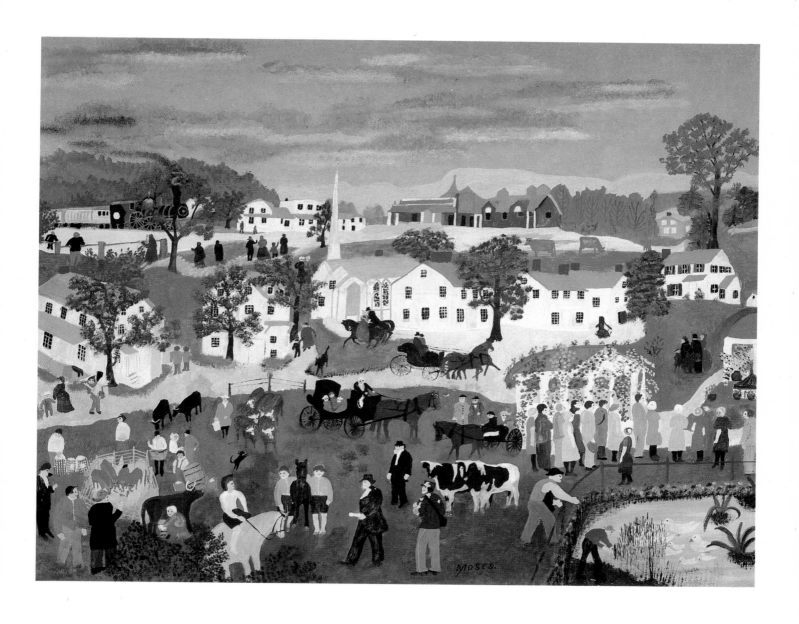

BONDSVILLE FAIR

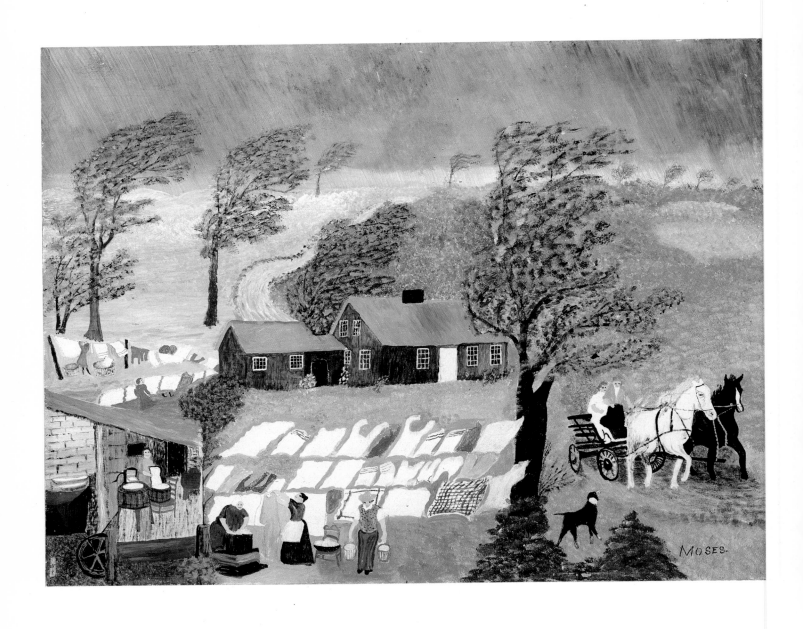

TAKING IN LAUNDRY

EENSY WEENSY SPIDER

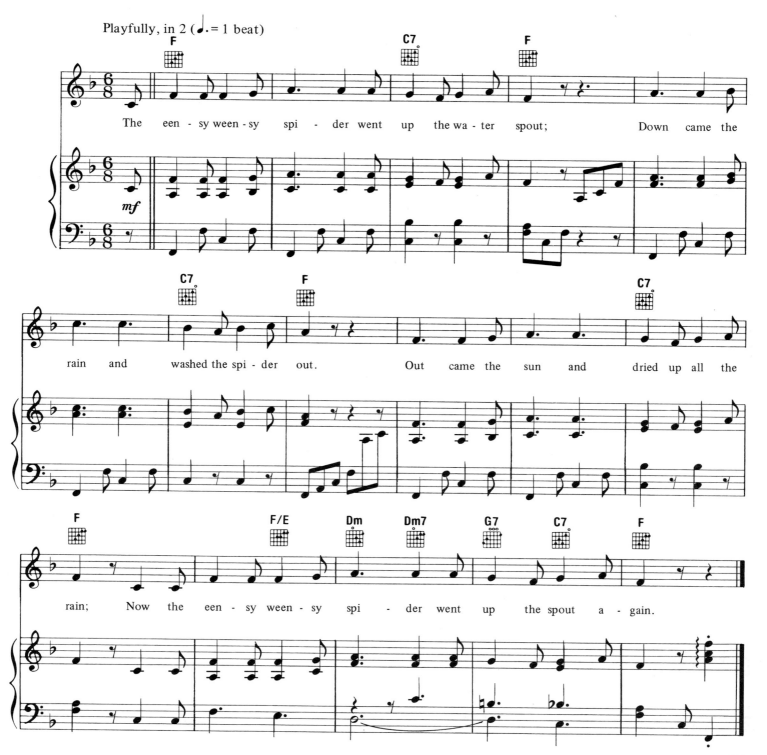

Playfully, in 2 (♩. = 1 beat)

The een-sy ween-sy spi-der went up the wa-ter spout; Down came the

rain and washed the spi-der out. Out came the sun and dried up all the

rain; Now the een-sy ween-sy spi-der went up the spout a-gain.

97

THE GLOW WORM

Modern version by Johnny Mercer
Original lyric by Lilla Cayley Robinson
Music by Paul Lincke

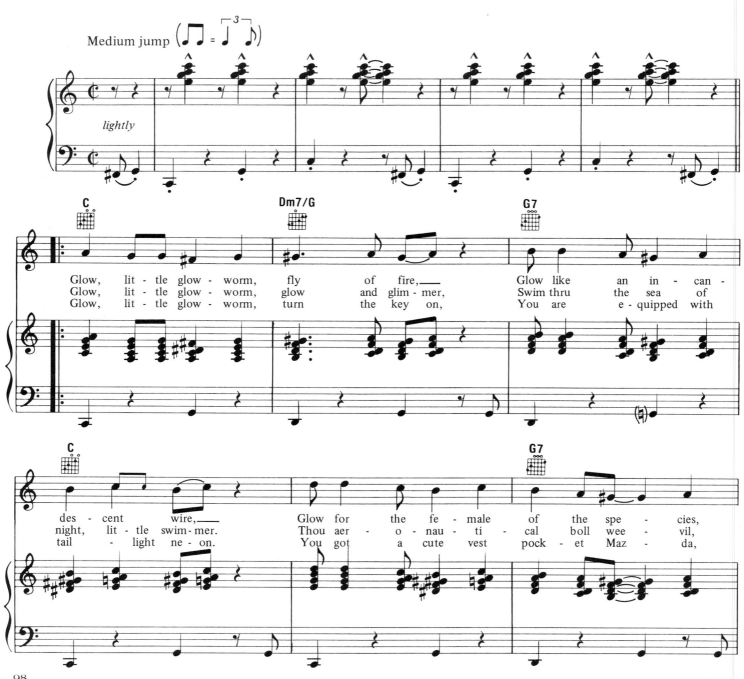

Glow, lit-tle glow-worm, fly of fire,___ Glow like an in-can-
Glow, lit-tle glow-worm, glow and glim-mer, Swim thru the sea of
Glow, lit-tle glow-worm, turn the key on, You are e-quipped with

des-cent wire,___ Glow for the fe-male of the spe-cies,
night, lit-tle swim-mer. Thou aer-o-nau-ti-cal boll wee-vil,
tail-light ne-on. You got a cute vest pock-et Maz-da,

98

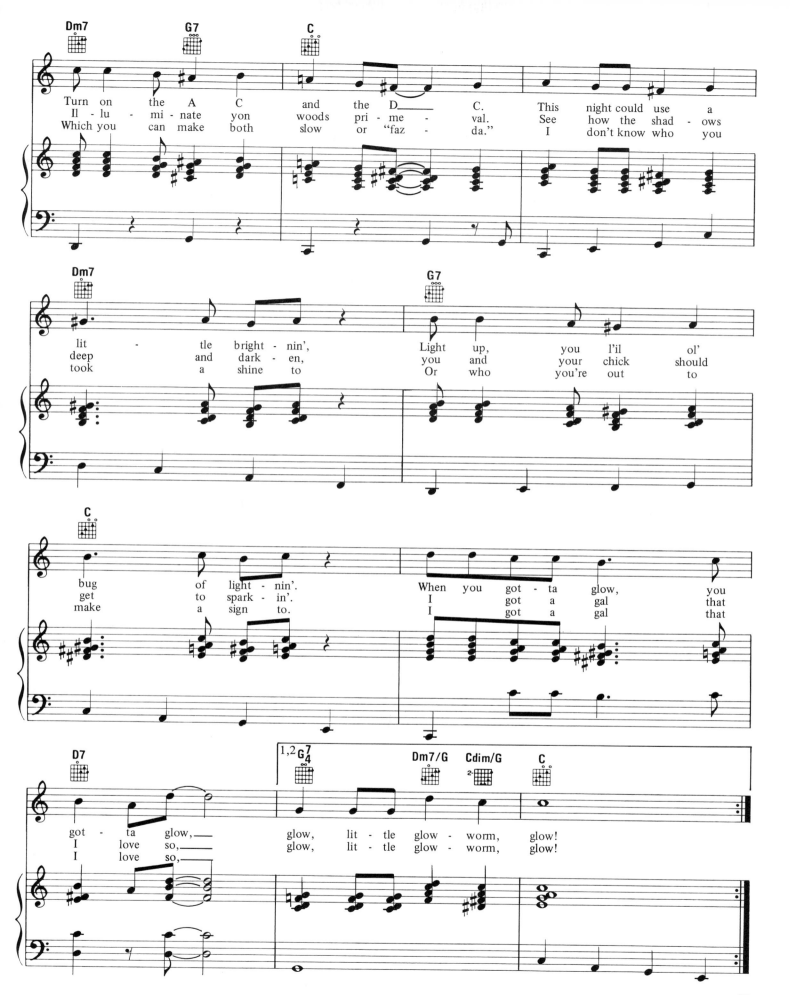

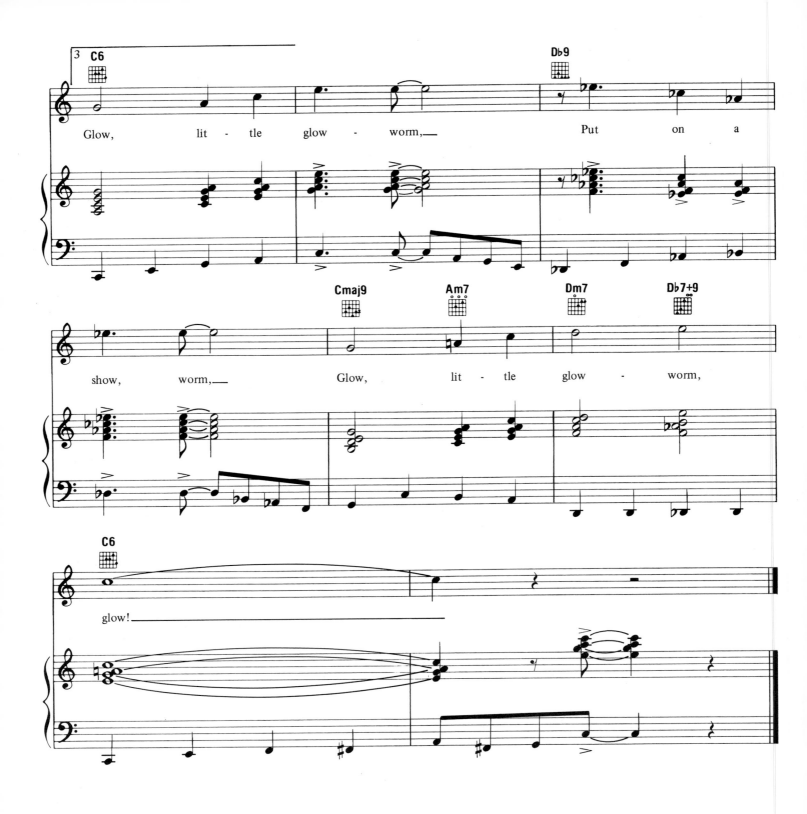

Original words
Shine, little glowworm, glimmer, glimmer,
Shine, little glowworm, glimmer, glimmer.
Lead us, lest too far we wander,
Love's sweet voice is calling yonder!
Shine, little glowworm, glimmer, glimmer,
Shine, little glowworm, glimmer, glimmer!
Light the path, below, above
And lead us on to Love!

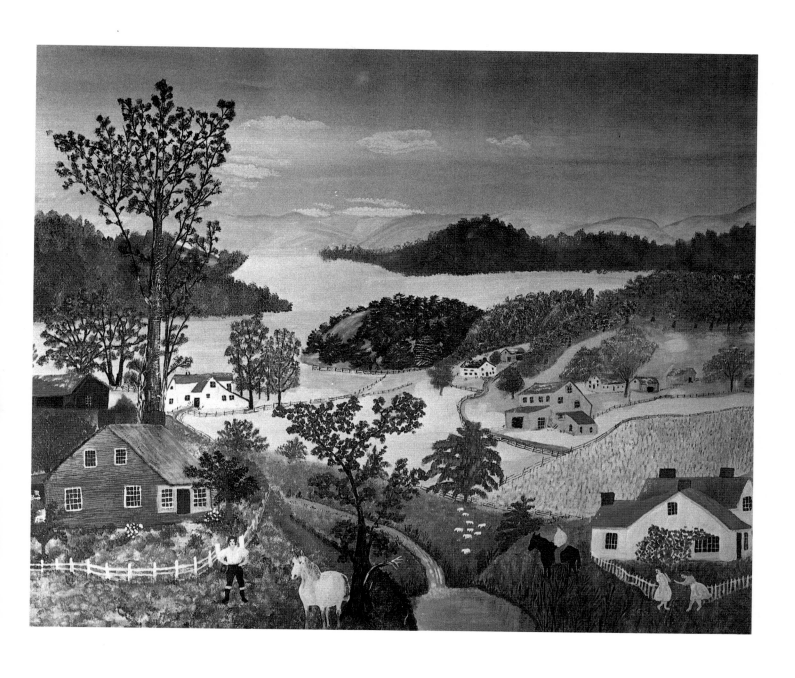

A BEAUTIFUL WORLD

THE FOX

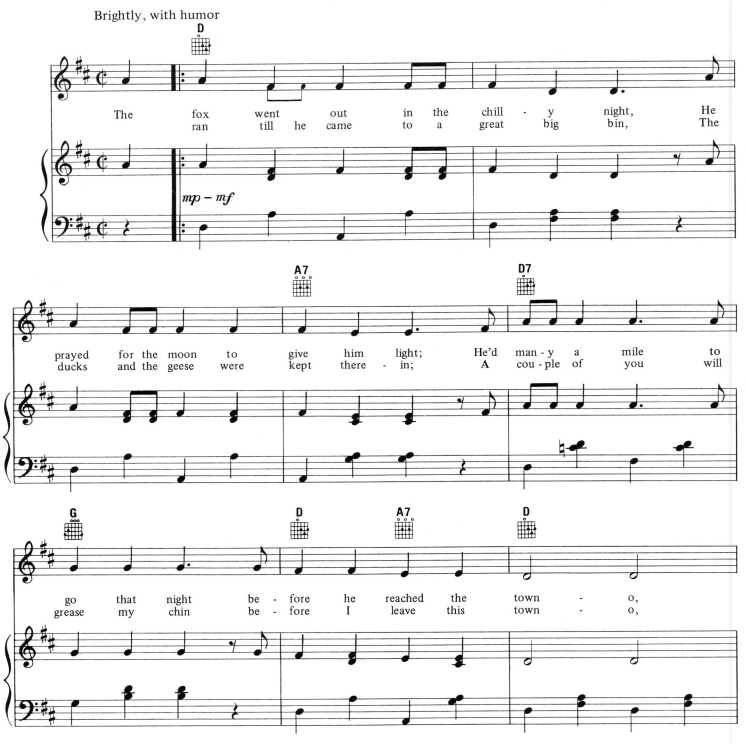

Brightly, with humor

The fox went out in the chill-y night, He
ran till he came to a great big bin,

prayed for the moon to give him light; He'd man-y a mile to
ducks and the geese were kept there-in; A cou-ple of you will

go that night be - fore he reached the town - o,
grease my chin be - fore I leave this town town - o,

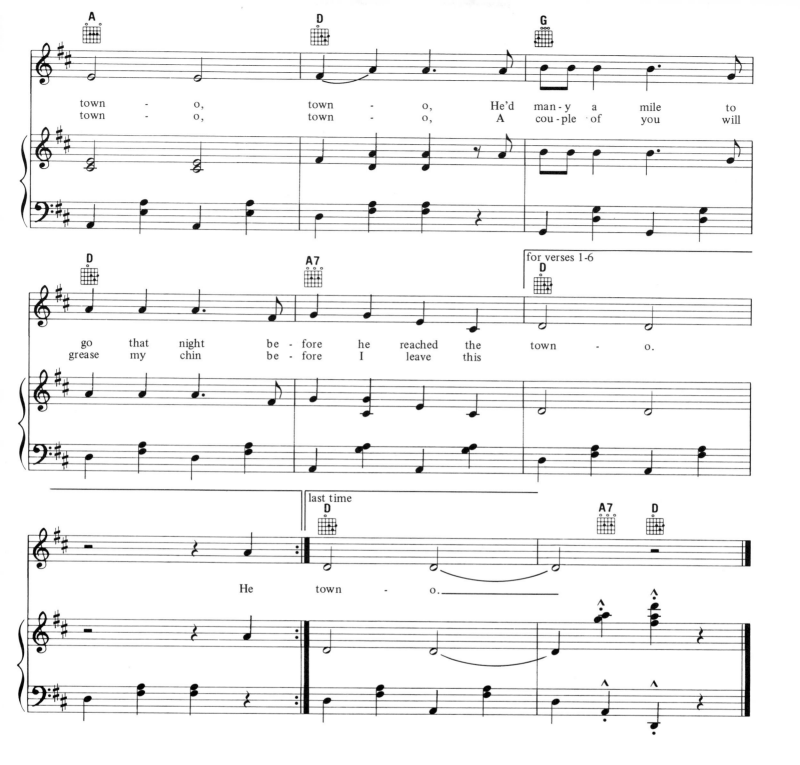

3. So he grabbed a gray goose by the neck
And threw a duck across his back;
He didn't mind their "quack, quack, quack"
And their legs all dangling down-o, down-o, down-o,
He didn't mind their "quack, quack, quack"
And their legs all dangling down-o.

4. Then old Mother Flipper-flopper jumped out of bed
And out of the window she stuck her head;
Said, "John, John, the gray goose is gone,
And the fox is in the town-o, town-o, town-o" etc.

5. So John he ran to the top of the hill
And he blew his horn both loud and shrill;
The fox he said, "I better flee with my kill
Or they'll soon be on my trail-o, trail-o, trail-o," etc.

6. He ran till he came to his cozy den
And there were his little ones, eight, nine, and ten;
They said, "Daddy, you better go back again
'Cause it must be a mighty fine town-o, town-o, town-o," etc.

7. So the fox and his wife, without any strife,
They cut up the goose with a fork and a knife;
They never had such a supper in their lives
And the little ones chewed on the bones-o, bones-o, bones-o, etc.

MY OLD HEN

With rollicking good humor

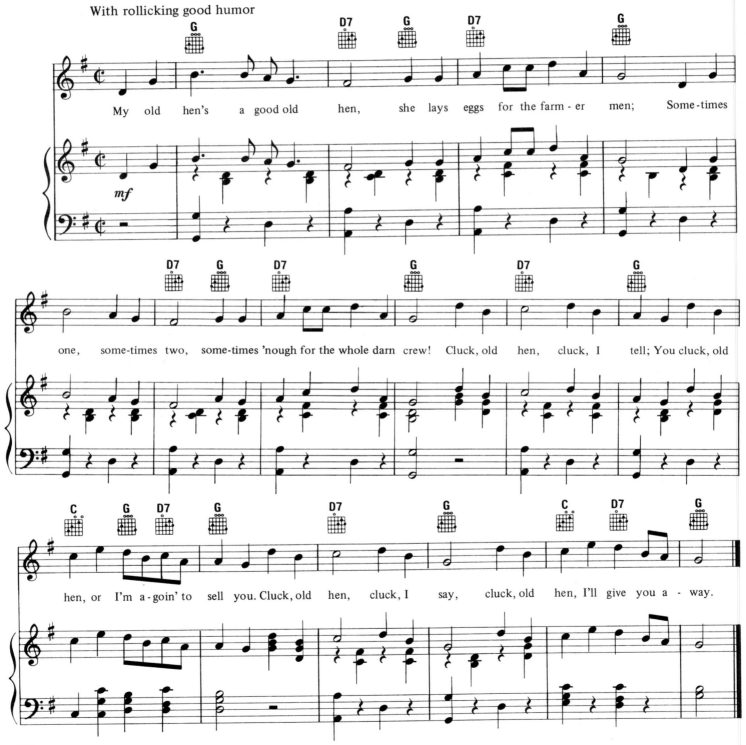

My old hen's a good old hen, she lays eggs for the farm-er men; Some-times one, some-times two, some-times 'nough for the whole darn crew! Cluck, old hen, cluck, I tell; You cluck, old hen, or I'm a-goin' to sell you. Cluck, old hen, cluck, I say, cluck, old hen, I'll give you a-way.

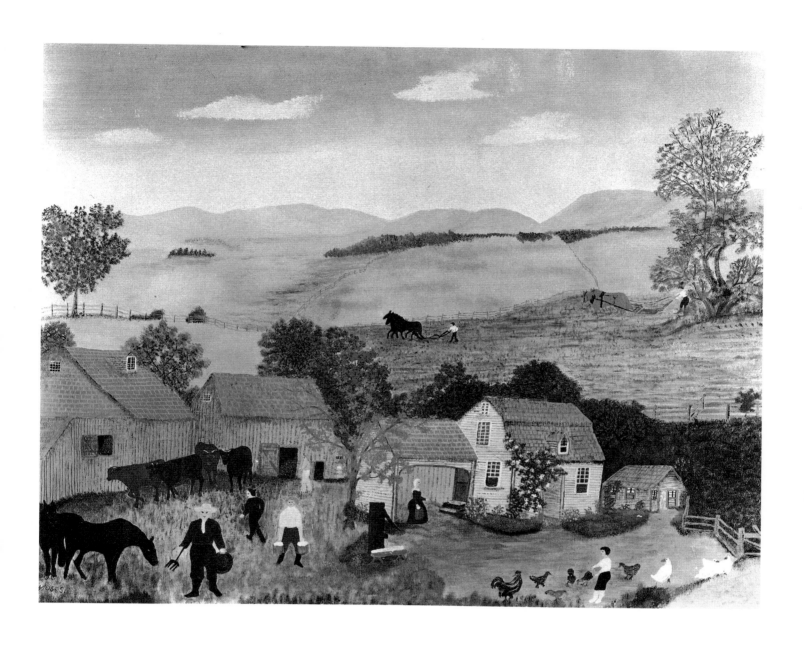

IN THE SPRINGTIME

OH WHERE, OH WHERE HAS MY LITTLE DOG GONE?

Words by Septimus Winner

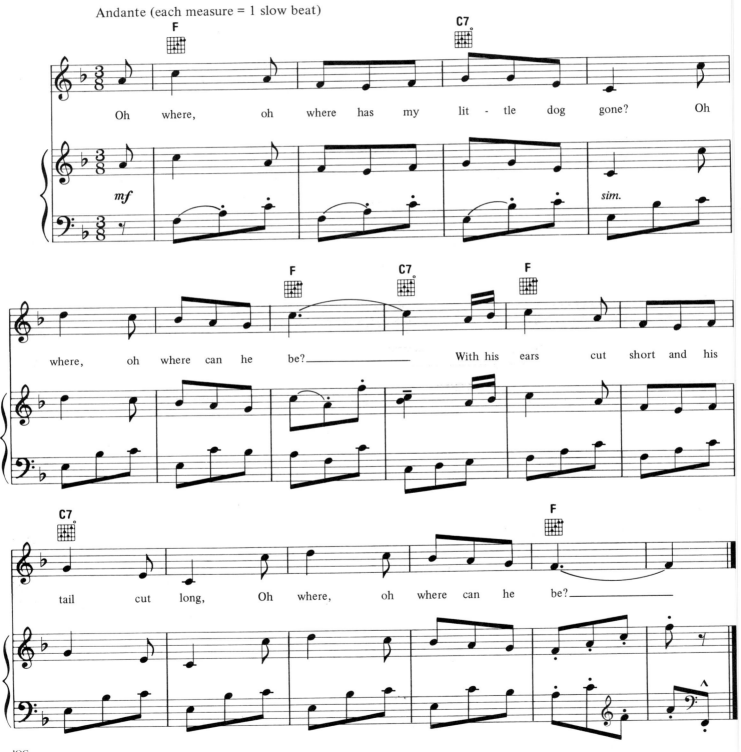

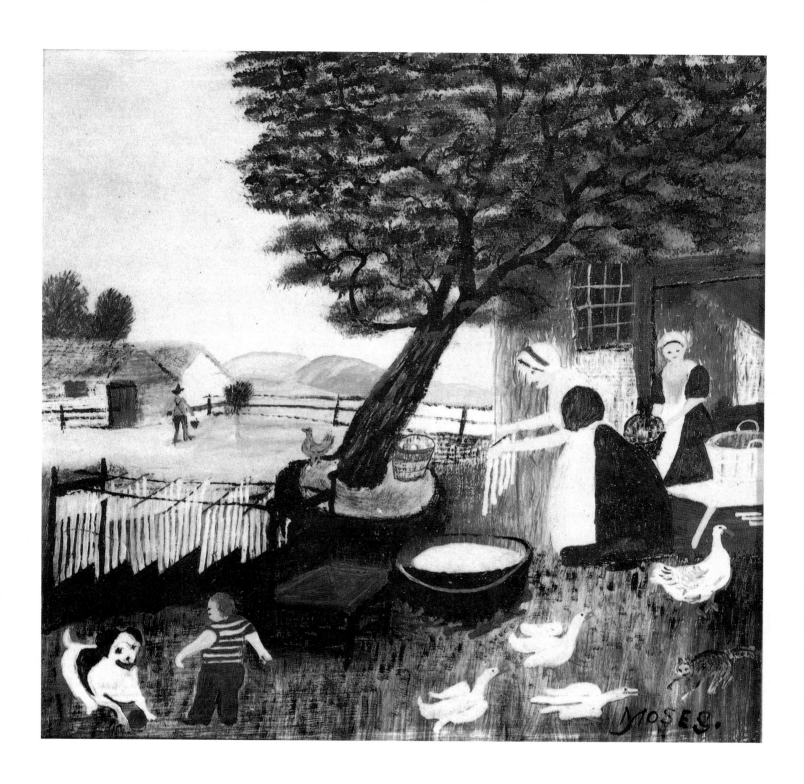

CANDLE DIP DAY IN 1800

OLD DOG TRAY

Words and music by Stephen C. Foster

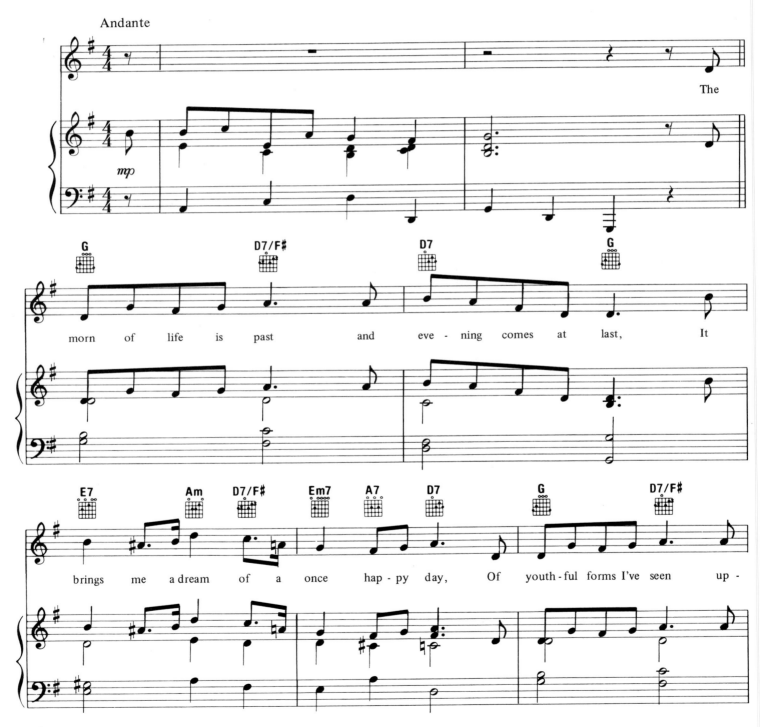

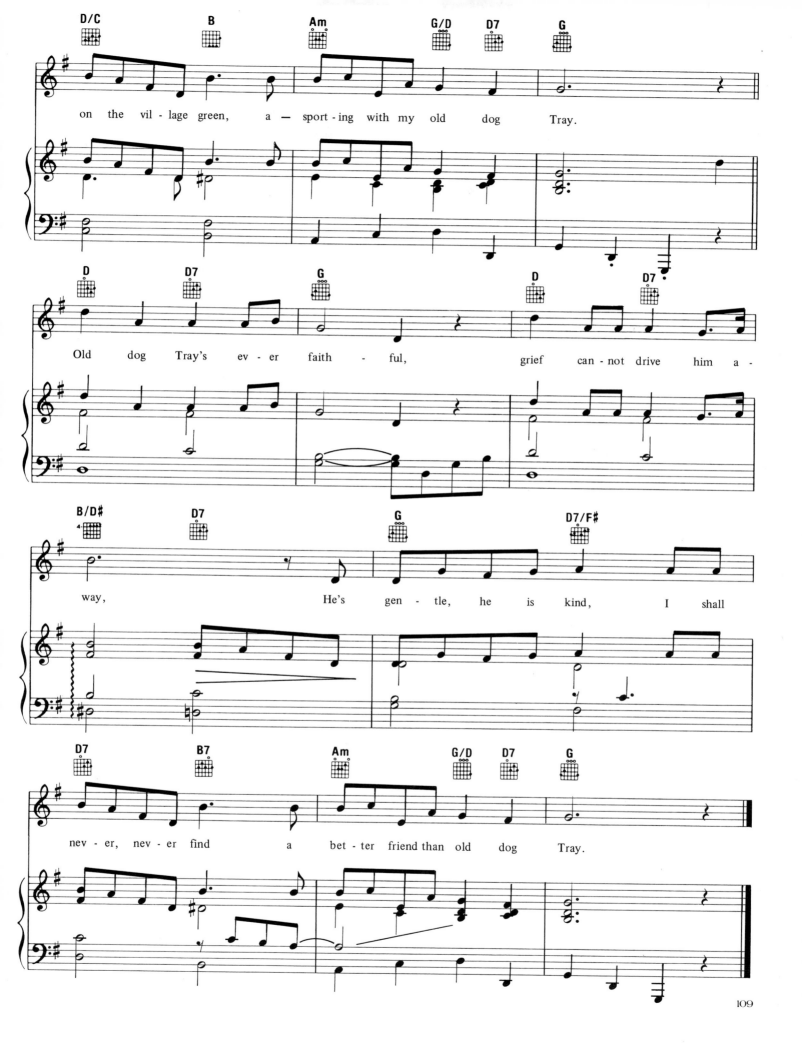

on the vil - lage green, a — sport - ing with my old dog Tray.

Old dog Tray's ev - er faith - ful, grief can - not drive him a -

way, He's gen - tle, he is kind, I shall

nev - er, nev - er find a bet - ter friend than old dog Tray.

THE OLE GREY GOOSE

Mon - day was my wed - ding day, Tues - day I was mar - ried, Wed'ns-day night my
Wed'ns-day night my wife took sick, de - spair of death come o'er her, Some did cry but

wife took sick, Sat' - day she was bur - ied. Oh! Look - y here! Oh, look - y where?
I did laugh to see that death go from her.

Look right o - ver yan-der. Don't you see the old grey goose Smil - ing at the gan - der?

(D.C.)

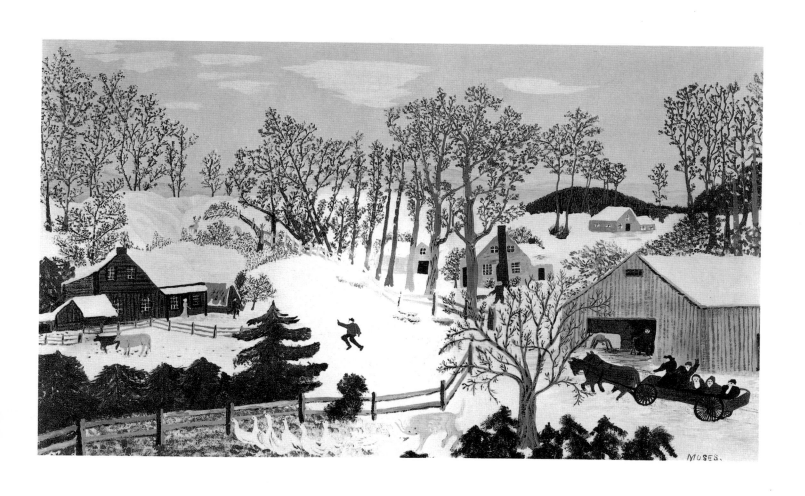

EARLY SPRINGTIME ON THE FARM

ROBIN REDBREAST

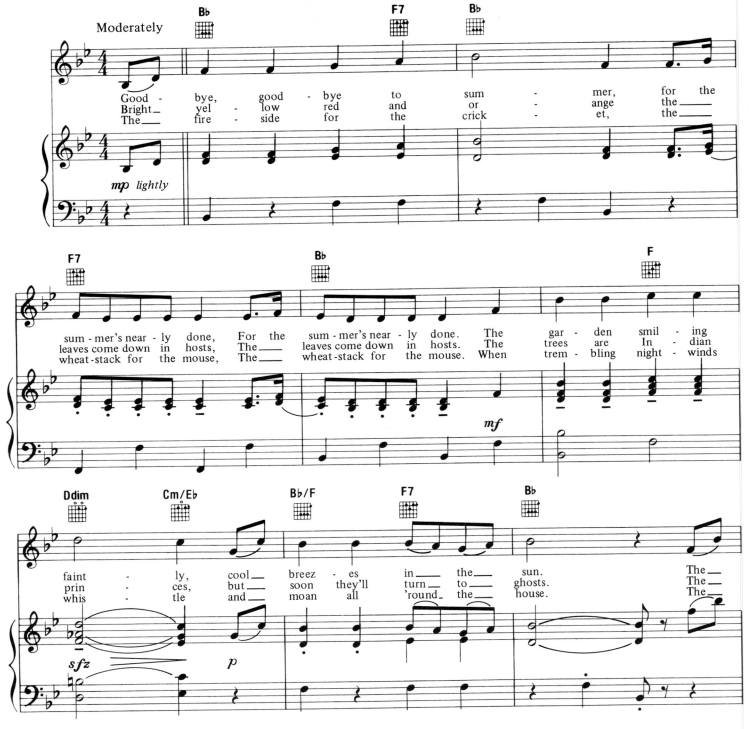

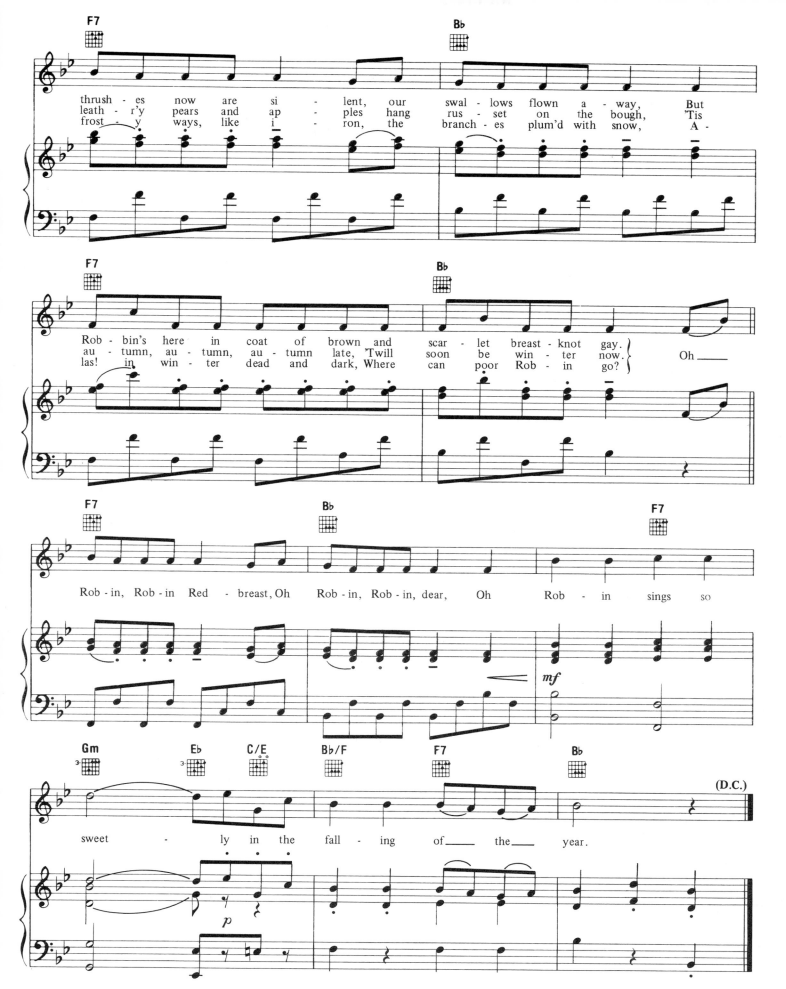

THE SOW TOOK THE MEASLES

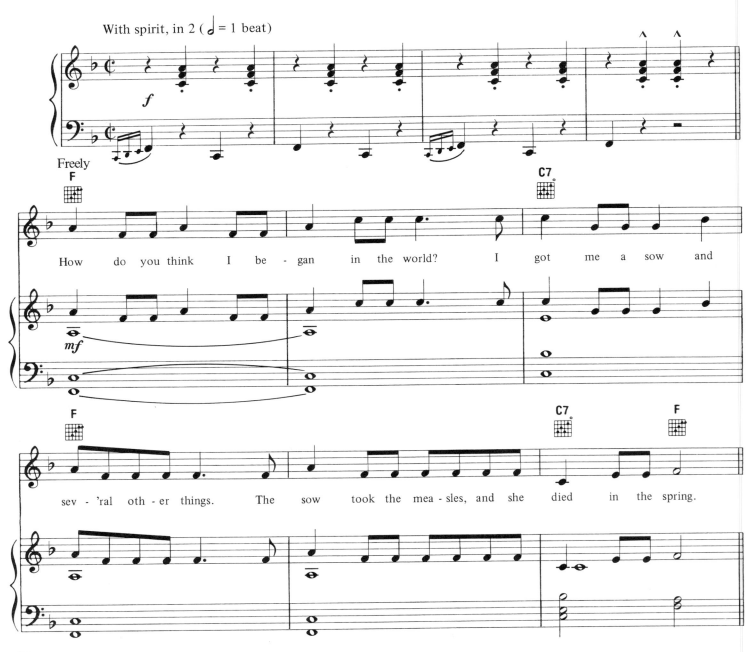

With spirit, in 2 (𝅗𝅥 = 1 beat)

Freely

How do you think I be - gan in the world? I got me a sow and

sev - 'ral oth - er things. The sow took the mea - sles, and she died in the spring.

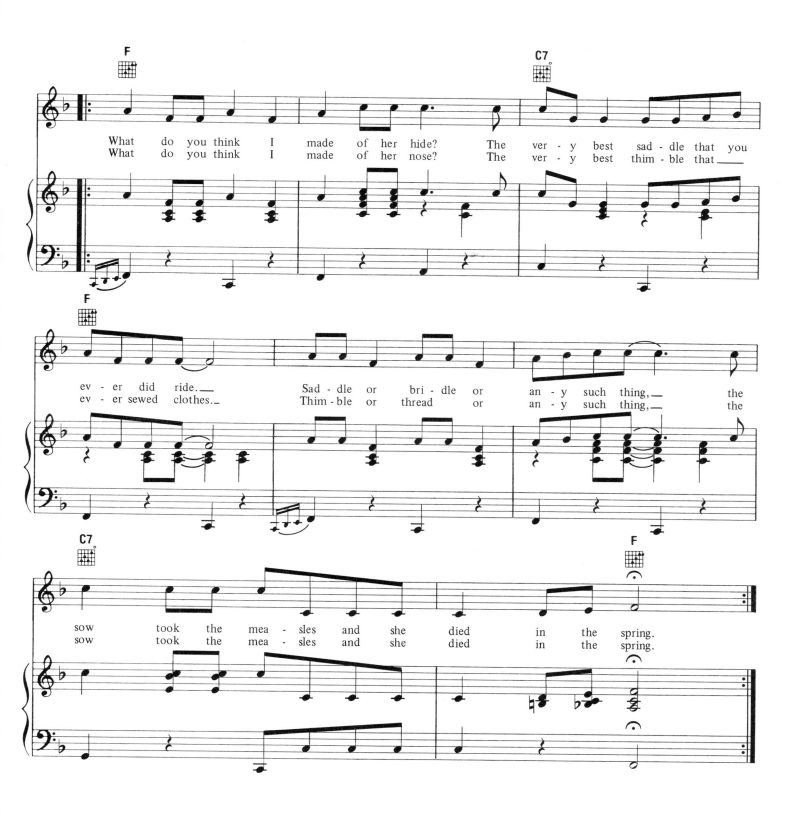

What do you think I made of her hide? The ver-y best sad-dle that you
What do you think I made of her nose? The ver-y best thim-ble that

ev-er did ride.__ Sad-dle or bri-dle or an-y such thing,__ the
ev-er sewed clothes.__ Thim-ble or thread or an-y such thing,__ the

sow took the mea-sles and she died in the spring.
sow took the mea-sles and she died in the spring.

3. What do you think I made of her tail?
 The very best whup that ever sought sail.
 Whup or whup socket, any such thing,
 The sow took the measles and she died in the spring.

4. What do you think I made of her feet?
 The very best pickles that you ever did eat.
 Pickles or glue or any such thing,
 The sow took the measles and she died in the spring.

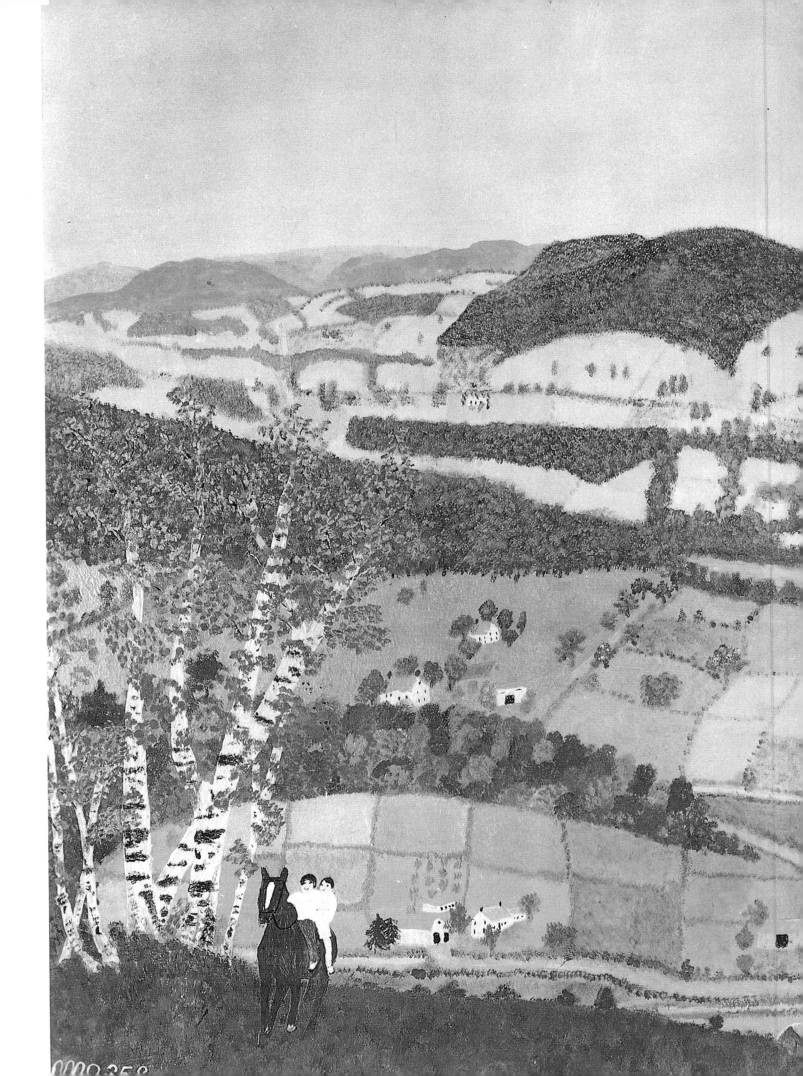

UPWARD AND ONWARD

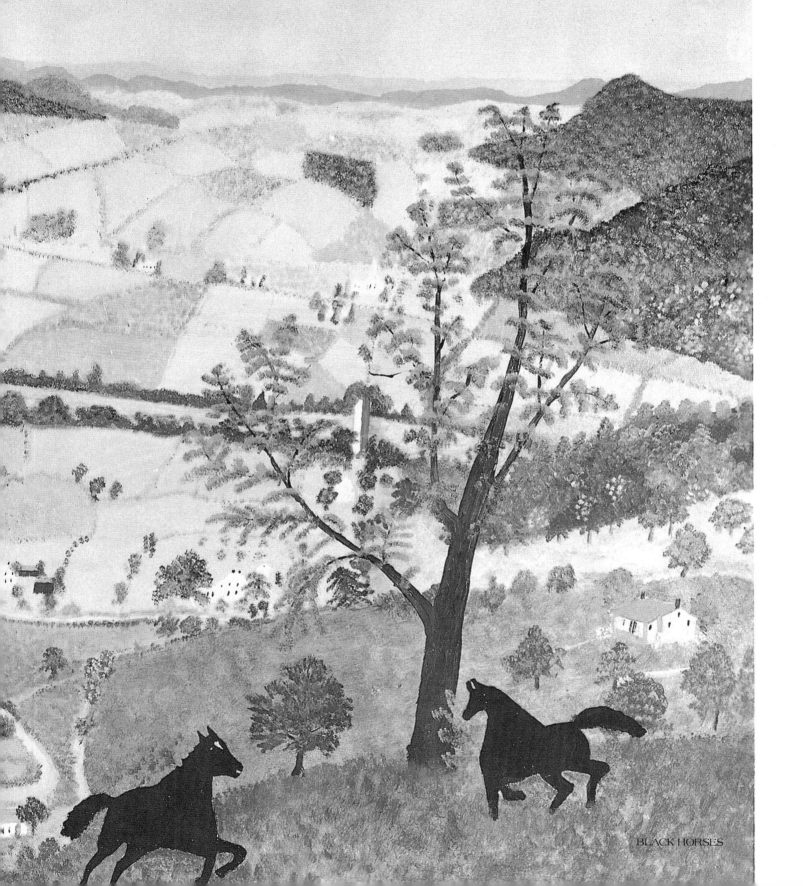

BLACK HORSES

APRIL SHOWERS

Words by B.G. DeSylva
Music by Louis Silvers

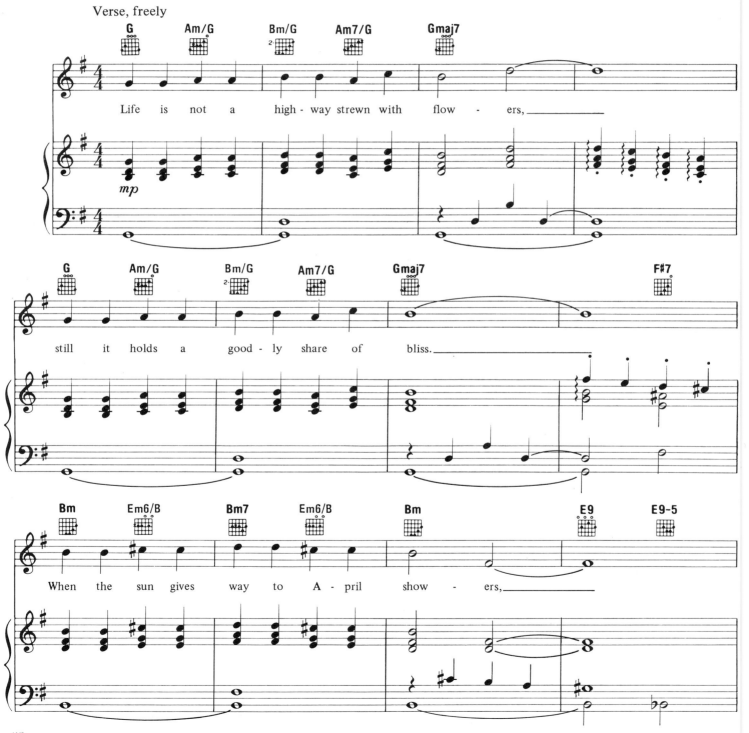

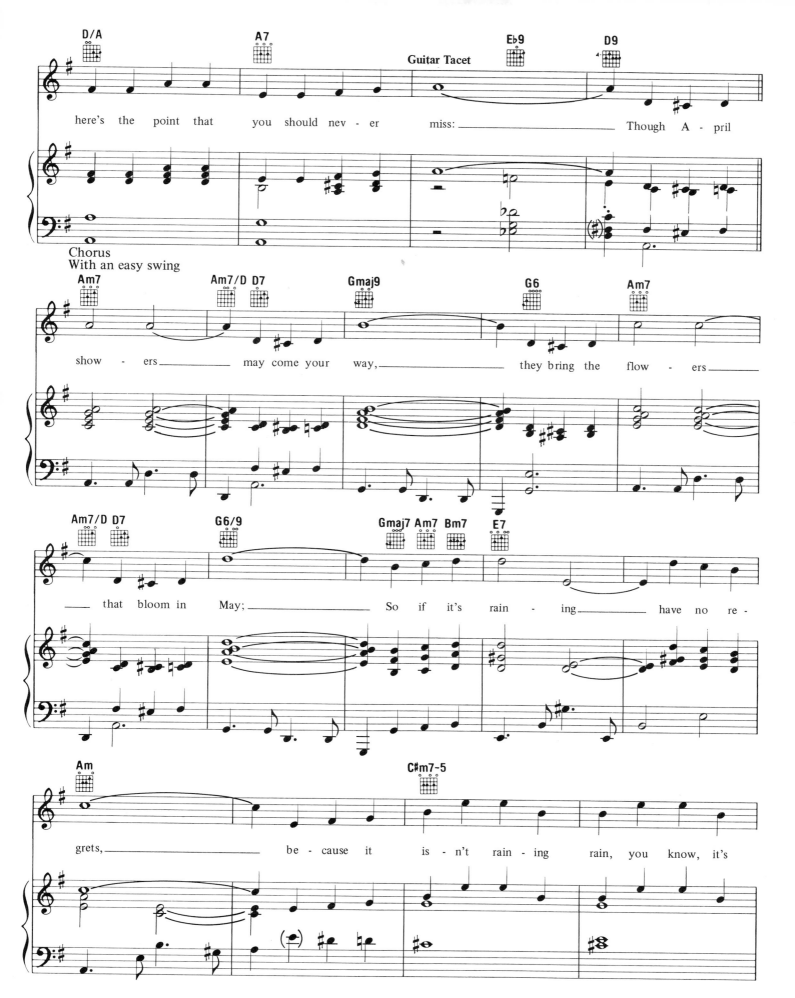

here's the point that you should nev - er miss: _____ Though A - pril

Chorus
With an easy swing

show - ers _____ may come your way, _____ they bring the flow - ers _____

_____ that bloom in May; _____ So if it's rain - ing _____ have no re -

grets, _____ be - cause it is - n't rain - ing rain, you know, it's

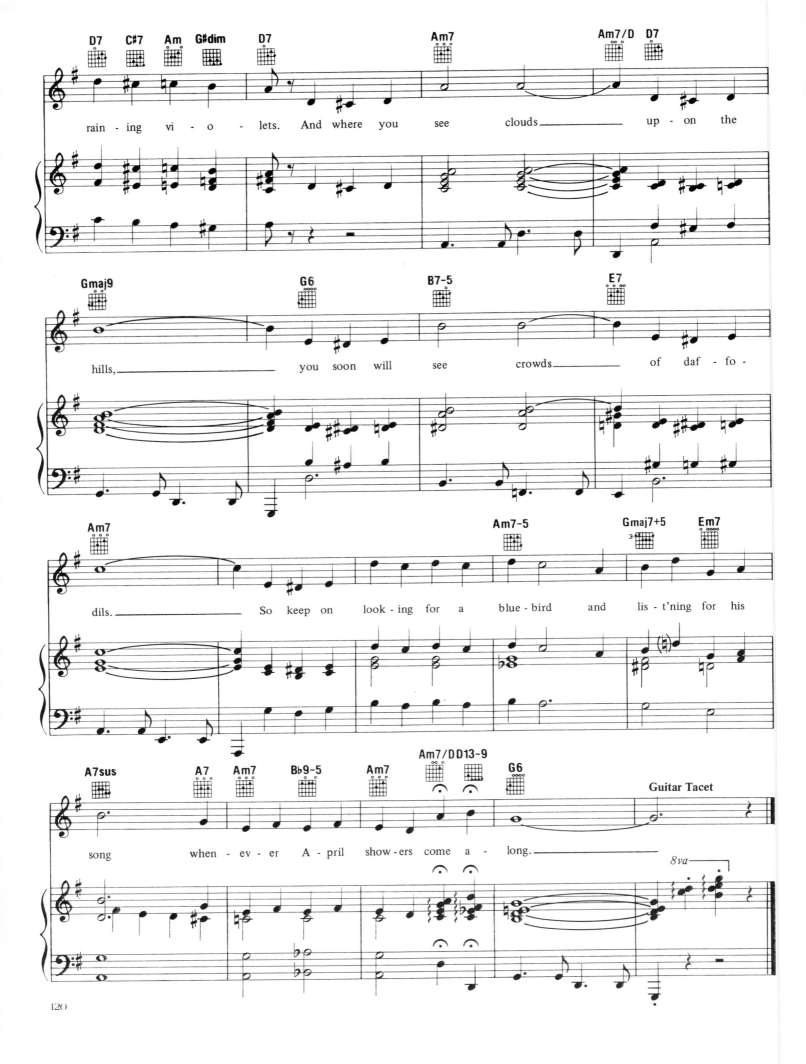

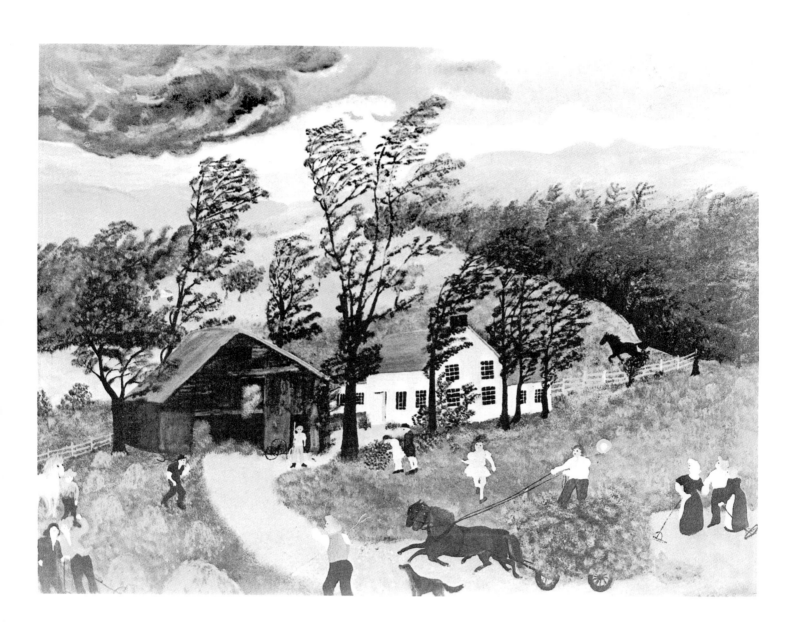

THE THUNDERSTORM

THE BEST THINGS IN LIFE ARE FREE

Music and Lyrics by B.G. DeSylva, Lew Brown, and Ray Henderson

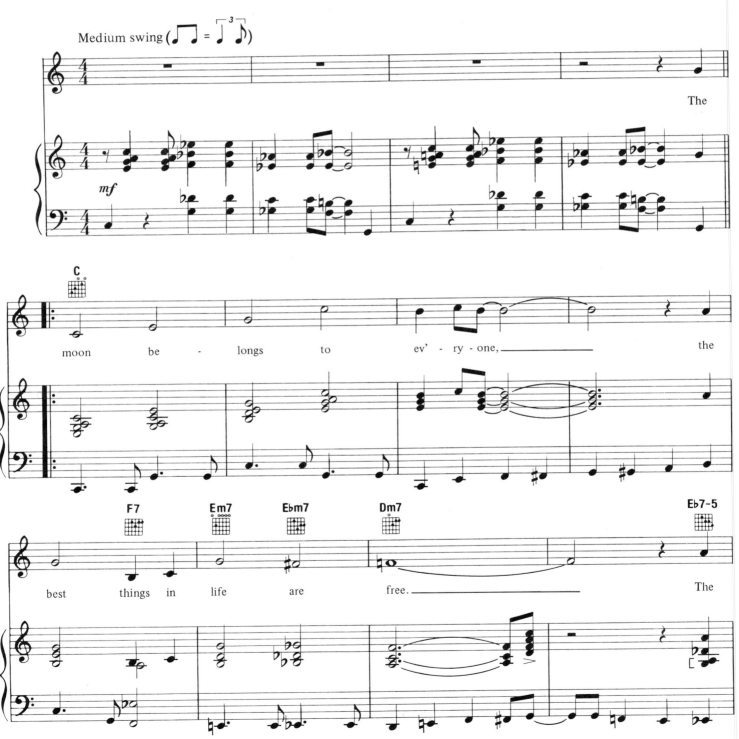

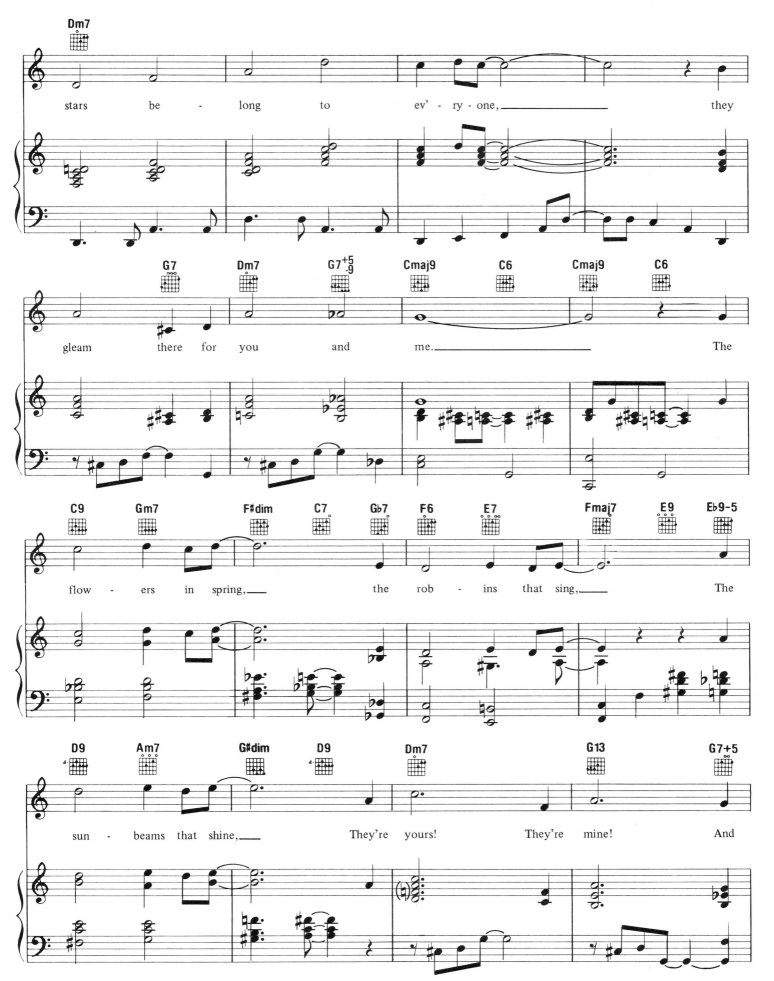

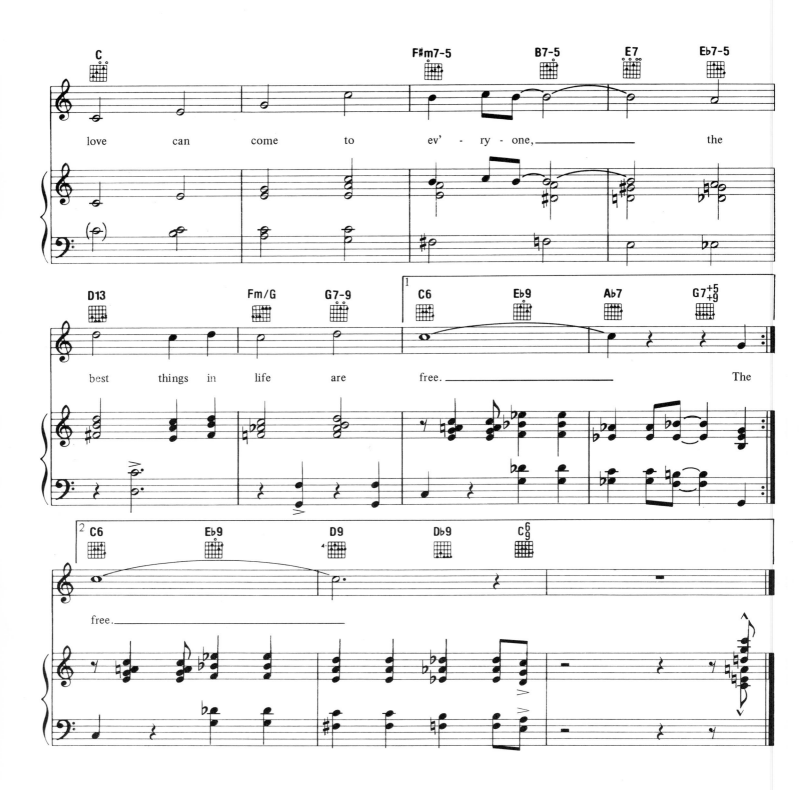

love can come to ev' - ry - one, _____ the

best things in life are free. _____ The

free. _____

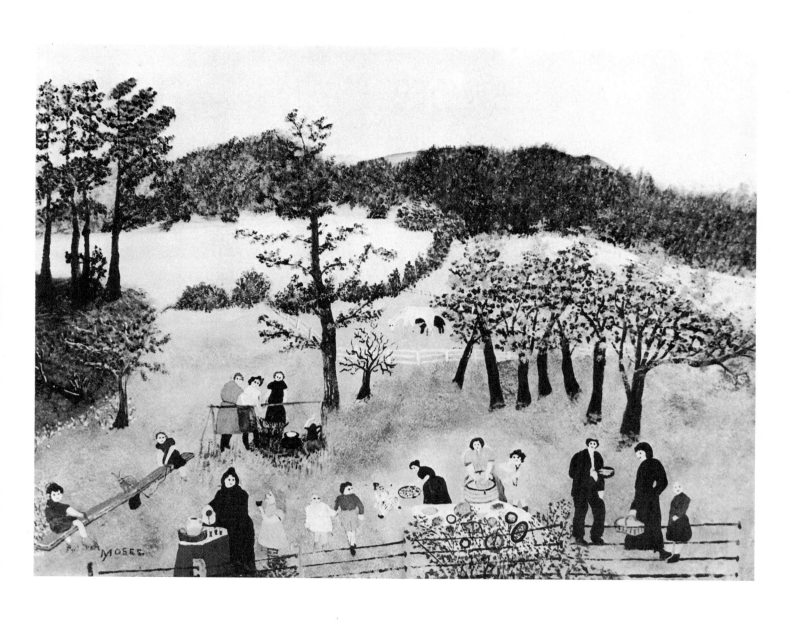

THE FAMILY PICNIC

CLIMB EV'RY MOUNTAIN

Words by Oscar Hammerstein II
Music by Richard Rodgers

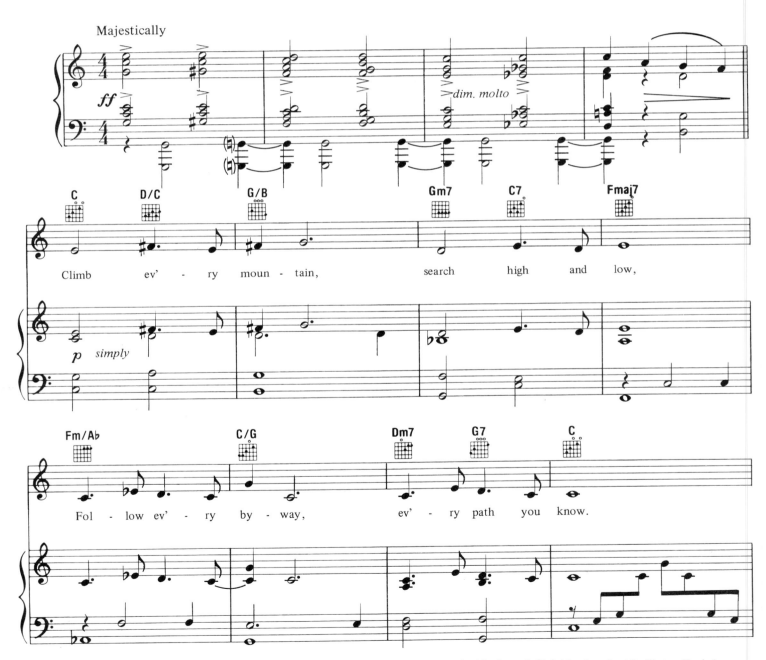

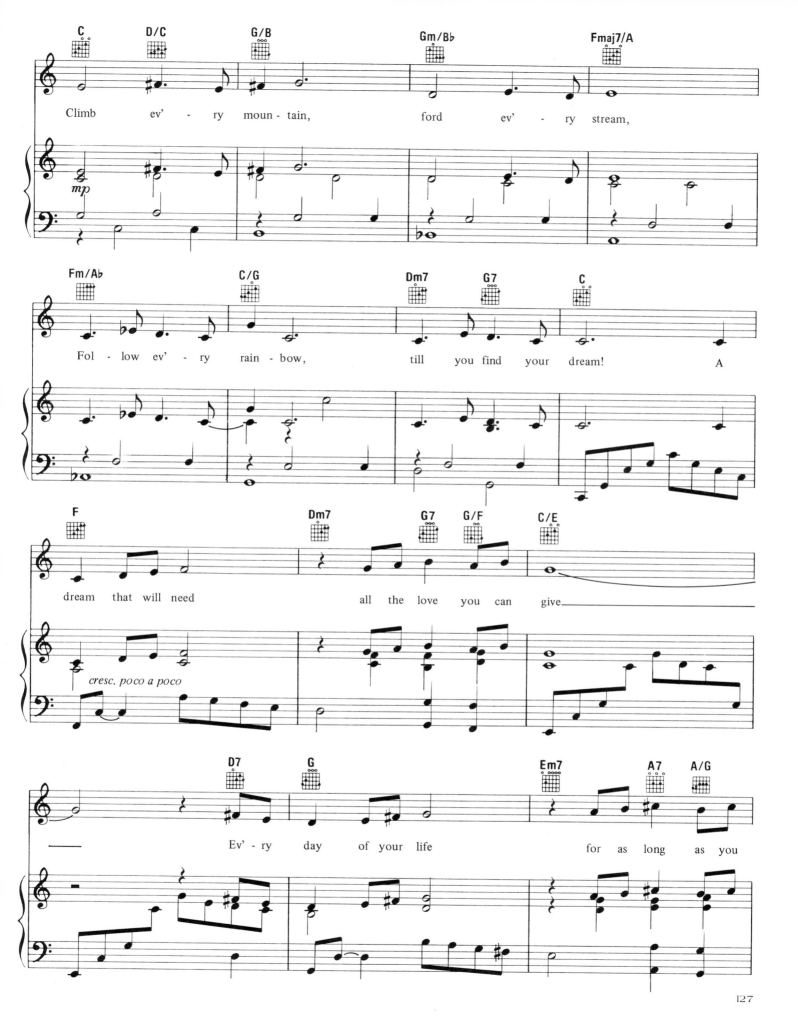

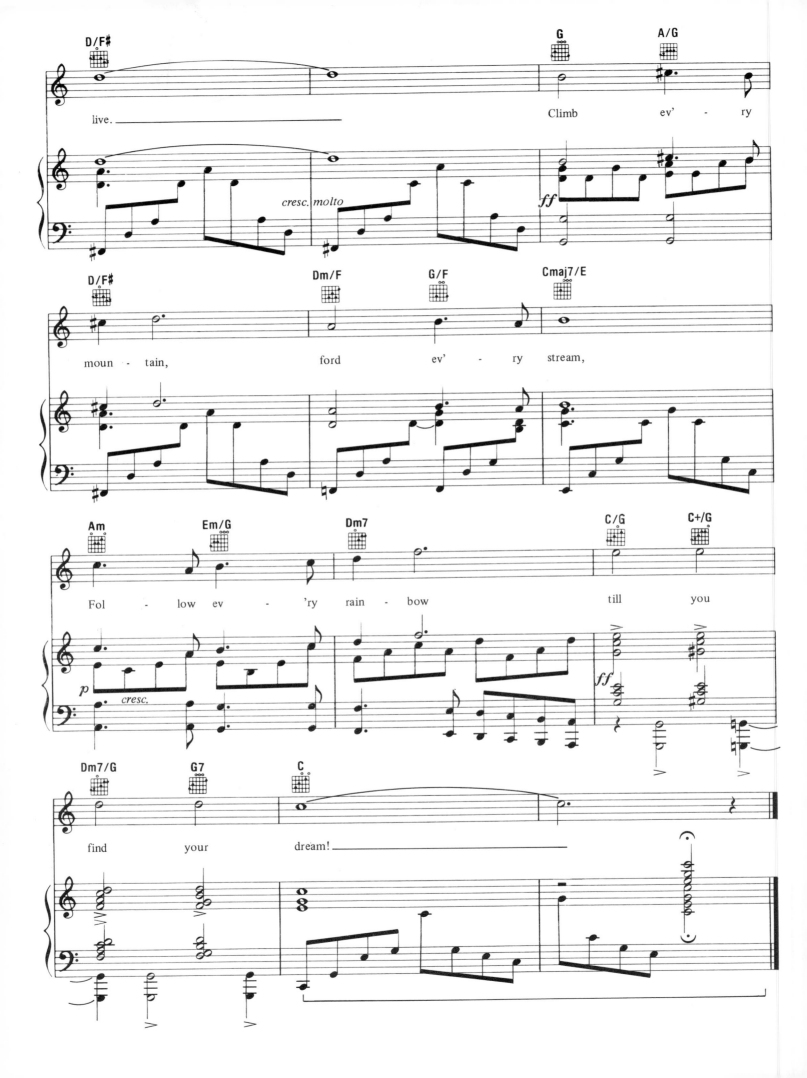

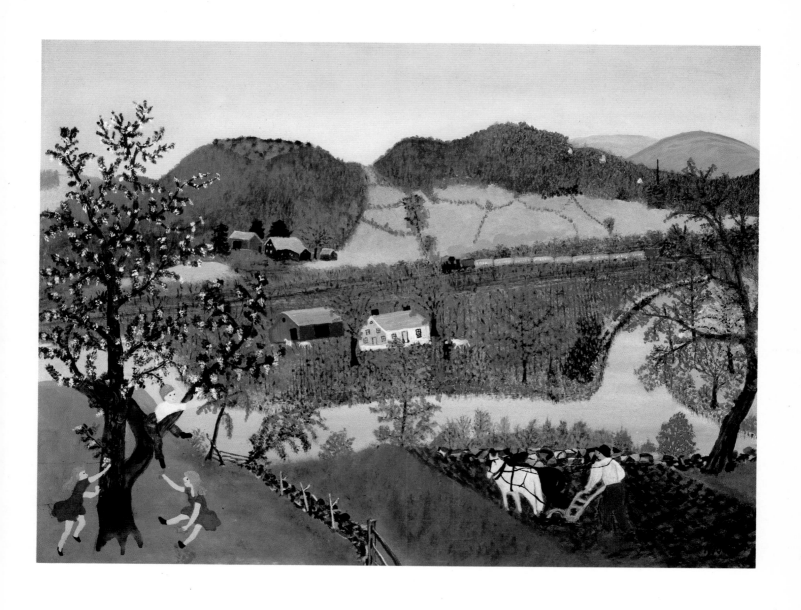

HOOSICK RIVER, SUMMER

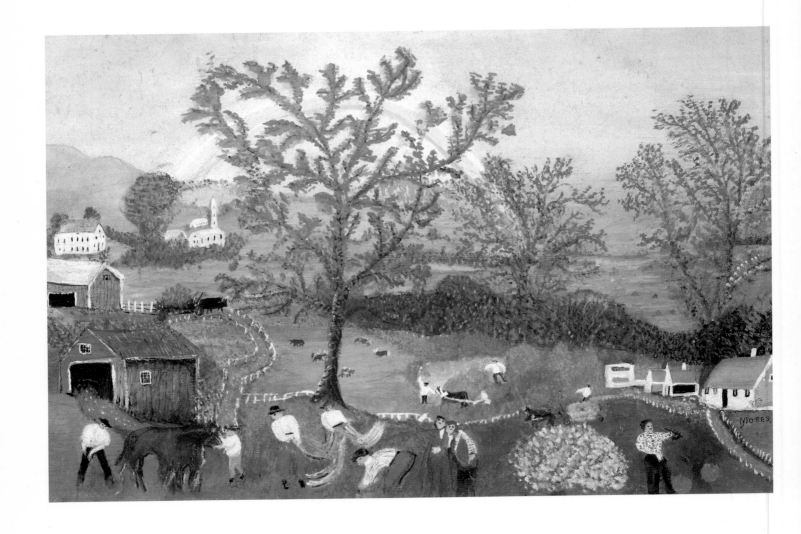

RAINBOW

LOOK TO THE RAINBOW

Words by E.Y. Harburg
Music by Burton Lane

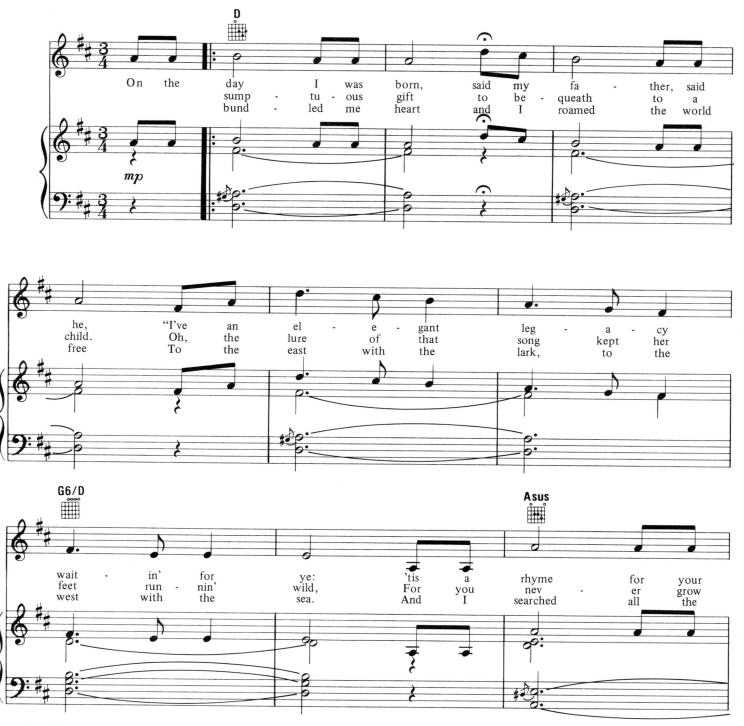

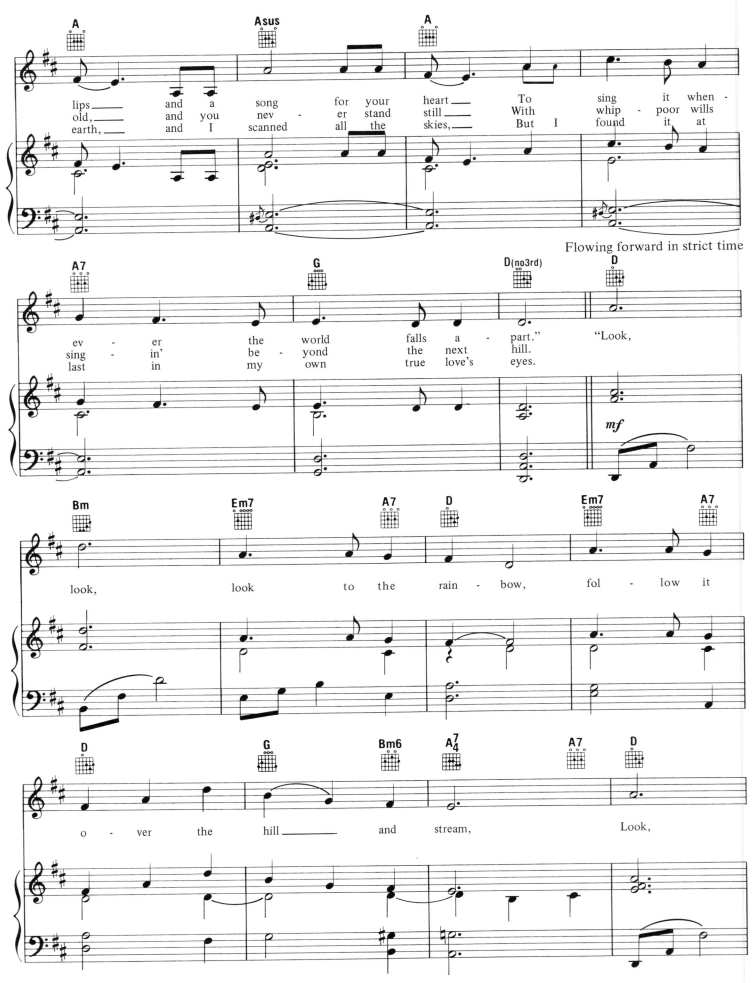

Flowing forward in strict time

132

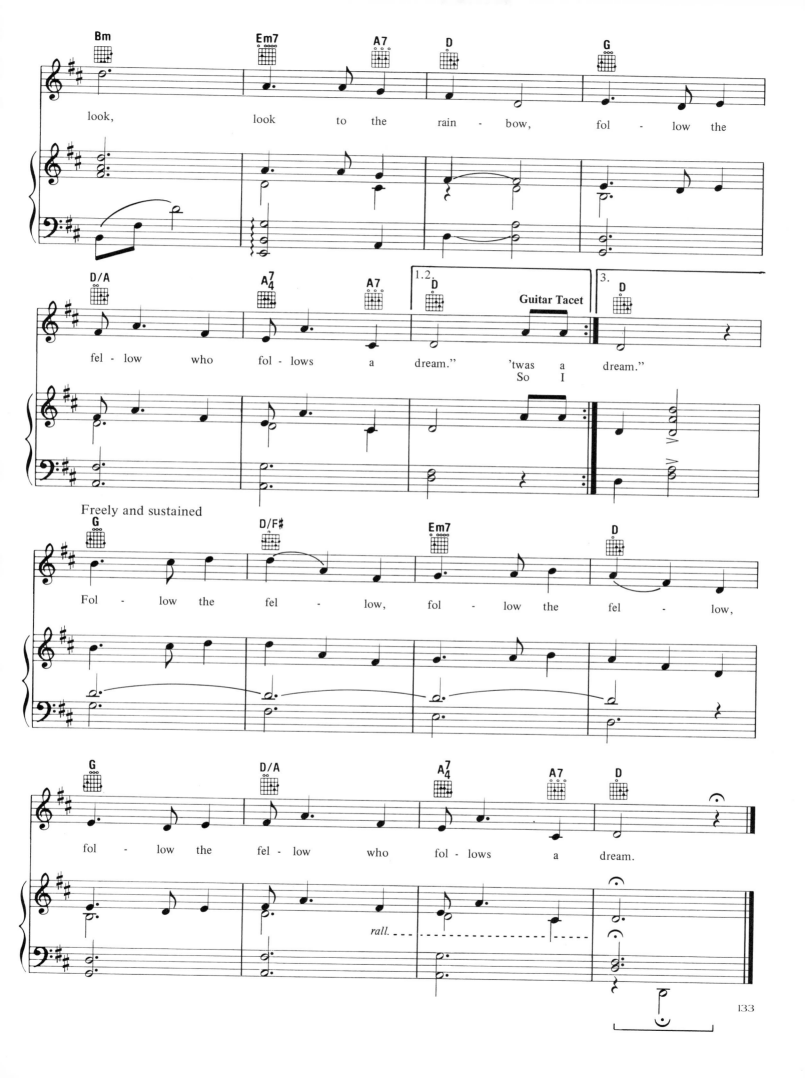

look, look to the rain - bow, fol - low the

fel - low who fol - lows a dream." 'twas a dream."
So I

Guitar Tacet

Freely and sustained

Fol - low the fel - low, fol - low the fel - low,

fol - low the fel - low who fol - lows a dream.

rall. _ _ _ _ _ _ _ _ _ _ _ _ _ _ _ _ _ _

MY FAVORITE THINGS

Words by Oscar Hammerstein II
Music by Richard Rodgers

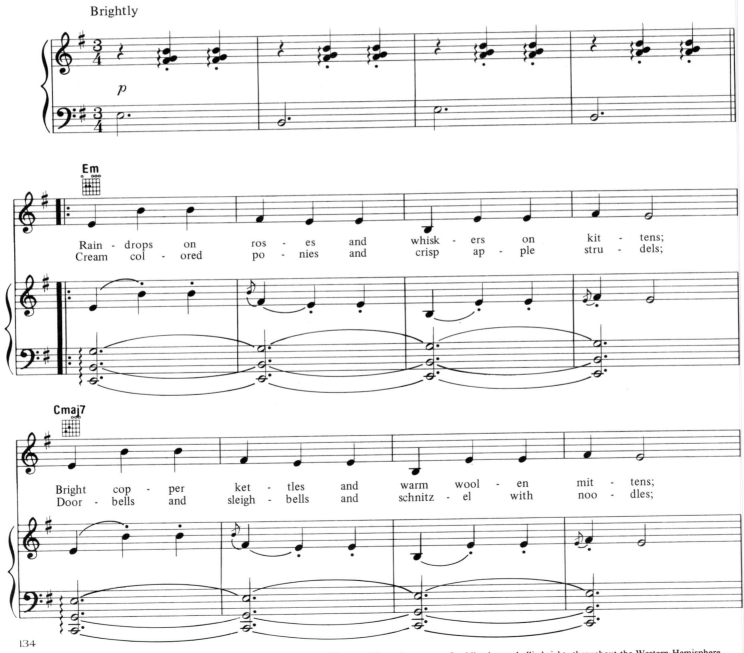

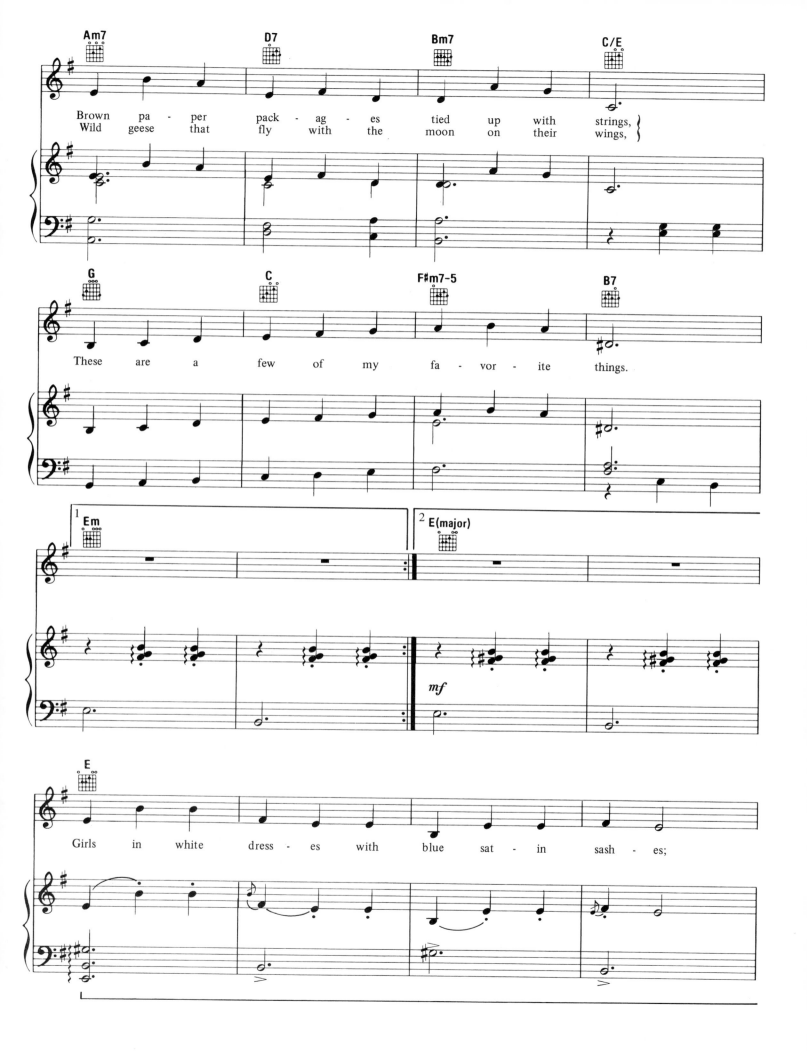

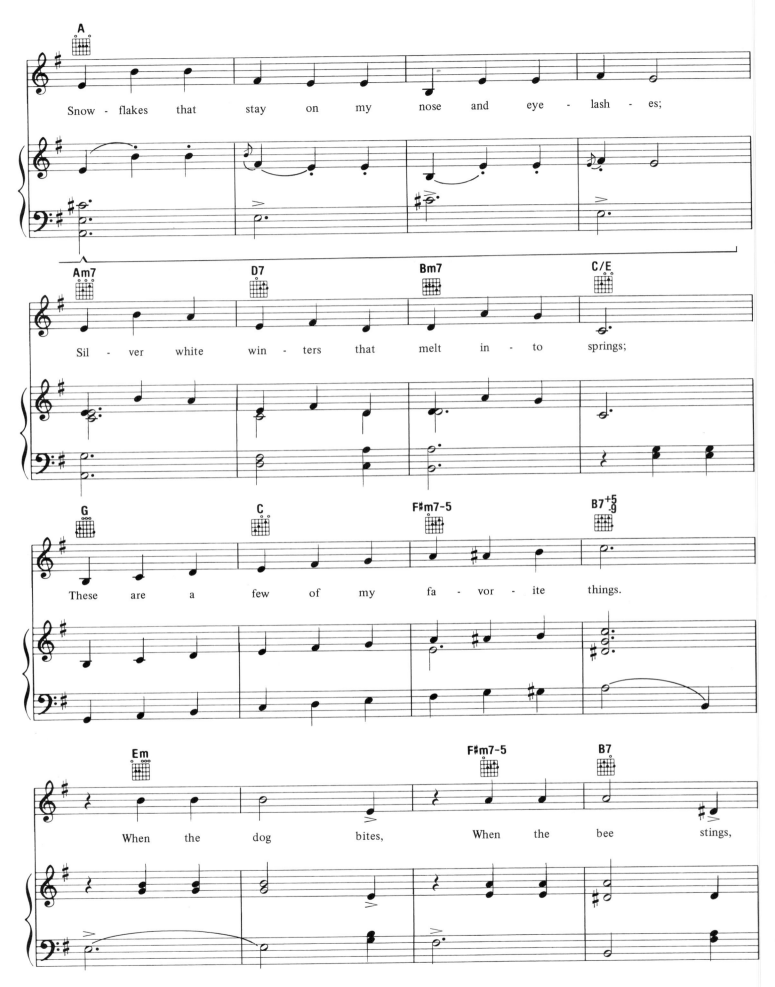

Snow - flakes that stay on my nose and eye - lash - es;

Sil - ver white win - ters that melt in - to springs;

These are a few of my fa - vor - ite things.

When the dog bites, When the bee stings,

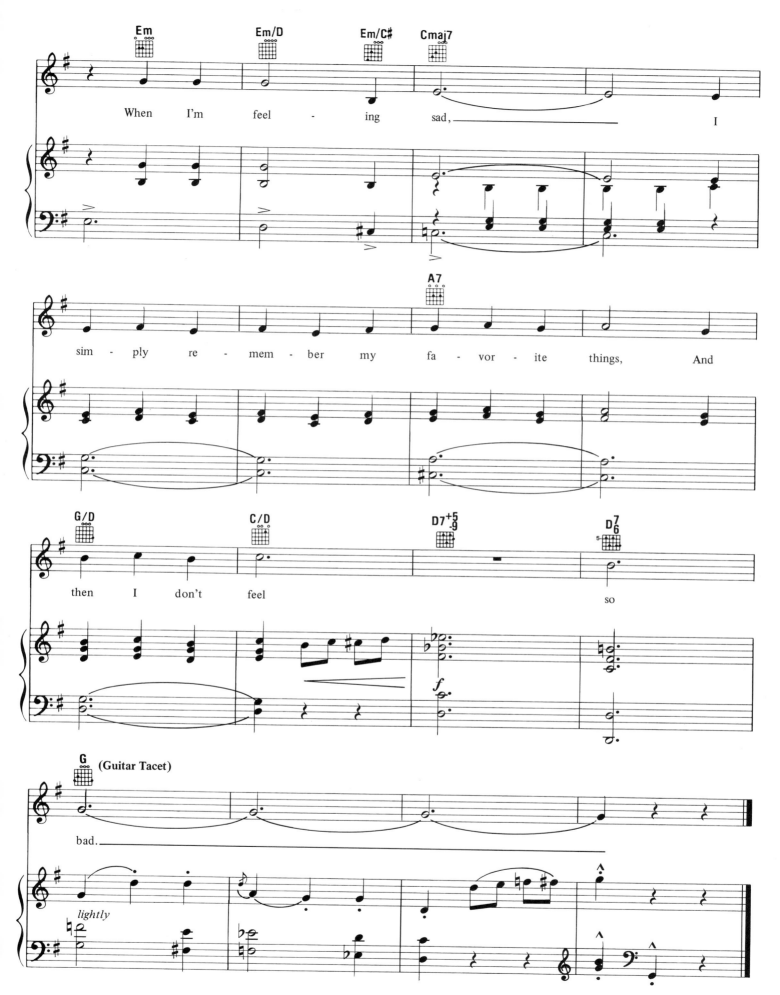

MY GRANDMA'S ADVICE

Words and music by "M"

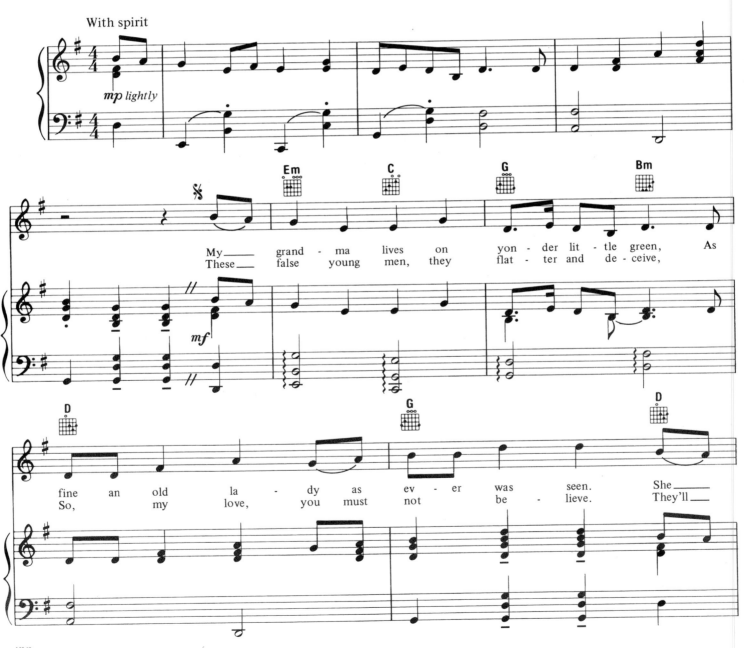

My____ grand - ma lives on yon - der lit - tle green, As
These____ false young men, they flat - ter and de - ceive,

fine an old la - dy as ev - er was seen. She____
So, my love, you must not be - lieve. They'll____

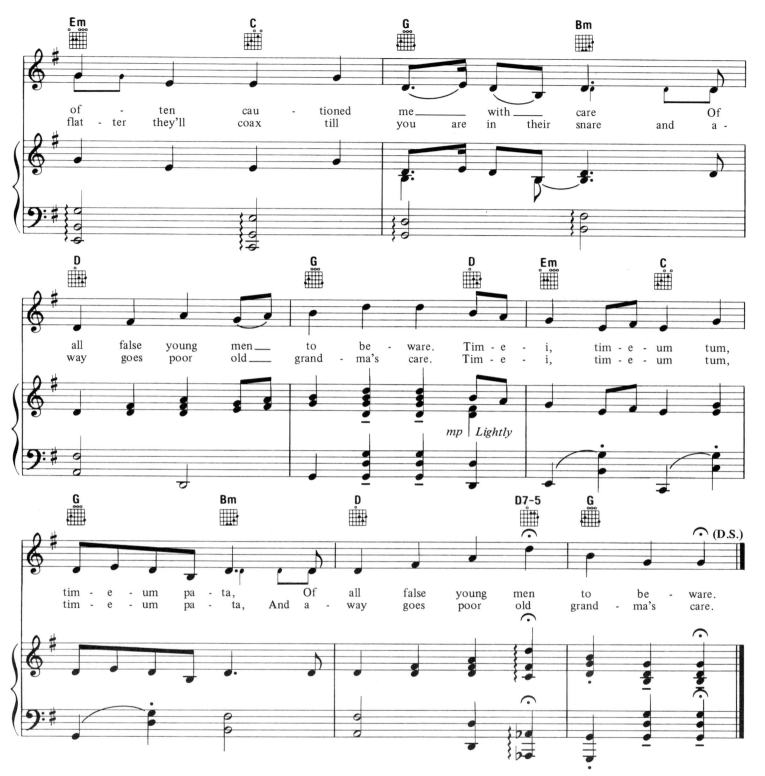

3. The first came a-courting was little Johny Green,
 As fine a young man as ever was seen;
 But the words of my Grandma run in my head,
 And I could not hear one word he said.
 Tim-e-i tim-e um tum tim-e um pa ta
 And I could not hear one word he said.

4. The next came a courting was young Ellis Grove,
 'Twas then we met with a joyous love;
 With a joyous love I couldn't be afraid,
 You'd better get married than die an old maid.
 Tim-e-i tim-e um tum tim-e um pa ta
 You'd better get married than die an old maid.

5. Think I to myself there's some mistake,
 What a fuss these old folks make;
 If the boys and the girls had all been so afraid,
 Then Grandma herself would have died an old maid.
 Tim-e-i tim-e um tum tim-e um pa ta
 Then Grandma herself would have died an old maid.

OH, WHAT A BEAUTIFUL MORNIN'

Words by Oscar Hammerstein II
Music by Richard Rodgers

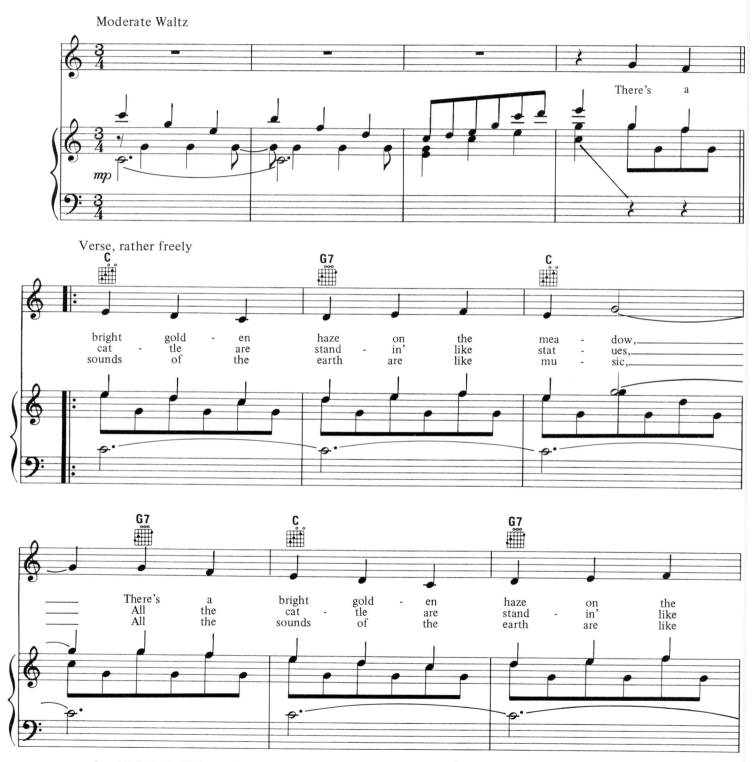

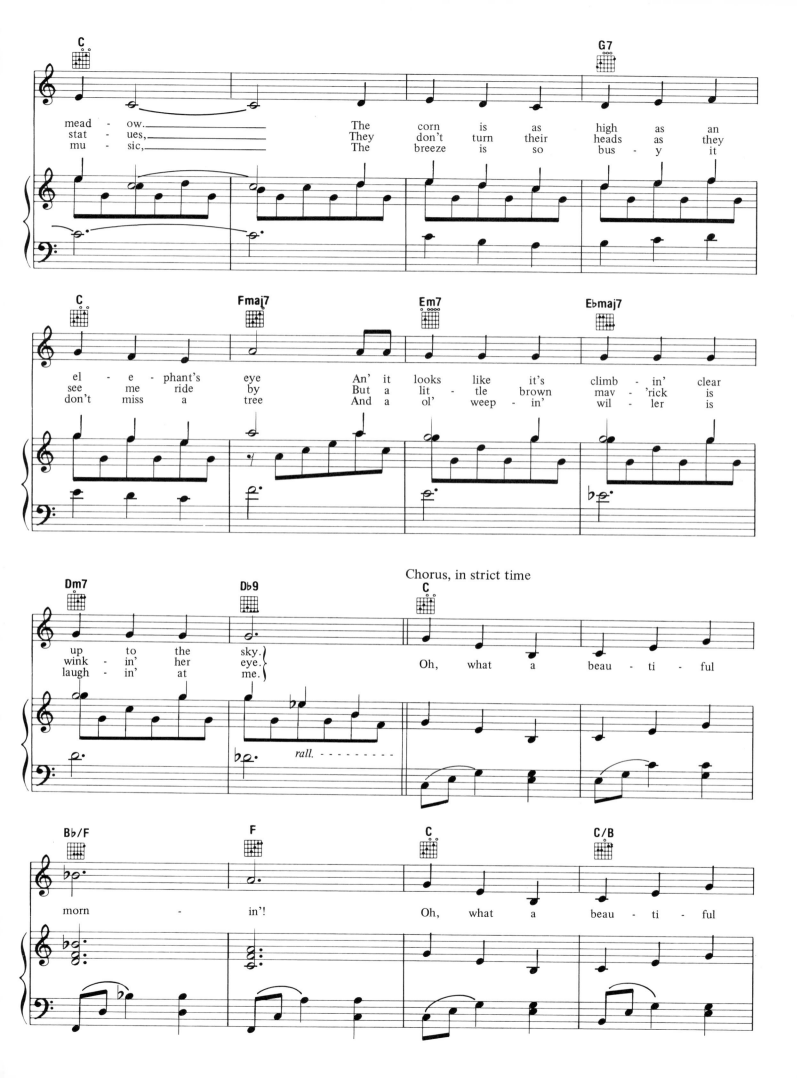

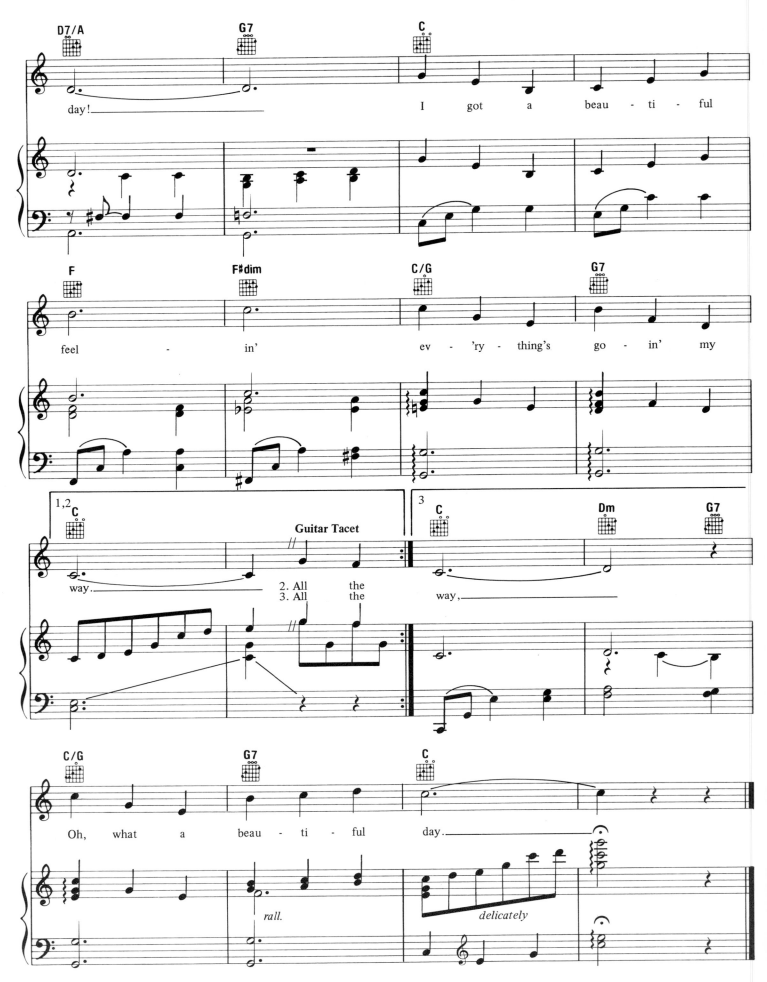

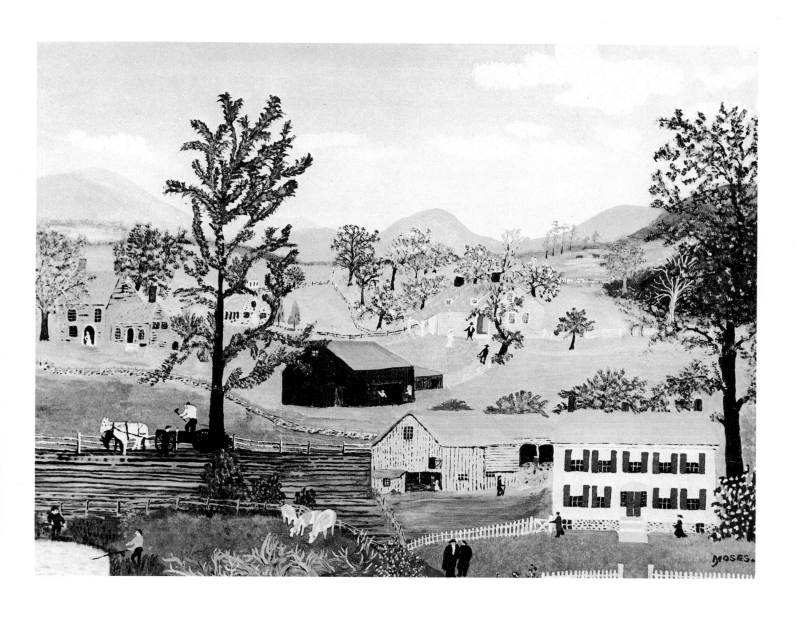

A BEAUTIFUL MORNING

ON A CLEAR DAY (YOU CAN SEE FOREVER)

Words by Alan Jay Lerner
Music by Burton Lane

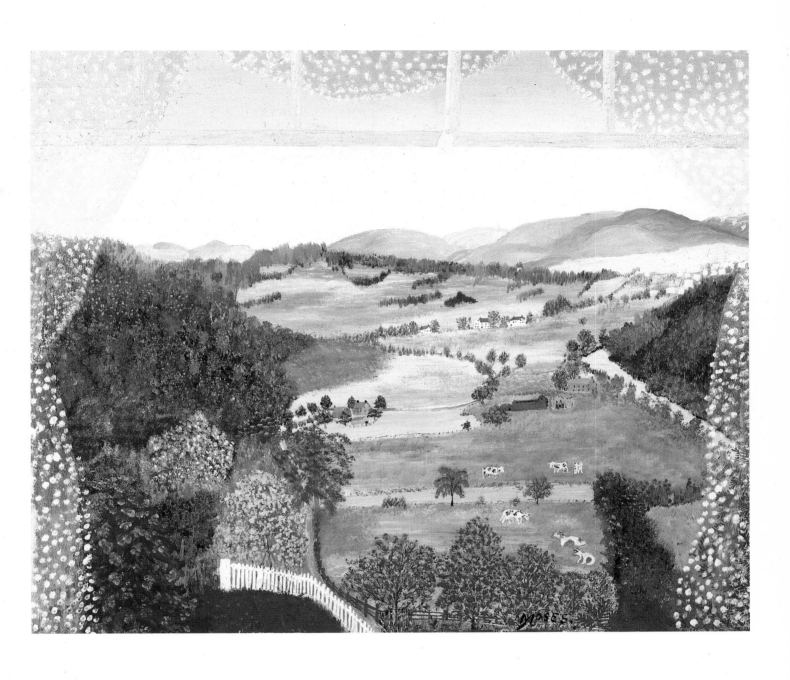

HOOSICK VALLEY (FROM THE WINDOW)

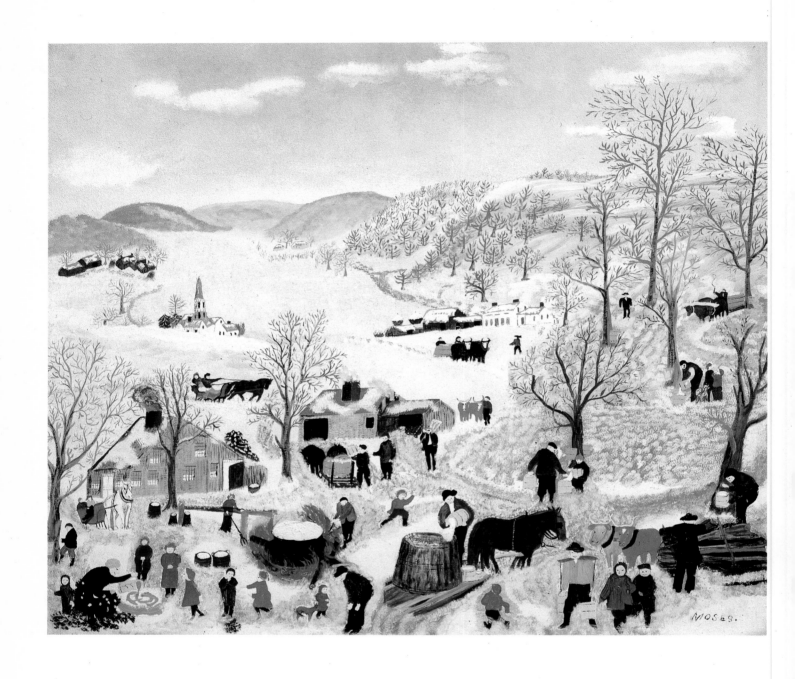

SUGARING OFF

YOUNG AT HEART

Words by Carolyn Leigh
Music by Johnny Richards

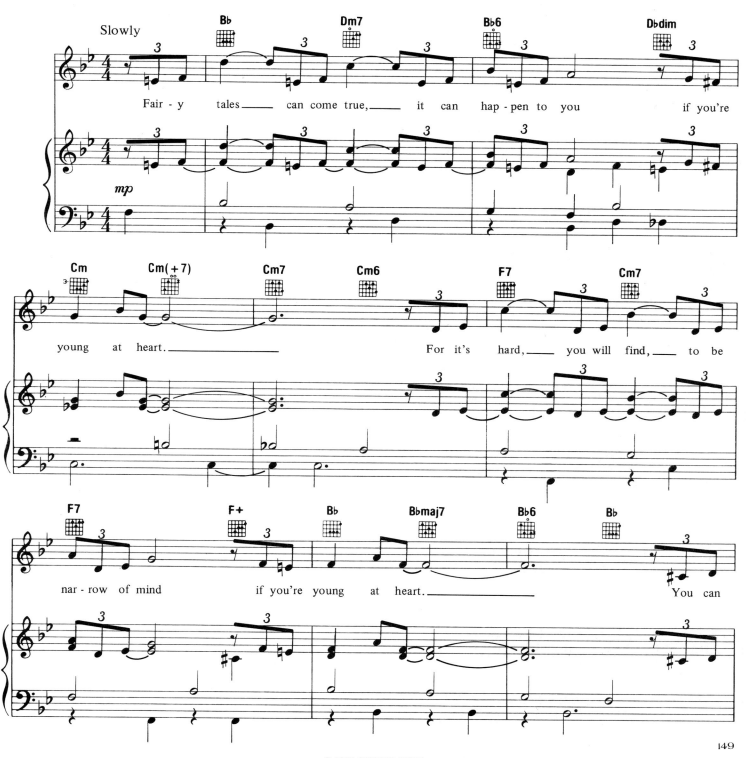

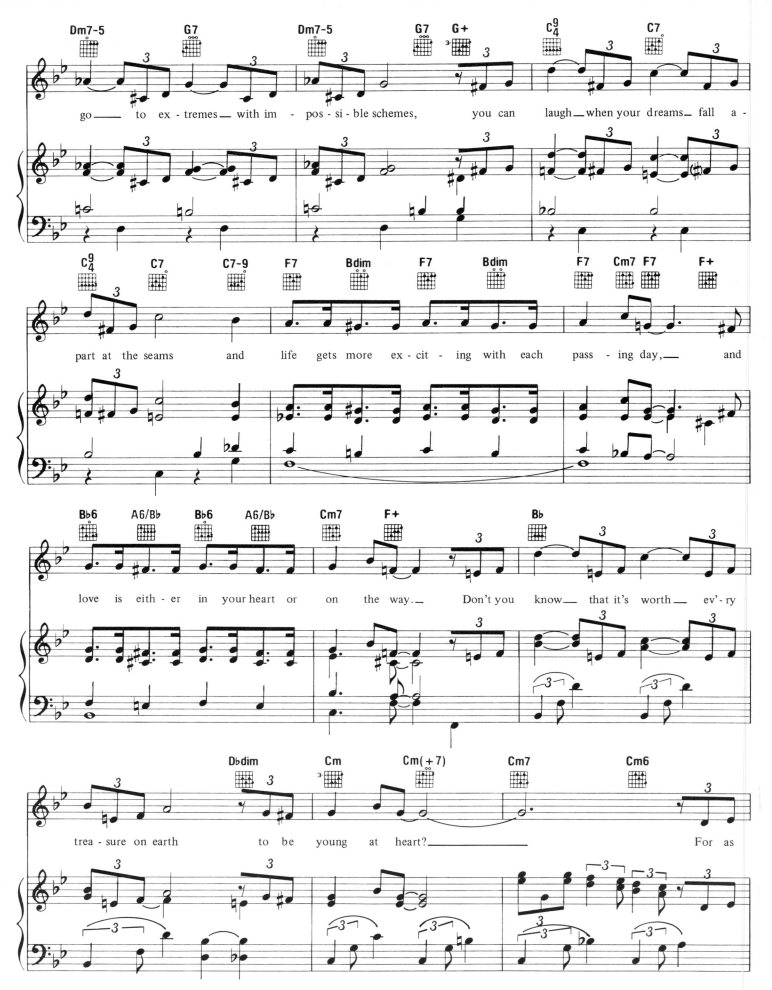

go ___ to ex - tremes ___ with im - pos - si - ble schemes, you can laugh ___ when your dreams ___ fall a -

part at the seams and life gets more ex - cit - ing with each pass - ing day, ___ and

love is eith - er in your heart or on the way. ___ Don't you know ___ that it's worth ___ ev' - ry

trea - sure on earth to be young at heart? ___ For as

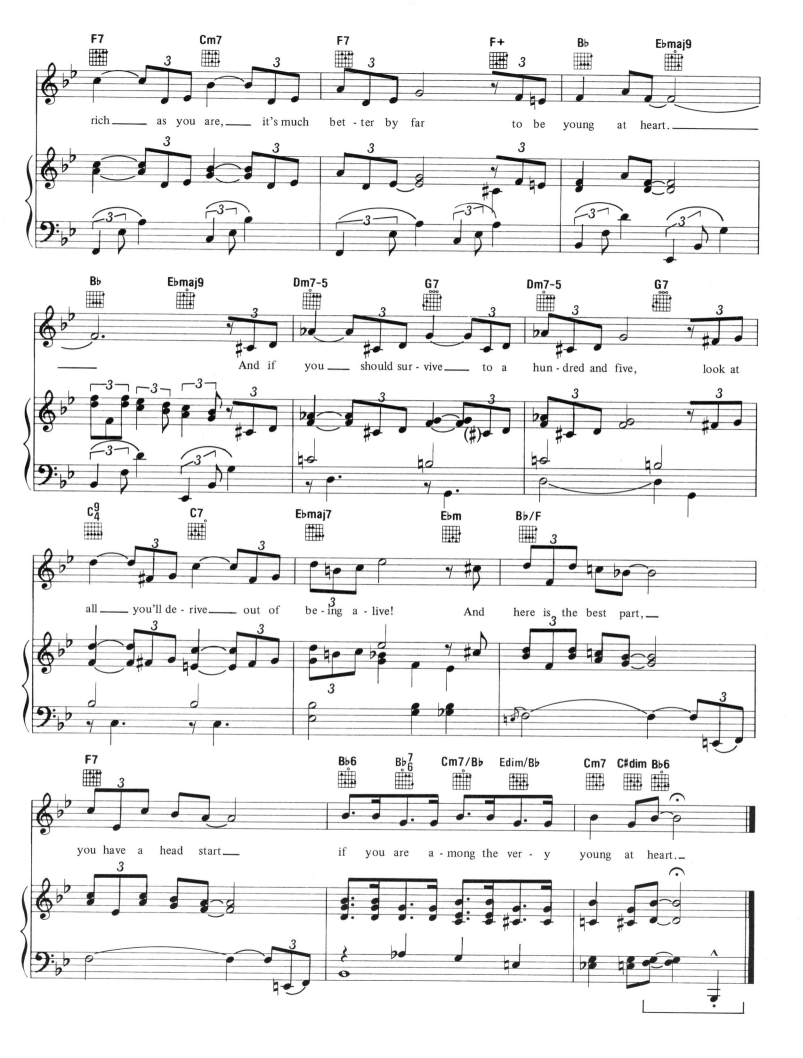

THERE'S MUSIC IN THE AIR

Words by Fanny Crosby
Music by George F. Root

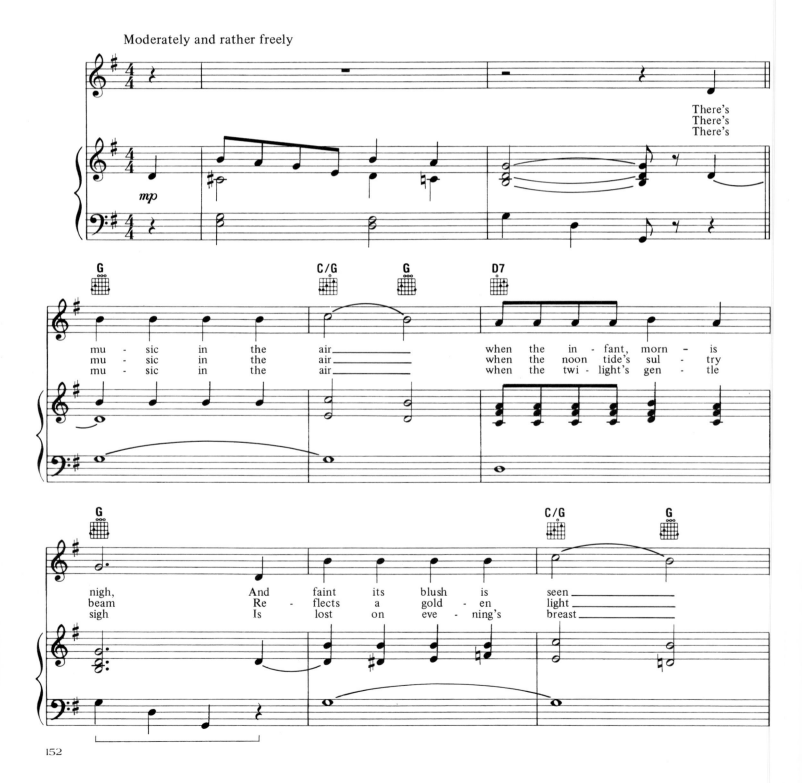

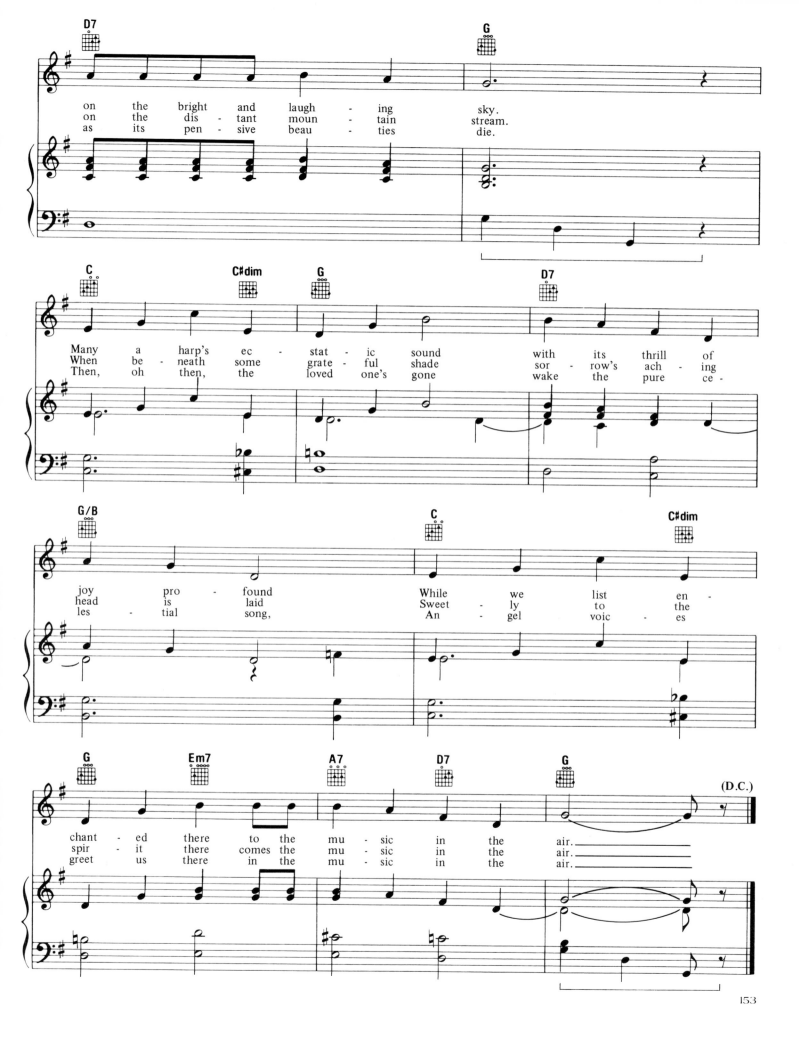

153

SUDDENLY THERE'S A VALLEY

Words and music by Chuck Meyer and Biff Jones

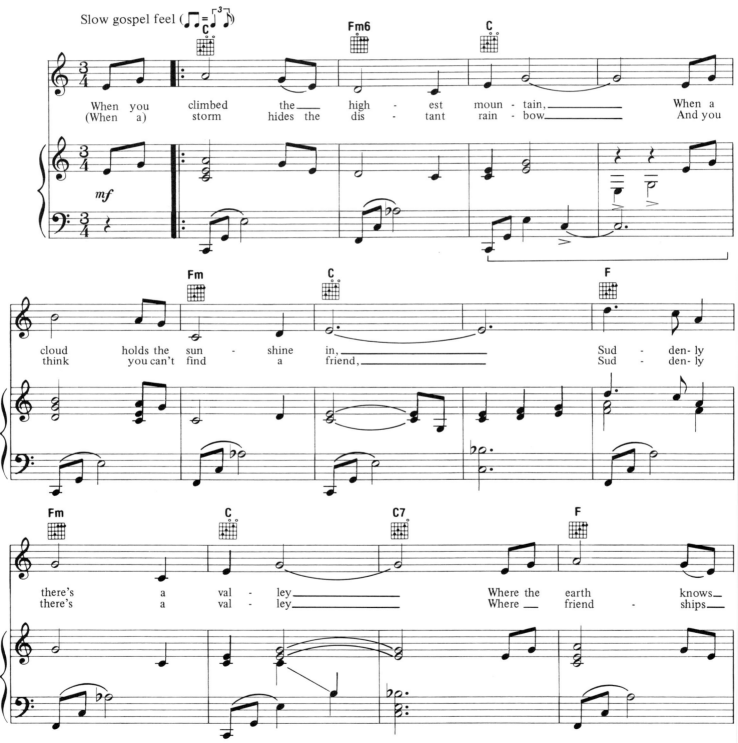

154

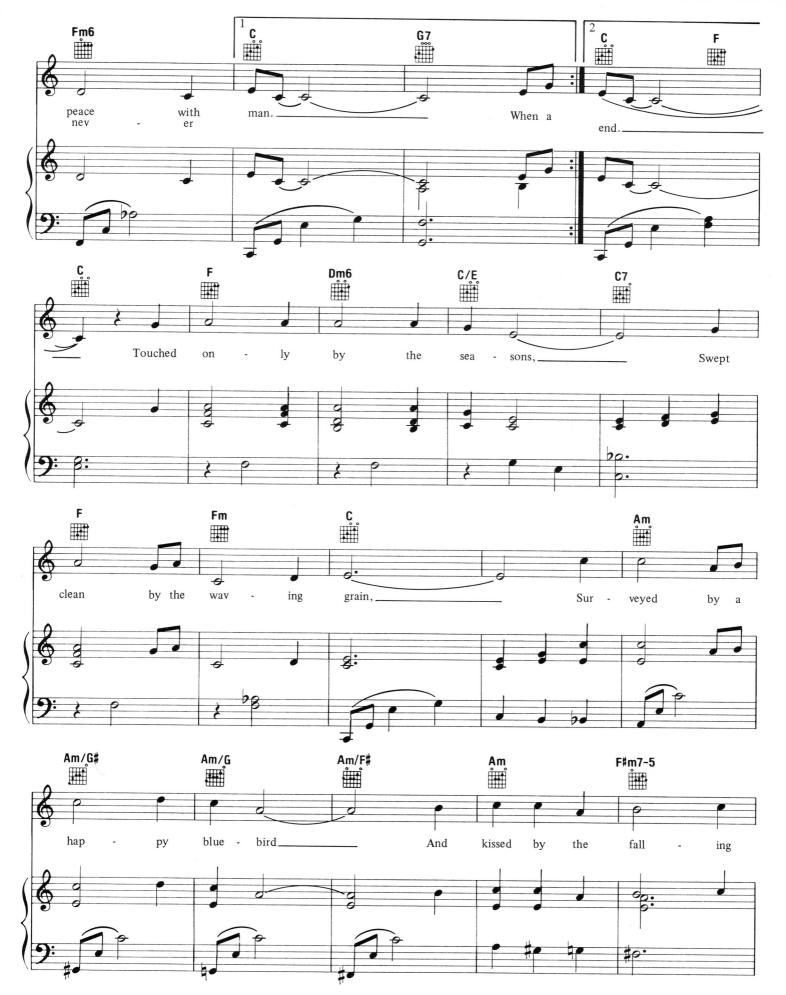

rain. _____ When you think there's no bright to-mor-rows _____ And you feel you can't try a-gain, _____ Sud-den-ly there's a val-ley _____ Where hope and love be-gin. _____

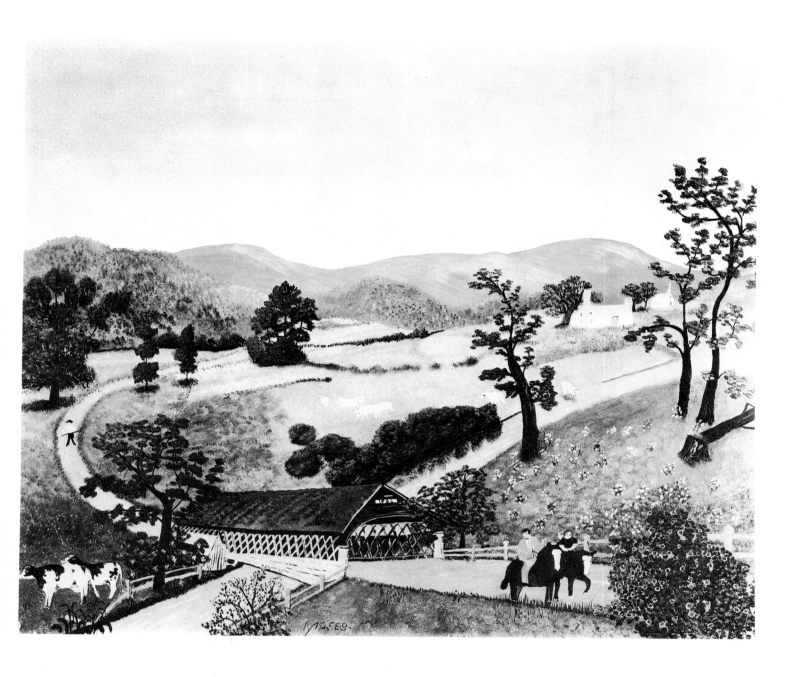

MISSOURI

THE SOUND OF MUSIC

Words by Oscar Hammerstein II
Music by Richard Rodgers

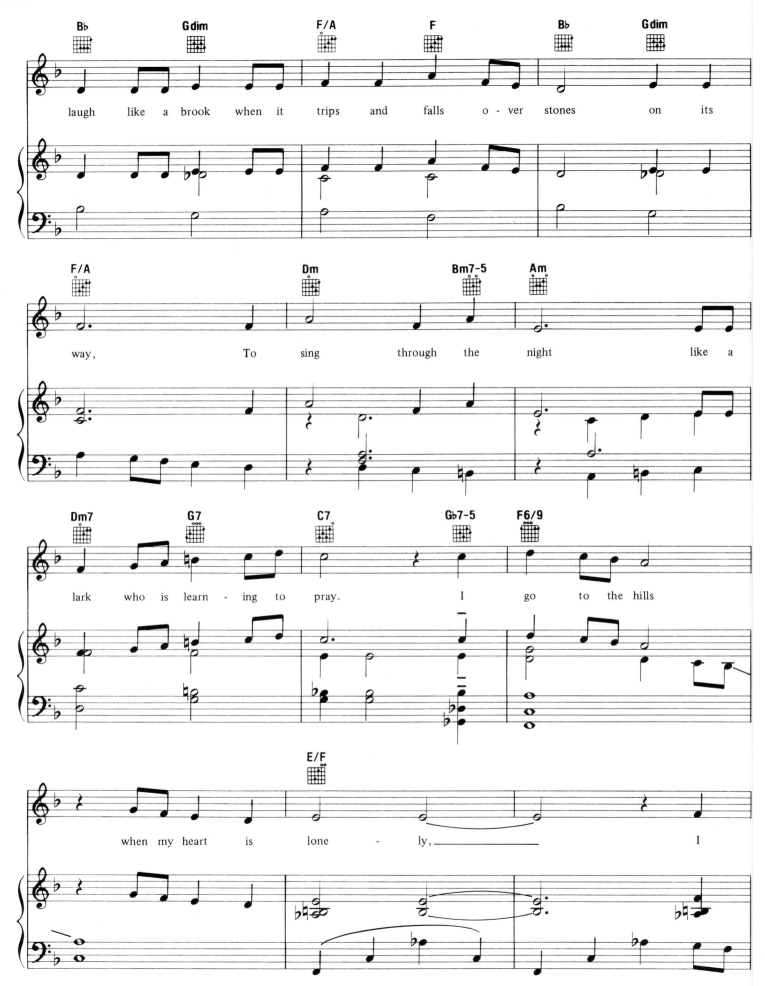

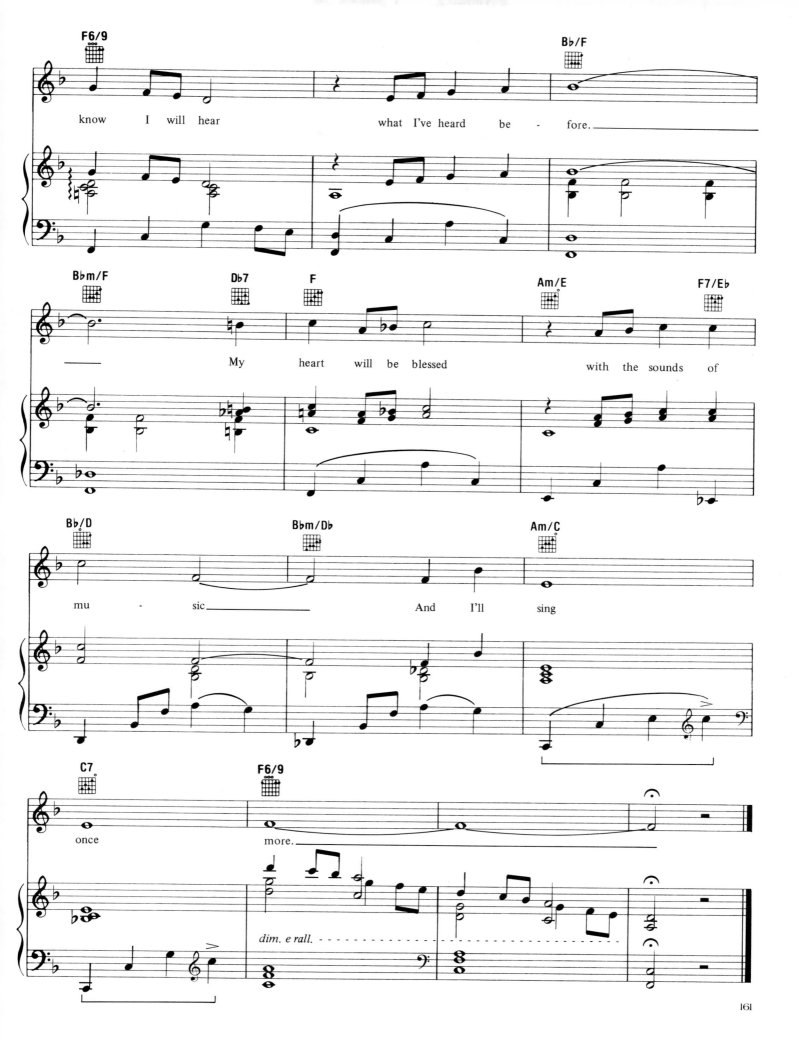

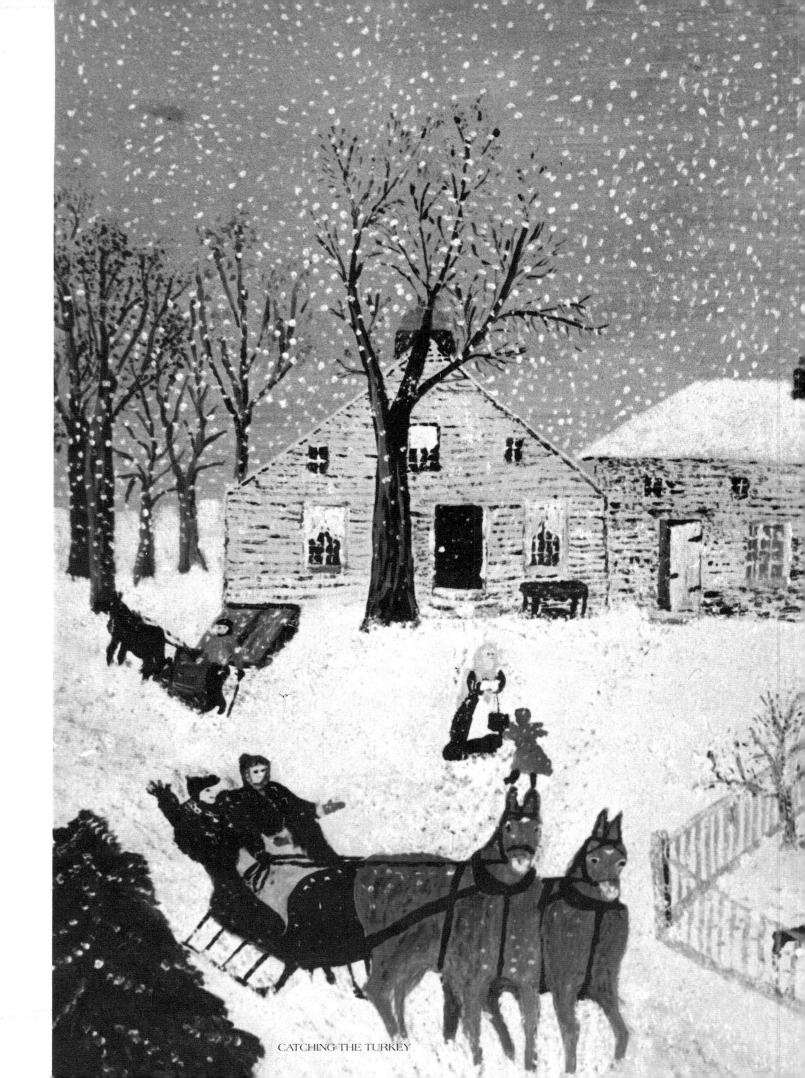

CATCHING THE TURKEY

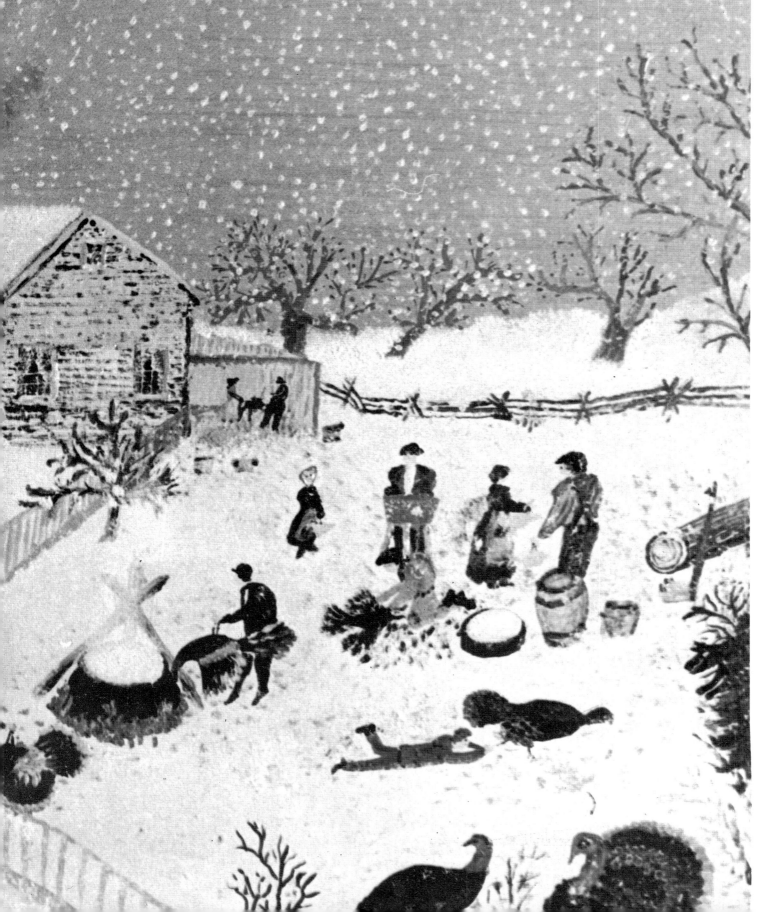

BUT ONCE
A YEAR

I'LL BE HOME ON CHRISTMAS DAY

Words and music by Michael Jarrett

165

oh, too many tears that fell, My soul filled with
mem-o-ries still lin-ger With-in my trou-bled

yearn-ing. If I had an-y sense at all, I'd
mind. If I could set a-side my pride And

just be on my way. I'd be on that train to-mor-row, And be
I'd be on my way. I'd catch that train to-mor-row, And be

1
home on Christ-mas Day. Ev'-ry

2
Day.

166

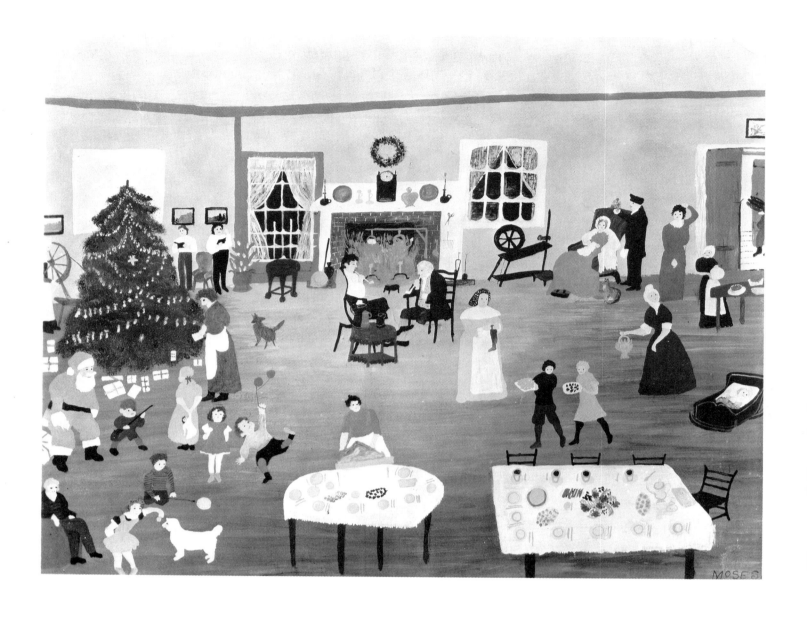

CHRISTMAS AT HOME

O TANNENBAUM

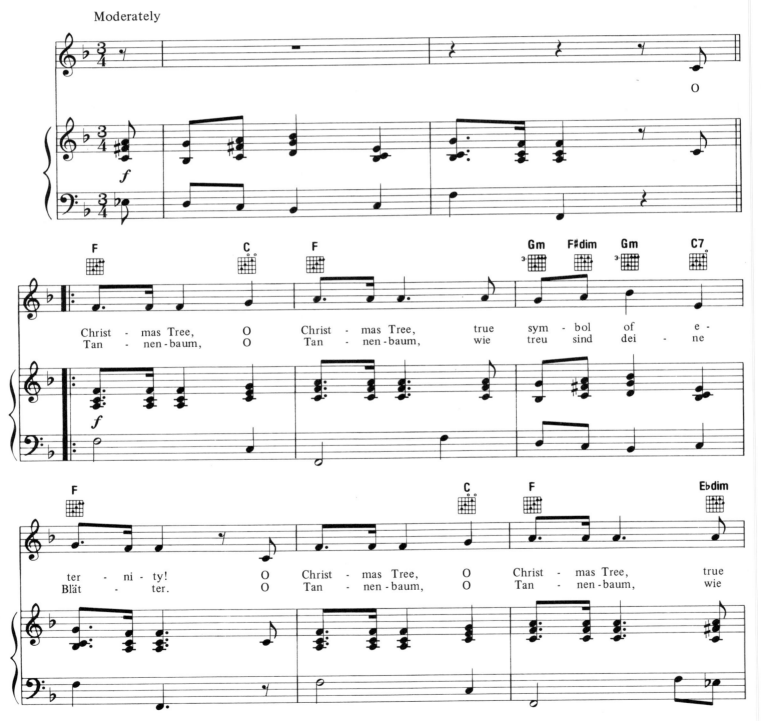

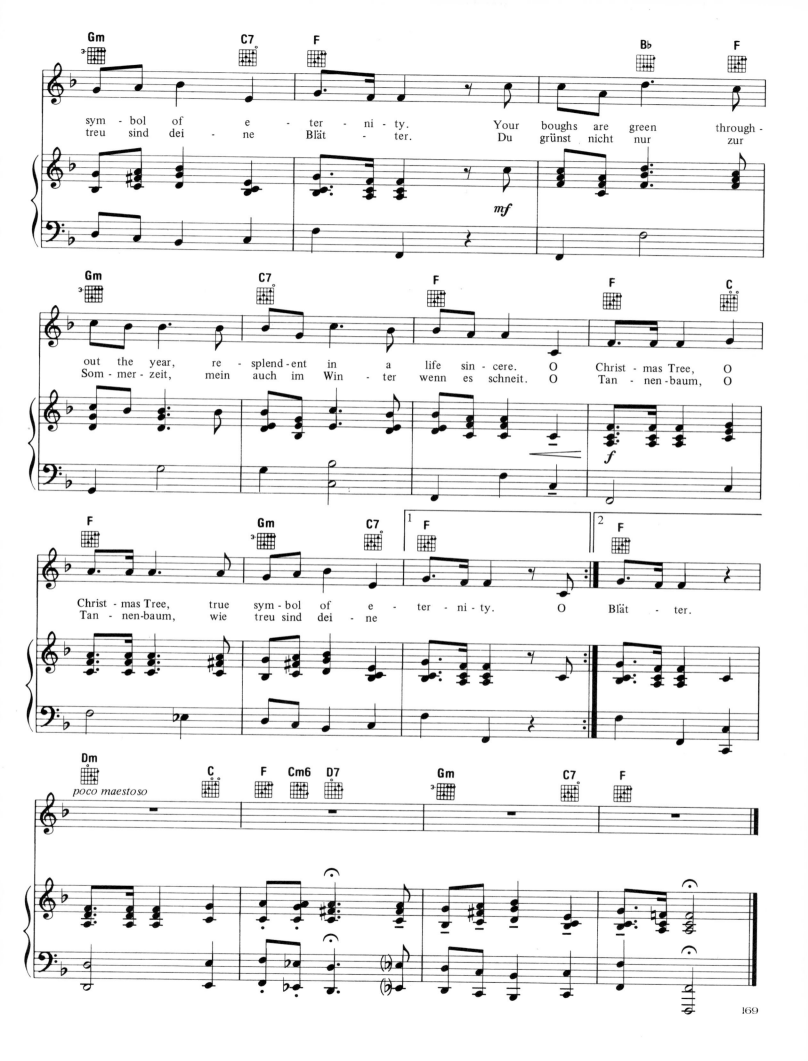

169

ON THE FIRST THANKSGIVING DAY

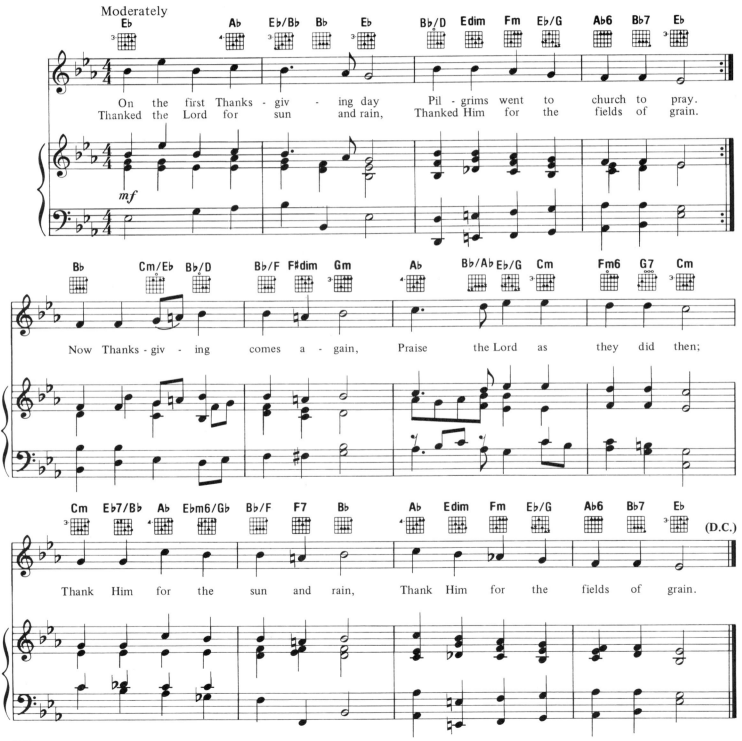

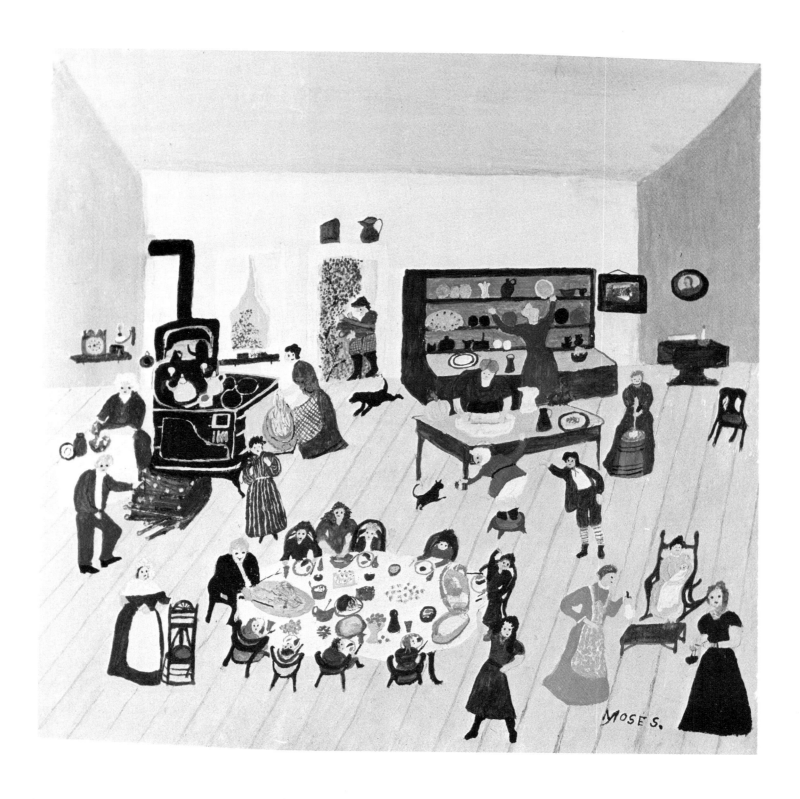

THANKSGIVING

OVER THE RIVER AND THROUGH THE WOODS

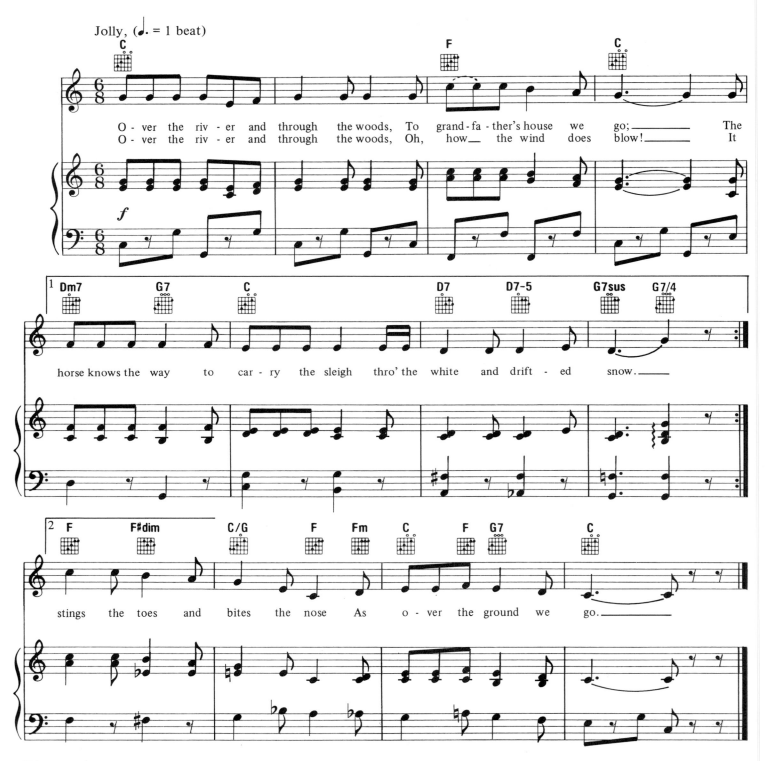

Jolly, (♩. = 1 beat)

Over the river and through the woods, To grand-fa-ther's house we go;____ The
Over the river and through the woods, Oh, how__ the wind does blow!____ It

horse knows the way to car-ry the sleigh thro' the white and drift-ed snow.____

stings the toes and bites the nose As o-ver the ground we go.____

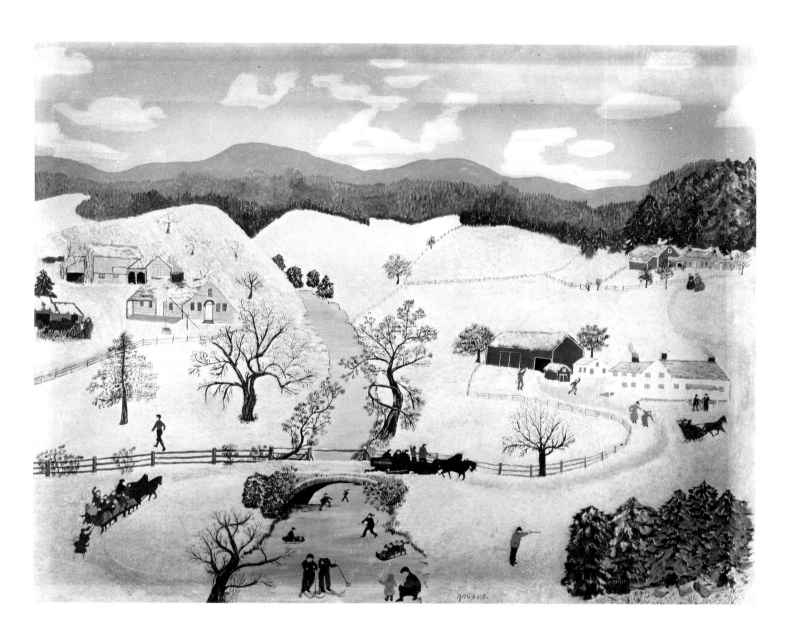

OVER THE RIVER

THE SLEIGHING GLEE

Words and music by T.J. Cook

Allegro moderato

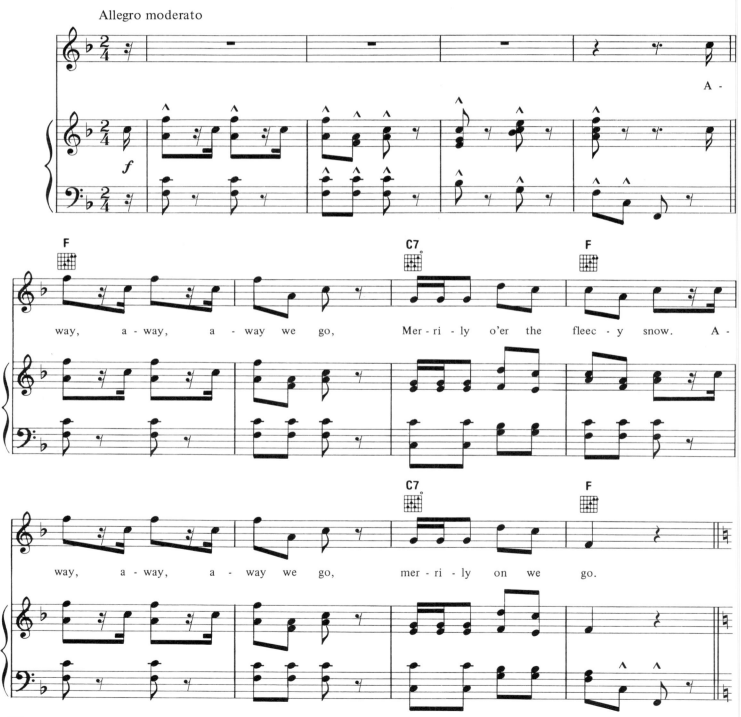

way, a - way, a - way we go, Mer - ri - ly o'er the fleec - y snow. A -

way, a - way, a - way we go, mer - ri - ly on we go.

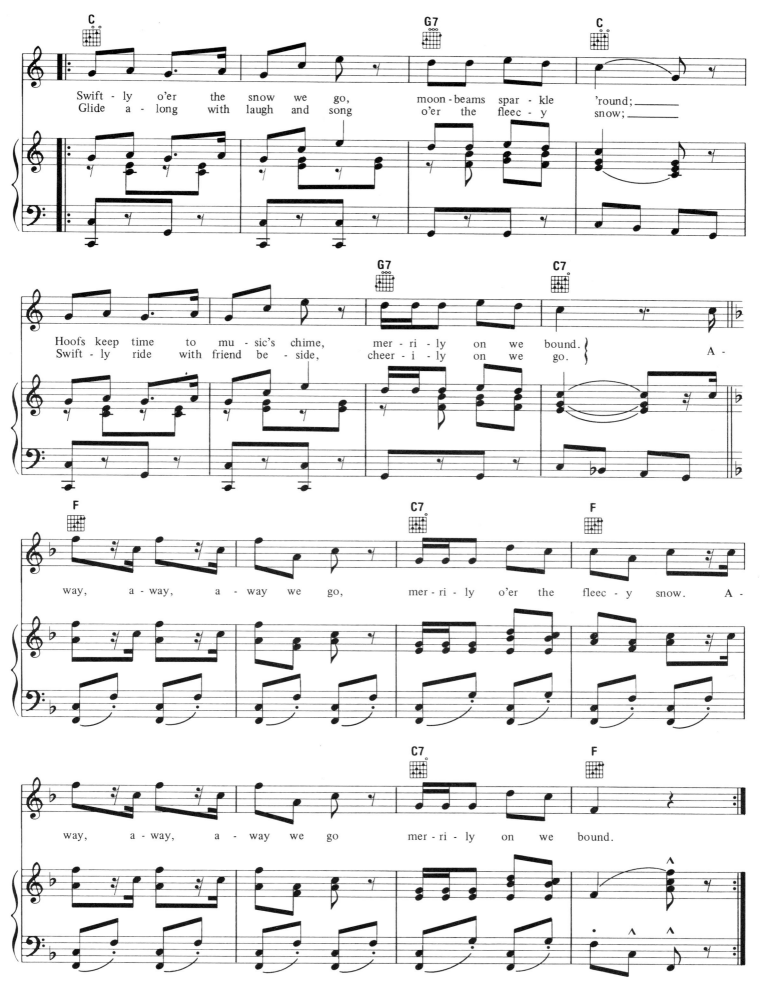

Swift - ly o'er the snow we go, moon-beams spar - kle 'round;____
Glide a - long with laugh and song o'er the fleec - y snow;____

Hoofs keep time to mu - sic's chime, mer - ri - ly on we bound.
Swift - ly ride with friend be - side, cheer - i - ly on we go.

A -

way, a - way, a - way we go, mer - ri - ly o'er the fleec - y snow. A -

way, a - way, a - way we go mer - ri - ly on we bound.

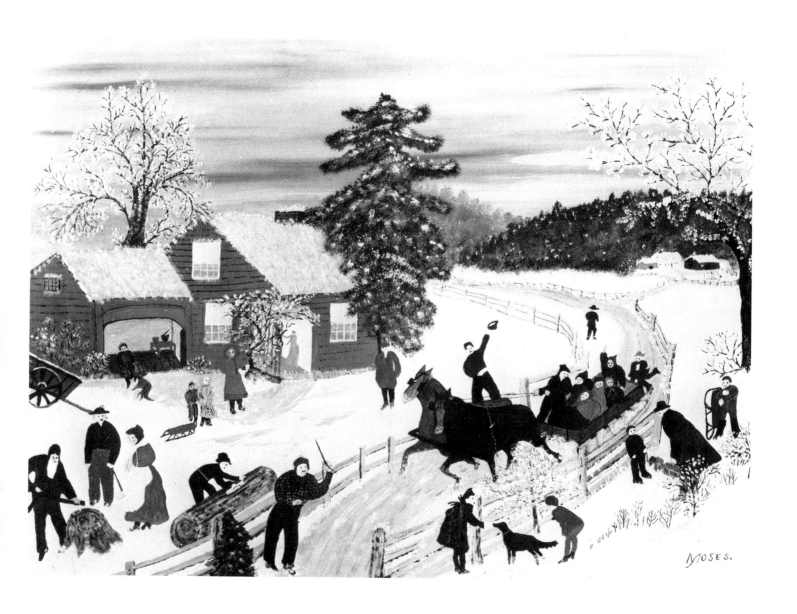

JOY RIDE

OF THEE I SING

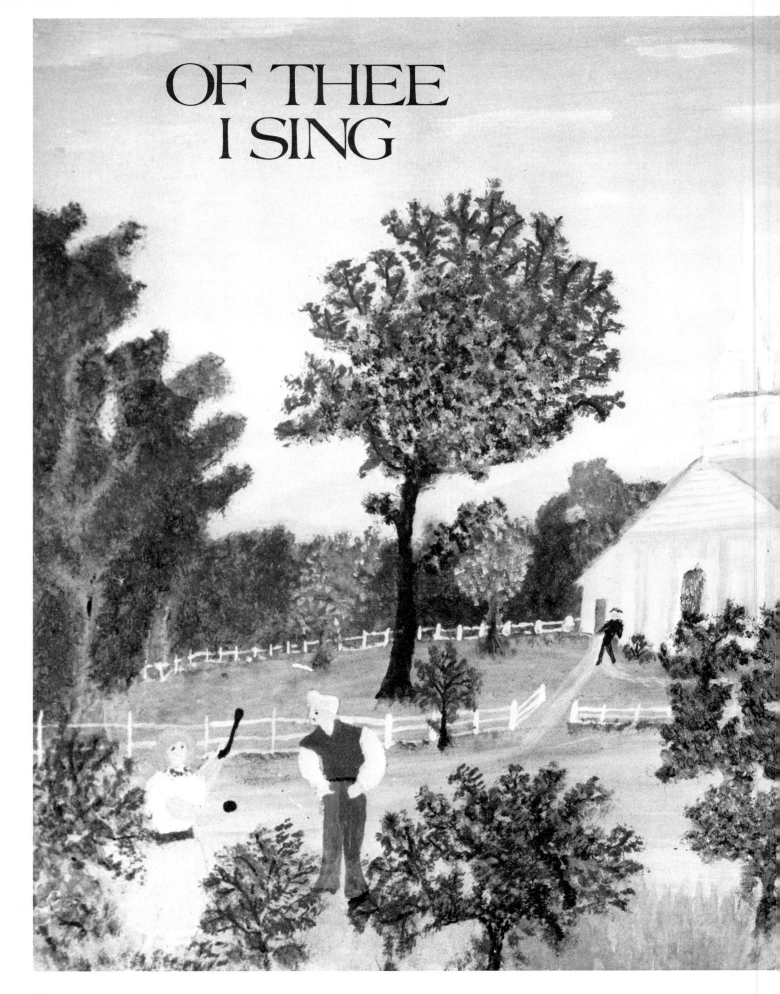

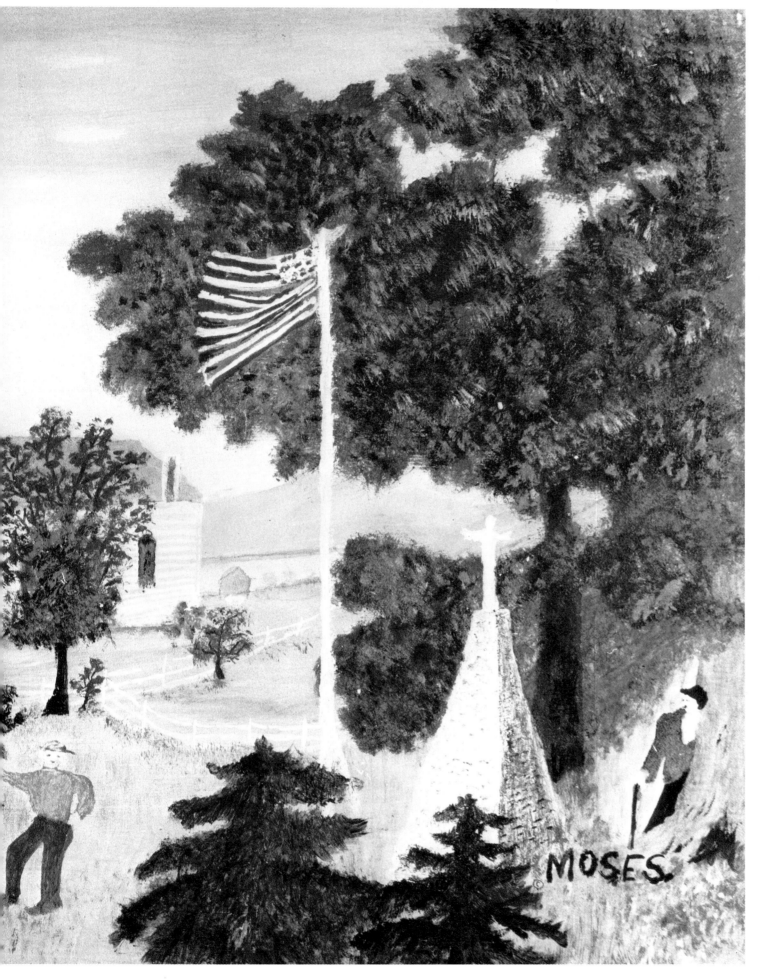

THE FLAG

AMERICA THE BEAUTIFUL

Music by Samuel A. Ward
Words by Katherine Lee Bates

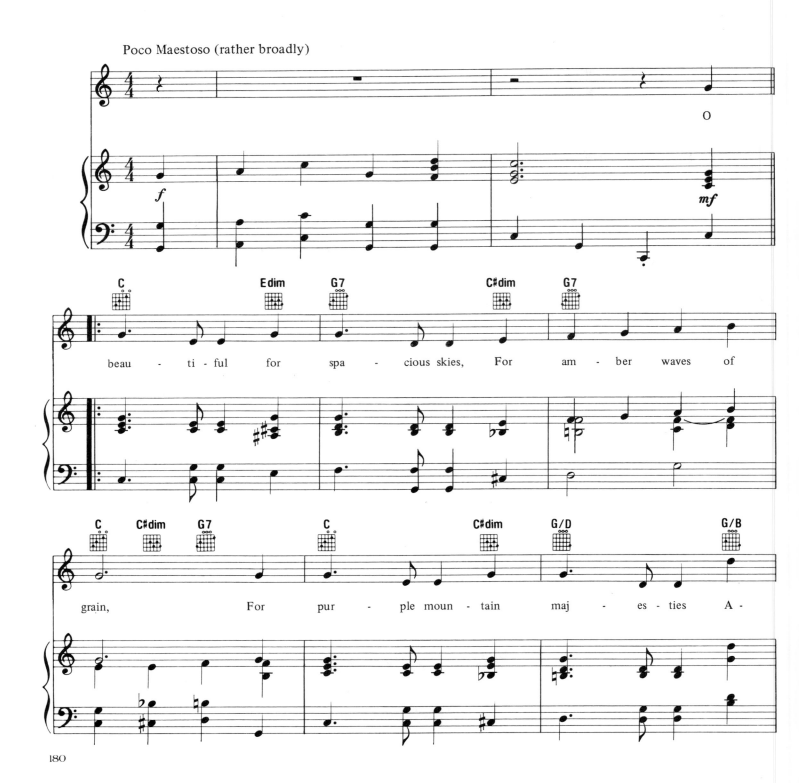

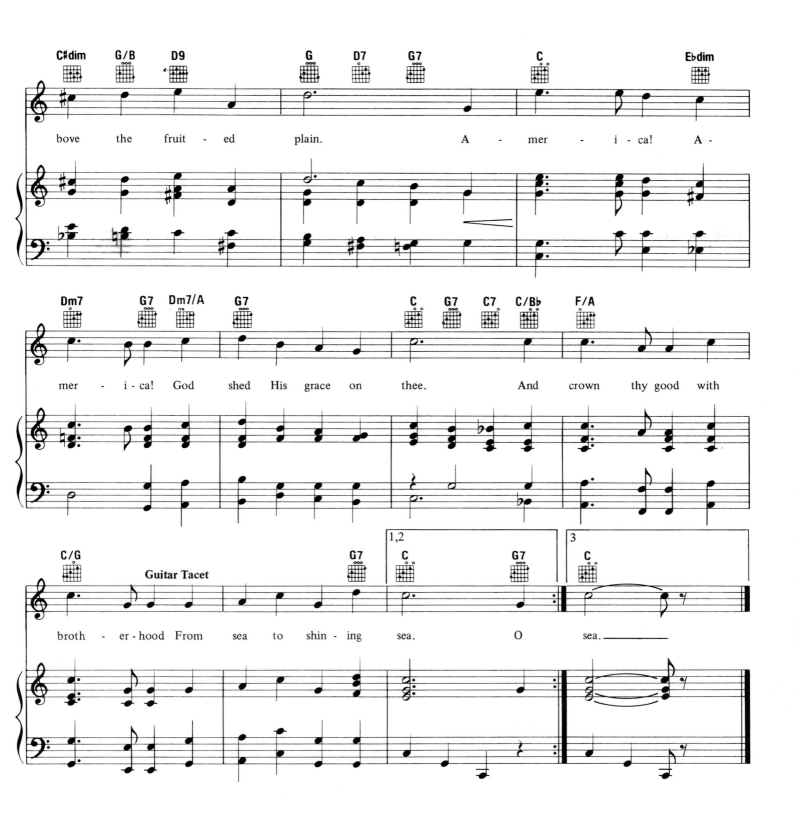

2. O beautiful for pilgrim feet,
 Whose stern impassioned stress,
 A thoroughfare for freedom beat,
 Across the wilderness.
 America! America!
 God mend thine ev'ry flaw,
 Confirm thy soul in self-control,
 Thy liberty in law.

3. O beautiful for patriot dream
 That sees beyond the years,
 Thine alabaster cities gleam,
 Undimmed by human tears.
 America! America!
 God shed His grace on thee,
 And crown thy good with brotherhood
 From sea to shining sea.

COLUMBIA, THE GEM OF THE OCEAN

Words and music by David T. Shaw

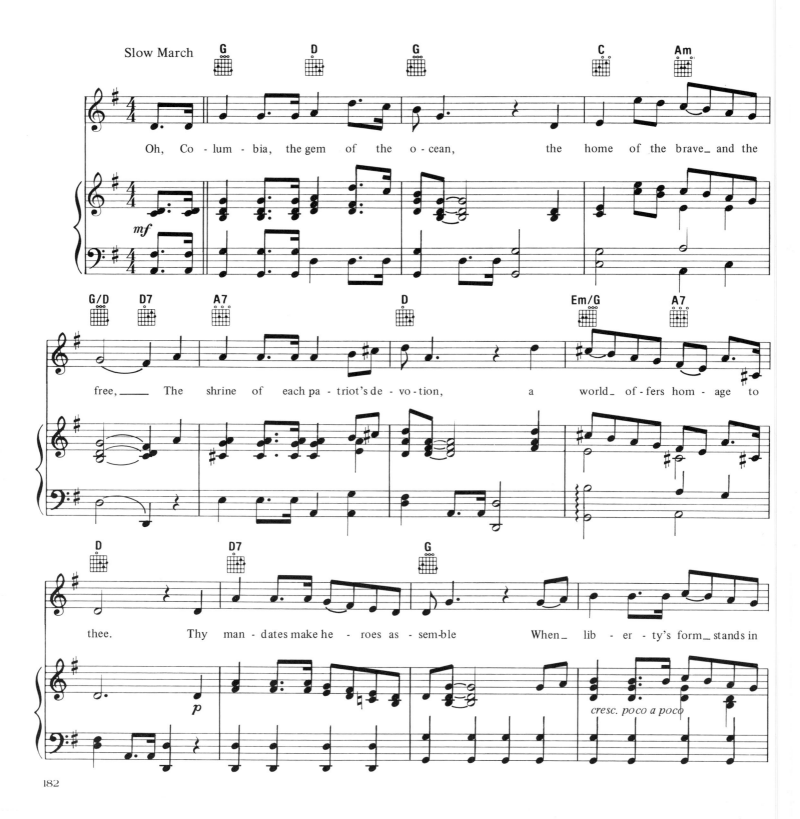

Oh, Co - lum - bia, the gem of the o - cean, the home of the brave_ and the free, _____ The shrine of each pa - triot's de - vo - tion, a world_ of - fers hom - age to thee. Thy man - dates make he - roes as - sem - ble When_ lib - er - ty's form_ stands in

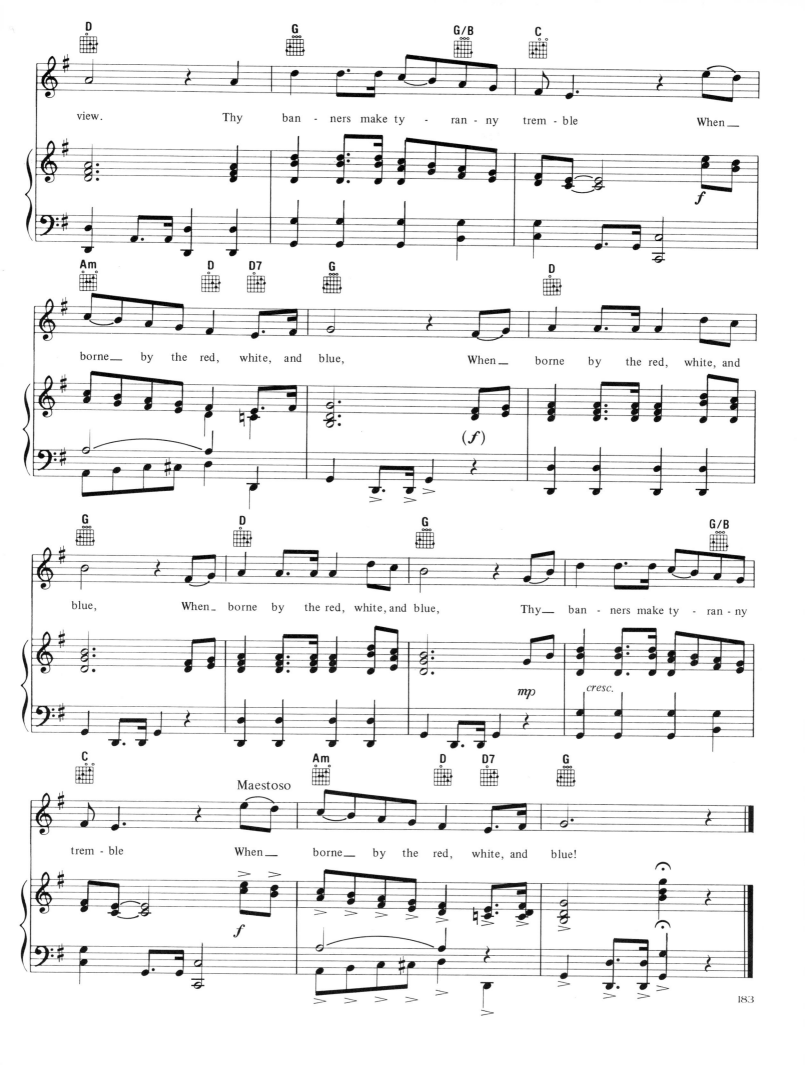

THE HOUSE I LIVE IN

Words by Lewis Allan
Music by Earl Robinson

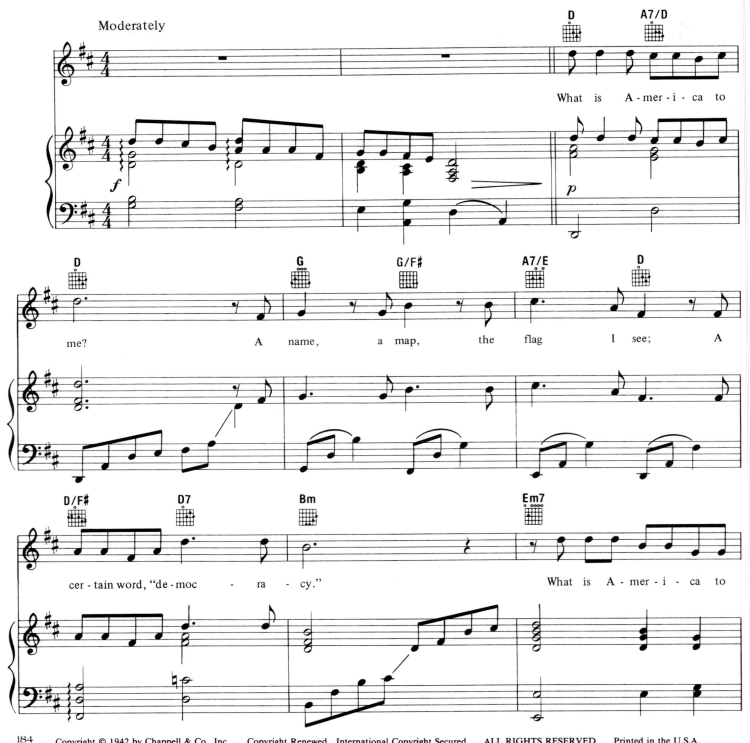

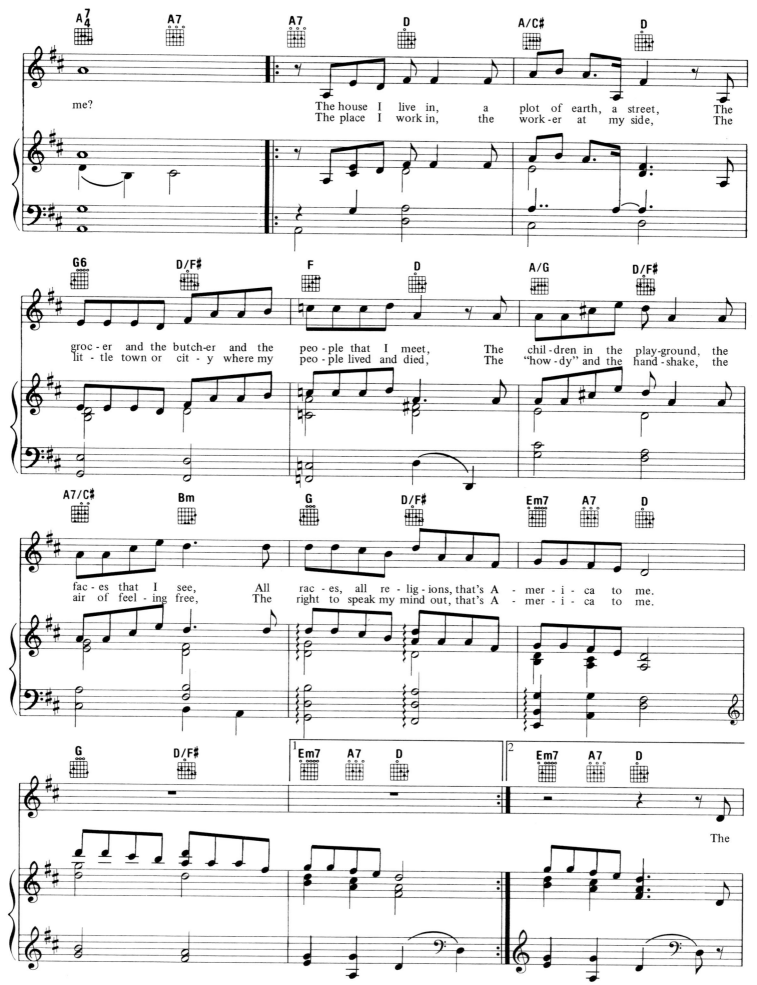

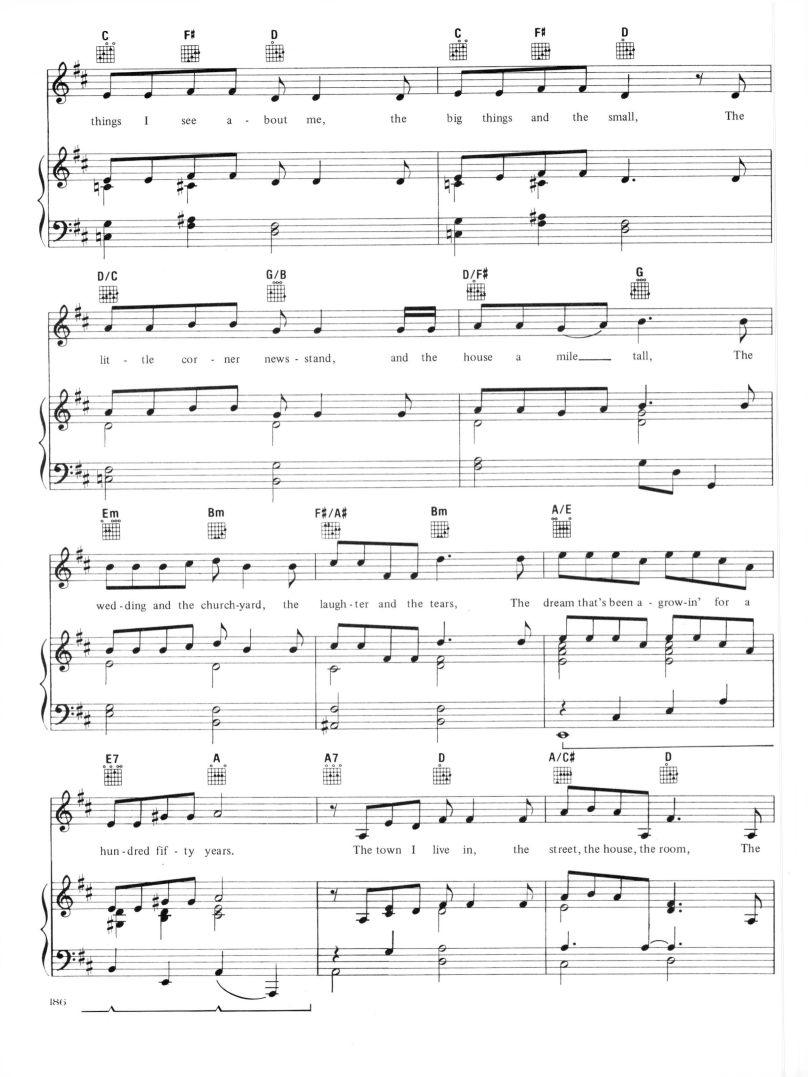

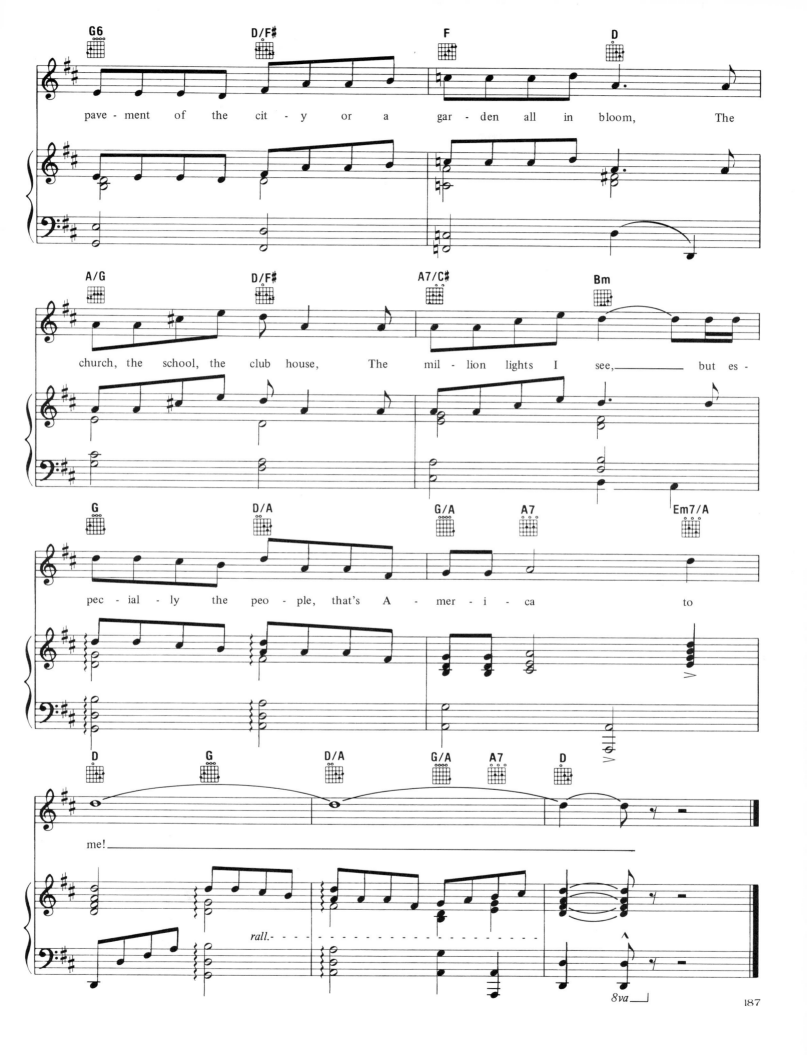

OUR STATE FAIR

Words by Oscar Hammerstein II
Music by Richard Rodgers

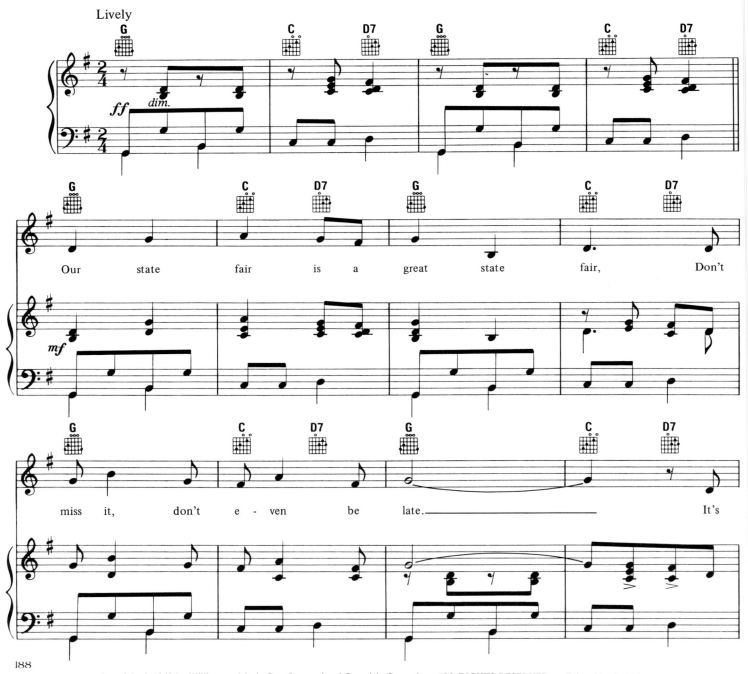

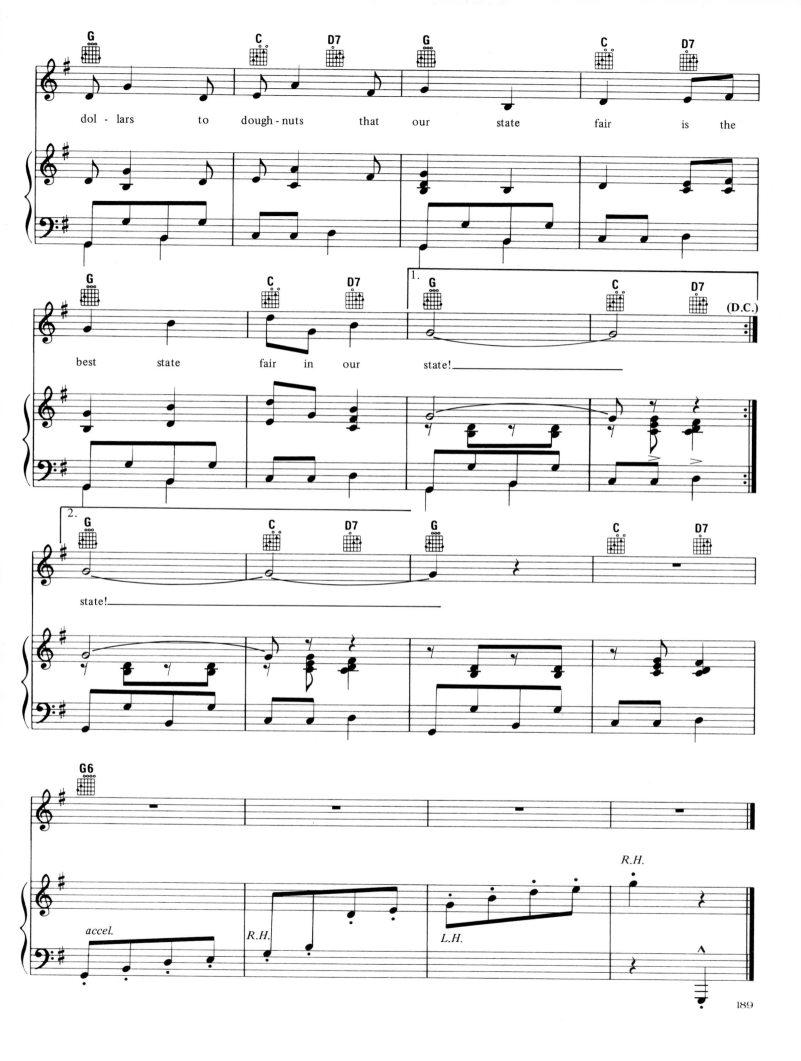

dol - lars to dough - nuts that our state fair is the

best state fair in our state!_____

state!_____

SHENANDOAH

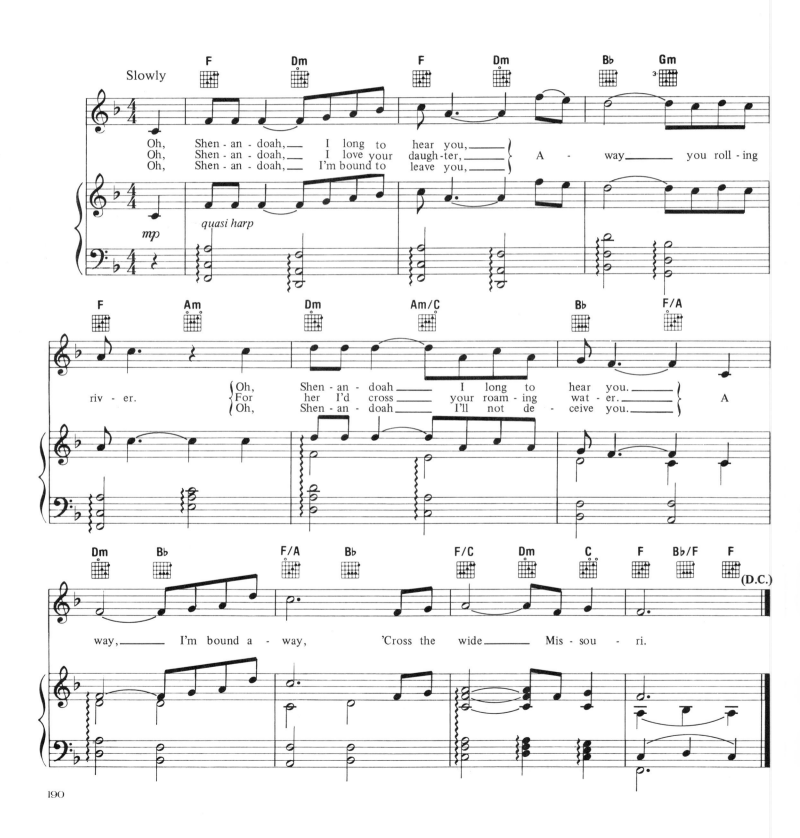

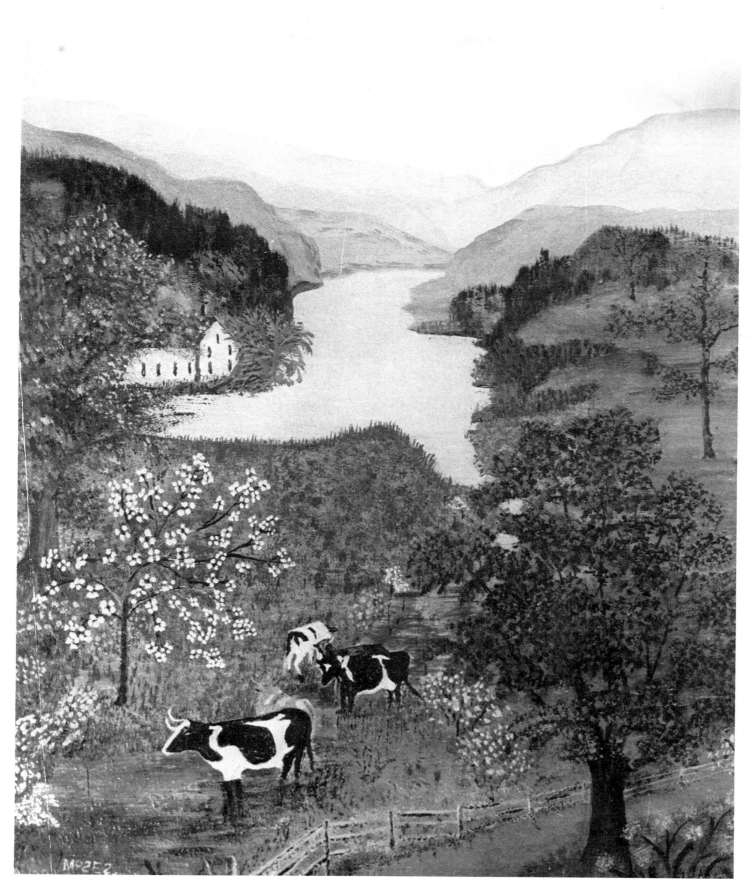

SHENANDOAH

STARS AND STRIPES FOREVER

Music by John Philip Sousa

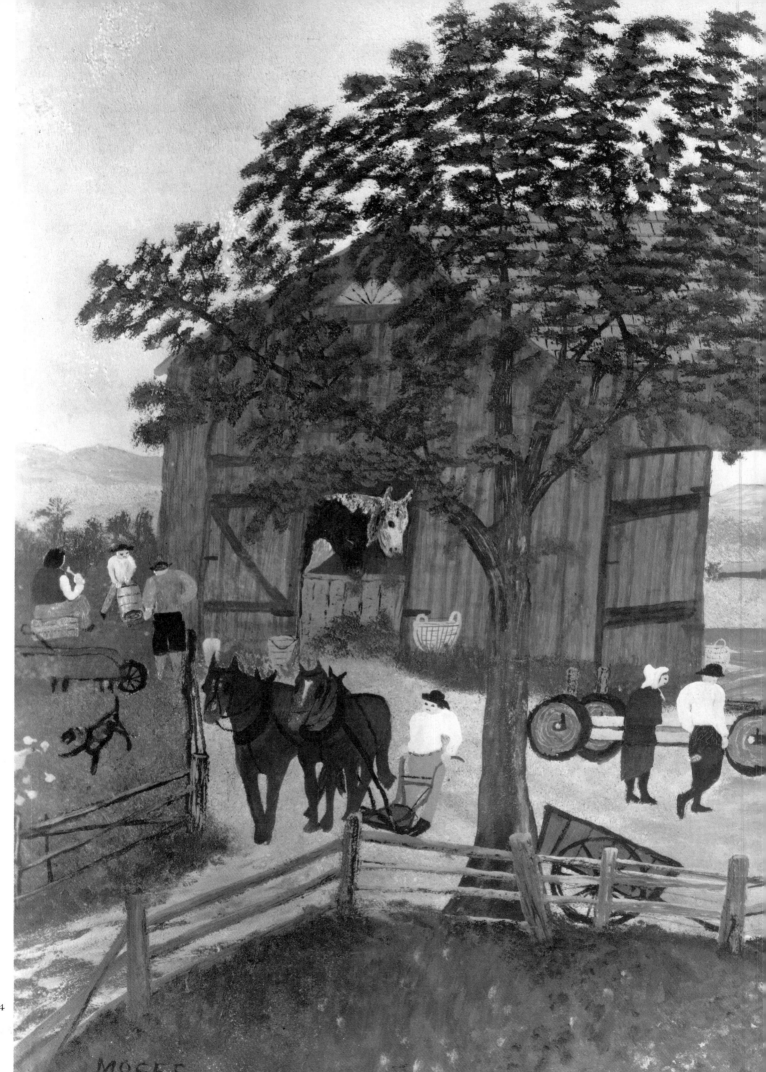

A LITTLE
WORK

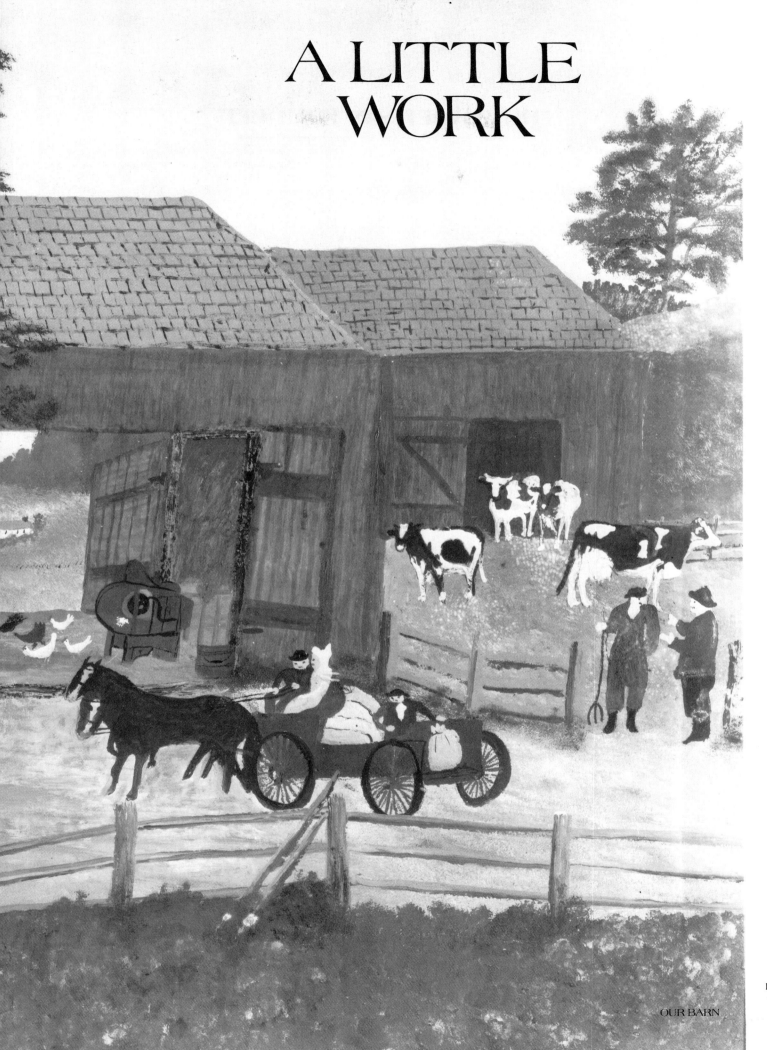

OUR BARN

195

THE FARMER'S IN THE DELL

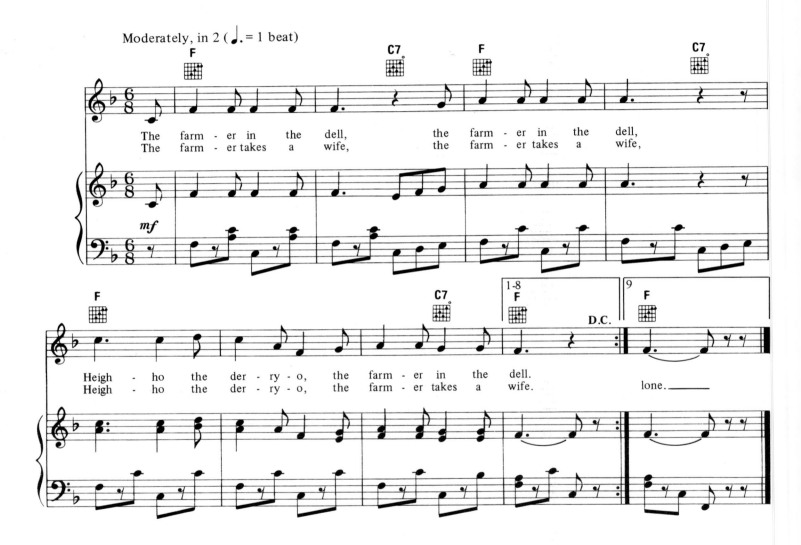

Moderately, in 2 (♩. = 1 beat)

The farm - er in the dell, the farm - er in the dell,
The farm - er takes a wife, the farm - er takes a wife,

Heigh - ho the der - ry - o, the farm - er in the dell.
Heigh - ho the der - ry - o, the farm - er takes a wife.

lone._____

3. The wife takes a nurse, etc.

4. The nurse takes a child, etc.

5. The child takes a dog, etc.

6. The dog takes a cat, etc.

7. The cat takes a rat, etc.

8. The rat takes the cheese, etc.

9. The cheese stands alone, etc.

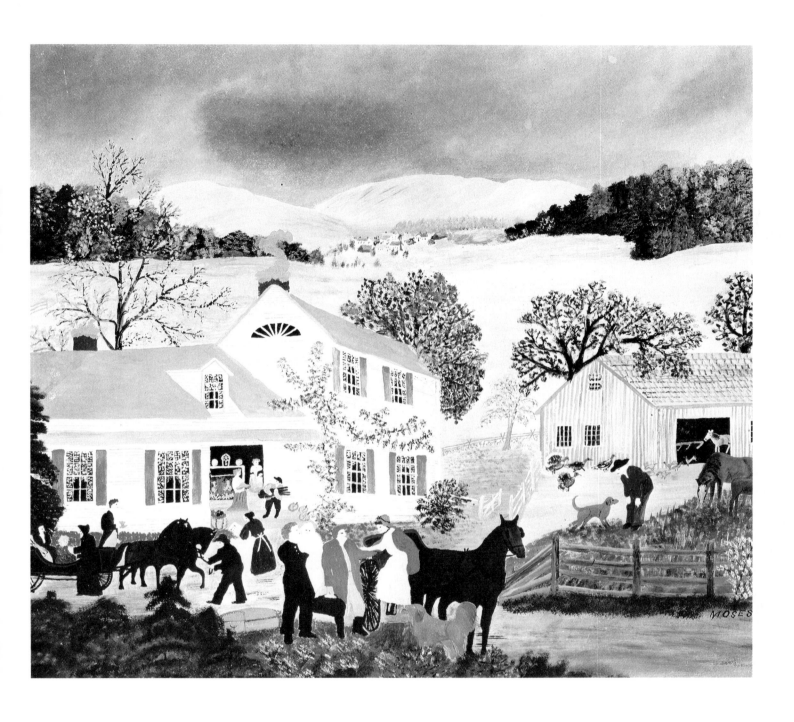

HOME FOR THANKSGIVING

THE HONEST PLOUGHMAN

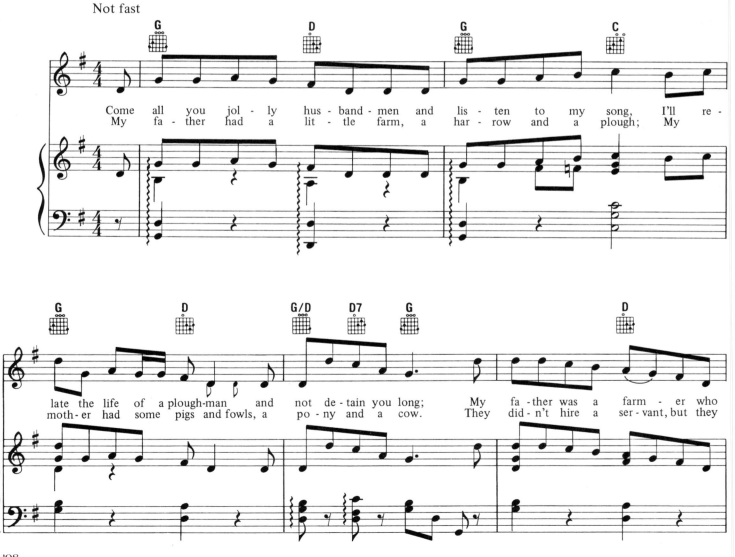

Not fast

Come all you jol - ly hus - band - men and lis - ten to my song, I'll re -
My fa - ther had a lit - tle farm, a har - row and a plough; My

late the life of a plough - man and not de - tain you long;
moth - er had some pigs and fowls, a po - ny and a cow. They

My fa - ther was a farm - er who
did - n't hire a ser - vant, but they

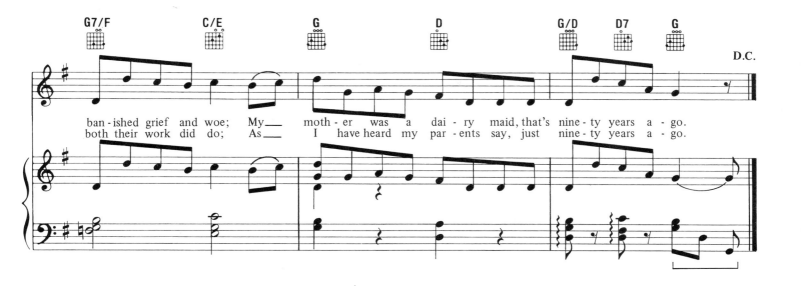

G7/F C/E G D G/D D7 G D.C.

ban-ished grief and woe; My__ moth-er was a dai-ry maid, that's nine-ty years a-go.
both their work did do; As__ I have heard my par-ents say, just nine-ty years a-go.

3. The rent that time was not so high, but far as I will pen,
For now one family's nearly twice as big as then was ten;
When I was born my father used to harrow, plough, and sow,
I think I've heard my mother say, 'twas ninety years ago.

4. To drive the plough, my father did a boy engage,
Until that I had just arrived to seven years of age;
So then he did no servant want, my mother milked the cow,
And with the lark I rose each morn to go and drive the plough.

5. When I was fifteen years of age, I used to thrash and sow,
I harrowed, ploughed, and harvest-time I used to reap and mow;
When I was twenty years of age, I could manage well the farm,
I could hedge and ditch, and plough and sow, or thrash within the barn.

6. At length when I was twenty-five, I took myself a wife,
Compelled to leave my father's house, as I have changed my life;
The younger children in my place, my father's work would do,
Then daily as an husbandman to labour I did go.

7. My wife and me, tho' very poor, could keep a pig and cow,
She could sit and knit, and spin, and I the land could plough;
There nothing was upon a farm at all, but I could do,
I feel things very different now - that's many years ago.

8. We lived along contented, and banished pain and grief,
We had not occasion then to ask parish relief;
But now my hairs are grown quite grey, I cannot well engage
To work as I had used to do - I'm ninety years of age.

9. But now that I'm ninety years of age, and poverty do feel,
If for relief do go, they shove me in a Whig Bastille,
Where I may hang my weary head, and pine in grief and woe,
My father did not see the like, just ninety years ago.

10. When a man has laboured all his life, to do his country good,
He's respected just as much when old as a donkey in a wood,
His days are gone and past, and he may weep in grief and woe,
The times are very different now, to ninety years ago.

ONE MAN WENT TO MOW

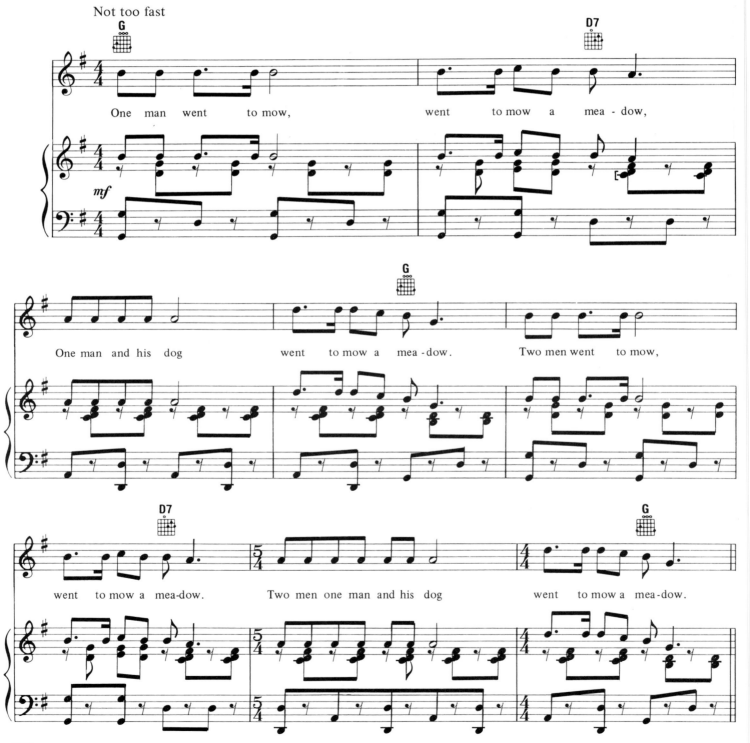

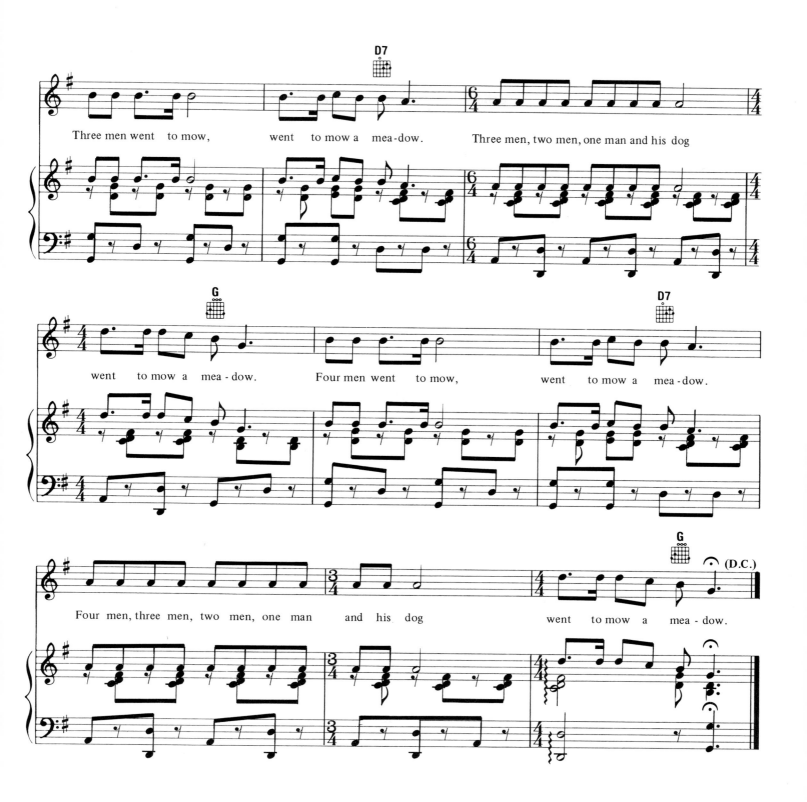

5. Five men went to mow,
 Went to mow a meadow,
 Five men, four men, three men,
 two men, one man and his dog,
 Went to mow a meadow.

6. Six men went to mow,
 Went to mow a meadow,
 Six men, five men, four men, three men,
 two men, one man and his dog,
 Went to mow a meadow.

7. Seven men went to mow,
 Went to mow a meadow,
 Seven men, six men, five men, four men,
 three men, two men, one man and his dog,
 Went to mow a meadow,

8. Eight men went to mow,
 Went to mow a meadow,
 Eight men, seven men, six men, five men, four men,
 three men, two men, one man and his dog,
 Went to mow a meadow.

SHUCKIN' OF THE CORN

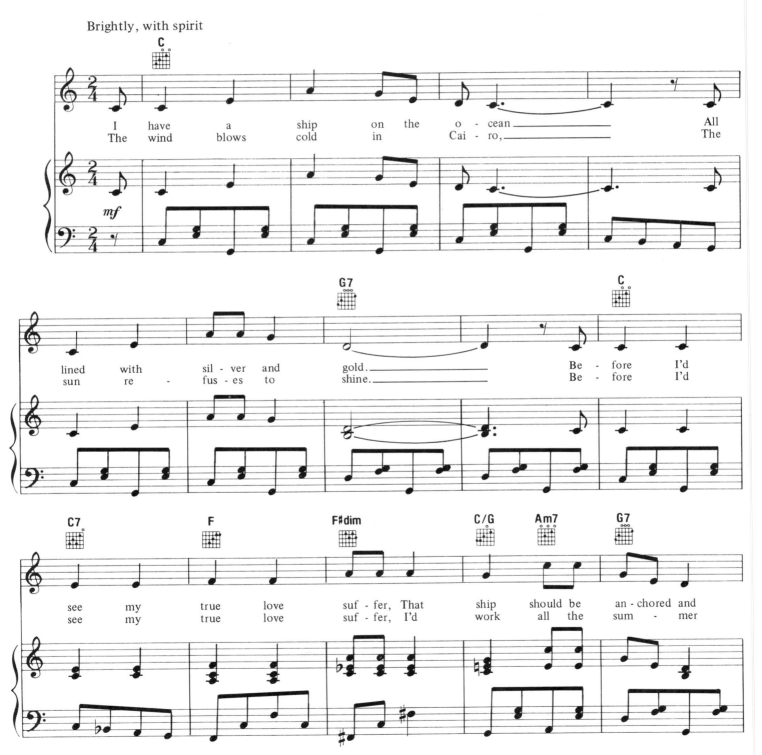

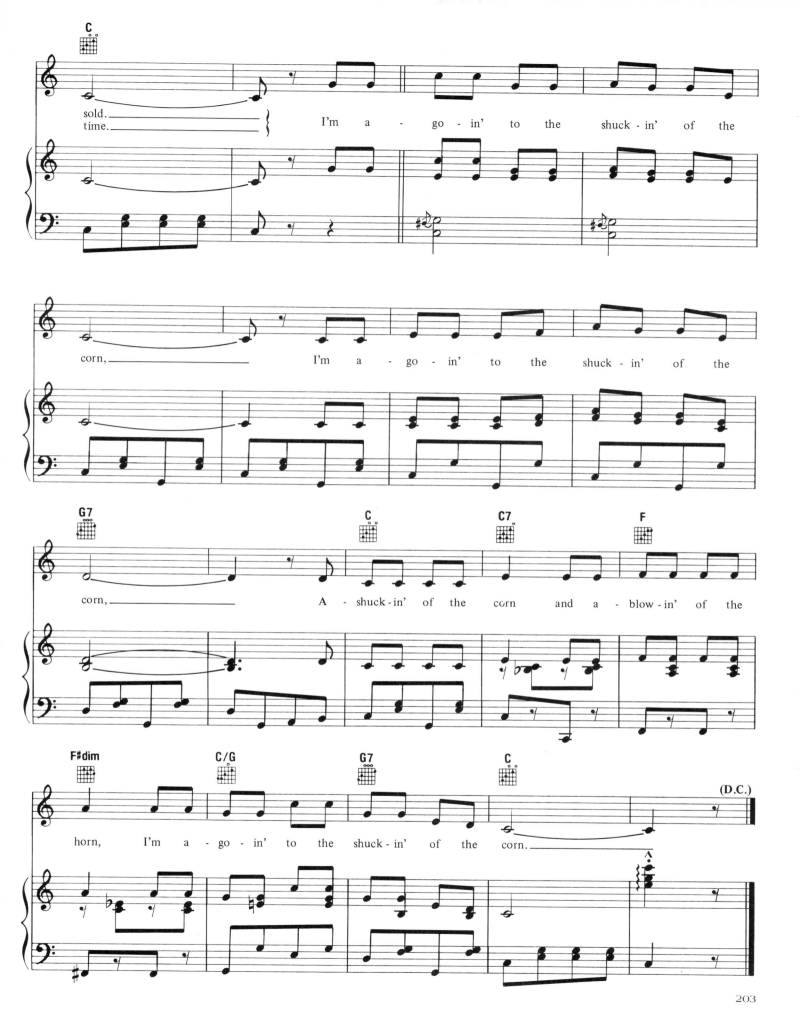

203

THE VILLAGE BLACKSMITH

Words by Henry Wadsworth Longfellow
Music by W.H. Weiss

Moderato rubato

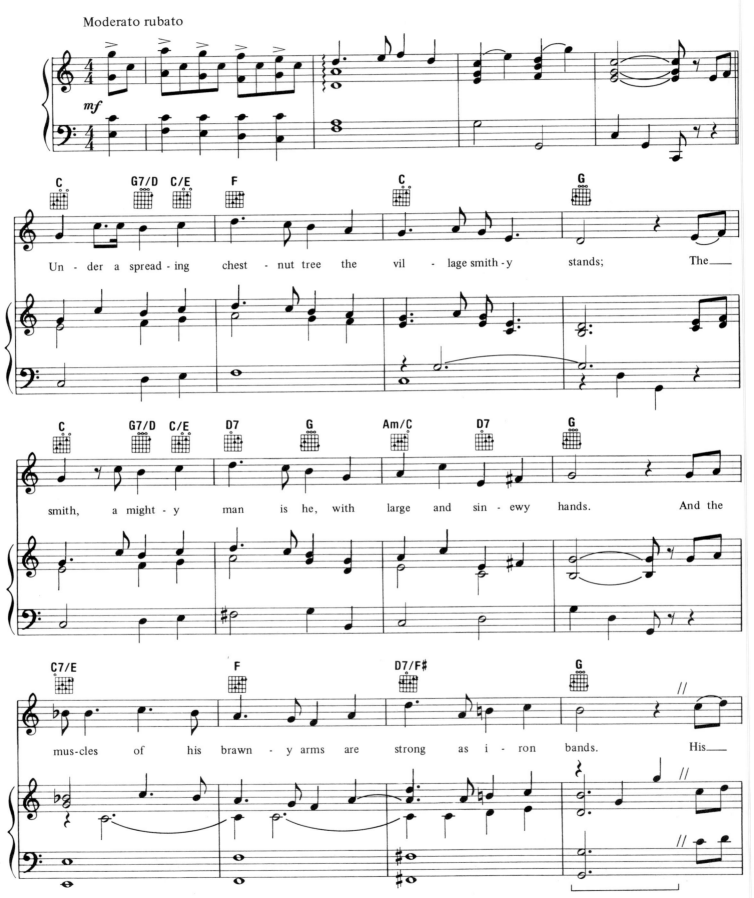

Un - der a spread - ing chest - nut tree the vil - lage smith - y stands; The___

smith, a might - y man is he, with large and sin - ewy hands. And the

mus - cles of his brawn - y arms are strong as i - ron bands. His___

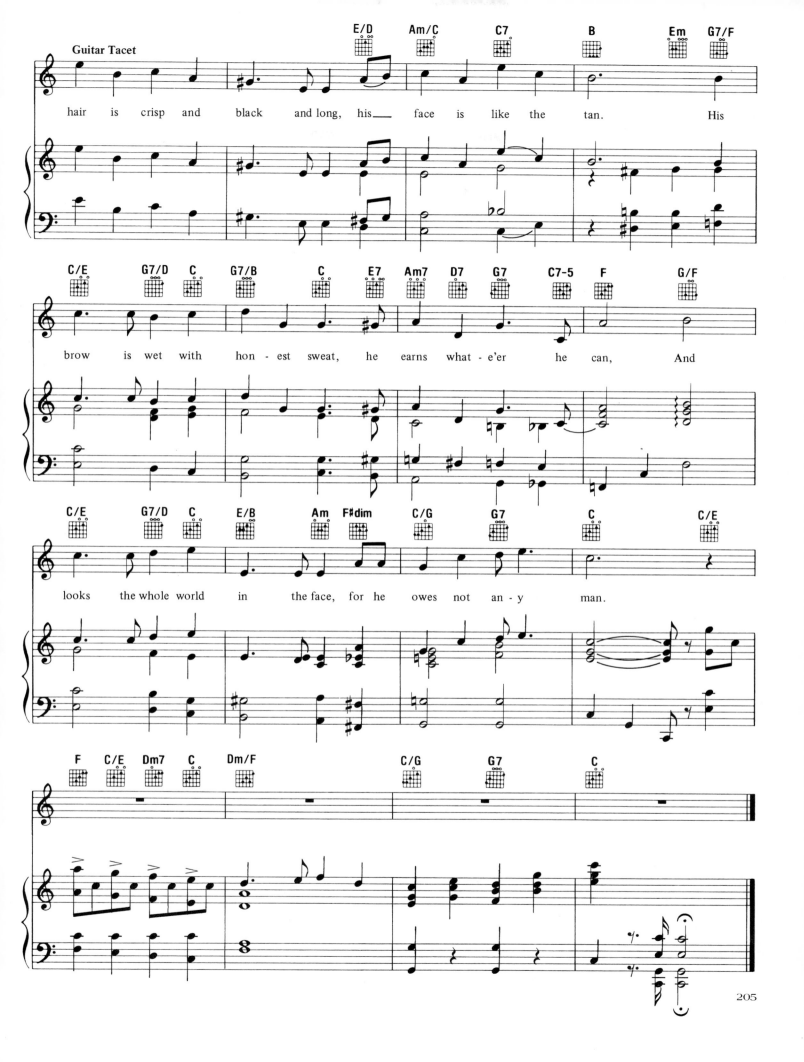

TURKEY IN THE STRAW

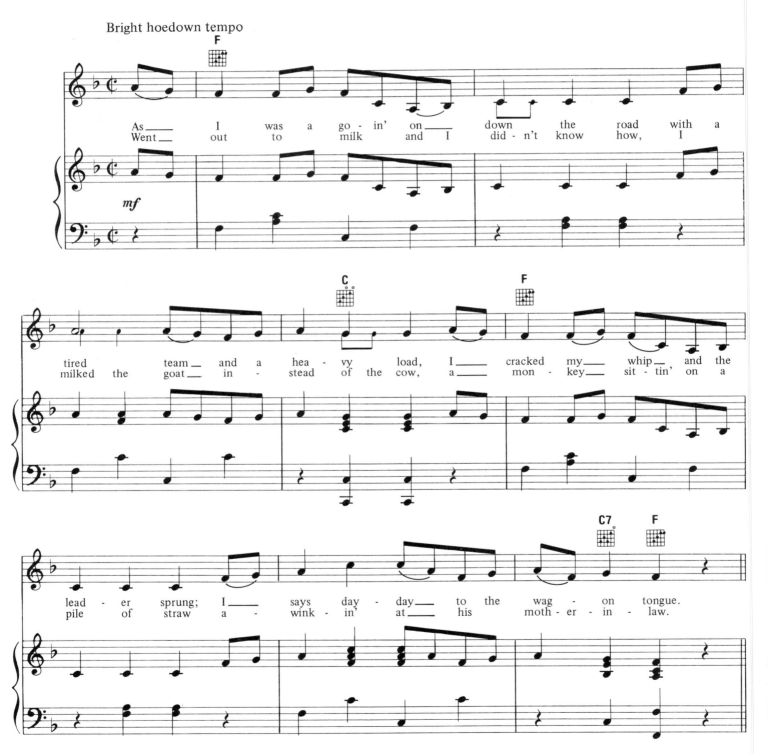

Bright hoedown tempo

As ___ I was a go - in' on ___ down the road with a
Went ___ out to milk and I did - n't know how, with I

tired the team ___ and a hea - vy load, I ___ cracked my ___ whip ___ and the
milked the goat ___ in - stead of the cow, a ___ mon - key ___ sit - tin' on a

lead - er sprung; I ___ says day - day ___ to the wag - on tongue.
pile of straw a - wink - in' at ___ his moth - er - in - law.

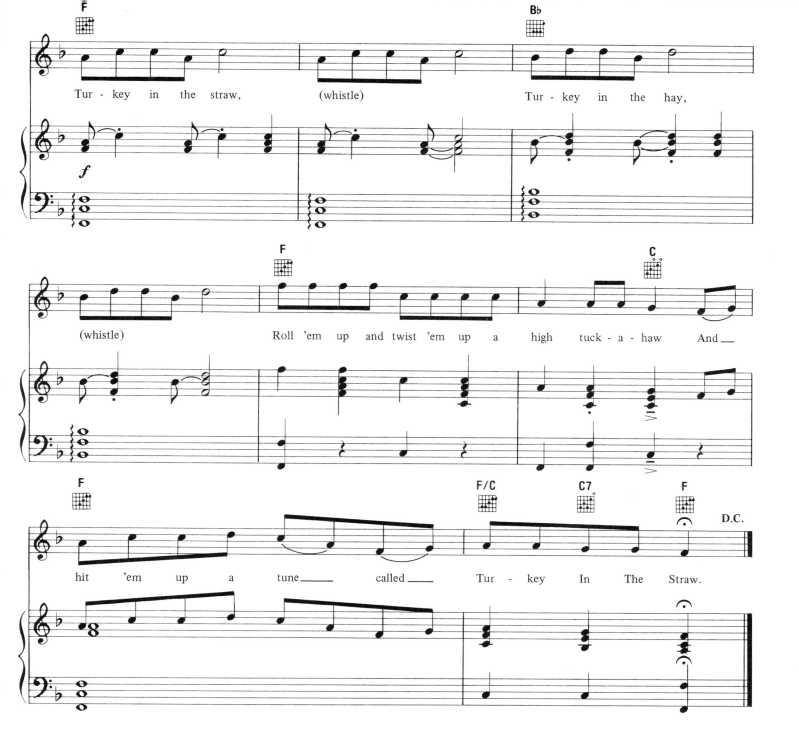

3. Met Mr. Catfish comin' down stream,
 Says Mr. Catfish, "What does you mean?"
 Caught Mr. Catfish by the snout
 And turned Mr. Catfish wrong side out.
 Chorus:

4. Came to the river and I couldn't get across,
 Paid five dollars for an old blind hoss
 Wouldn't go ahead, nor he wouldn't stand still,
 So he went up and down like an old saw mill.
 Chorus:

5. As I came down the new cut road
 Met Mr. Bullfrog, met Miss Toad,
 And every time Miss Toad would sing
 Ole Bullfrog cut a pigeon wing.
 Chorus:

6. Oh, I jumped in the seat, and I gave a little yell,
 The horses run away, broke the wagon all to hell;
 Sugar in the gourd and honey in the horn,
 I never was so happy since the hour I was born.
 Chorus:

CHORUS
Turkey in the straw, turkey in the hay,
Roll 'em up and twist 'em up a high tuckahaw,
And hit 'em up a tune called Turkey in the Straw.

THE WASHING DAY

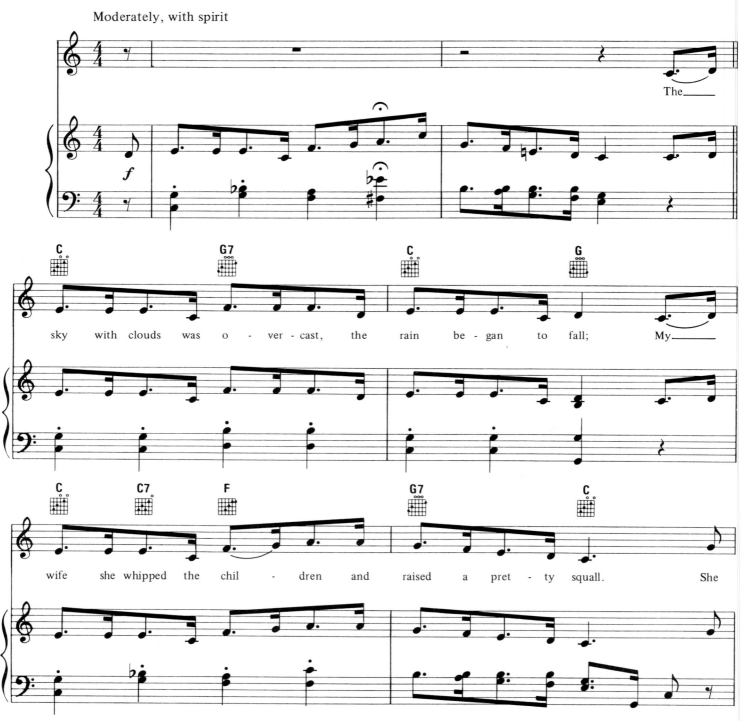

Moderately, with spirit

The___

sky with clouds was o - ver - cast, the rain be - gan to fall; My___

wife she whipped the chil - dren and raised a pret - ty squall. She

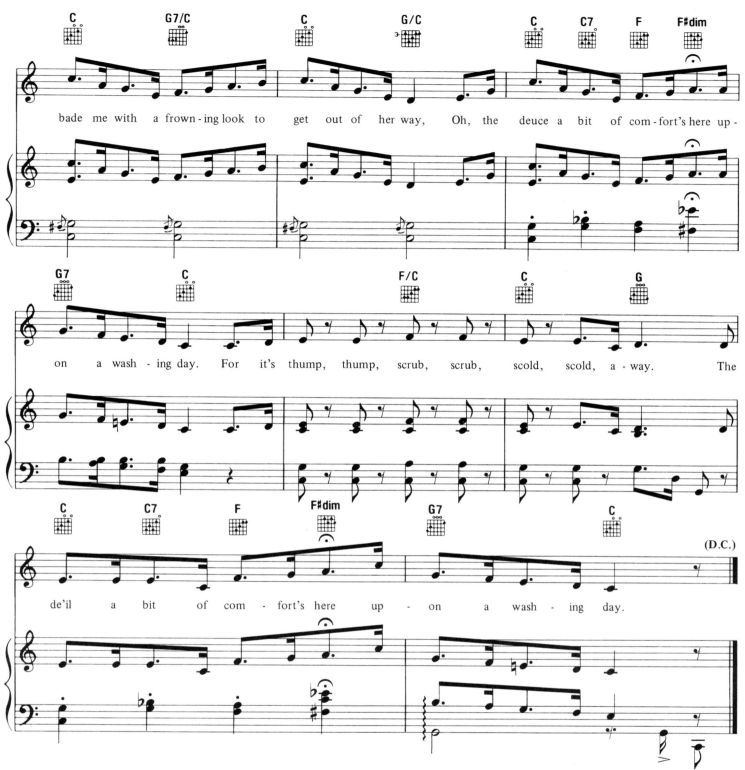

bade me with a frown-ing look to get out of her way, Oh, the deuce a bit of com-fort's here up-

on a wash-ing day. For it's thump, thump, scrub, scrub, scold, scold, a-way. The

(D.C.)

de'il a bit of com-fort's here up-on a wash-ing day.

2. My Kate, she is a bonny wife,
 There's none so free from evil
 Unless upon a washing day,
 And then she is the devil!
 The very kittens on the (h) earth
 They dare not even play,
 Away they jump with many a bump
 Upon the washing day,
 For 'tis thump, etc.

3. I met a friend who ask'd of me,
 "How long's poor Kate been dead?"
 Lamenting the good creature, gone
 And sorry I was wed
 To such a scolding vixen, while
 He had been far away!
 The truth it was, he chanced to come
 Upon a washing day!
 When 'tis scrub, scrub, etc.

4. I ask'd him then, to come and dine,
 "Come, come." quoth I, "Ods buds!
 I'll no denial take, you must;
 Tho' Kate be in the suds!"
 But what we had to dine upon,
 In truth I cannot say,
 But I think he'll never come again,
 Upon a washing day!
 When 'tis scrub, scrub, etc.

5. On that sad morning, when I rise,
 I put a fervent prayer,
 To all the gods, that it may be
 Throughout the day quite fair!
 That not a Cap or Handkerchief
 May in the ditch be laid
 For should it happen so egad,
 I get a broken head!
 For 'tis thump, thump, etc.

6. Old Homer sang a royal wash,
 Down by a crystal river;
 For dabbling in the palace halls
 The king permitted never
 On high Olympus, Beauty's queen
 Such troubles well may scout,
 While Jove and Juno with their train
 Put all their washing out!
 Ah! happy gods, they fear no sound,
 Of thump and scold away;
 But smile to view the perils of
 A mortal washing day!

209

SCHOOL-DAYS

Words and music by Will D. Cobb and Gus Edwards

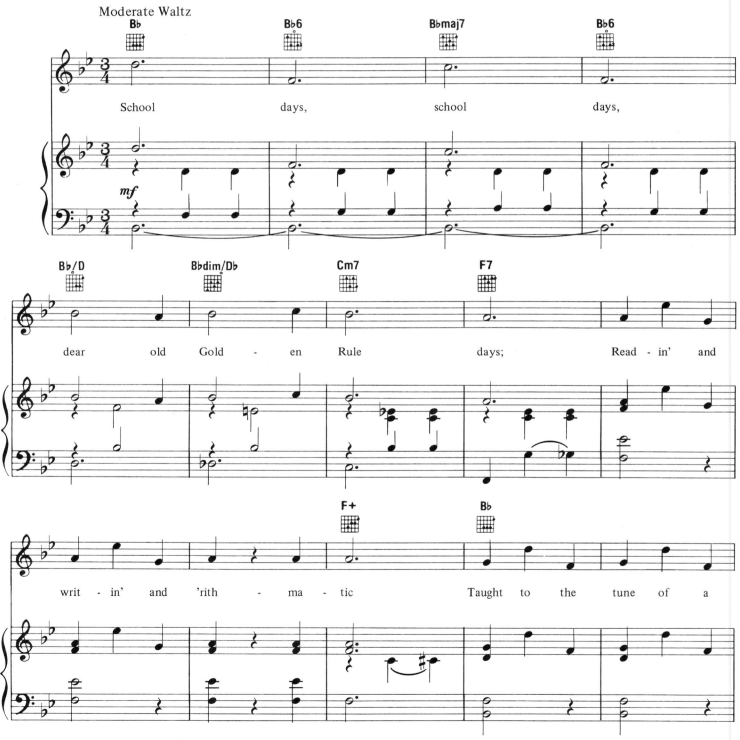

School days, school days, dear old Gold - en Rule days; Read - in' and writ - in' and 'rith - ma - tic Taught to the tune of a

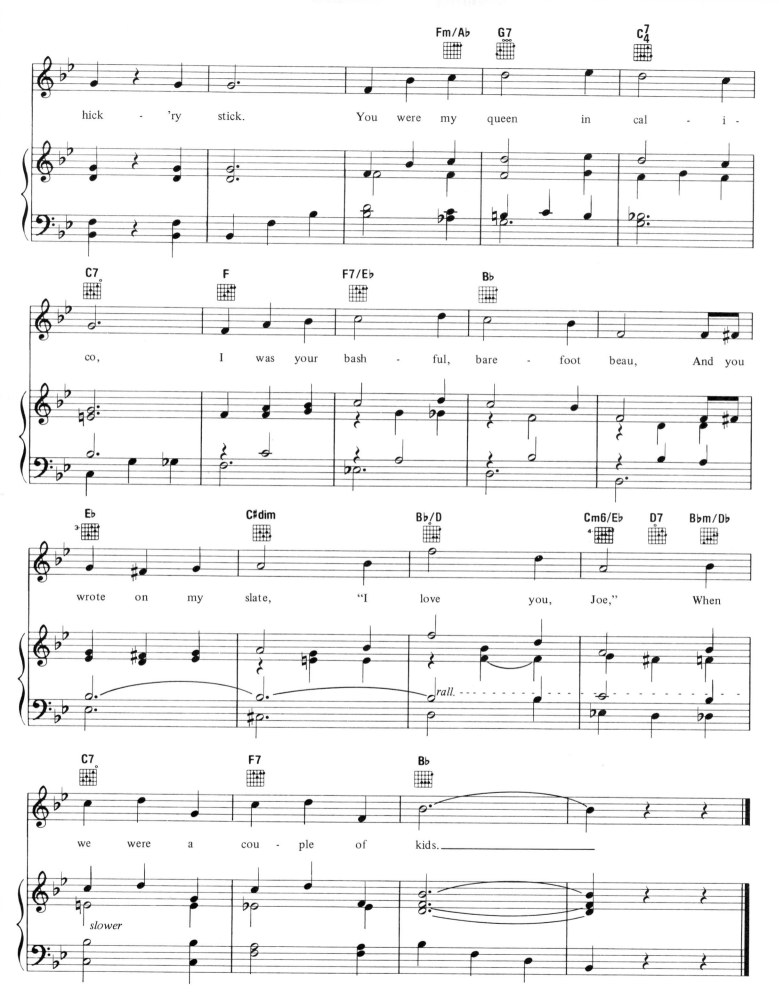

hick - 'ry stick. You were my queen in cal - i - co, I was your bash - ful, bare - foot beau, And you wrote on my slate, "I love you, Joe," When we were a cou - ple of kids.

YOUNG MAN WHO WOULDN'T HOE CORN

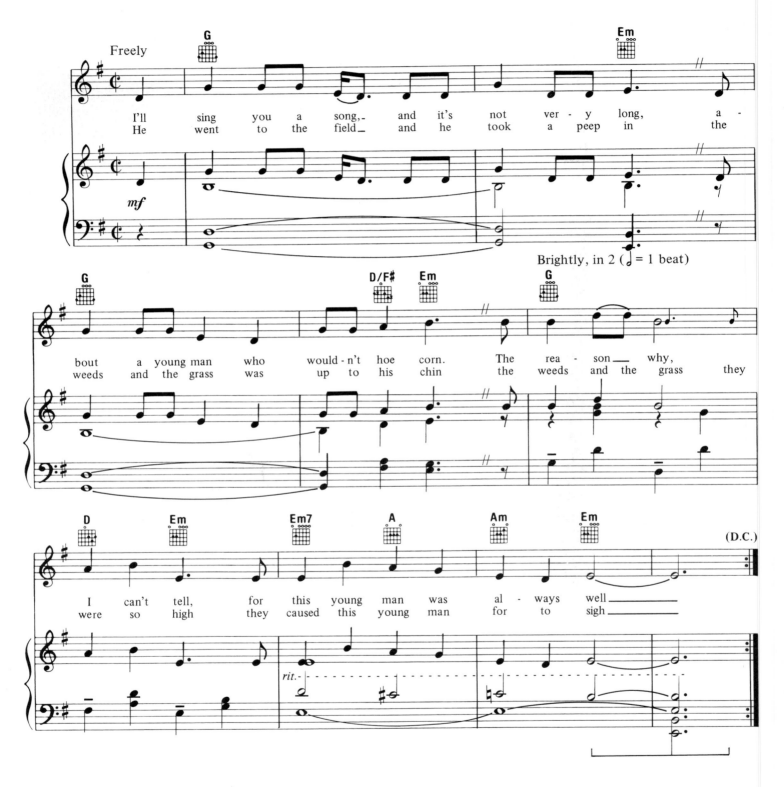

3. He went down to his neighbor's door
 Where he had been many times before;
 Pretty little miss, will you marry me,
 Pretty little miss, what do you say?

4. Well, here you air a-wantin' for to wed
 And cannot make your own corn bread.
 Single I be, single I remain;
 A lazy man I won't maintain.

5. Now go down to that cute little widder,
 And I hope that you don't git her.
 She gave him the mitten as sure as you're born,
 Because this young man wouldn't hoe corn.

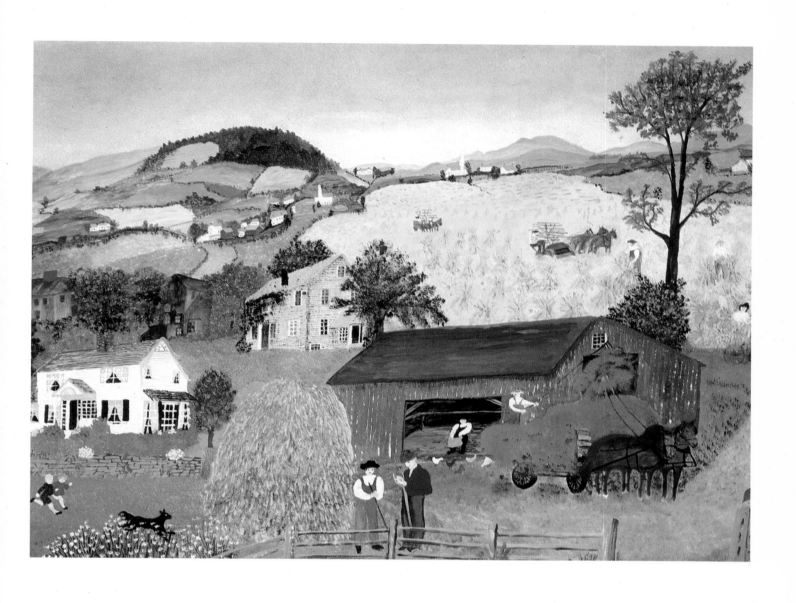

IN HARVEST TIME (detail)

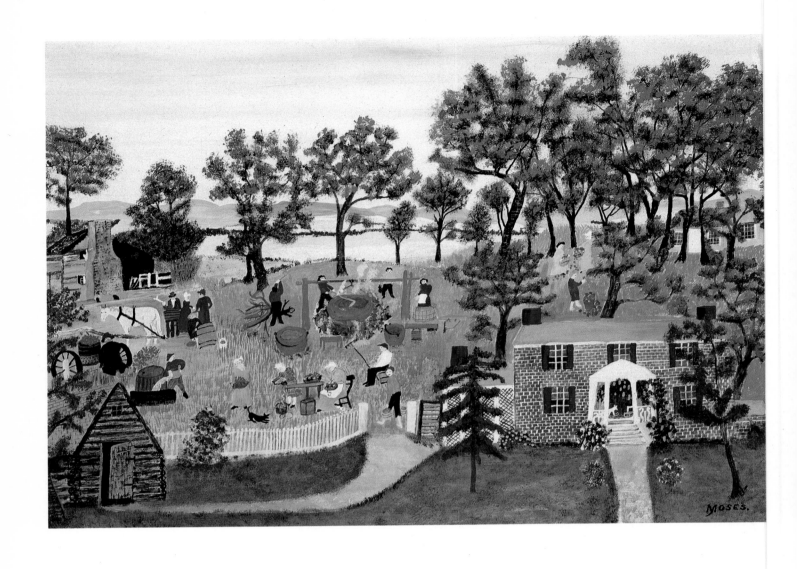

APPLE BUTTER MAKING

WORK FOR THE NIGHT IS COMING

Words by Ann L. Walker-Coghill
Music by Lowell Mason

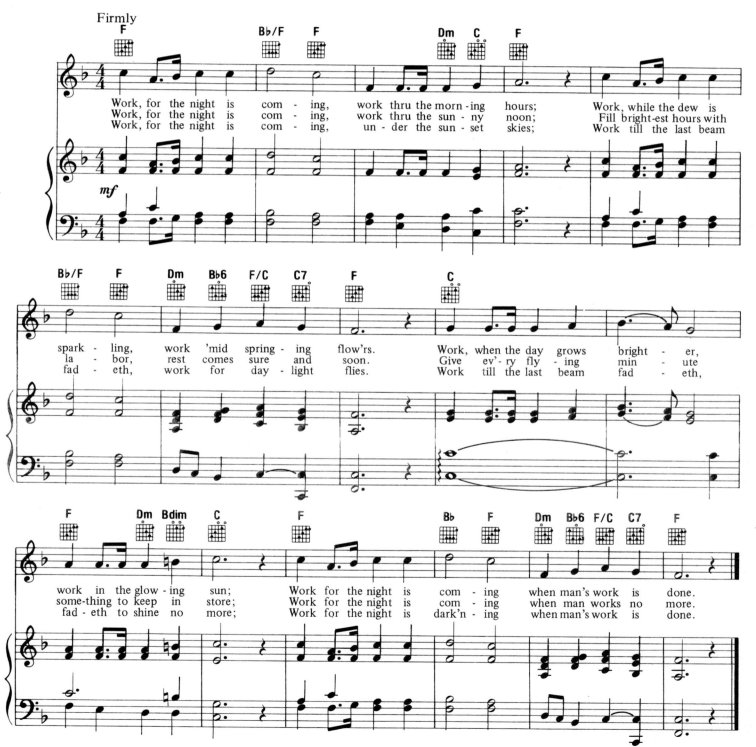

Work, for the night is com - ing, work thru the morn-ing hours; Work, while the dew is
Work, for the night is com - ing, work thru the sun - ny noon; Fill bright-est hours with
Work, for the night is com - ing, un - der the sun - set skies; Work till the last beam

spark - ling, work 'mid spring - ing flow'rs. Work, when the day grows bright - er,
la - bor, rest comes sure and soon. Give ev' - ry fly - ing min - ute
fad - eth, work for day - light flies. Work till the last beam fad - eth,

work in the glow - ing sun; Work for the night is com - ing when man's work is done.
some-thing to keep in store; Work for the night is com - ing when man works no more.
fad - eth to shine no more; Work for the night is dark'n - ing when man's work is done.

215

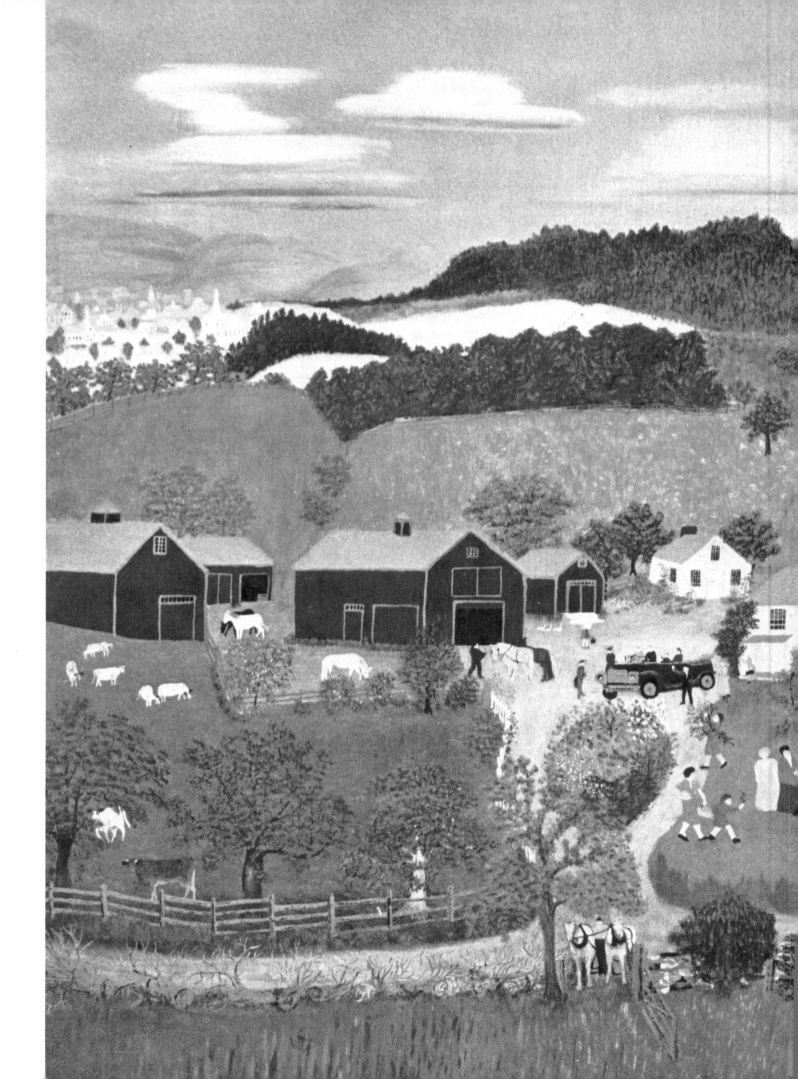

A LITTLE PLAY

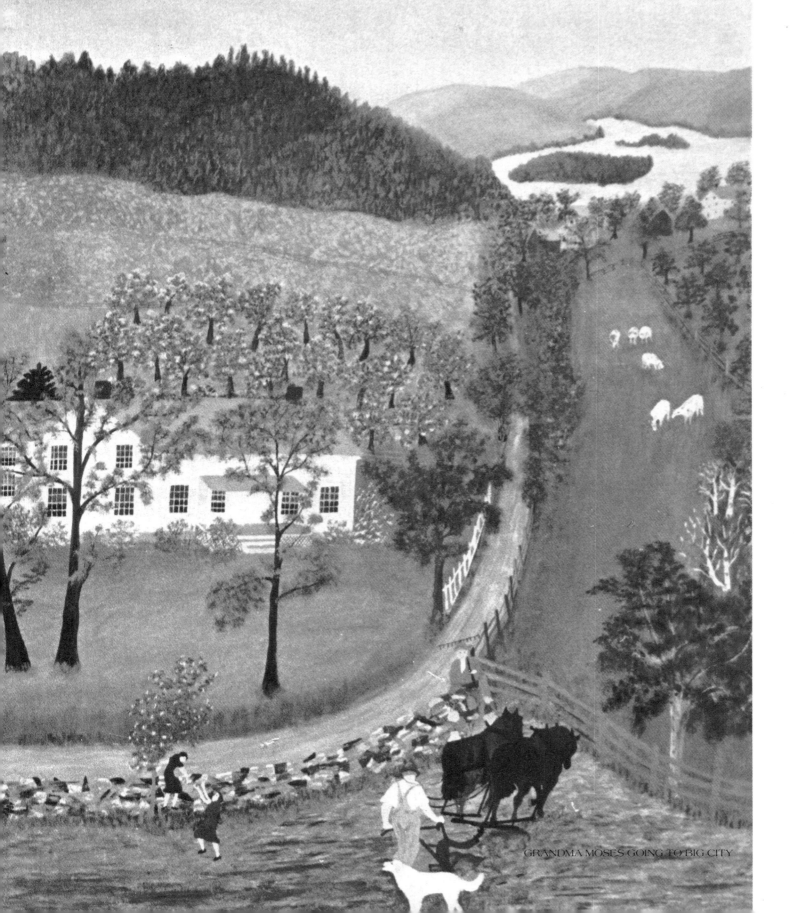

GRANDMA MOSES GOING TO BIG CITY

THE BIG ROCK CANDY MOUNTAIN

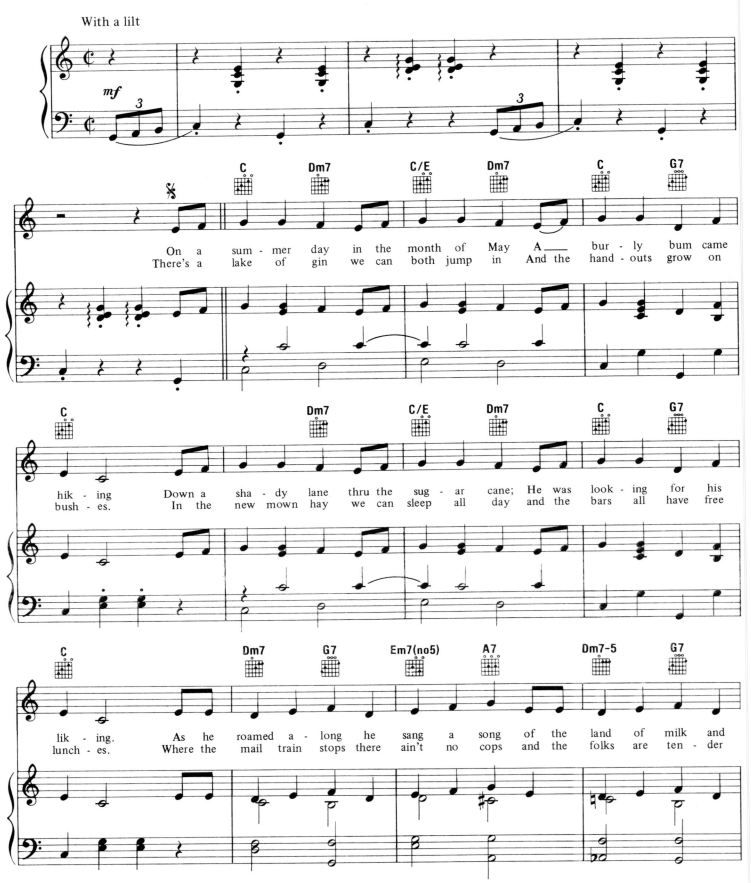

On a sum - mer day in the month of May A___ bur - ly bum came
There's a lake of gin we can both jump in And the hand - outs grow on

hik - ing. Down a sha - dy lane thru the sug - ar cane; He was look - ing for his
bush - es. In the new mown hay we can sleep all day and the bars all have free

lik - ing. As he roamed a - long he sang a song of the land of milk and
lunch - es. Where the mail train stops there ain't no cops and the folks are ten - der

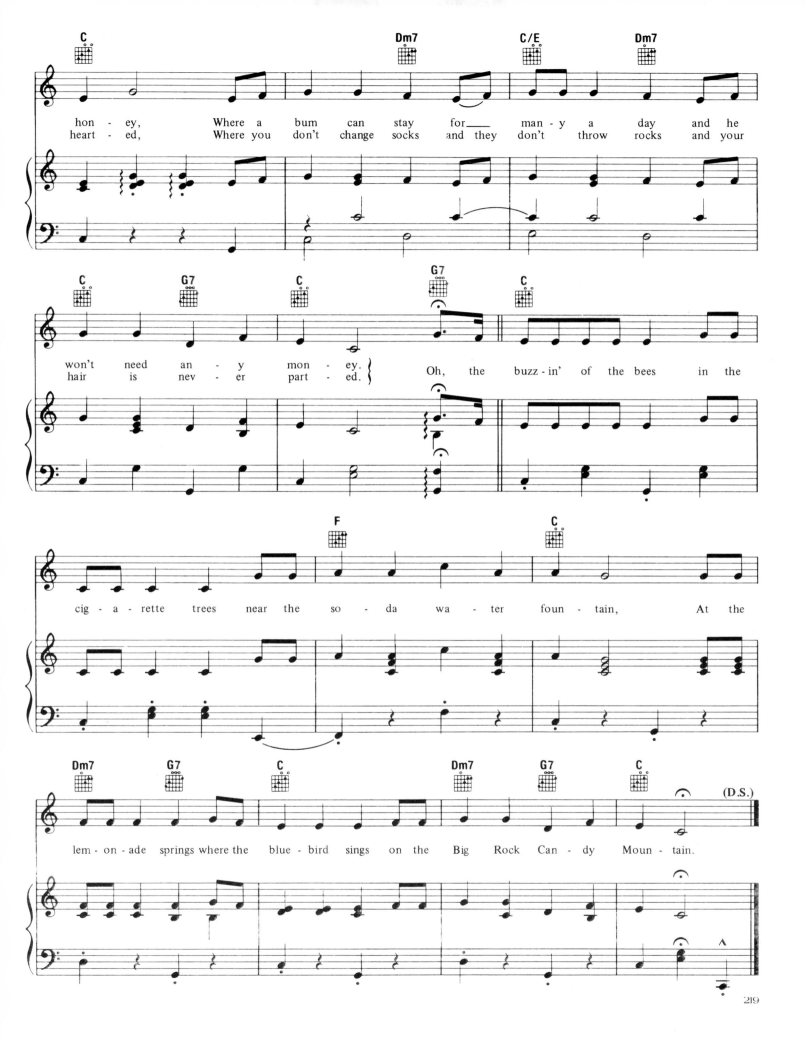

honey, Where a bum can stay for___ man-y a day and he
heart-ed, Where you don't change socks and they don't throw rocks and your

won't need an-y mon-ey.
hair is nev-er part-ed. } Oh, the buzz-in' of the bees in the

cig-a-rette trees near the so-da wa-ter foun-tain, At the

lem-on-ade springs where the blue-bird sings on the Big Rock Can-dy Moun-tain.

(D.S.)

DO-RE-MI

Words by Oscar Hammerstein II
Music by Richard Rodgers

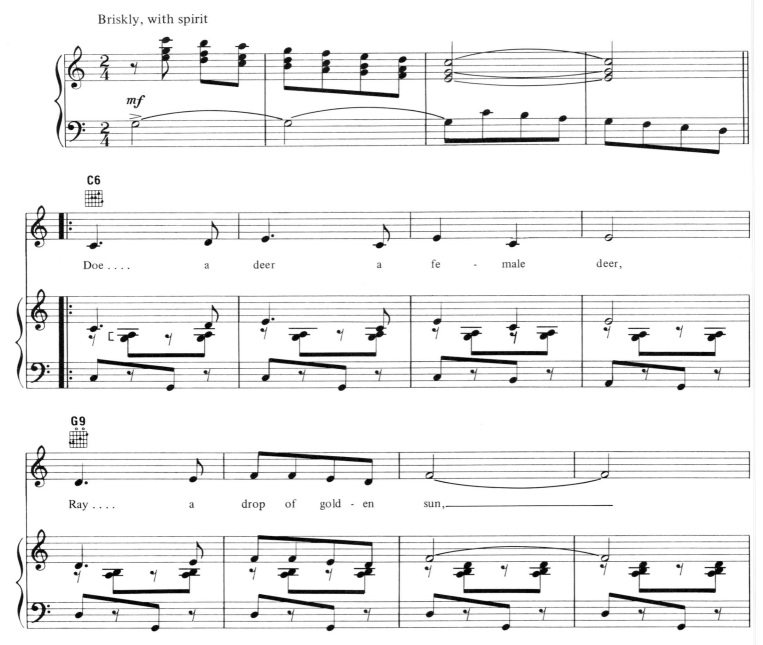

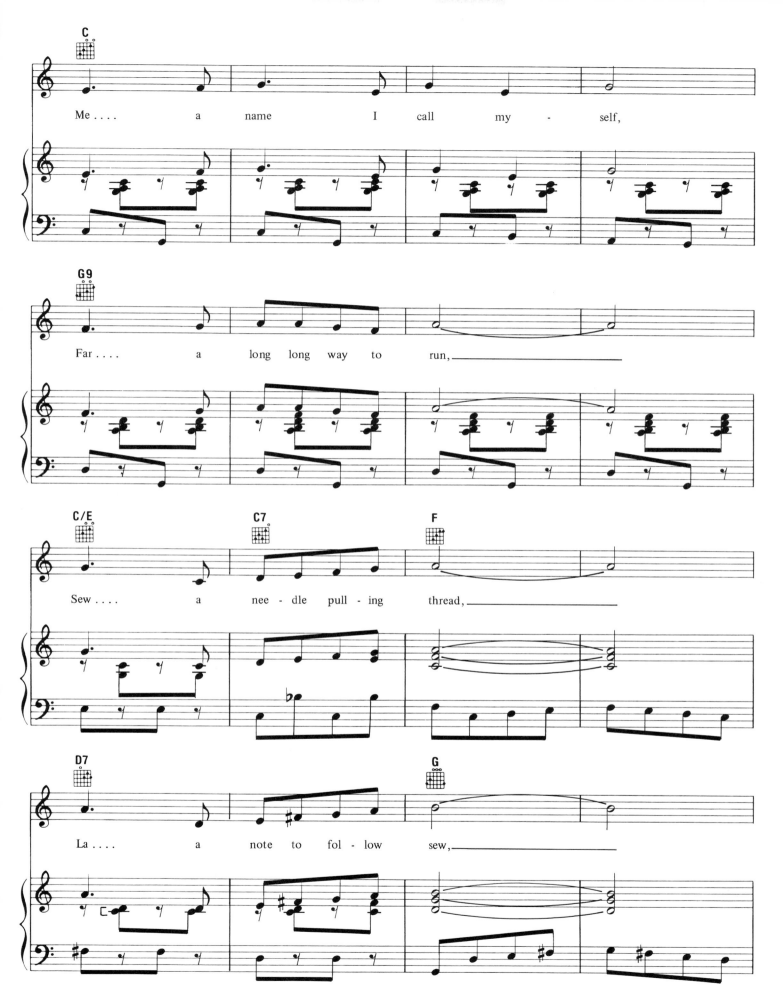

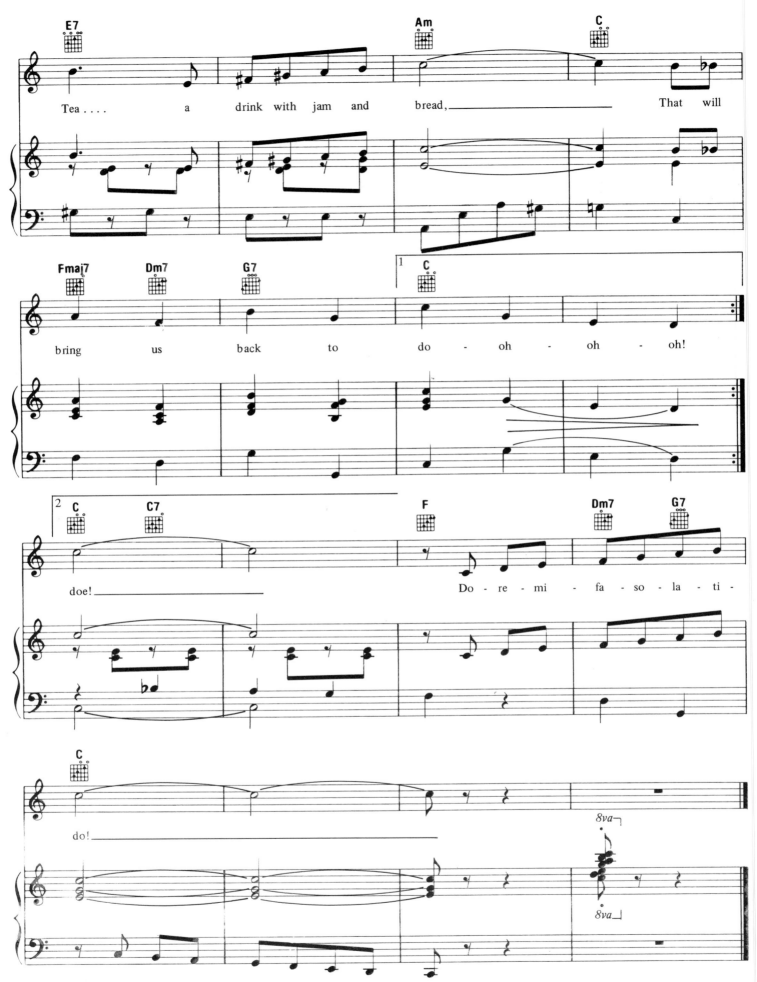

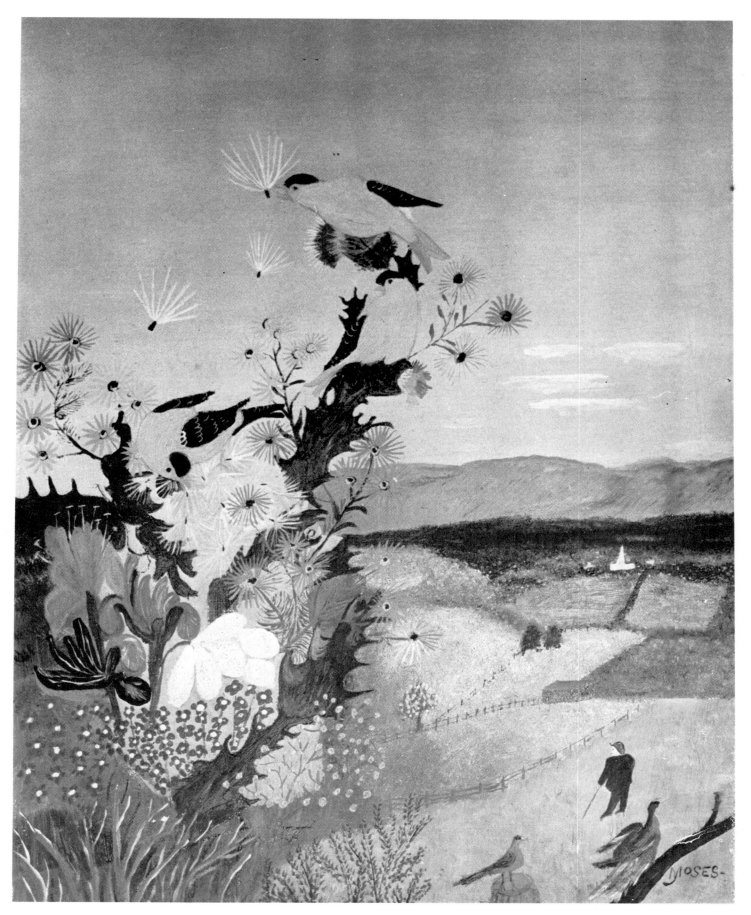

THE YELLOW BIRDS

FROSTY THE SNOW MAN

Words and music by Steve Nelson and Jack Rollins

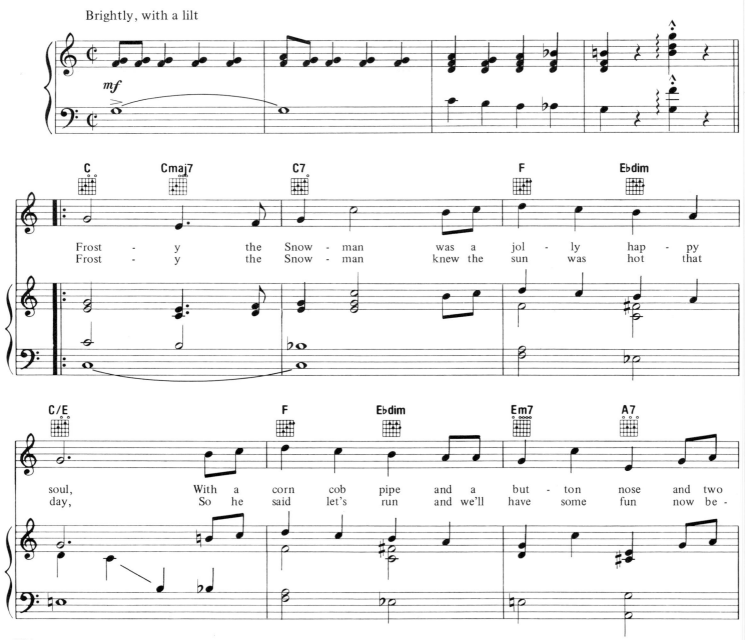

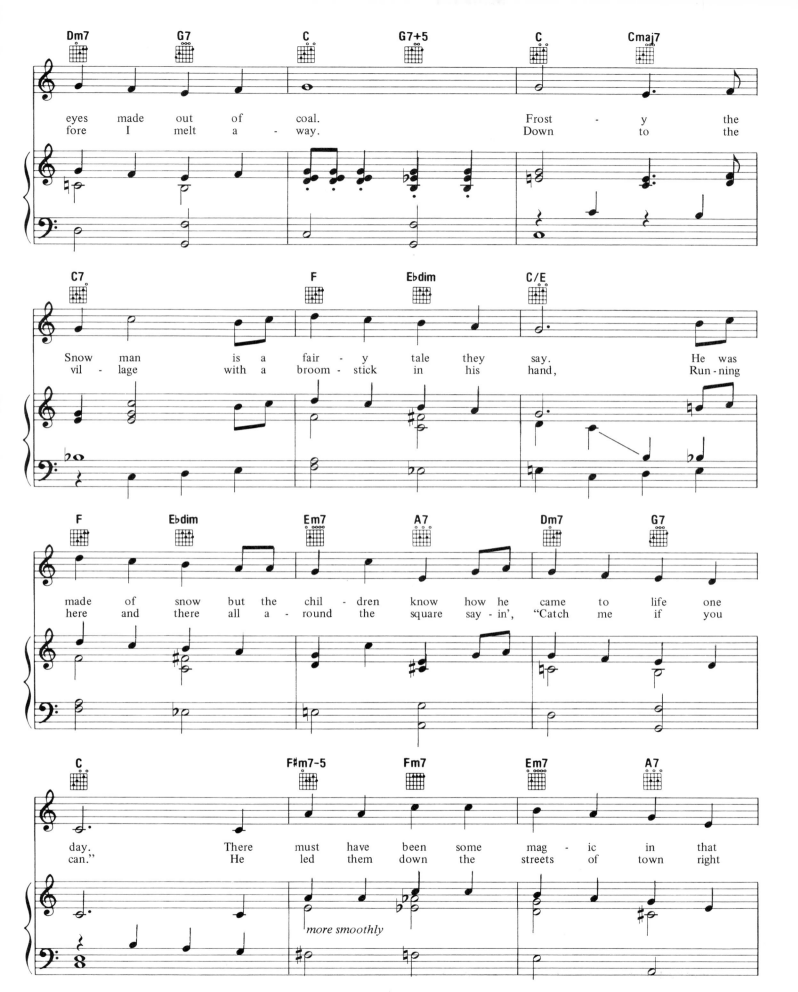

Dm7 G7 C G7+5 C Cmaj7

eyes made out of coal. Frost - y the
fore I melt a - way. Down to the

C7 F E♭dim C/E

Snow man is a fair - y tale they say. He was
vil - lage with a broom - stick in his hand, Run - ning

F E♭dim Em7 A7 Dm7 G7

made of snow but the chil - dren know how he came to life one
here and there all a - round the square say - in', "Catch me if you

C F#m7-5 Fm7 Em7 A7

day. There must have been some mag - ic in that
can." He led them down the streets of town right

more smoothly

225

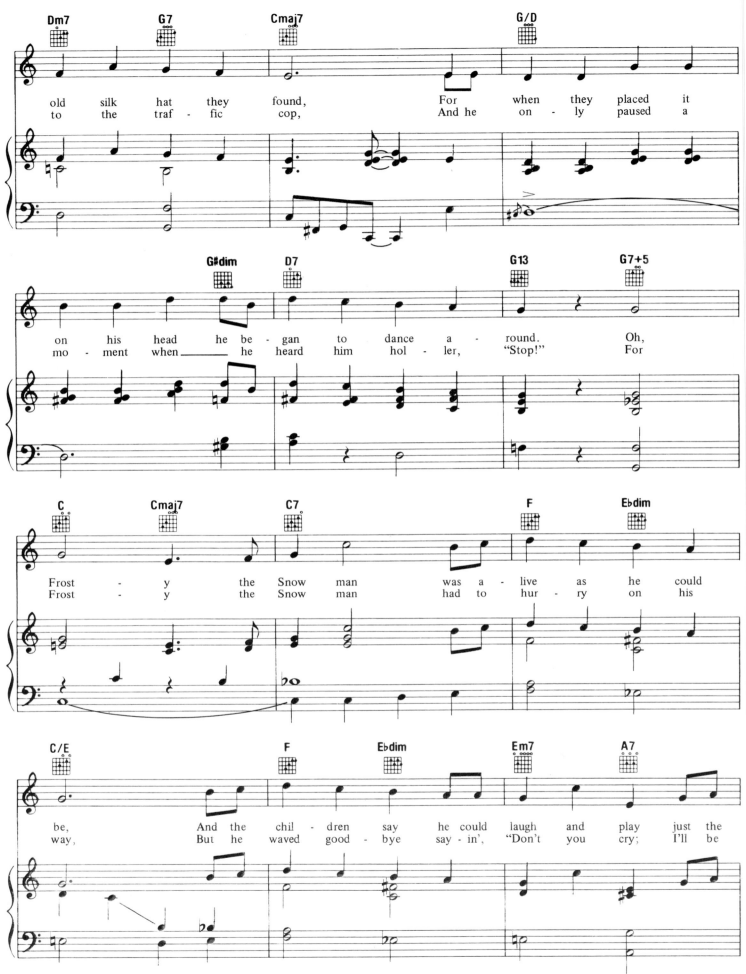

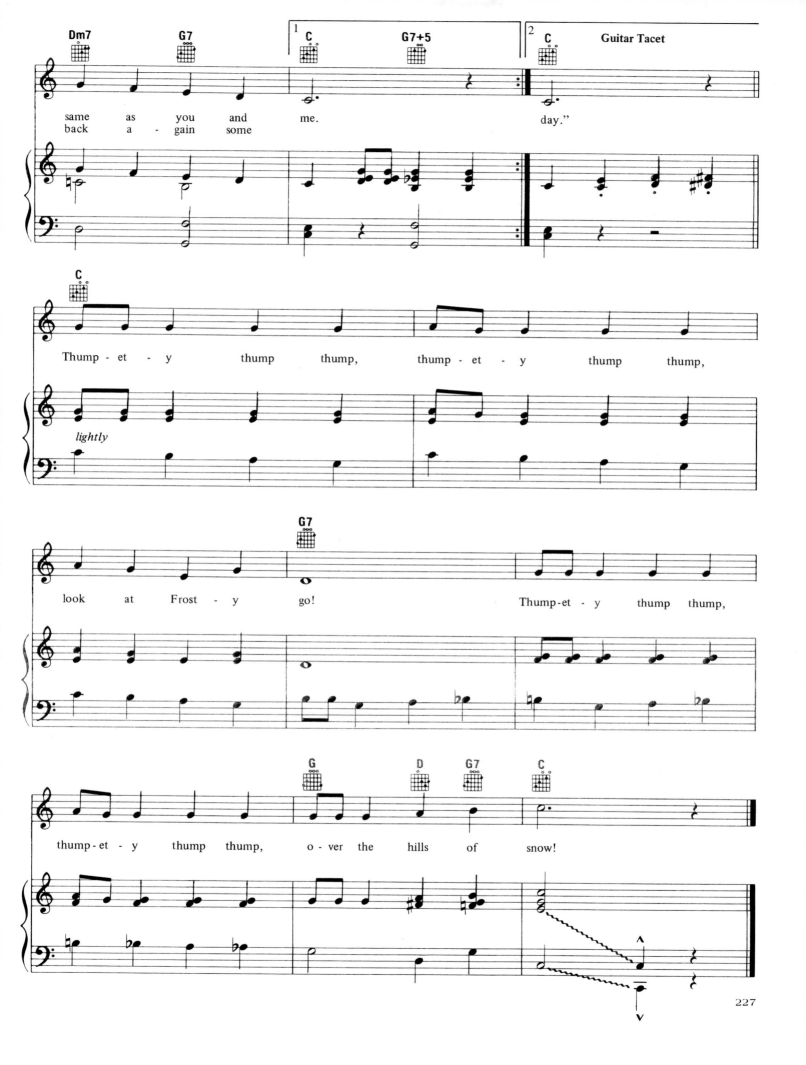

same as you and me.

back a - gain some day."

Thump - et - y thump thump, thump - et - y thump thump,

lightly

look at Frost - y go! Thump - et - y thump thump,

thump - et - y thump thump, o - ver the hills of snow!

I DON'T WANT TO PLAY IN YOUR YARD

Words by Philip Wingate
Music by H.W. Petrie

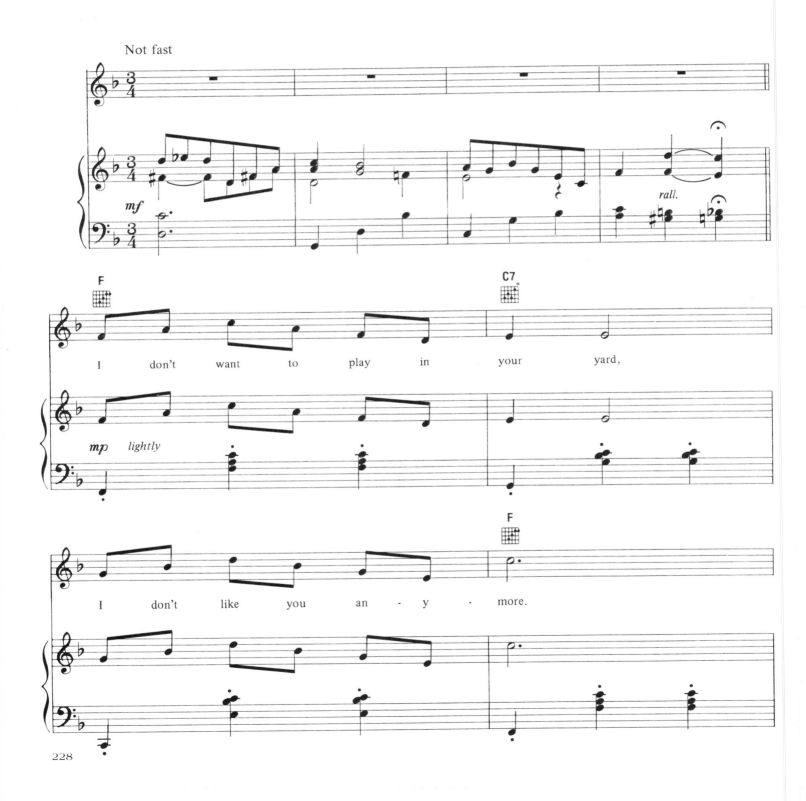

I don't want to play in your yard, I don't like you an - y - more.

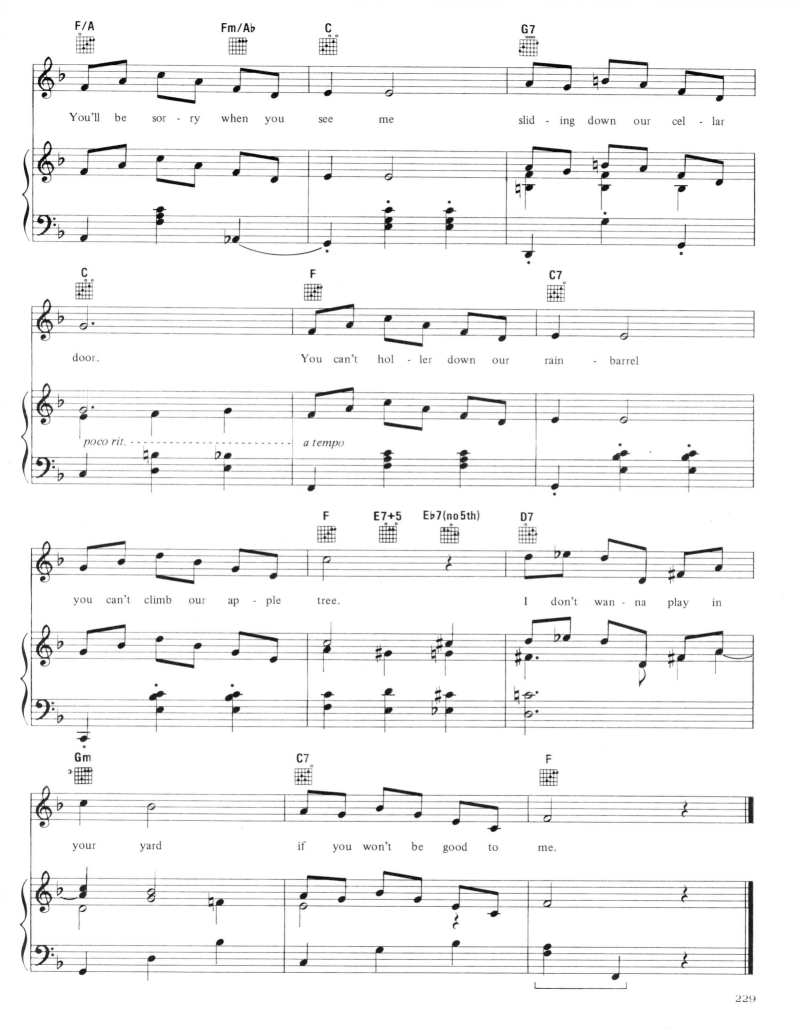

You'll be sor-ry when you see me slid-ing down our cel-lar door. You can't hol-ler down our rain-barrel you can't climb our ap-ple tree. I don't wan-na play in your yard if you won't be good to me.

JACK AND JILL

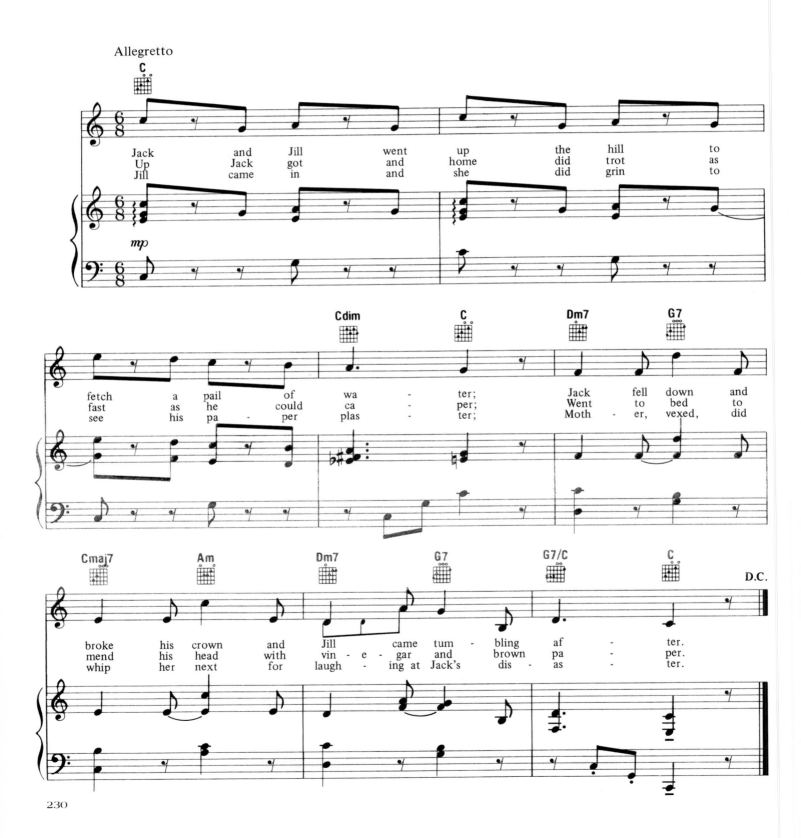

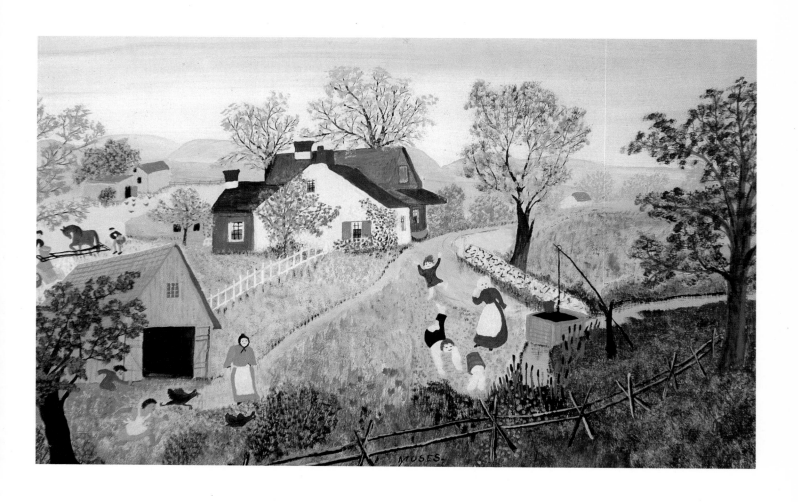

JACK AND JILL

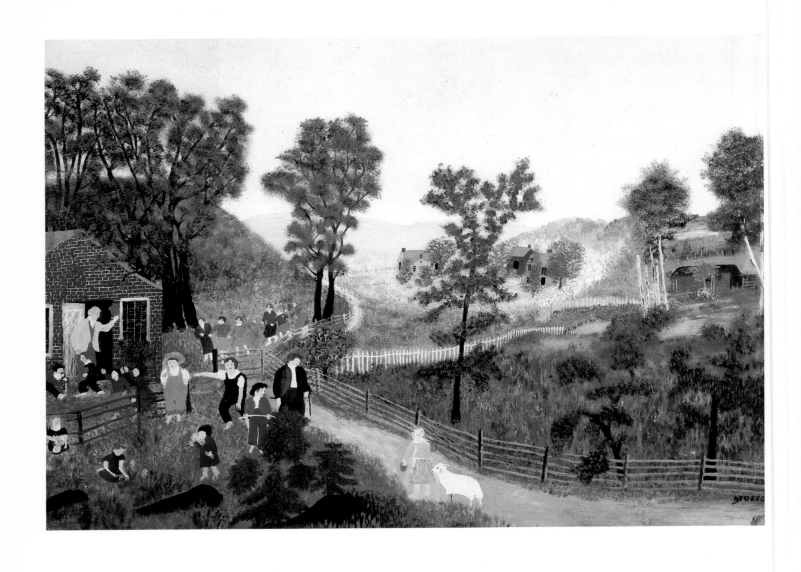

MARY AND LITTLE LAMB

MARY HAD A LITTLE LAMB

Words by Sarah J. Hale

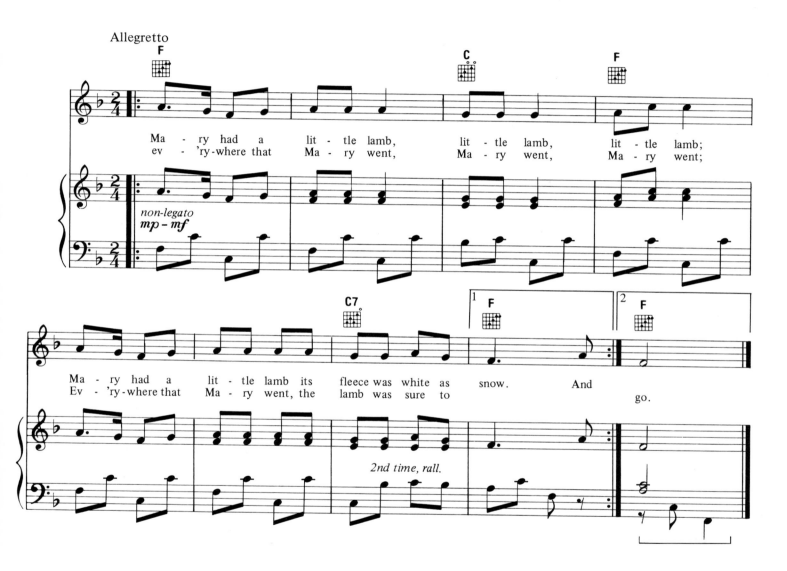

3. It followed her to school one day,
 School one day, school one day.
 It followed her to school one day
 Which was against the rule.

4. It made the children laugh and play,
 Laugh and play, laugh and play.
 It made the children laugh and play
 To see a lamb at school.

5. So the teacher turned it out,
 Turned it out, turned it out.
 So the teacher turned it out,
 But still it lingered near.

IN MY MERRY OLDSMOBILE

Words by Vincent Bryan
Music by Gus Edwards

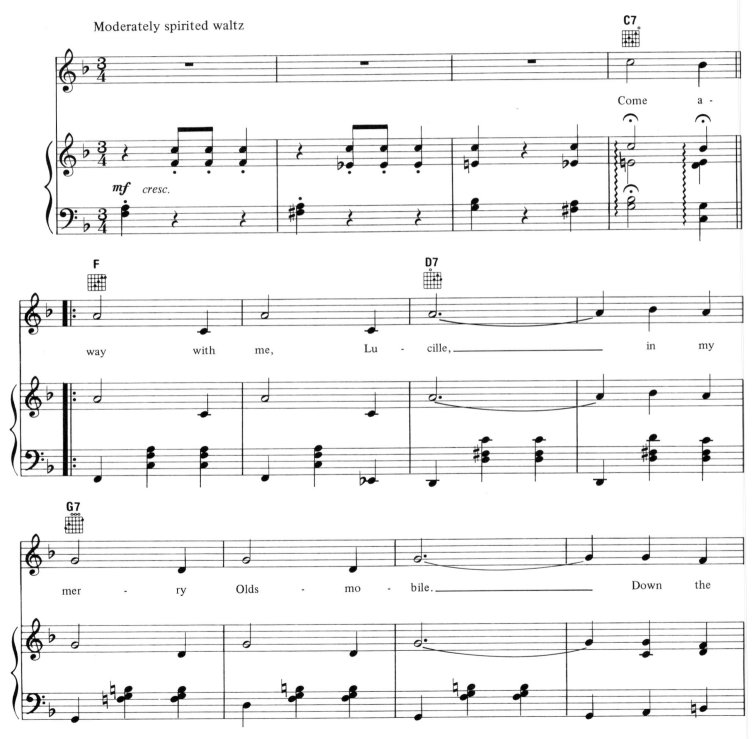

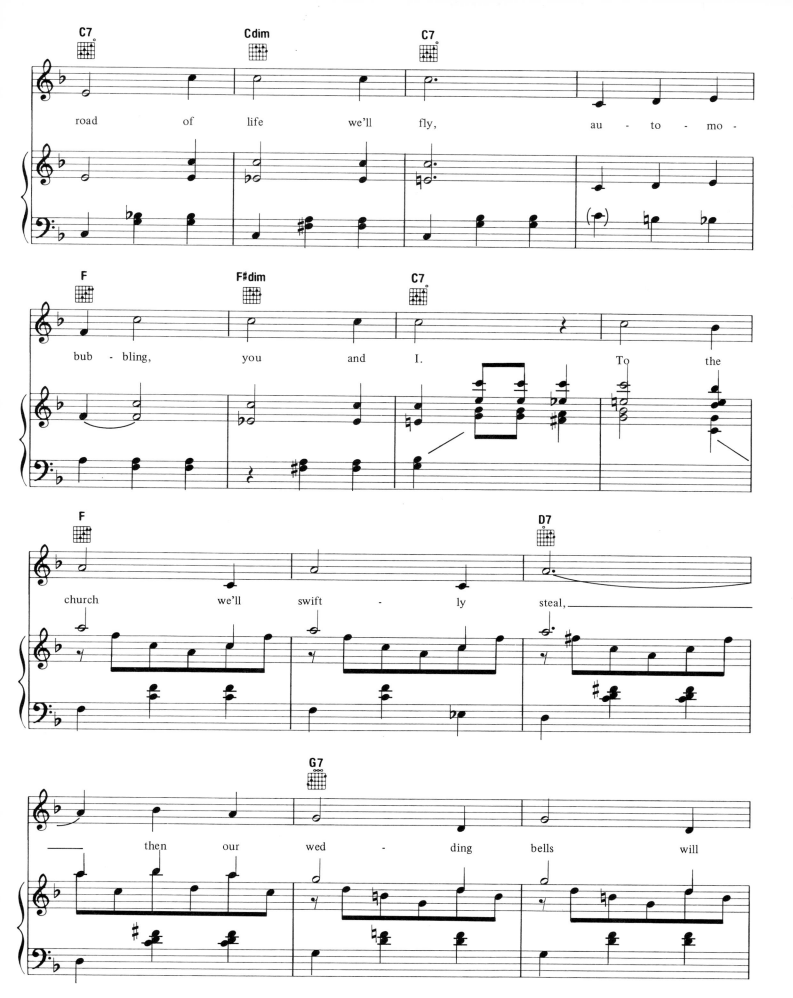

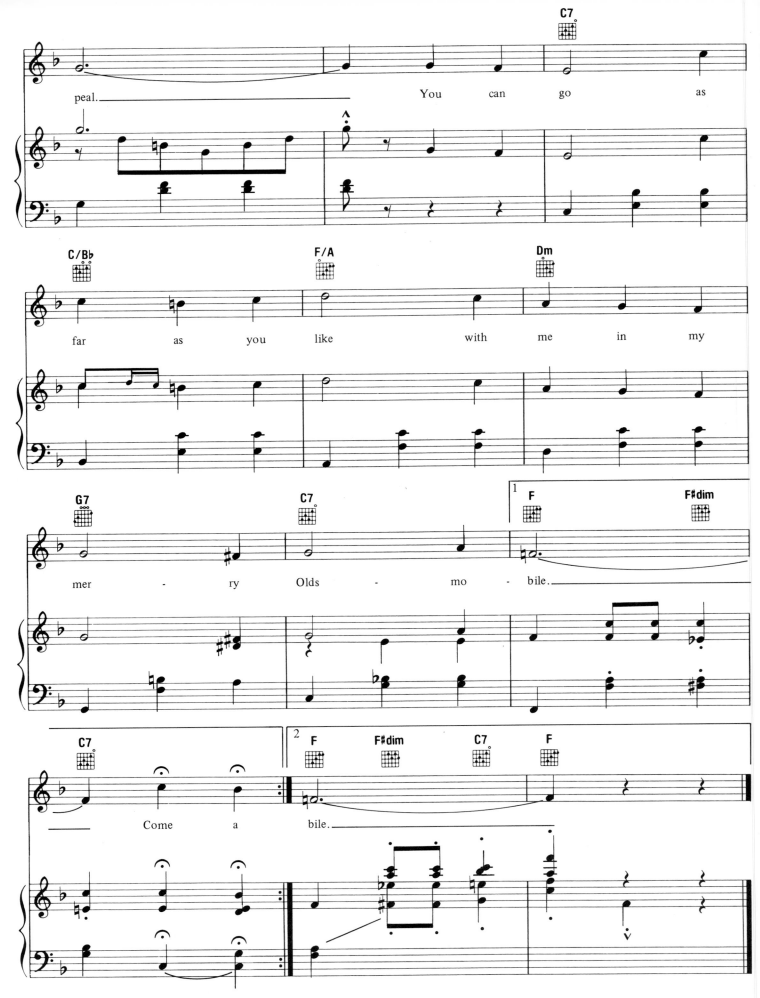

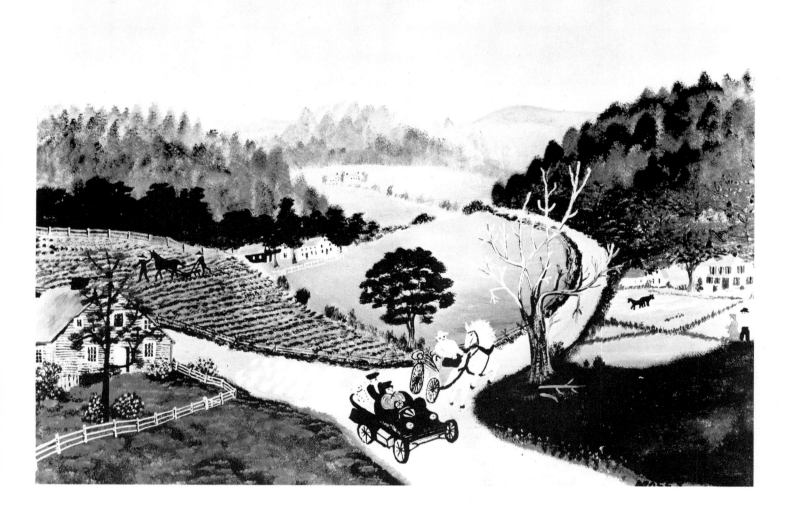

THE OLD AUTOMOBILE

THE SKATERS

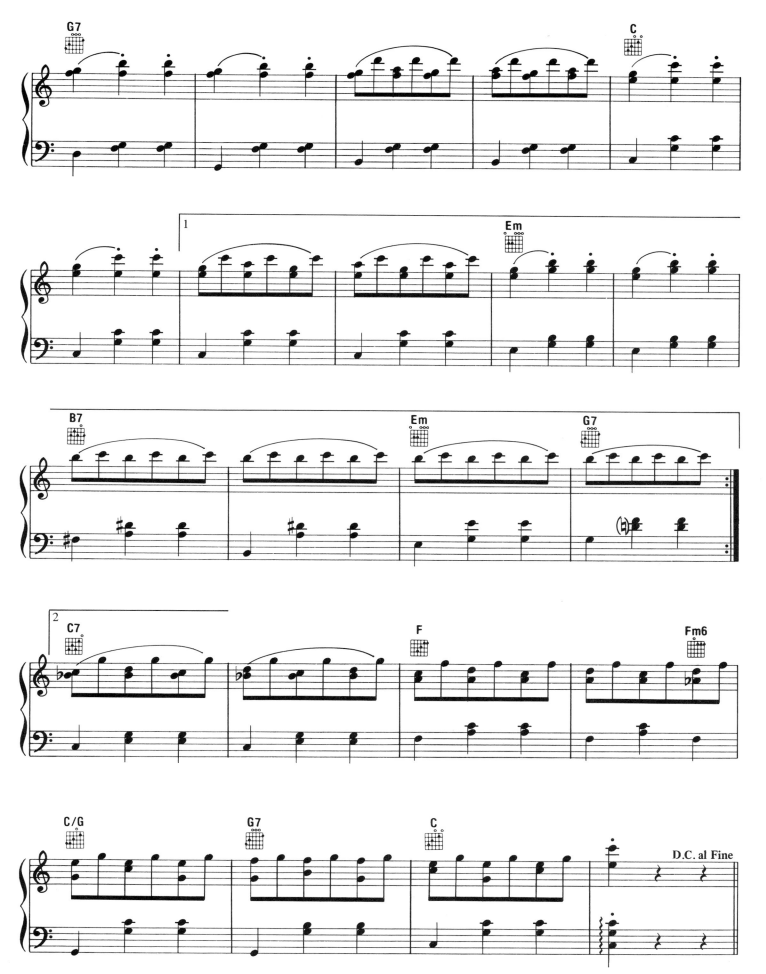

239

LITTLE BROWN JUG

Words and music by Eastburn (Joseph Eastburn Winner)

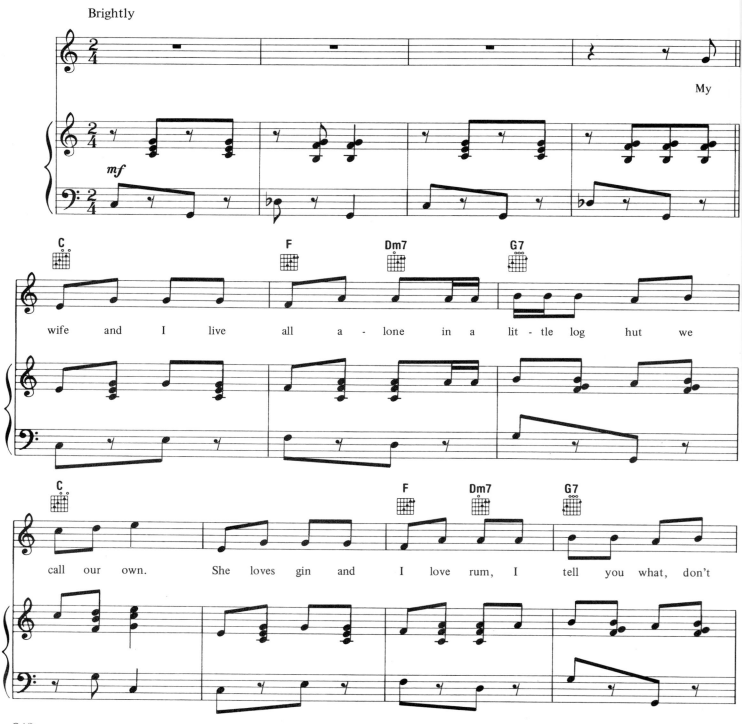

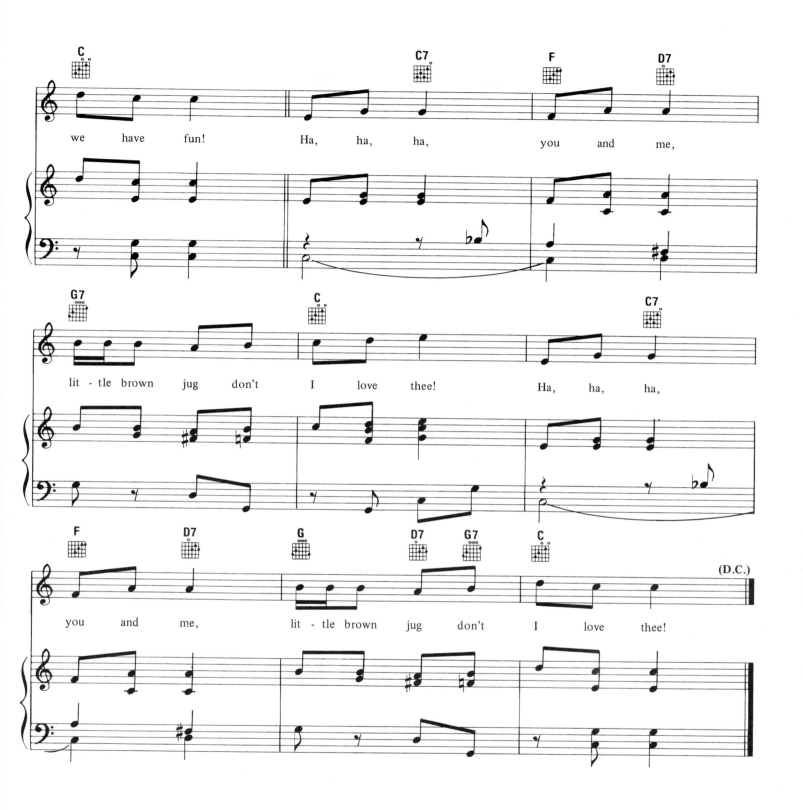

2. 'Tis you who makes my friends my foes,
 'Tis you who makes me wear old clothes,
 Here you are so near my nose,
 So tip her up and down she goes.

4. If all the folks in Adam's race,
 Were gather'd together in one place,
 Then I'd prepare to shed a tear,
 Before I part from you, my dear.

3. When I go toiling to my farm,
 I take little brown jug under my arm
 I place it under a shady tree,
 Little brown jug 'tis you and me.

5. If I'd a cow that gave such milk
 I'd clothe her in the finest silk;
 I'd feed her on the choicest hay,
 And milk her forty times a day.

THE TREE IN THE WOOD

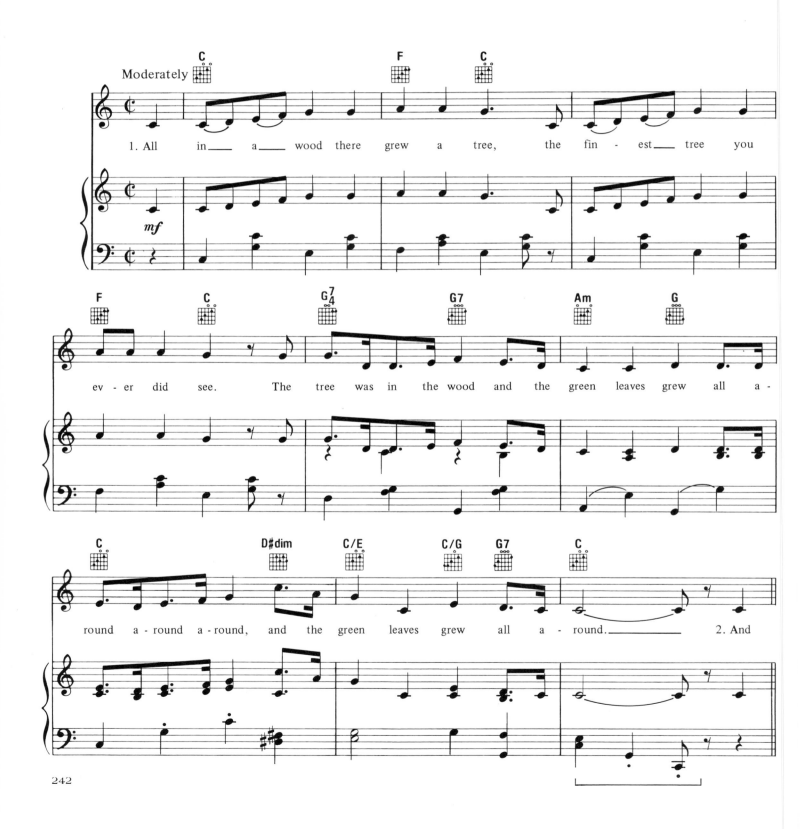

Moderately

1. All in____ a____ wood there grew a tree, the fin - est____ tree you

ev - er did see. The tree was in the wood and the green leaves grew all a -

round a - round a - round, and the green leaves grew all a - round.____ 2. And

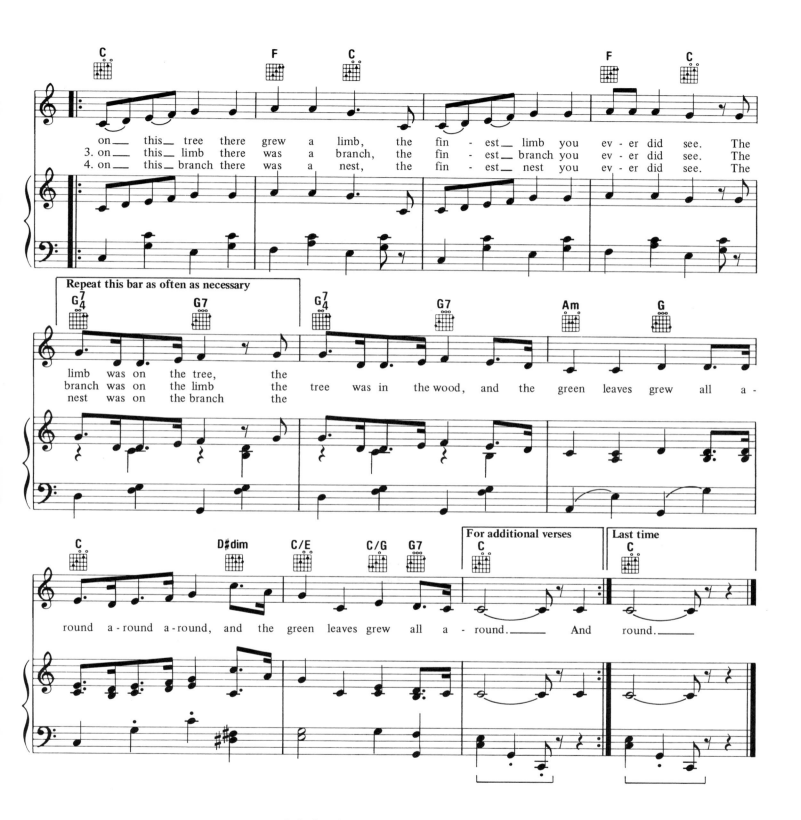

5. And in this nest there was an egg, etc.

6. And in this egg there was a bird, etc.

7. And on this bird there was a wing, etc.

8. And on this wing there was a feather, etc.

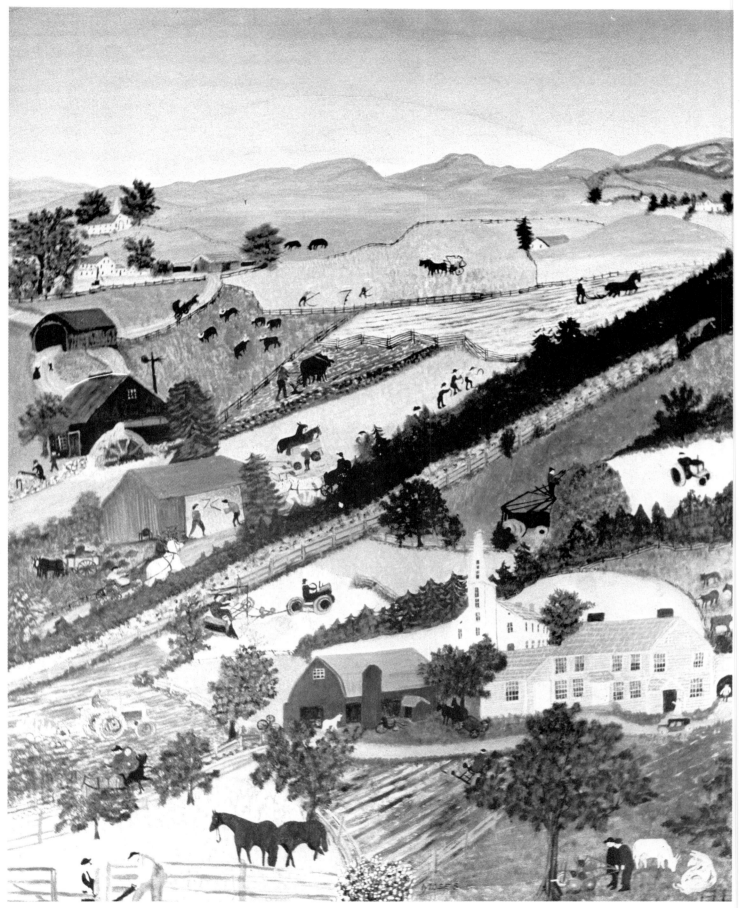

YEAR 1860 AND YEAR 1940

TITLE INDEX

Anna Mary Robertson Moses, famous as "Grandma Moses," was born in 1860 in New York State and died there (at Eagle Bridge) in 1961, but spent twenty years in Virginia, where her ten children were born. Her education, in a one-room schoolhouse, ended when she was twelve, and she worked as a hired girl until her marriage to a farmer. She lived all her life on a farm and began to paint only after her husband had died and her five surviving children were grown. She was then in her seventies. Her pictures of life in rural America, the changing seasons, and the daily chores and pleasures of farming, have met with ever-wider response in the years since her first solo exhibition, held in 1940 at the Galerie St. Etienne in New York.

Dan Fox has long been active on the New York music scene. He has arranged songs for some of the greatest pop stars of the last twenty years and has also arranged and edited many of the most successful songbooks, as well as scores of instruction books, choral works and band pieces. In his specially commissioned arrangements of the music for The Grandma Moses Songbook, he has admirably succeeded in making the songs relatively simple to play while at the same time retaining their effectiveness and tonal color.